Site-Writing
The Architecture of Art Criticism

For Alan and Beth

Site-Writing
The Architecture of Art Criticism

JANE RENDELL

I.B. TAURIS
LONDON · NEW YORK

Published in 2010 by I.B.Tauris & Co Ltd
6 Salem Road, London W2 4BU
175 Fifth Avenue, New York NY 10010
www.ibtauris.com

Distributed in the United States and Canada Exclusively by Palgrave Macmillan
175 Fifth Avenue, New York NY 10010

ISBN: 978 1 84511 999 7

A full CIP record for this book is available from the British Library
A full CIP record is available from the Library of Congress

Library of Congress Catalog Card Number: available

Printed and bound in Spain from camera-ready copy edited and supplied by the author.

Contents

Images

Configuration 2

Configuration 5

Serpentine Gallery, London, 2002. Photograph: Stephen White. Reproduced with kind permission of Serpentine Gallery.

77 Marc Quinn, *Alison Lapper Pregnant* (2005). Photograph: 237
Cornford & Cross, 2007.

78 A composite image comprising top left and right: two stills 239
from Sigfrido Ranucci and Maurizio Torrealto, *Fallujah: The Hidden
Massacre*, shown in Italy on RAI on 1 November 2005, http://www.
youtube/com/watch?v=WbuiHYdwU (accessed 21 June 2008)
reproduced with kind permission of Sigfrido Ranucci; bottom left,
Marc Quinn, *Alison Lapper Pregnant* (2005). Photograph: Cornford
& Cross, 2007; bottom right: George Cannon Adams, *General Sir
Charles James Napier* (1855). Photograph: Cornford & Cross, 2007.

Epilogue

79 Moonrock brought to earth by Apollo 11 in 1969. Object 244
Number: NG-1991-4-25. Collection: Rijksmuseum, Amsterdam.
Reproduced with kind permission of the Rijksmuseum,
Amsterdam.

80 *The Blue Marble*. View of the Earth as seen by the Apollo 17 crew 247
travelling towards the moon. This image was taken on 7 December
1972. NASA still images are not copyrighted. This image was
reproduced from the NASA website: http://veimages.gsfc.nasa.
gov/1597/AS17-148-22727_Irg.jpg (accessed 9 July 2008).

Acknowledgements

Site-Writing has been configured across the passage that divides and connects inner concerns and outer imperatives, through voices that are intimate but respond to broader political issues. The book endeavours to *write sites of art* – artworks certainly, but people too – artists, curators, editors – and places – galleries, books, trains, memories, dreams. This architecture of art criticism has been constructed out of genres that write and those that inspire writing – conversations, dialogues, essays, papers, walks, talks.

More than anything else this book is a response to others and their invitations to write and speak about art and its relation to architecture, culture, criticism and theory. So I would like to thank all those who have brought me out of myself: Karly Allen, Maria Alicata, Daniel Arsham, Suzi Attiwell, Vardan Azatyan, Domo Baal, Matthew Barac, Kathy Battista, Brandon LaBelle, David Blamey, Bik Van Der Pol, Katarina Bonnevier, Louise Braddock, brook & black, Nick Brown, Jemima Burrill, Cecilia Canziani, Alex Coles, David Cottingham, David Cunningham, Claire Doherty, Bobbie Entwistle, Miren Eraso, Elvan Altan Ergut, Murray Fraser, Hélène Frichot, Maria Fusco, Mark Garcia, Louise Garrett, Johnny Golding, Katja Grillner, Dorita Hannah, Angela Harutyunyan, Hawkins\Brown, Felipe Hernandez, Hilde Heynen, Jonathan Hill, Helen Hills, Daniel Hinchcliffe, Rolf Hughes, Popi Iacovou, Mary Jacobus, Vitor Oliveira Jorge, Kari Jormakka, Nazareth Karoyan, Sharon Kivland, Amy and Perry Kulper, Sasa Lada, Gini Lee, Junghee Lee, Oren Lieberman, Stephen Loo, Joni Lovenduski, Felicity Lunn, Jane McAllister, Lesley McFadyen, Brigid McLeer, Katy McLeod, Martina Margetts, Doreen Massey, Marsha Meskimmon, Malcolm Miles, Alicia Miller, Guillermo H. Garma Montiel, Joanne Morra, Sabine Nielson, Rosa Nguyen, Belgin Turan Ozkaya, Mike Pearson, Doina Petrescu, Steve Pile, David Pinder, Karine Pradier, Julieanna Preston, Malcolm Quinn, Shirin Rai, Heike Roms, Gillian Rose, Judith

Rugg, Ralph Rugoff, Michael Rustin, Ingrid Ruudi, Naomi Segal, Meike Shalk, Paul Shepheard, Paulette Singley, Marquard Smith, Sally Tallant, Jeremy Till, Jane Tormley, Elisabeth Tostrup, Igea Troiani, Gavin Wade, Linda Marie Walker, Maria Walsh, Neil Wenman, Richard Williams, Jules Wright and Gillian Whiteley.

At the Bartlett School of Architecture, UCL, my research interests have evolved into a pedagogical programme in which modes of working adopted from the studio spatialize writing processes, resulting in creative propositions in textual form that critique and respond to specific sites. This approach has been taken up, on and out into the world by wonderful students like Ana Araujo, Nick Beech, Lilian Chee, Willem de Bruijn, Sophie Handler, Teresa Hoskyns, Lucy Leonard, Kristen Krieder, Zoe Quick, Aslihan Senel, Juliet Sprake, Sant Suwatcharapinun, Robin Wilson, Ivana Wingham and many more, whose responses to the suggestion offered by 'site-writing' have been invaluable in the development of my own work. So too has the supportive and adventurous spirit of colleagues engaged in similar endeavours of their own: Penny Florence, Penelope Haralambidou, Jonathan Hill, Sharon Morris and Yeoryia Manolopoulou. The scholarship and friendship of Iain Borden, Ben Campkin, Adrian Forty and Barbara Penner have been really important to me, and when the going got tough my conversations with Rob Holloway, Brigid McLeer and Peg Rawes heartened me with their unique blend of art, philosophy and poetry, and perhaps more importantly pizza and wine.

Every effort has been made to contact copyright holders for permission to reprint material in this book. The publishers would be grateful to hear from any copyright holder who is not acknowledged here and will undertake to rectify any errors or omissions in future editions of the book. And I would personally like to thank all those who have so kindly given permission to reproduce texts and images in this volume.

I am grateful to UCL for funding a sabbatical period solely dedicated to working on this manuscript and for supporting my amazing time as a Visiting Fellow at CRASSH, at the University of Cambridge, where Mary Jacobus was an inspirational host and I found such valuable interlocutors as Willard Bohn, Becky Conekin, Garry Hagberg, Rukmini Bhaya Nair, Jennifer Richards and Laurence Simmons. I would like to acknowledge the support of the AHRC, whose Research Leave Scheme has provided an incredibly precious resource for academics, allowing a period of sustained focus for sole-authored projects like this to finally come to completion. The AHRC also funded *Spatial Imagination in Design*, a research cluster I directed in 2005–06 that created a valuable forum for making work at an earlier stage. Finally I would like to thank my publishers I.B. Tauris, especially Jayne Ansell, Philippa Brewster, Susan Lawson and Stuart Weir for supporting this book, Wendy Toole for her meticulous attention to the text, Visual Aspects for their professional work on the images and Penelope Haralambidou for her warm enthusiasm, creative suggestions and skilful design.

My parents' decision to work and raise their family in the Middle East has been the impetus for this book. Freya arrived in the middle. Nigel we lost at the end. David has been there for me throughout. This book is for them.

Prologue

Pre-Positions

If, following cultural critic Mieke Bal's definition, 'art-writing' is a mode of criticism which aims to 'put the art first',[1] then *Site-Writing: The Architecture of Art Criticism* aims to put the sites of engagement with art first. These include the sites – material, emotional, political and conceptual – of the artwork's construction, exhibition and documentation, as well as those remembered, dreamed and imagined by the artist, critic and other viewers. *Site-Writing* explores these sites of engagement through five different spatial configurations, each one both architectural and psychic.

In conducting 'close readings' of specific artworks, Bal recognizes the important role that architecture plays in encounters with art. In her book on Louise Bourgeois's *Spider*, in which she coins the wonderful phrase 'the architecture of art-writing', from which this book draws its subtitle,[2] she approaches the 'architecturality' of the work through narrative. In a discussion around her more recent essay on artist Doris Salcedo, Bal has referred to architecture's role in creating the 'context' for art.[3] *Site-Writing* extends these tempting propositions into the construction of texts – essays and installations – architectures of art criticism – that write the sites of this critic's encounters with artworks by artists as diverse as Jananne Al-Ani, Elina Brotherus, Nathan Coley, Tracey Emin, Cristina Iglesias and Do-Ho Suh.

Informed by my background in architectural design, followed by research in architectural history, and then a period teaching public art, my writing has evolved through examinations of particular interdisciplinary meeting points – feminist theory and architectural history, conceptual art practice and architectural design, and most recently art criticism,

psychoanalysis and autobiography.[4] Although my aim remains constant
– to articulate the position of the writing subject and her choice of objects
of study and subject matters, processes of intellectual enquiry and creative
production – over time my methods have transformed from writing a feminist
Marxist critique of the gendering of architectural space in nineteenth-
century London to my current site-writing project where the boundary
between subjects and objects is more porous and arguments are made not
only directly, but indirectly, through association and implication.[5]

Art and Architecture: A Place Between marked a transition, where, through
the process of writing *about* critical spatial practice – a theorized account
of a series of projects located between art and architecture – I realized that
the changing positions I occupied in relation to art, architecture and theory
– physical as well as ideological, private as well as public – informed my
critical attitude.[6] I concluded *Art and Architecture* by arguing that criticism
is a form of critical spatial practice in its own right. *Site-Writing* picks up
where *Art and Architecture* left off, shifting the focus from a place between art
and architecture to the sites between critic and work.

Site-Writing explores the position of the critic, not only in relation to
art objects, architectural spaces and theoretical ideas, but also through
the site of writing itself, investigating the limits of criticism, and asking
what it is possible for a critic to say about an artist, a work, the site of a
work and the critic herself and for the writing to still 'count' as criticism.[7]
Site-Writing is composed of a series of texts developed over the last ten
years – some newly authored, others radically transformed for this volume.
The culmination of this research is set within an inter-, or perhaps intra-,
disciplinary framework that reinvigorates the concepts, processes and
subjects of art criticism through the use of spatial terms – psychoanalytic
concepts and architectural conditions. While a number of critics have
written about situated practice, including site-specific art,[8] as well as the
importance of location in feminist and postcolonial art,[9] this book argues
for and attempts to produce a form of art criticism which is *itself* a form of
situated practice.

Situated Criticism

Over the past twenty years feminism, postcolonial studies and human
geography have increasingly focused on issues of identity, difference
and subjectivity. With words such as 'mapping', 'locating', 'situating',
'positioning' and 'boundaries' appearing frequently, the language of these
texts is highly spatialized. Discussions of new ways of knowing and being
are articulated through spatial terms, developing conceptual and critical
tools such as 'situated knowledge' and 'standpoint theory' for examining
the relationship between the construction of subjects and the politics of
location.[10] The work of feminist philosopher Rosi Braidotti exemplifies this
attitude beautifully; for her the figure of the 'nomadic subject' describes

not only a spatial state of movement, but also an epistemological condition, a kind of knowingness (or unknowingness) that refuses fixity.[11]

In art practice, while minimalism brought to the fore the role of the viewer's perception in producing the work, since minimalism art, notably that which derives from feminism and postcolonialism, has developed a more sophisticated understanding of how the viewer's experience, comprising both perception *and* conception, varies according to cultural identity and geographic location, and has an intimate as well as public dimension. Most recently what has been termed relational or dialogical art has focused on how the viewer's interaction, participation and collaboration is central to the production of art's aesthetic dimension.[12] However, debates around the position of the critic as a specific kind of art viewer are only just beginning to be worked through.

Umberto Eco in his classic essay from 1962, 'The Poetics of the Open Work',[13] argued that the 'poetics of the work in movement … installs a new relationship between the contemplation and the utilization of a work of art', so setting in motion the important notion that a work might be used as well as contemplated. The interesting relation between viewing and using that Eco's proposition provokes is played out differently depending on the art form in question. For example, it comes as no surprise to a discipline like architecture, where, owing to its role as a social art, and emphasized by the functionalist discourse of modernism, use has long been established as the dominant form of engagement with a building.[14]

That Eco's comments come out of his reflection on music helps to explain his adoption of the terms 'performer' and 'interpreter' in this text. In a footnote he notes that 'for the purposes of aesthetic analysis, however, both cases can be seen as different manifestations of the same interpretive attitude'.[15] It is precisely these differences in interpretative attitudes and their performative manifestations that interest me in *Site-Writing*, produced as they are according to the distinctive locations of interpretation and the varying distances and conditions of responsibility interpreters and performers have in relation to authors and audiences. This observation is of special relevance to art criticism today since it draws attention to the various types of art interpreter and performer and the specific sites of their engagement with art, from the curator to the collector, from the critic to the invigilator, from the viewer who has visited the work once to the user who has read the catalogue a thousand times from a million miles away. In *Site-Writing* I consider the critic to be a particular kind of art *user*, since for me this term suggests a more active and inherently spatial role, one which includes the optic but which is not driven solely by the visual and which involves both interpretation and performance.

In arguing that the history of installation art needs to be based on the viewer's experience, art critic Claire Bishop has drawn attention to specific kinds of viewing subjects. She describes the tension between the activated spectator who in engaging with the work is understood to politically interact with the world, and the decentred experience favoured by feminist and

postcolonial artworks as a critique of dominance, privilege and mastery.[16] Bishop suggests that it is the 'degree of proximity between model subject and literal viewer' which may 'provide a criterion of aesthetic judgement for installation art'.[17] Although she does refer in passing to the processes of writing criticism in terms of the implications of not experiencing the work first-hand,[18] Bishop does not discuss the critic as a precise category of viewing subject. I suggest, however, that with his/her responsibility to 'interpret' and 'perform' the work for another audience, the critic occupies a discrete position as mediator between the artwork and Bishop's viewing and model subjects.

This is a point I will return to and elaborate later in relation to a discussion of the work of psychoanalyst Jean Laplanche, but for now I would just like to draw attention to the specificity of criticism's modes of viewing and using art and the part *situatedness* plays in determining the performance of that interpretative role. For my part, I am interested in criticism's spatial potential, in examining the kind of writing that emerges from acknowledging the specific and situated position of the critic. I shall now go on to explore how the special aspect of the critic's position as interpreter and performer of the work for others has been addressed in spatial terms.

When art critic Hal Foster discusses the need to rethink critical distance, he points to the different distances produced by the optical and the tactile, but warns of the dangers of both dis-identification and over-identification with the object of study.[19] Foster rejects those who lament the end of 'true criticality' as well as those who see critical distance as 'instrumental mastery in disguise'. However, despite advocating the need to think through questions of critical distance, Foster still proposes that the critic's role is to judge and make decisions without fully examining how these modes of operation are spatially conditioned.[20]

Also drawing attention to critical distance, but in response to literary works, Isobel Armstrong has closely examined the differences between close and distant reading. Armstrong distinguishes between a criticism of affect and one of analysis, but rejects the tendency to use a binary model to divide feeling and thought. Instead, Armstrong calls for affect to be included within rational analysis:

> *The task of a new definition of close reading is to rethink the power of affect, feeling and emotion in a cognitive space. The power of affect needs to be included within a definition of thought and knowledge rather than theorized as outside them, excluded from the rational.*[21]

Using highly spatialized language, Armstrong argues that it is the feeling/ thought binary which itself installs a form of critique where the subject is located in a position of power 'over' the text as other, producing a form of distant rather than close reading. She states that this form of reading rests

upon an account of the text as 'outside, something external which has to be grasped – or warded off'.[22]

Howard Caygill's study of the writings of Walter Benjamin presents a view of criticism that mobilizes spatial terms such as 'external' to examine how discriminations and judgements may be both partial and performed. Following his own reading of philosopher Immanuel Kant, Caygill asserts: 'It is axiomatic for immanent critique that the criteria of critical judgement be discovered or invented in the course of criticism.'[23] For Caygill, 'strategic critique shares with immanent critique the refusal to judge work according to given criteria' but rather to 'make discriminations while deferring judgement'.[24] Caygill maintains that there is 'no position outside the work from which the critic may judge it'; rather, a critic 'must find moments of externality within the work – those moments where the work exceeds itself, where it abuts on experience'.[25] These moments for making discriminate judgements are, although Caygill does not develop this aspect of his argument, intrinsically spatial:

> Strategic critique moves between the work and its own externality, situating the work in the context of experience, and being in its turn situated by it.[26]

In the introduction to his edited collection of essays *After Criticism*, Gavin Butt argues for something very similar.[27] Following Jacques Derrida's oft-quoted remark that 'there is no outside to the text', Butt claims that since there is no 'anterior vantage point set apart from criticism's object from which the task of critique could be launched', the postmodernist critic is 'always already imbricated in the warp and weft of the cultural text'.[28] Butt's book 'calls for the recognition of an "immanent", rather than a transcendent, mode of contemporary criticality' which, for Butt, following the work of Michael Hardt and Antonio Negri, is 'apprehended within – and instanced as – the performative act of critical engagement itself'.[29]

Critics from feminist and performance studies have also expressed an interest in the performative qualities of criticism. Amelia Jones and Andrew Stephenson, for example, take issue with the tradition that the interpreter must be neutral or disinterested in the objects, which s/he judges, and posit instead, with reference to spatial mobility, that the process of viewing and interpreting involves 'entanglement in intersubjective spaces of desire, projection and identification':

> Interpretation is, we would argue, a kind of performance of the object … Interpretation, like the production of works of art, is a mode of communication. Meaning is a process of engagement and never dwells in any one place.[30]

Jones, following feminist critic Jane Gallop, proposes that criticism is an invested activity, a rebellious response against the object's power, involving a desire to install superiority over a 'needy' object.[31]

In a recent edited volume, *The State of Art Criticism*, where a wide range of critics interrogate such questions of judgement and distance, Michael Schreyach's introductory essay argues that we have reached a position where self-reflective criticism is the norm and, making use of the spatial and visual term 'frame', he suggests that critics are able to recognize and acknowledge the frame in which they write. However, in Schreyach's opinion, since 'admitting one's own preferences and investments is self-exposure not self-criticism', this frame is one of which critics are only 'partially conscious'.[32] His stance is that the task of criticism should be to set up an equivalence with an artwork, which does more than simply 'mirror its object',[33] and instead converts the first experience, the authentic or original experience of an encounter with an artwork, into one with a value for other perspectives. Schreyach holds that one of the key criteria for judging the success of such criticism is derived from how the critic communicates his/her encounter with the work to the reader and 'handles the vertiginous shifts in perspective (authorial, historical, social) afforded by the indeterminacies of writing'.[34]

These commentaries on the operations of criticism make use of spatial terms, such as distance, frame, externality and outside, to explore conceptual issues governing the relation between critic and artwork. As stressed by cultural critic Irit Rogoff, artist and film-maker Trinh T. Minh-ha has drawn attention to the significance assigned to the shift in use of prepositions, particularly from speaking 'about' to speaking 'to'.[35] Following Minh-ha, Rogoff underscores how, by 'claiming and retelling narratives ("speaking to"), we alter the very structures by which we organize and inhabit culture'.[36] Adopting the preposition 'with' rather than 'to', Rogoff discusses how the practice of 'writing with' is a 'dehierarchization' of the social relations governing the making of meaning in visual culture.[37]

> *Instead of 'criticism' being an act of judgement addressed to a clear-cut object of criticism, we now recognize not just our own imbrication in the object or cultural moment, but also the performative nature of an action or stance we might be taking in relation to it.*[38]

I have also explored the use of prepositions, especially 'to',[39] in order to investigate how position informs relation, so altering the terms of engagement between critic and artwork as two equivalent entities. Initially this followed feminist philosopher Luce Irigaray's insertion of the term 'to' into 'I love you' producing 'I love to you' in order to stress the reciprocity and mediation – the 'in-direction between us',[40] and Michel Serres's focus on the transformational aspect of prepositions:

> *That's prepositions for you. They don't change in themselves, but they change everything around them: words, things and people … Prepositions transform words and syntax, while* pré-posés *transform men.*[41]

More recently I have considered the possibilities of prepositions through Laplanche's notion of an enigmatic signifier – a message which signifies 'to' rather than 'of' – which I discuss in detail later in this *Prologue: Pre-Positions*, as well as in *Configuration 3: A Rearrangement* and *Configuration 5: Decentring/Recentring*.

A shift in preposition allows a different dynamic of power to be articulated, where, for example, the terms of domination and subjugation indicated by 'over' and 'under' can be replaced by the equivalence suggested by 'to' and 'with'. In an early attempt to define the intentions of site-writing, my own impulse was to 'write' rather than 'write about' architecture, aiming to shift the relation between the critic and her object of study from one of mastery – the object *under* critique – or distance – writing *about* an object – to one of equivalence and analogy – writing *as* the object.[42] The use of analogy – the desire to invent a writing that is somehow 'like' the artwork – allows a certain creativity to intervene in the critical act as the critic comes to understand and interpret the work by remaking it on his/her own terms. In the next part of this *Prologue* I go on to investigate the value of insights derived from psychoanalysis concerning the relation of one *to* another for art criticism, before discussing how writing the object or the encounter with the object is rather like one of the main aims of the psychic function, according to psychoanalyst André Green: 'not only to relate to objects but to create them'.[43]

Relating to an Other

If criticism can be defined by the purpose of providing a commentary on a cultural work – art, literature, film and architecture – then criticism always has an 'other' in mind. The central task of criticism might then be considered as addressing the question: how does one relate to an 'other'? As psychoanalyst Jessica Benjamin writes, this question of 'how is it possible to recognize an other?' has been a key concern of feminism,[44] while in her view the central task of psychoanalysis is the 'double task of recognition: how analyst and patient make known their own subjectivity and recognize the other's'.[45] Benjamin's interest is in pushing beyond reversal, 'by contemplating the difficulty of creating or discovering the space in which it is possible for either subject to recognize the difference of the other'.[46] Grounded in the object relations theory of D.W. Winnicott, while well versed in feminist theory influenced by the work of Jacques Lacan, Benjamin argues that psychoanalysis requires both an intrapsychic focus to examine relations between the self and the internalized other as object, and an intersubjective approach to explore the relationship between subjects and externalized others.[47]

Andreina Robutti, coming from a Milanese group of psychoanalysts also working with Winnicottian concepts, outlines how an intrapsychic

approach attaches greater importance to the patient's inner world, with the analyst as merely the container of projections, while an interpersonal approach places greater importance on the 'relationship unfolding in the here and now'. For Robutti, 'the analytic encounter … is … a complex "two-way affair"', where the intrapsychic worlds of both patient and analyst, with their defence mechanisms, compulsions to repeat and unconscious phantasies, occur in both directions.[48]

Such theoretical perspectives suggest that objects exist both internally and externally and mediate inner and outer worlds. In visual and spatial culture, feminists have drawn extensively on psychoanalytic theory to think through relationships between the spatial politics of internal psychical figures and external cultural geographies.[49] The field of psychoanalysis explores these various thresholds and boundaries between private and public, inner and outer, subject and object, personal and social in terms of a complex understanding of the relationship between 'internal' and 'external' space. Cultural geographer Steve Pile has described it like this:

> *While inner life is distinct, there is continuous exchange between the internal and external, but this 'dialectic' is itself interacting with the transactions between 'introjection' and 'projection'.[50]*

The psychic processes of introjection and projection, as well as identification, provide a rich source of conceptual tools for exploring the complex relationships made between subjects and others, and between people, objects and spaces. Benjamin argues that once we start to think in terms of relationships between subjects, or subjectivity, we have no choice but to consider these intraphysic mechanisms of relation, most importantly identifications: 'Once subjectivity is embraced,' she says, 'we have entered into a realm of knowledge based on identifications, hence knowing that is intrapsychically filtered.'[51]

Feminist theorist Diane Fuss also states that identification is 'a question of relation, of self to other, subject to object, inside to outside';[52] it is, she writes, 'the psychical mechanism that produces self-recognition'.[53] While Fuss outlines how identification involves the interrelationship of two processes each working in different directions – introjection, the internalization of certain aspects of the other through self-representation, and projection, the externalization of unwanted parts of the self onto the other – visual theorist Kaja Silverman has explored identification in terms of cannibalistic or idiopathic identification where one attempts to absorb and interiorize the other as the self, and heteropathic identification where 'the subject identifies at a distance' and in the process of identification goes outside his/herself.[54]

A psychoanalyst who trained with Lacan, Laplanche is best known for his re-examination of the points at which he argues Freud went astray. This includes most famously Freud's controversial abandonment of the seduction theory, and his turn to the child's fantasy to explain seduction,

thus at some level avoiding thinking through the complex interplay of inner and outer worlds between the child and what Laplanche calls 'the concrete other'.[55]

Laplanche maintains that this early scene of seduction is of key importance to psychoanalysis as it works to de-centre the position of the subject in its articulation of the formation and role of the unconscious. For Laplanche, it is the embedding of the alterity of the mother in the child which places an 'other' in the subject; this other is also an other to the mother – as it involves her unconscious. Thus the message imparted to the subject by the other, for Laplanche the mother or concrete other, is an enigma both to the receiver, and also to the sender of the message: the 'messages are enigmatic because … [they] are strange to themselves'.[56]

The reason why Laplanche's writing is of such interest to me is because he does not confine his discussion of the enigmatic message to psychoanalysis, but suggests instead that transference occurs not first in the psychoanalytic setting to be applied in culture, but the other way around: 'maybe transference is already, "in itself", outside the clinic'.[57]

> *If one accepts that the fundamental dimension of transference is the relation to the enigma of the other, perhaps the principal site of transference, 'ordinary' transference, before, beyond or after analysis, would be the multiple relation to the cultural, to creation or, more precisely, to the cultural message. A relation which is multiple, and should be conceived with discrimination, but always starting from the relation to the enigma. There are at least three types of such a relation to be described: from the position of the producer, from that of the recipient, and from that of the recipient-analyst.[58]*

For Laplanche, then, the critic or recipient-analyst is involved in a two-way dynamic with the enigmatic message: s/he is 'caught between two stools: the enigma which is addressed to him, but also the enigma of the one he addresses, his public'.[59]

In more recent work, Laplanche has supplemented his concept of the enigmatic signifier with an account of seduction that emphasizes the importance of inspiration, or the role of the other as muse.[60] In this investigation Laplanche inverts the traditional model of creative self-expression outlined in Freud's 'Creative Writers and Daydreaming' (1908), arguing that the 'moment of address' should be inverted from its narcissistic aspect, where it moves from the creator's self-expression to a receptive public who are expected to provide a beneficial response, to one where it is the expectation of a public that provokes the creative work:

> *The Ptolemaic-narcissistic movement of creation is undeniable; but beyond it, and together with it, an inversion takes place: it is the public's expectation, itself enigmatic, which is therefore the provocation of the creative work … There would thus be an opening, in a double sense: being opened by and being open to – being opened up by the encounter which renews the trauma of the*

originary enigmas; and being opened up to and by the indeterminate public
scattered in the future.[61]

In recognizing the importance of the enigmatic message sent 'to' its
addressee, the location of transference and counter-transference outside
the clinic in culture, the specific position of the critic as recipient analyst
positioned between and provoked by both work and audience, the writing
of Laplanche is key to conceptualizing questions of relation in criticism.[62]
It is interesting to compare his approach to a more traditional usage of
psychoanalytic theory in art and literary criticism, which has, following
Freud, tended to 'psychoanalyse' an artist or a work,[63] aiming to use
psychoanalytic theory to 'explain' the intention of an artist and to unravel
the 'unconscious' aspects of a work. If we follow Laplanche, the critic
occupies not only the position of recipient analyst but also the analysand,
paralleling an earlier suggestion put forward by Green, and picked up by
Laplanche, that: 'In applied psychoanalysis … the analyst is the analysand
of the text.'[64]

 Green closely compares the processes of interpretation carried out by
the literary critic and by the psychoanalyst.[65] He suggests that 'In brief, the
analyst reacts to the text as if it were a product of the unconscious. The
analyst then becomes the *analyzed* of the text.'[66] When 'confronted' with
a text, the analyst 'performs a transformation' which involves rigorous
but also 'loose free-floating reading'.[67] Green notes how the 'analyst is
captivated, when the work … has touched, moved, or even disturbed him',
and that the work of criticism which occurs next does so in response to the
analyst's initial reaction. For Green:

> *It is out of the question that he [the critic] analyze a text to order; the request
> that can only come from within – that is, if something has already happened
> between the text and the analyst.* The analysis of the text is an analysis
> after the fact.[68]

Green maintains that since 'psychoanalytical interpretation involves a
process of deformation of the subject's conscious intentions', it is not the
author who is the analysand but the analyst himself.[69] In his view 'the
analyst-interpreter becomes that critic who is the privileged interlocutor,
the mediator between reader and author, between the text as writing and
its realization as reading'.[70] Both Green and Laplanche position the critic
as mediator, between author and reader in Green's account and between
work and audience in Laplanche's case. However, if for Green the critic is
a reader whose analysis of the text comes from within, in Laplanche's later
formulation the critic is always responding to another reader, an otherness
that comes from without, following the poet Stefan Mallarmé, from 'the
indeterminate public scattered in the future', but also from the original
enigma of the past:

> *But what I think I know is that analysis, sometimes, maintains a type of opening-up: and it is precisely this that is its mark of origin, its being marked by the origin. This opening-up can be maintained, transferred into other fields of otherness and of inspiration. This is what must indeed be called the transference of the transference … the transference of the relation to the enigma as such.*[71]

Green's account of the process which occurs when a psychoanalyst analyses a literary text rather than a person raises important questions concerning the distinction between the two relationships – analyst and analysand, on the one hand, critic and work, on the other. My intention in *Site-Writing* is not to attempt to psychoanalyse artworks, but rather to develop an understanding of art criticism's spatiality through psychoanalytic concepts. The psychoanalytic space of the setting, that place which frames the encounter between analyst and analysand and the processes of transference and counter-transference that occur between them, provides a useful reference point.

In psychoanalytic theory, the terms 'frame' and 'setting' are used to describe the main conditions of treatment which, following Sigmund Freud, include 'arrangements' about time and money, as well as 'certain ceremonials' governing the physical positions of analysand (lying on a couch and speaking) and analyst (sitting behind the analysand on a chair and listening).[72] Freud's 'rules' for the spatial positions of the analytic setting were derived from a personal motive – he did not wish to be stared at for long periods of time – but also from a professional concern – to avoid giving the patient 'material for interpretation'.[73]

> *I insist on this procedure, however, for its purpose and result are to prevent the transference from mingling with the patient's associations imperceptibly, to isolate the transference and to allow it to come forward in due course sharply defined as a resistance.*[74]

In a discussion of Freud's method, Winnicott distinguishes the technique from the 'setting in which this work is carried out'.[75] In his view, it is the setting which allows the reproduction of the 'early and earliest mothering techniques' in psychoanalysis.[76] While Italian psychoanalyst Luciana Nissin Momigliano describes how Winnicott 'defined the "setting" as the sum of all the details of management that are more or less accepted by all psychoanalysts',[77] Argentinian psychoanalyst José Bleger redefines Winnicott's term 'setting' to include the totality of the 'psychoanalytic situation': the process – what is studied, analysed and interpreted – and the non-process or frame – an institution, which he argues provides a set of constants or limits to the 'behaviours' that occur within it.[78] Other analysts have used slightly different spatial terms to describe the setting: for Laplanche, a double-walled tub,[79] and for Green, a casing or casket which holds the 'jewel' of the psychoanalytic process.[80] Green, as I describe in more

detail in *Configuration 1: Triangular Structures with Variable Thirds*, considers the setting a third space homologous to the analytic object created between analyst and analysand.[81] In *Site-Writing* there are two 'analytic objects': the artwork that lies between the critic and the artist, and the critical essay or text, which is located between critic and reader.

The concept of the psychoanalytic setting is indispensable for exploring the spatial relationship between critic and artwork – certainly, following Bleger, in investigating how the non-process or frame in which the critic encounters the work influences the process of criticism. The frame may include the site in which the critic encounters the work – completed, with the curator in the gallery; in process, with the artist in the studio; and documented and accompanied by another critic's essay in a publication. It may also involve the brief which plays a determining role in defining the commission or invitation to write – including its place of publication, the role of the editor, curator, gallery and artist in influencing (implicitly and explicitly) its content and, of course, the fee. Additionally in an authored book, where the critic chooses the artworks to be discussed, his/her own conceptual agenda and the conditions governing the amount of time s/he has to devote to the project operate even more strongly as a framing device.

Psychoanalyst Christopher Bollas has noted that Freud's clearest account of his method, outlined in 'Two Encyclopaedia Articles: A. Psycho-Analysis',[82] suggests that psychoanalysis takes place if two functions are linked – the analysand's free associations and the psychoanalyst's evenly suspended attentiveness.[83] In 'On Beginning the Treatment', Freud explains how, in including rather than excluding 'intrusive ideas' and 'side-issues', the process of association differs from ordinary conversation.[84] Bollas defines free association as that which occurs when we think by not concentrating on anything in particular, and where the ideas that emerge, which seem to the conscious mind to be disconnected, are instead related by a hidden and unconscious logic.[85] In order to achieve evenly suspended attentiveness, Bollas explains that the analyst also has to surrender to his own unconscious mental activity; s/he should not reflect on material, consciously construct ideas or actively remember.[86] Bollas connects the relation between free association and evenly suspended attentiveness to the interaction between transference and counter-transference,[87] as does Green, who describes the role of transference as creating an 'analytic association'.[88]

According to literary critic Elizabeth Wright, 'free association' brings to aesthetics not the emergence of the truth of the unconscious as she holds that the surrealists believed, but rather the overruling of the censorship between conscious and preconscious. In her view, it is in the process of analysis that the revelation of unconscious defences allows not the 'direct expression of the impulse of the drive', but 'the idea or image which has attached itself to it'. For Wright, it is only by 'working through' this material that the unconscious fantasy can be pieced together.[89]

Present in Freud's later writings, where he distinguishes between construction and interpretation as different forms of analytic technique, is an indication of the creative aspect of the analyst's work:

> 'Interpretation' applies to something that one does to some single element of the material, such as an association or a parapraxis. But it is a 'construction' when one lays before the subject of the analysis a piece of his early history that he has forgotten … [90]

Green also proposes that the analyst uses a form of 'conjectural interpretation'.[91] And psychoanalyst Ignes Sodré, in a conversation with writer A.S. Byatt, asserts that in 'offering the patient different versions of himself' the analyst operates as a storyteller, suggesting an inventive aspect of interpretation.[92] Laplanche, however, has been strongly critical of the 'putting-into-narrative' or storytelling approach to analysis. This understanding of narrative with its own 'driving power', for him, 'privileg[es] the construction of a coherent, satisfying and integrated story', and as such works against the aim of analysis, which is to recollect the past.[93] French psychoanalyst Didier Anzieu, who has described 'interpretation' as the analyst's most crucial tool, has been somewhat more radical in his proposition that 'twofold interpretative work' occurs *between* analyst and analysand.[94] In this volume, I propose that the critic, in occupying the positions of both analyst and analysand, combines associative and attentive modes of writing, including forms of interpretation which construct, conject and invent.

In my view T. J. Clark's adventurous book *The Sight of Death: An Experiment in Art Writing* does just this. Arriving at the Getty Institute for a period of study leave to examine Picasso's work between the wars, Clark decides instead to write about two paintings by Nicolas Poussin, which happen to be exhibited in the gallery. Returning to view the same paintings every day, at least in the first six months of the research,[95] Clark intends his book 'to be about what occurs in front of paintings more or less involuntarily, not what I think ought to occur'.[96] He keeps returning to a detail in the painting, where finally through an act of free association he is reminded of a gesture of his mother's, and later, in turn, by a haunting image of her face in death:

> *I go back and back to the space between the two figures, therefore, because one voice (or eye) within my unconscious goes on telling me that the distance in question is infinite, and the woman's expression and gesture are precisely what make it so; and always an answering voice (or eye) refuses to accept this, and tells me to look at the interval again.*[97]

Literary critic Mary Jacobus has described 'the scene of reading' in terms of a relation, perhaps a correspondence, which exists between the inner world of the reader and the world contained in the book.[98] Taking up

this insightful observation, I suggest that criticism involves such a double movement to and fro between inside and outside: works can take critics outside themselves, offering new geographies, new possibilities, but they can also return critics to their own interiors, their own biographies. Although the critic is expected to remain 'objective' or exterior to the work, at the same time s/he is invited inside – to enter the world of the artist. As well as its physical position outside the critic, the work also occupies the site of the critic's psychic life, igniting interior emotions and memories. This pair of two-way movements between critic and work suspends what we might call judgement or discrimination in criticism, and instead, through what I call the practice of 'site-writing', traces and constructs a series of interlocking sites, relating, on the one hand, critic, work and artist, and on the other, critic, text and reader.

Art Writing

Although art criticism operates through the medium of writing, little attention has been paid to the textual construction of the critical essay. Since the publication of *Artwriting* in 1987, the work of David Carrier has been an exception.[99] In a later publication from 2003, *Writing about Visual Art*, he argues:

> *In the literature of art, it is impossible to absolutely separate or entirely distinguish, the arguments of an art writer from the literary structures used to present the arguments.*[100]

Carrier asks *how* a written artefact describes art,[101] and whether it is possible to create a written artefact that is able both to perform an equivalence 'with' art, and articulate an interpretative position. Yet while providing a clear account of how writing operates in particular pieces of art criticism, the implications of Carrier's interesting observations, that art writing is an object, and, following J.L. Austin, that 'art writing performs actions',[102] are not investigated through his writing style, nor by developing his own mode of analysis to deal with the question of 'viewpoint' from a literary and therefore more textual perspective.

The question of viewpoint has been explored in depth by Bal, who, as art historian Norman Bryson has pointed out, considers visual art through narrative and structures her own texts through processes of 'focalization'.[103] The disciplinary trace of Bal's earlier work as a literary critic is evident in her more recent writing on art. Following her desire for critical writing to bring one closer to art, Bal places the artwork at the centre of her texts, arguing that:

Writing about art is not a substitute for the art. Rather than standing for the visual objects, texts about them ought, in the first place, to lead the reader (back) to those objects.[104]

But in wishing to lead the reader back to the object, Bal tends to underemphasize the role the writing in her own texts plays in constructing meaning. In order to examine this issue a little further, I shall draw briefly on some key points concerning positionality and textuality coming out of literary criticism, for example in the work of Italo Calvino, who has explicitly explored the relationship the writer has to his/her writing in terms of position – where a writer stands – inside and/or outside a text:

Maybe the critical analysis I am looking for is one that does not aim directly at the 'out-of-doors' but, by exploring the 'indoors' of the text and going deeper and deeper in its centripital movement, succeeds in opening up some unexpected glimpses of that 'out-of-doors' – a result that depends less on the method itself than on the way one uses the method.[105]

Calvino has also discussed the places writers occupy in relation to their writing in terms of their different identities as subjects or 'I's:

And in these operations the person 'I', whether explicit or implicit, splits into a number of different figures: into an 'I' who is writing and an 'I' who is written, into an empirical 'I' who looks over the shoulder of the 'I' who is writing and into a mythical 'I' who serves as a model for the 'I' who is written. The 'I' of the author is dissolved in the writing. The so-called personality of the writer exists within the very act of writing: it is the product and the instrument of the writing process.[106]

And Roland Barthes has described his choice of authorial voice in terms of four regimes: including an 'I', the pronoun of the self, a 'he', the pronoun of distance, and two forms of 'you', as a pronoun which can be used in a self-accusatory fashion and to separate the position of the writer from the subject.[107] The structuralist linguist Emile Benveniste, much admired by Barthes, has also emphasized that 'I' is a pre-existing position in language that is always taken up in relation to a 'you'. Benveniste argues that the terms 'I' and 'you' are terms which cannot be conceived separately; they are complementary and reversible:

Language is possible only because each speaker sets himself up as a subject *by referring to himself as* I *in his discourse. Because of this,* I *posits another person, the one who, being, as he is, completely exterior to 'me', becomes my echo to whom I say* you, *and who says* you *to me.*[108]

Feminist and postcolonial critics have drawn on the possibilities offered by multiple subject positions and voices as well as languages, genres and

modes of writing to produce texts that have spatial qualities, developing notions of 'subject to subject encounter' through linguistic constructions.[109] Some have woven the autobiographical into the critical in their texts, exploring the politics of location through positions adopted in language, and combining poetic practice with theoretical analysis to articulate hybrid voices, such as in the groundbreaking work of Gloria Anzaldúa.[110]

The autobiographical aspect of feminist writing has been particularly resonant in literary criticism since the late 1970s, developed through the radical work of writers such as Nancy K. Millar and Susan Rubin Suleiman.[111] Reflecting on the wider implications of feminism's autobiographical passage for contemporary scholarship, Tess Cosslett, Celia Lury and Penny Summerfield, the editors of a collection of essays entitled *Feminism and Autobiography*, state that:

> *What is happening now is less a search for the correct epistemology than a methodological concern to reveal the complex autobiographical underpinnings of feminist research. If as feminists have argued, all research is situated, and pure objectivity is a pretence, it is ethically and politically right that feminist researchers should lead the way in coming clean on the way research is produced and lived by those producing it.[112]*

Cosslett, Lury and Summerfield note that this might involve detailing what is usually hidden – for example, personal investments in a subject area, intellectual affiliations and their influence on the choice of research frameworks adopted – as well as an examination of the relationship between the research and the private life of the researcher.[113]

In art criticism, there are a few brave writers, namely Lynne Tillmann and Jeanne Randulph, who, in bringing autobiography into art criticism, have reworked the genre by blending fact and fiction.[114] Through a form of writing she calls 'ficto-criticism', Randulph's work blurs 'the distinction between the objective and the subjective realms', something 'widely accepted in genres such as science fiction or mystery writing' but which 'remains taboo in the realm of critical writing and theory'.[115]

The autobiographical approach to Peggy Phelan's commentaries on performance art have developed a mode of writing criticism that declares its own performativity and the presence of the body of the critic in the writing as 'marked'.[116] In drawing attention to the conditions of its own making at the level of the signifier, not only the signified, much autobiographical writing is performative. In Della Pollock's highly informative discussion of the key qualities of performance writing, she includes being subjective, evocative, metonymic, nervous, citational and consequential as exceptional aspects of this type of writing.[117] And in Butt's edited volume, referred to earlier, the attempt by critics and practitioners to 'renew criticism's energies' occurs specifically through a 'theatrical turn'.[118]

Across the arena of experimental writing, new possibilities are being invented – sometimes autobiographical, often performative, usually both –

which question the distanced objectivity of academic writing styles.[119] Those operating at the intersection of art and writing include artists producing text-based works[120] and writers exploring the poetics of criticism,[121] as well as performance writers,[122] poet-artist practitioners[123] and philosophers who question subjectivity through alternative visual writing forms.[124] I draw inspiration from this intensely creative and theoretically rigorous strand of speculative criticism, yet within it I am also trying to do something quite particular – to enhance criticism's spatial qualities and in so doing explore the 'position' of the critic through the textual qualities of writing.

As I have outlined above, art critics are also beginning to consider the possibilities that the medium of their work affords, but as yet, although many have written about the spatial potential of writing, fewer have actively exploited its textual and material possibilities, the patterning of words on a page, the design of a page itself – its edges, boundaries, thresholds, surfaces, the relation of one page to another – or wondered what it would mean for criticism to take on new forms – those of art, film or even architecture.[125] Each medium has an architectonics – a series of procedures for the material organization and structuring of space. Literary critic Mary Ann Caws's concept of 'architexture' is helpful here in allowing us to take texts, structures which are not buildings, as architecture, a move which is rather more closely guarded against in architecture itself, where the professional view still tends to dominate. A term that refers to the act of reading rather than writing, for Caws, architexture 'situates the text in the world of other texts', drawing attention to the surface and texture of the text as a form of construction.[126]

In the discipline of architecture itself, several writers have engaged with the potential of writing architecture. In her wonderful *Atlas of Emotion*, Guiliana Bruno sets forth an aim that the form of the book she is writing will follow the design of the building in which she works,[127] while Katja Grillner has been exploring the possibilities for a writing that is architectural by, for example, situating herself as a subject in a landscape, among those she writes about.[128] Karen Berman's reflection on Anne Frank's diary describes the spaces provided by writing while hiding as a 'mobile homeland', articulated by a hybrid text fashioned through spatial details and conditions.[129] But perhaps the textual projects of architect and critic Jennifer Bloomer have been the most influential in their attempt to write architecture. Spatially structured, Bloomer's texts operate metaphorically to explore imaginative narratives and employ metonymic devices to bring the non-appropriate into architecture. For Bloomer, different modes of writing construct architecture through the intimate and personal, through multi-sensual rather than purely visual stimulation.[130]

Site-Writing

I am interested in constructing an architecture of art criticism – in how writing operates to reflect one set of relations while producing another. *Site-Writing* creates architectural texts out of this critic's use of a number of artworks, extending the spatial aspects of Bal's exploration of 'art-writing' as a form of architecture,[131] and adopting and adapting Caygill's notion of strategic critique where the criteria for making judgements are discovered or invented through the course of criticism.[132] Combining differing genres and modes of writing in art criticism, whose critical 'voices' are objective and subjective, distant and intimate, this approach develops alternative understandings of subjectivity and positionality. From the close-up to the glance, from the caress to the accidental brush, *Site-Writing* draws on spaces as they are remembered, dreamed and imagined, as well as observed, in order to take into account the critic's position in relation to a work and challenge criticism as a form of knowledge with a singular and static point of view located in the here and now.

This enactment of art criticism as a critical spatial practice occurs through the five configurations of *Site-Writing* in different ways. In each one, the relation between interior and exterior is investigated and arranged through the spatial qualities and architectural dimensions of particular psychic conditions, drawn from the work of Freud and revisions of his material by Green and Laplanche, namely the transitional space of the setting, the to and fro movement across the frontier between conscious, preconscious and unconscious, the rearrangement of words and things, the folded memory of *déjà vu* as that secret which is covered but keeps coming back, and the recentring and decentring devices of the Ptolemaic and Copernican revolutions. The intention is not to 'apply' spatial concepts to psychoanalyse certain artworks, but to put into play certain ways of working and creating inspired by psychoanalysis – free association, conjectural interpretation and construction, for example – to write the sites of this critic's engagement with specific artworks.

Configuration 1: Triangular Structures with Variable Thirds looks at Green's description of the triadic structure of the setting, in order to examine the shifting psychic vantage point adopted by the subject in relation to both others and objects, as well as Benjamin's understandings of the potential third in the dyad. The configuration's three parts are structured through three voices, each of which articulates a different position in relation to questions of architecture and subjectivity. In the first part, three voices perform the doing, undoing and overdoing of an architectural space. In the second I explore how, in Tracey Emin's exhibition *You Forgot to Kiss my Soul* (2001), the viewer or user of the work is positioned in a triadic relation to the artist and her mother, her father and an alterative version of herself, and actively involved in the construction of psychic architecture. Following the reading of a text-based installation, through voices drawn from autobiography, psychoanalytic theory and building specifications,

the third part explores to show how a 'confessional construction' conceals rather than reveals the 'I' of the author.

Referencing Anzieu's work on the skin-ego, while also drawing on the differing spatial relations between conscious, preconscious and unconscious, and ego, id and superego, in Freud's first and second topographies, *Configuration 2: To and Fro*, explores movement across boundaries. Materially present in artworks by Nathan Coley and Jananne Al-Ani, screens and veils are considered to separate and join critic and artwork. Sited at particular positions in relation to the artworks, the texts play with a changing fluctuation of 'I', 'you' and 's/he' to and fro across the threshold. Referencing the repetitive play of *fort/da*, one piece of site-writing returns in another, to be re-worked finally in a two-part text installation: *An Embellishment: Purdah* (2006).

In *Configuration 3: A Rearrangement*, the Freudian concepts of screen-memory and word- and thing-presentations inform an exploration of the role of nostalgia, longing and yearning in the writing of art criticism, looking at how remembered and imagined scenes presented through objects, images and words operate in the work of artists but also feature in critics' essays as sites for both reminiscence and daydreaming. The configuration begins by describing a series of screen memories, arrangements of words prompted by a set of things. One scene is then rearranged along with two others in response to Elina Brotherus's artwork *Spring* (2001), and then again to form a final rearrangement of words and things in a three-part installation, *Les Mots et Les Choses* (2002).

Configuration 4: That Which Keeps Coming Back draws on Freud's understanding of *déjà vu* as a category of the uncanny, as well as Bollas's notion of the aesthetic moment as a *déjà vu* experience, in order to explore spatial aspects of *déjà vu* through the fold of the cover-up and the secret – that which keeps returning. Stimulated by Cristina Iglesias's description of her 2003 show at the Whitechapel Art Gallery, London, as 'some things you see will remind you of others', the configuration connects *Passages* (2002), her final piece in the exhibition, to Sharon Kivland's works on the passage of women through arcades and the uncanny aspects of urban exploration. The final part of the configuration takes the title of a work by Kivland, 'She is walking about in a town which she does not know', drawn in turn from Freud's discussion of Dora's second dream, as the guiding principle for a site-writing, which, written for the group show *Elles sont passées par ici* (2005), blends the imagined and anticipated with a memory that keeps coming back.

Finally, *Configuration 5: Decentring/Recentring* forms a series of movements of recentring and decentring in relation to Laplanche's concept of the Copernican revolution. In the first part, 'Somewhere Else She is Told', accounts of three cross-cultural encounters are discussed in relation to notions of (dis)locatedness and hybridity put forward by cultural critics such as Susan Stanford Friedman and Homi Bhabha. Through the work of Do-Ho Suh a subsequent essay explores the role of biography in recentring

and decentring viewer and critic in relation to an artwork. In the next part, 'Everywhere Else', a site-writing composed in response to the group show *Ausland* (2002), domoBaal contemporary art, London, questions the 'centre' of art criticism by locating the viewer somewhere else – in spaces outside the gallery as well as those overlooked within its frame. The configuration ends with a series of *détournements*; sites of battle during the colonization of India and in the current war in Iraq create a topographical mapping which displaces the position of the public sculptures, including Mark Quinn's *Alison Lapper* (2005) situated at the centre of London in Trafalgar Square.

In the *Epilogue: Alien Positions*, I return to a question introduced at the start of *Site-Writing*, to reflect on what it means to 'use' an object – a theory, an artwork, even perhaps an artist. Following my reading of Juliet Mitchell's discussion of Winnicott's concept of 'using' rather than 'relating to' an object, and her desire to 'use' theory, I came to realize that throughout the process of writing this book I had been producing a form of criticism, which 'used' artworks, while continuing to 'relate to' theoretical concepts. At this last moment, in response to the work of artists Bik Van Der Pol, the theory is finally recognized and so used, rather than simply related to, and therefore destroyed, thus transforming the relationship between the critical subject and her objects – artworks, essays and theories.

Site-Writing configures what happens when discussions concerning situatedness and site-specificity extend to involve art criticism, and the spatial qualities of writing become as important in conveying meaning as the content of the criticism. My suggestion is that, in operating as mode of a practice in its own right, this kind of criticism questions the terms of reference that relate the critic to the work positioned 'under' critique, and instead proposes alternative positions for the critic to adopt – in relation 'to' the work and through the use 'of' the work. This process of configuring writes the sites between critic, work and artist, as well as between critic, text and reader, and in so doing constructs an architecture of art criticism.

Configuration 1

Triangular Structures with Variable Thirds

Transitional Space

When I put forward the model of the double limit ... Two fields were thus defined: that of the intrapsychic on the inside, resulting from the relations between the parts comprising it, and that of the intersubjective, between inside and outside, whose development involves a relationship to the other ... The object is thus situated in two places: it belongs both to the internal space on the two levels of the conscious and the unconscious, and it is also present in the external space as object, as other, as another subject.[1]

The focus of the theory of object relations created and developed by the Independent British Analysts is the unconscious relationship that exists between a subject and his/her objects, both internal and external.[2] In continuing to explore the internal world of the subject, their work can be thought of as a continuation of Sigmund Freud's research, but there are also important differences, particularly in the way that the instincts are conceptualized and the relative importance assigned to the mother and father in the development of the infant. Developing the concept of an object relation to describe how bodily drives satisfy their need, Freud theorized the instincts as pleasure-seeking, but Ronald Fairbairn, an influential member of the Independent Group, suggested instead that they were object-seeking, that the libido is not primarily aimed at pleasure but at making relationships with others. For Melanie Klein, too, objects play a decisive role in the development of a subject and can be either part-objects, like the breast, or whole-objects, like the mother. But whereas for Freud it is the relationship with the father that retrospectively determines

the relationship with the mother, for Klein it is the experience of separation from the first object, the breast, that determines all later experiences.[3]

Following on and also developing aspects of Klein's work, D.W. Winnicott introduced the idea of a transitional object, related to, but distinct from, both the external object, the mother's breast, and the internal object, the introjected breast. For Winnicott, the transitional object or the original 'not-me' possession stands for the breast or first object, but the use of symbolism implies the child's ability to make a distinction between fantasy and fact, between internal and external objects.[4] This ability to keep inner and outer realities separate yet interrelated results in an intermediate area of experience, the 'potential space', which Winnicott claimed is retained and later in life contributes to the intensity of cultural experiences around art and religion.[5]

Contemporary French psychoanalyst André Green, who uses both Freudian and Winnicottian concepts in his work, considers the analytic setting a 'homologue' for what he calls the third element in analysis, the 'analytic object', which 'corresponds precisely to Winnicott's definition of the transitional object',[6] and is formed through the analytic association between analyst and analysand.[7]

> *The analytic object is neither internal (to the analysand or to the analyst), nor external (to either the one or the other), but is situated between the two. So it corresponds precisely to Winnicott's definition of the transitional object and to its location in the intermediate area of potential space, the space of 'overlap' demarcated by the analytic setting.[8]*

Green compares the closed space of the consulting room to Winnicott's notion of transitional space, noting that it has a 'specificity of its own', which differs from both outside and inner space.[9] Michael Parsons, in a commentary on Green's work, draws attention to his understanding of the analytic setting not as a static tableau, but as a space of engagement, not as 'just a representation of psychic structure', but as 'an expression of it'.[10] Parsons explains that for Green: 'It is the way psychic structure expresses itself, and cannot express itself, through the structure of the setting, that makes the psychoanalytic situation psychoanalytic.'[11] Green understands this as a spatial construction, as a 'generalised triangular structure with variable third':[12]

> *The symbolism of the setting comprises a triangular paradigm, uniting the three polarities of the* dream (narcissism), *or maternal caring (from the mother, following Winnicott) and of the* prohibition of incest (from the father, following Freud). What the psychoanalytic apparatus gives rise to, therefore, is *the symbolisation of the unconscious structure of the Oedipus Complex.[13]*

In Green's work triadic structures do not have to be Oedipal in the traditional sense; they incorporate Winnicott's transitional space

between mother and child, mediated by the choice of a 'not-me object'. In conversation with Green, Gregorio Kohon suggests that he [Green] is trying to 'make sense of this mad passion for the mother within an Oedipal constellation, but the mad passion for the mother does not include the mother at all. It only includes the unknown object of bereavement, which can be the text created, or the painting, or the piece of music.'[14] And as Green emphasizes, 'the structure is triangular but it doesn't mean that it is Oedipal. The third can be, for instance, art.'[15]

In *Shadow of the Other*, Jessica Benjamin has argued that the dialogue between mother and child can take the place of 'Jacques Lacan's third term that breaks the dyad'; instead of thinking of the maternal dyad as a trap with no way out, Benjamin understands the dialogue itself to be a third co-created by two subjects.[16] She maintains that while the intrapsychic perspective continuously reverses through identification, the intersubjective view aims to create a third position 'that is able to break up the reversible complementarities and hold in tension the polarities that underly them'.[17] Rather than a person located outside the dyad, the third may therefore be considered a function, for example, to symbolize.

In a subsequent paper, Benjamin develops this point furthur, emphasizing how there is always a potential third, or triadic structure, in the dyad: 'the thirdness of dialogue between mother and infant always implies the presence of others in the mother, there is, properly speaking, never an encapsulated dyad'.[18] As well as the potential third in the dyad, Benjamin also reminds us that there is a 'dyadic infrastructure in all triadic relations',[19] and that the 'dyadic third is what enables the parental third, real or symbolic, to constitute an occasion for intersubjective observation'.[20] She points to the Kleinian version of the Oedipal triangle where the child, watching the parents, perceives itself on the outside, and is able to take 'the position of both subject and object of observation'.[21] Benjamin's most recently articulated view describes two forms of thirdness: the 'one in the third', which involves early 'union experiences and accommodation', as well as 'later moral and symbolic forms of thirdness that introduce differentiation' that she terms 'the third in the one'.[22]

The configuration that follows is structured around a triadic pattern, comprising three parts, each one composed of three voices, where the relation of objects and subjects is situated between the intrapsychic and the intersubjective. In the first part, the inner and outer worlds of architect and user are negotiated through the objects and spaces of a home, in the second, artist and critic encounter one another through artworks positioned in a gallery, and in the third, writer and reader engage through words on a page structured both as an opening and as a closure.

The first part, *Undoing Architecture*, is a trialogue constructed out of eleven scenes, which tell the story of acts of DIY (Doing-it-Yourself) in a home. The normative procedures for 'doing' architecture are described in terms of the modernist design principles of patriarchal capitalism, while the words of French feminist theorists suggest acts of 'undoing'. My own

practice of living, following the trajectory of an alternative mode of DIY, is set as a third position of fluctuating allegiance between the 'father' of modernist architecture and the 'mother' of feminist critique.

The second part, *One + One = Three*, explores the architectural artworks in Tracey Emin's solo show *You Forgot to Kiss my Soul* (2001), White Cube, London. I suggest that the sculptures, which include *Self-portrait*, *Conversation with my Mum*, *The Perfect Place to Grow* and *The Bailiff*, are related to psychic conditions. The architectural form of *Self-portrait* has been argued to represent a psychic state – the downward spiral of depression – while I put forward the possibility that the other three works invite interpretation through the critic's occupation. Each one articulates a different two-way relationship between the artist and a family member: Emin and her mother, Emin and her father, and two versions of Emin herself. As pieces of architecture these artworks can be understood as analytic or transitional objects, but following Green they are also settings, which provide sites of occupation for the user or critic between the subjects and their objects. The critic is asked to sit on a chair at a table, to climb a ladder to see into a shed, and to step into a tiny cubicle. In each situation s/he enters the space of the two-way relationship that is in the process of being played out. The triadic structures or psychic architectures created vary according to their particular materiality and the configuration of each setting, but also in direct relation to the specific position each user occupies as a response to his/her own personal version of the Oedipal triangle.

The configuration ends with *Confessional Construction*, a third triadic text, which explores the confession as a form of construction rather than revelation. In order to demonstrate how material concerned with an interior can be used to build an exterior covering, the text comprises a main statement – an autobiographical detail – interwoven with more critical reflections upon what it means to confess. Footnotes consisting of architectural specifications concerning the detailing of walls and openings are located down the side of the page, numbered from bottom to top, to read upwards as one builds a wall.

Undoing Architecture

When Jonathan Hill asked me to contribute a chapter about DIY for a book he was editing called *Occupying Architecture*, at first I declined. Then, at the suggestion of a friend, Iain Borden, I decided to write about a place in which I had previously lived. My co-habitant in that house had been making our living space through an unusual mode of DIY, much of which involved the removal, rather than the addition, of building elements, as well as the use of objects for non-designed purposes.[23] This was the first piece of writing where I juxtaposed my own voice with those of various critical theorists, and where I referred to my life as the subject matter for theoretical reflection. This incorporation of the personal into the critical had different kinds of effect depending on the reader. Other academics and artist friends loved the piece because I was so 'present' in the work. But my retelling of events disturbed two important people in my personal life. My mother was upset by my description of this house, as 'more like home to me than any other', and for my co-inhabitant my text rendered his home unrecognizable.

The responses I received made me aware that words do not mean the same thing for writer and reader, and this raised many questions about storytelling. While the subject matter and subjective stance of a personal story may upset the objective tone of academic writing, writing for a theoretical context repositions events in ways that may be uncomfortable for those involved in the story. Writing about the DIY practices in a house where I once lived in order to question the authorial position of the architect and the permanence of architecture assumed by the profession

involves recounting a story. Like the fiction writer who uses friends and family as the basis for characters, I use others in my writing, but unlike the fiction writer, who provides a disguise through character, my writing offers nowhere to hide. Adopting a narrative form in which they feature as subjects in order to make a critical point reveals that there is more involved than simply telling a good story. So what do these others make of the subjects they become in my writing? As a writer, what ethical responsibility do I have to them?

The question of how it is possible to recognize another is a problem at the heart of much feminist writing.[24] To negotiate a feminist understanding of relationships with respect to architecture is no easy task. The feminist poet Audré Lourde once stated that 'the master's tools will never dismantle the master's house': if so, then what other tools do we have at our disposal?[25] This essay draws on the words of French feminist philosophers Luce Irigaray and Hélène Cixous, who both suggest modes of relating which differ from the masculine, from what might be described as an economy of appropriation or the self-same rather than one of difference. My own use of architecture is placed between the authority of the father, the male architect, on the one hand, who sets out the modernist principles of design still largely adhered to by the profession, and the voice of the mother, the female theoretician, on the other, who suggests alternative modes of producing space: through using and writing.

The essay has a way with words, a particular patterning of speech, a feminine rhetoric that undoes architecture. This speaking subject speaks in threes. Her speech is tripled. 1 and 1 is three. 11 threes.

i
Between Doing It and Undoing It
Any Theory of the 'Speaking' Subject

The architectural profession encourages us to think of architecture as something only architects do. As architects, we remain true to this ideal and ensure that we, and only we, do things our way.

> *We can assume that any theory of the subject has always been appropriated by the 'masculine'. When she submits to (such a) theory, woman fails to realise that she is renouncing the specificity of her own relationship to the imaginary.*[26]

I was taught how to do architecture, taught how to do it the right way. I was taught that architects do architecture all by themselves. They imagine architecture, and then, as if by magic, with minimal fuss, and certainly no mess, they make it, whole and perfect pieces of it, just like in their dreams.

ii
Between Use and Misuse
Écriture Feminine

Architects do architecture. Builders do architecture. Long after 'completion', users do architecture, they 'do-it-themselves'. Architects do architecture with designs on the user – that the user will follow certain intended patterns of consumption. Consuming – the act of acquiring and incorporating goods – indicates distinct social identities. These distinctions can be created not only by buying more of the same or even different goods, but by playing with an existing 'vocabulary' of goods, inventing subtle variations, developing a 'rhetoric' of use.[27] One of the causes, but also the consequences, of social comparison through distinction is desire. Desiring creatures transgress; they resist the logic of architecture as the other who completes the self. They undo architecture as architecture undoes them.

> *Writing is working; being worked: questioning (in) the between (letting oneself be questioned) of same and of other without which nothing lives; undoing death's work by willing the togetherness of one-another, infinitely charged with a ceaseless exchange of one with another – not knowing one another and beginning again only from what is most distant, from self, from other, from the other within. A course that multiplies transformations by the thousands.[28]*

One hot day in Moscow, I visited Mr. Melnikov's house, a symphony of architectural geometry, and there, in the marital bedroom, in that safe haven of harmony, at the heart of their home, Mrs. Melnikov had made a mess. With complete disregard to her esteemed husband's endeavours, she had gathered together all manner of ugliness, decorative trappings, ornaments and lace. Mrs. Melnikov's Soviet bric-a-brac, or as the Russians call it poshnost, *was architecture undone.[29]*

iii
Between Home and Nomadism
'Where and How to Dwell?'

Houses are by far the most expensive of commodities. The houses we buy and the way we choose to live in them allow us to distinguish ourselves from others. Our choices are limited by factors of all kinds, not least our desires. Nowhere do these desires resonate more spatially than in the place we call 'home'.

> *You grant me space, you grant me my space. But in so doing you have always taken me away from my expanding place. What you intend for me is the place which is appropriate for the need you have of me. What you reveal to me is the place where you have positioned me, so that I remain available for your needs.[30]*

On a leafy street in south London is an ordinary terraced house, which was my home for two years. Scattered all over London, all over the world, are other homes, houses where I have once lived. In some still standing, I return and revisit past lives and loves. Others have been destroyed, physically crushed in military coups, or erased from conscious memory only to be revisited in dreams. In all the places I have lived I recognize lost parts of myself, but this particular house means something very special to me. Its neglected and decaying fabric, its disparate and drifting occupants, offered me a way of living that had nothing to do with comfort, security, safety and permanence. Through its fragile structure this house physically embraced my need for transience, and perhaps this is what made it feel like home to me.

iv
Between Profitability and Generosity
The Gift

The economy of the capitalist market is based on pricing mechanisms – specialization, efficiency, scarcity, the maximization of profit and utility – and on principles of homogeneity, rationalism and calculation. This masculine economy requires the strict delineation of property, from the ownership of one's body to the fruits of one's own labour.

> *But how does woman escape this law of return? Can one speak of another spending? Really, there is no 'free' gift? You never give something for nothing. But all the difference lies in the why and how of the gift, in the values that the gesture of giving affirms, causes to circulate; in the type of profit the giver draws from the gift and the use to which he or she puts it. Why, how, is there this difference?*
> *When one gives, what does one give oneself?*[31]

The woman who owned the house I lived in refused rent. Although her home was large, five stories, she lived frugally off her pension in two first-floor rooms. She occupied a world beyond the everyday, inhabited by spirits – 'the powers that be'. The powers were not adept in the material world; their decisions were unreasonable and random. Large pieces of furniture moved nightly; plumbing, electrics and general household maintenance followed erratic management systems. The 'powers' refused council money for repairs – this disturbed the karma of decay. Theirs was the rhetoric of generosity.

v
Between Property and Reciprocity
Porosity

In patriarchy men own women and space. Women do not own their own space but are space for men. The space of property is defined by boundaries, walls that are closed, fixed and permanent, with controlled thresholds.

Openness permits exchange, ensures movement, prevents saturation in possession or consumption … My lips are not opposed to generation. They keep the passage open … The wall between them is porous. It allows passage of fluids.[32]

My house was home to quite a number – friends and strangers – all people who in their own ways set themselves outside conventional codes of living. I lived on the top floor with my friend, the one who originally discovered the house – derelict, with a pigeons' graveyard in the roof – and made it home (for me). There were conflicts, vicious attempts from inside and outside to wrest control of the space from the powers that be, to categorize, to establish some kind of hierarchy of property ownership.

vi
Between Divisibility and Multiplicity
Two Lips

Doing architecture, we follow certain rules: we categorize. We plan spaces for specific activities. Living space is mapped and defining according to ideologies of domesticity, where sleeping is divided from playing, from working, from cooking, from eating, from cleaning and so on. Every activity has its compartment, is one, is autonomous.

Woman is neither open nor closed. She is indefinite, in-finite, form is never complete in her.[33]

In my home the boundaries, which usually control and contain, were intentionally blurred. This was not to enable the free flow of pure space as in the modernist open plan, but rather to intensify the occupation of space by overlaying one kind of living over another – intentions of use, overlaid with mis-use, questioned the boundaries of bodies and places. The bath sat in the centre of the roof – bedworklivingspace. From the bath you could talk to the person lying next to you in bed, look up into the sky, down onto the stove, beyond to those eating, and further, through the window onto the street. Architecture is soft like a body if you undo it.

vii
Between the 'Self-same' and the 'Other'
Mimicry

Doing architecture, we follow certain rules: decor follows structure. In modernism, the displayed surface is expected to represent exactly what lies beneath, to disguise or cover is perceived as duplicitous. To play with the surface for its own sake is perceived as problematic, as formalism.

… woman must be nude because she is not situated, does not situate herself in her place. Her clothes, her makeup, and her jewels are the things with which

she tries to create her container(s), her envelope(s). She cannot make use of the envelope that she is, and must create artificial ones.[34]

Our house was resistant to the logic of decoration. The soil pipe gushed diagonally through the stairwell and out of the rear wall of the house: a proud dado rail. The stripping back of partition walls asserted the fabric of the building as a living component of the space. Cracking brickwork and rubble revealed between the splintering stud partitions formed a decorative skin. Metal rivets holding the decrepit ceiling plaster together shone at night like stars. You could see into the toilet – a place where we traditionally demand privacy from prying eyes, ears and noses. The doors to this tiny blue room were spliced open like a swing saloon. Bare bottomed in an intimate space, to flush you placed your hand through a smooth circular hole out into the public void of the stairwell and grabbed a wooden spoon hanging from the ceiling on a rope. Rejecting the constraints imposed by rules of domestic order where 'everything has its place', the dividing line between messiness and tidiness disappeared. The seams were the decor.

viii
Between Scarcity and Abundance
Jouissance

Doing architecture, we follow certain rules: we design objects for particular purposes.

> *No, it is at the level of sexual pleasure [*jouissance*] in my opinion that the difference makes itself most clearly apparent in as far as woman's libidinal economy is neither identifiable by a man nor referable to the masculine economy.[35]*

A limited number of possessions demand reuse. For this a detailed knowledge of the geography of the local skips is required, to collect, scavenge and recycle. Only in wealthy pockets can fine furnishings be found abandoned in the street: rugs, three-piece suites, four-poster beds, washing machines and duvets. This condition of potentiality also provided the catalyst to achieve flexibility through transformation, through misuse. Within one life a single table was the crowded focus of a drunken evening, it then became several café tables, then again frames for candle-lit icons, and finally a hot blaze on a cold night. Deciding just how and when to use an object in a certain way provokes interesting questions. At what point does furniture become firewood?

ix
Between Calculation and Approximation
The Female Imaginary

Doing architecture, we follow certain rules: we use specified materials in prescribed ways.

If there is a self proper to woman, paradoxically it is her capacity to depropriate herself without self-interest: endless body, without 'end', without principal 'parts'; if she is a whole, it is a whole made up of parts that are wholes, not simple, partial objects but varied entirety, moving and boundless change, a cosmos where eros never stops travelling, vast astral space. She doesn't revolve around a sun that is more star than the stars.[36]

A desire for starlit baths and a seamless transition from inside to outside meant cutting holes in the roof. We stapled and re-stapled blue plastic sheets over the twin holes, but the wind blew in and rain water dripped onto the edge of my bed. We waited through the winter, finely tuning the exact design details. Finally, glass sheets were laid to rest directly on slim timber linings rising just proud of the roof slates; elegant steel yachting hooks and rope delicately attached the glass to the frame, revealing the sky an unobscured fantasy blue. But alas for bathing en plein air. Lifted to allow in balmy air on a sunny morning, one pane shattered directly into the soapy water narrowly missing a tender-skinned bather. We had many disagreements about the unsuitability of nautical details for domestic requirements. Finally I threatened to buy a Velux roof light from Texas Homecare.

x
Between Efficiency and Excess
Fluid Mechanics

Doing architecture, we follow certain rules: efficiency is to be achieved in structure, in services and in construction detailing. To challenge ideals of low maintenance, the ordered comforts of domestic routine and laziness, is to question notions of efficiency and opt instead for a high degree of strenuous user involvement, tipping the balance of safety and danger.

This is how I figure it: the ladder is neither immobile or empty. It is animated. It incorporates the movement it arouses and inscribes. My ladder is frequented. I say my because of my love for it; it's climbed by those authors I feel a mysterious affinity for; affinities, choices, are always secret.[37]

The ladder to the upper floor, far too short, had missing rungs, and in one place, a piece of sharp cold iron. Vertical movement, especially at night, took place as a series of jolts and slipped footings. No room for complacency, every moment of occupation was écriture feminine – a writing from, and on, the body. Architecture here was no longer solid and dependable, but transient, as fragile as human life. Life lived with unstable materiality is fraught with physical danger. One morning I awoke to a crash and a scream. A friend unfamiliar with the intricacies of the household had missed her step and fallen to the kitchen floor below. Her head narrowly missed the cast iron stove.

xi
Between Safety and Danger
The Angel Goes Between

The angel is that which unceasingly passes through the envelope(s) or container(s), goes from one side to the other, reworking every deadline, changing every decision, thwarting all repetition.[38]

Shortly after the accident I moved on.
The house moved on.
The home I remember is only my imagining.
Only in dreams do I ever go home.

•

In August 2000, I was invited to participate in the International Women's University, an extraordinary event that took place in several German cities over the summer months. I was located for a week in the town of Kassel, giving lectures and conducting seminars on the topic of gender, space and architecture. The diversity of the women who attended was incredible, in terms of both geography and profession. There were women working for NGOs in India, architects from Brazil, sociologists from Nigeria. Despite my history, I was received as an English-trained architect and academic, whose role was to give lectures in traditional raked auditoriums with the lights down.

But who was I to speak to them? What could these intelligent women learn from me? Was it possible within this setting to somehow turn things around? With this is mind I took the paper I had been about to deliver for my last lecture, 'Undoing Architecture', which told of the architecture of my private life, and cut it up into pieces. I handed out bits of the text to all the women in the audience and then asked them to take up any position in the raked auditorium they wished, and when they felt ready to read aloud the piece of writing they had been given, not in English, but in their mother tongue.

What had I expected? A delirious cacophony, a rich celebration of cultural diversity, an overturning of the lecture-to and lectured-at relationship? How wrong I was. I had not anticipated how fearful the women would be. Slowly they did start to read, but in English, in quiet and reverend tones, struggling to pronounce the words just right. While it was beautiful to listen to so many female voices, with their different intonations, filling the lecture space rather than my own, the words were still mine. Rather than asking them to tell me about themselves, I had reinforced my own position of authority. How could these women speak, when my own words were silencing them?

I have come to call my sorry attempt to create a piece of performance writing that afternoon 'a confessional construction'. My failed endeavour

made me at least aware that stories of the self, confessionals if you like, are not revelations but constructions. The confession is a form of physic architecture that uses the interior to build a new exterior. In the piece of writing that follows, through a close engagement with a series of works by artist Tracey Emin, I examine the tensions and ambiguities that exist when intimacies of the autobiographical are performed in a public setting.

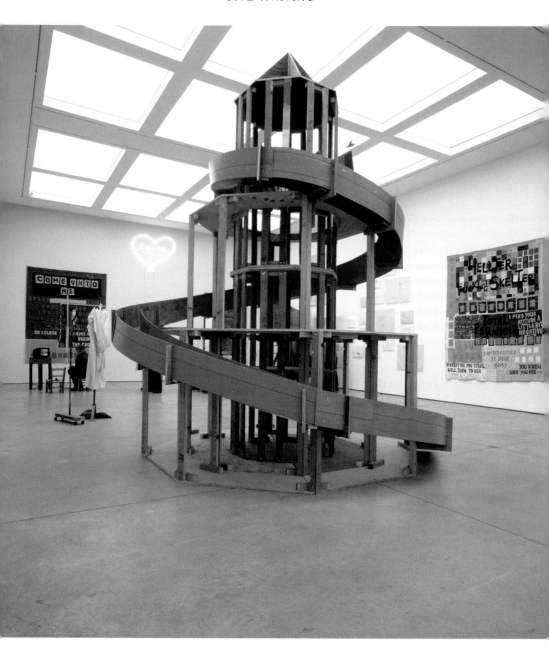

1
Tracey Emin, *Self-portrait* (2001). Reclaimed timber and sparrow. Height: 365.76 cm
Diameter: 355.6 cm. © the artist. Photograph: Stephen White. Courtesy: Jay Jopling/
White Cube, London.

One + One = Three
Tracey Emin's *You Forgot to Kiss my Soul*

I walk into a world of bright neon, verdant vegetation and the sounds of cicadas. Words surround me, great big misspelt words in light, in thread, in pencil and in fabric; there are sketches of birds, flowers and of the artist herself – Tracey Emin – lying on her back; and bits of furniture that might be part of an ongoing stage set or half-finished DIY left out in the back garden.[39] It feels familiar, partly because it reminds me of a house in which I once lived.

In the distance I can read:

> *Life without you (never).*[40]
> *You forgot to kiss my soul.*

Between those words and me is the most striking object in the gallery – a ramshackle helter-skelter that just about reaches the ceiling. *Self-portrait* (2001) is a crude construction, knocked up out of 'really cheap wood' recycled from the offices beneath the artist's studio.[41] A bit unsteady on its feet, it reminds me of Emin in her high heels.

> *Tracey Emin: Helter Fucking Skelter – it doesn't matter how good things are – How Good Life is – it only takes one little knock, ~~and~~ to start the never ending downward spiral, for me ~~still~~.*[42]

The helter-skelter represents psychic experience through architectural form, and so differs from other spatial works by Emin such as *Everyone I*

Have Ever Slept With 1963–1995 (1995). In this work, to read the names of each person the artist had slept with, from her mother to her lovers to her aborted babies, the art user had to enter and occupy a mass-produced tent embroidered by Emin. *Everyone I Have Ever Slept With 1963–1995* was understood to offer a 'protective' environment, described by critic Neal Brown as encouraging contemplation and remembrance,[43] and writer Jeanette Winterson as combining the pleasures of childhood, camping, coitus and culture.[44]

The sparrow that rises out of the top of *Self-portrait*[45] has also been interpreted as a representation: to be transcending the downward depression of the spiral,[46] and providing 'a counterpoint of liberation from the work's contained system of repetition'.[47] For her next sculptural *Self Portrait* (2005), for *When I think about Sex …* at the White Cube in 2005, Emin replaced the juxtaposition of wood and bird with a metal bathtub filled with bamboo poles, barbed wire and lit by neon. The gesture of producing what Sarah Valdez has called an 'optically enchanting dichotomy'[48] has been continued in sculptures such as *Salem* (2005), shown at Lehmann Maupin, New York, for *I Can Feel Your Smile.* Here the earlier contrast between depression and transcendence is reworked in rough wood and neon and described as an aesthetic of 'grit and glamour'.[49] Although *Salem* is not titled a self-portrait, the use of, in Valdez's words, 'a rough-hewn, latticed, spiraling tower' suggests comparisons to Emin's *Self-portrait* (2001).

The two sculptural self-portraits combine iconic (the helter-skelter) and symbolic (the sparrow) forms of representation with indexical. The bamboo, for example, like the wood, refers back to Emin's childhood, and on reading her autobiography it is possible to link it to a particular occasion when she stabbed herself with a bamboo pole as a girl.[50] However, unlike many of her other sculptures, such as *There's a Lot of Money in Chairs* (1994) and more famously *My Bed* (1998–99), *Self-portrait* (2001) and *Self Portrait* (2005) do not use actual items from Emin's life. Given how important the act of revealing intimate experience is in Emin's work, the status of an object or material in terms of its authenticity is of significance; if it is not *the* unique item then the precise nature of its resemblance to *that* original matters. In the case of *My Bed* (1998–99), for example, it was the dislocation of Emin's *actual* bed, this highly personal object that she had slept in, from its domestic setting to the space of the gallery, that, in Emin's view made it art.[51]

> *Tracey Emin: The whole idea was that My Bed came out of a bedroom and into another space – that's what made it art.*[52]

Self-portrait does not reference its subject matter through direct indexical pointing – this is not the helter-skelter that Emin once slid down dislocated from Margate pier – nor is it to be understood simply as an iconic or a symbolic representation of depression and transcendence as other critics have suggested; rather I argue that the material and tactile qualities of

the architectural construction are suggestive of, or make associations with, certain emotional states.

Other works by Emin, made both before and after the helter-skelter of *Self-portrait*, also utilize the beach and fairground architecture of her Margate childhood.[53] *Homage to Edvard Munch and All my Dead Children* (1998), for example, was set on a wooden jetty at the edge of the Oslo Fjord, the same location as the background for Munch's iconic figure in *The Scream* (1893) – a key influence on Emin.[54] She described the 'big sculpture' she was going to make for her show *This is Another Place* (2002) at Modern Art, Oxford, as a 'rustic and mad, demonic, chaotic, twisted bridge' based on a structure she had encountered in Cyprus.[55] And the piece *Knowing My Enemy* (2002) turned out to be a seaside pier broken in the middle. For *When I think about Sex …* (2005), her next solo-show at the White Cube, London, Emin made a rollercoaster. *It's Not the Way I Want to Die* (2005) was another dilapidated timber construction with seaside connotations, suggesting both the uplifting, exhilarating qualities of the fairground and the unstable qualities of deteriorating architecture.

Art historian Deborah Cherry has pointed out that many of Emin's works, in relating to the frontier condition of the shoreline and the liminal experience of the fairground, position themselves on the threshold.[56] The rough quality of the materials chosen and the casual architectural detailing employed reinforce the unstable nature of their location on the borderline. It is the 'couldn't care less' attitude embodied in the construction of these sculptures which points to edgy, potentially unstable emotional states.

The helter-skelter is starting to give me vertigo, just like I used to feel when spinning, round and around, out in the garden on a hot summer's day.[57] Behind it I glimpse Emin; she is out of it too, a rough but fluid line drawn on white paper, lying in the garden on her back. All around her are flowers – gaudy and ghastly – glossy fragments hacked out of magazines with a blunt pair of scissors.

Dying for it – in my dreams on back – legs open.

Scratchy sketches on paper with torn edges are stuck up with Sellotape on the pristine white gallery walls. One monoprint shows Emin: her legs long and sexy, shoes high and tottering.[58] She has a cigarette in one hand and a wineglass in the other. Her face is not to be seen; it is all screwed up and covered with hair. These self-portraits are accompanied by a handwritten scrawl. The text looks drunk to me, but with Emin it is hard to tell – all her writing is fast, furious and out of control:

Don't dare lie to me.
Conversation with a friend.

No clear thoughts.
It's just an idea of space.

A second grouping emphasizes the instability of *Self-portrait*:

> *Mind fuck.*
> *Self portrait reclining drunk.*
> *Well – this is it – I'm too pissed to even stand.*

Here the title frames the referent – the fragility of Emin herself.

Conversation with my Mum (2001)

> *Tracey Emin: Yes, so why would it be wrong for me to have children when I have actually done a lot in my life?*
> *Tracey Emin's Mum: [interrupts] Because once you've had a child your life becomes totally, completely different from your life, even to your way of thinking.*
> *TE: You think about my life, about how narcissistic, how self-centred I am to do what I have to do. I have to be pretty self-centred.*
> *TEM: Ahm, yes, yeah.*
> *TE: I have to be quite selfish to retain the kind of art that I make and to believe what I believe in.*
> *TEM: Yeah but if you had had children you wouldn't ever have done that.*
> *TE: Yeah but what if I get to a point in my life when I get tired and bored with the narcissism, bored with the selfishness and actually want to see the world through someone else's eyes. You must have had great pleasure watching Paul and I experience the world and a lot of distress when I think about it.*
> *TEM: Yeah, yeah, but at the same time, erm, I just wouldn't like to see you have children Tracey.*
> *TE: Ever?*
> *TEM: Yeah. Yeah. Yeah. I wouldn't like to see you have children.*
> *TE: You see it as a major failure in my life.*
> *TEM: I don't think it would be a failure but it'd be something, you, you, I don't think you could balance the two. I don't think you could balance the two, children and your career.[59]*

Each time I walk into the gallery there are two women sitting on two small wooden children's chairs, headphones on, totally engrossed in the video they are watching.[60] The image in the video positions the viewer opposite Emin and her mother at a lace-covered table chatting over cigarettes and cups of tea. Without the soundtrack, the conversation appears to be very light-hearted and full of fun.[61]

The mother and daughter watching are gripped, unable to tear themselves away, they are laughing, too.[62] Finally they take the headphones off, stand up and turn around, ready to re-enter the sombre silence of the gallery. Waiting behind them for my turn to take a seat at the table, I see

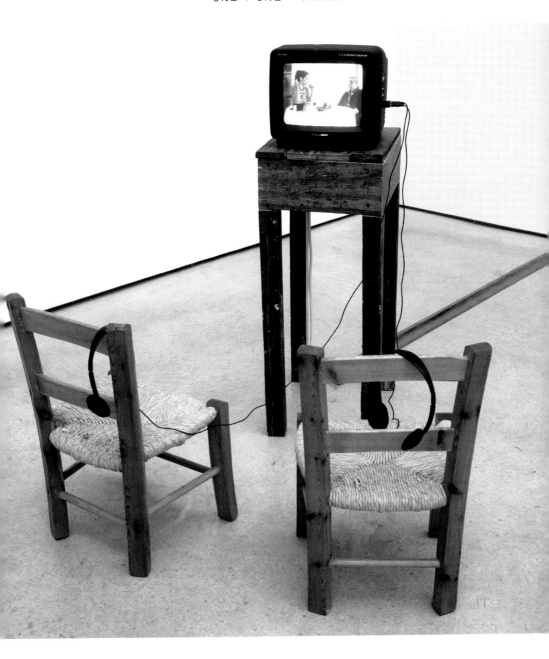

2
Tracey Emin, *Conversation with my Mum* (2001). Two children's chairs, DVD (shot on Mini-DV), TV and table 101 × 41 × 32 cm. Duration: 33 mins. © the artist. Courtesy: Jay Jopling/White Cube, London.

that their eyes are full of tears. A little embarrassed, they move away swiftly. I pull up a chair and put on the headphones. Emin is asking her mother why it would be 'wrong' for her to have children. She keeps returning to ask the same question, but her mother is insistent. Having a baby changes you, she says. Over and over again in many different ways she repeats her answer: it would not be possible for *you* to be a mother *and* an artist.

From Judy Chicago's seminal *Dinner Party* (1974–79) to Suzanne Lacy's *The Crystal Quilt* (1987), a choreographed project involving the sharing of stories between older women, there is a history of feminist artists working with tables. A significant place for gathering, sharing food and conversation, feminist architectural practices, such as muf and Sarah Wigglesworth, have also drawn attention to the position of the table at the threshold of private and public – between the intimate life of the family and the professional space of work.[63] The ambiguous nature of domestic furniture has been investigated by artists, too – the offer of comfort accompanied by a certain kind of constraint. A curvaceous white chest of drawers emanates milky breath as it freezes and melts. Marked with rose-red pinpricks visible like bruises just beneath the surface, Jane Simpson's *Sacred* (1993) bears the trace of family violence – emotional and physical.

Over my shoulder a drab blue dress hangs limply on a wire hanger. I turn around to look more closely: next to it is a drip on a hospital trolley, at the end of which dangles a half-empty Evian bottle. In its use of everyday objects, *Poor Thing* (2001), made in collaboration with artist Sarah Lucas, combines the hallmarks of both Lucas's and Emin's solo work. Lucas's *Au Naturel* (1994), for example, comprising a sagging mattress, two watermelons and a courgette, parodies traditional art historical subject matter through the use of familiar items. But while Lucas uses found things to make irreverent critiques of art, Emin focuses on the actual material that holds relevance: not any mass-produced mattress or hospital dress, but *this* dress worn on *that* particular occasion.

> *Tracey Emin: … Where you have the hospital drip – that comes from one of my abortions. … I used a real hospital gown for the* Poor Thing *sculpture, which is what I wore in hospital when I had a really bad kidney infection. I nicked it from the hospital.*[64]

The empty dress speaks of mothers spent as husks, the cheap fabric of the hospital gown as fragile as a skin that has been shed. Feminist critic Kim Chernin notes in *The Hungry Self* that, as lovers and rivals, mothers and daughters are locked into one another. The daughter cannot bear to be her mother, yet neither can she bear to do better, for this would reveal her mother's weakness.[65] For Caroline Broadhead's *Bodyscape* (1999) at the Angel Row Gallery, Nottingham, transparent dresses hung away from the wall, their bodies mysteriously absent. *Steppenwolf* (1997) and *Shadow Dress* (1998) cast shadows more solid than the fine material from which they were constructed.[66] In *Shadow of the Other*, Benjamin describes

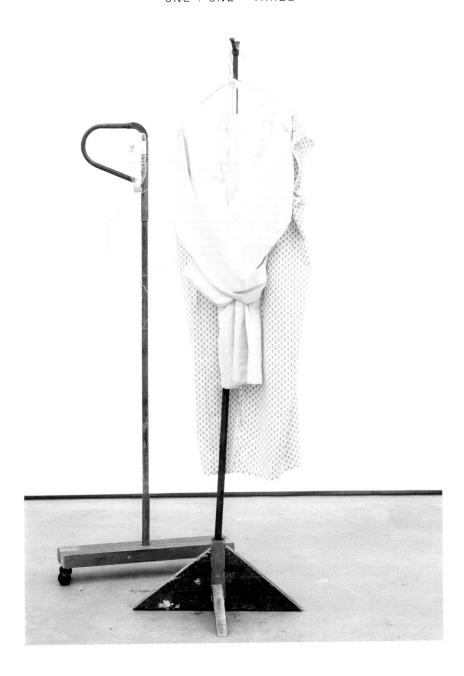

3
Tracey Emin, *Poor Thing (Sarah and Tracey)* (2001). Two hanging frames, hospital gowns, water bottle and wire 186.3 × 80 × 94 cm. © the artist. Photograph: Stephen White. Courtesy: Jay Jopling/White Cube, London.

how an insufficient theorization of the Oedipus complex from a gendered perspective has resulted in the inability to represent the mother as a person in her own right, splitting the female subject between the 'object position of femininity' and the 'labouring position of maternal activity', while the daughter must switch from identifying with the active mother, to being the father's passive object.[67]

On the wall behind *Poor Thing* are some monoprints: *Poor Love* (1999), a work that preceded *Poor Thing*, and some images of birds.

> *Shall we go to bed?*
> *You said what.*
> *You told me not to.*
> *Never ever bite the hand.*
> *If I wantet I could have been the most beautiful bird in the world.*
> *I've done that better than I thought I would.*
> *Nothings that cute.*

These cross birds with their ruffled feathers and their squawking beaks are mocking, accusatory and nagging, and at the same time frank, endearing and vulnerable. Art critic Michael Gibbs has described them as 'hieroglyphs of wounded creatures'.[68] Another version of Emin's presentation of her damaged self, these birds do not speak in monologues, but in the dialogue of mother and child.

> *Was will das Weib?*[69]

What wants the Woman?
What does a woman want?
What does a mother want?
How would I know?
I am only a daughter.

The Perfect Place to Grow (2001)

Next to *Conversation with my Mum* is another domestic setting. A small wooden shed, rather ramshackle, is perched on tall legs. A ladder leads up to a little peephole in its side. A collection of outdoor plants in big pots, red geraniums mostly, are arranged around the hut. Over the course of the show, they lose their husky petals to the floor, giving off the sweet aroma of verbena and the hot, dry scent of holidays in the Mediterranean.

Emin made this hut as a tiny home for her father, in response to the description he gave her of his 'perfect idea of heaven' – a little house on stilts located by the sea with the waves breaking and the sound of rain on a corrugated tin roof.[70] Although Emin describes the structure as a bird

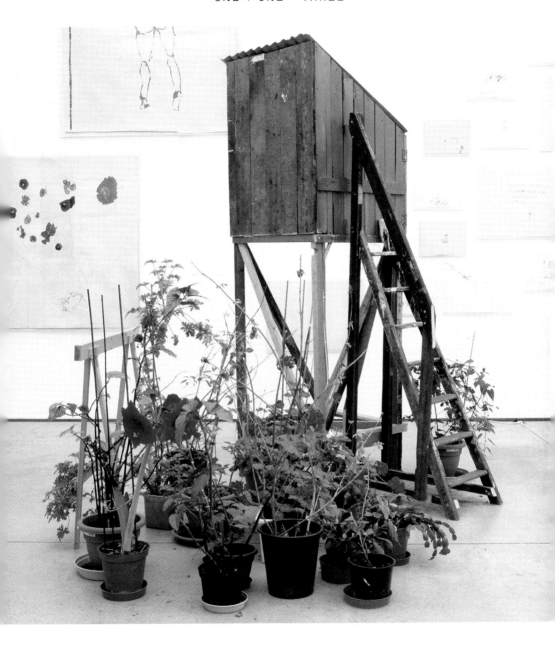

4
Tracey Emin, *The Perfect Place to Grow* (2001). Wooden birdhouse, DVD (shot on Super 8)
monitor, trestle, plants, wooden ladder 261 × 82.5 × 162 cm. Duration: 2 mins looped.
© the artist. Photograph: Stephen White. Courtesy: Jay Jopling/White Cube, London.

house rather than a hut, it is hard not to compare it to *The Last Thing I Said to You was Don't Leave Me Here (The Hut)* (1999), a reassembled beach hut once used for holidays with Lucas, also the location for the photographic self-portraits *The Last Thing I Said to You was Don't Leave Me Here I and II* (2000). There is an important distinction to be made between those works of Emin that consist of the actual objects of great personal value to the artist and those that are specially constructed for gallery display out of similar materials.[71] *Hut*'s status in this respect is marginal – the structure in the gallery is that hut but displaced and in the process reconstructed. *The Perfect Place to Grow* incorporates Emin's father's actual, and rather poor, efforts at DIY, including a very weak trestle which took him three weeks to build (the only one ever completed of a pair he intended to construct as a table), as well as plants he gave to Emin that seem to have influenced her desire to grow her own vegetables.[72]

> *Tracey Emin: Maybe one reason why I idealise my Dad is because he is 82 now. And then you've seen how he treats me – it's like I'm still a little girl of four. But even though I was brought up in a dysfunctional family, I was always loved dearly. What I do think is that it was really hard work for my Mum. My Dad got off quite lightly with the whole thing, and I think it might upset my Mum a bit because my Dad gets all the rewards. I just sometimes wish my Dad had been a gardener. If he had, he would have a really successful business now. He would have beautiful nurseries and maybe a really great organic greengrocer's shop.*[73]

The phrase 'The Perfect Place to Grow' featured in Emin's earlier appliqué quilt *Hotel International* (1993). From her written descriptions, you might imagine that this somewhat sordid location was not a perfect place to grow. But was it? The labyrinthine eighty-room hotel owned by Emin's father, run by her mother, and full of strangers, was where she and her twin brother Paul spent their early childhood. It was the place where Emin missed her absent father and came home to when abused. It was 'perfect' perhaps because it positioned Emin between private and public, precisely on the boundary she transgresses in her work, exposing herself and the intimate details of her life to an art-going audience of strangers.[74]

As I climb up the ladder, bending forward ready to peer in, I become conscious that I am positioned somewhat provocatively in the gallery, just above eye height. I imagine myself viewed from behind, juxtaposed against the image in the background, the big one of Emin accompanied by some angry scrawls:

Don't look for revenge it
Just happens
if you don't like it
then go and fuck
yourself don't take it
out on me.

Described by critic Mark Durden as 'a riposte to Marcel Duchamp's *Etant donnés*',[75] *The Perfect Place to Grow* inverts the usual gendering of voyeurism – positioning the viewer with the female artist behind the camera spying on a man. But the work is not simply a reversal. The secretive gaze of voyeurism is not that guarded; Emin's father knows he is being filmed, and as object of the gaze he plays gleefully to the camera. The work also engages with the spectatorship of exhibitionism. Emin positions her voyeur not in a hidden viewpoint, from which to throw a furtive gaze, but exposed in the act of looking itself – poised halfway up a ladder.

I take a peek through the hole. A middle-aged man, tanned, overweight and slightly sweating, wearing a sun hat and trunks, comes towards me through the lush undergrowth. Emin's father is holding a red flower out for me to take. I lean forward to inhale its scent, and he moves back, turns around and disappears off the way he has come. Smiling over his shoulder, he lurches through the vegetation into the distance. And then he appears again, coming forward towards me, this time with a white bloom. And then again he turns away …

Fort/da.
Away/there.
Disappearance/return.
What does a father's absence mean to his daughter?[76]

I stumble backwards down the ladder.

The Bailiff (2001)

I hear an angry exchange, but it is not quite possible to make out the words. To find out more, I follow the voices, open an ill-fitting wooden door and step into a tiny room, the size of a toilet cubicle, where a video is playing. The image shows another door, Emin's front door, in section. Emin is there, twice, inside and outside. The Emin indoors seems quite nice, timid and a bit frightened in her dressing gown, holding tight a bread knife for protection. Outside in the stairwell, is a much nastier version of Emin, tough and mean, smoking, in black leather and jeans, battering at the door, and shouting:[77]

> *Tracey Emin 1: Oi! [TE 1 knocks again]*
> *Tracey Emin 2: Who is it? [TE 1 kicks the door] Who is it? What d'you want?*
> *TE 1: Open the door. [Pauses] Open the door. [Knocks on the door]*
> *TE 2: Who is it?*
> *TE 1: I know you're in there. Open the door. [Kicks the door] Can you hear me?*
> *Can you hear me? I know you're in there. I know you're in there. Open the door.*
> *[Pauses] Open the door or I'll break the door down. [Pauses, then kicks again]*

TE 2: Go-away, [TE 1 kicks the door] go away. [TE 1 kicks the door]
TE 1: [Taunting] I can hear you. I can hear you.
TE 2: What d'you want?
TE 1: [mimicking] 'What d'you want?' 'What d'you want?' 'What d'you want?' I don't want your fuckin' weakness that's what I don't want. You fucking piece of shit. You tiny, snivelling, weak piece of little shit. [Spits, then lights a cigarette, then taunts] Oh, I can hear you crying. [Kicks the door][78]

As these two conflicting sides of Emin face up to each other – one pathetic and compliant, the other aggressive and domineering – poised on either side of the doorway to her house, the viewer is placed right on the threshold witnessing the confrontation from a midway point.

Behind *The Bailiff* I come across Emin again. She is lying on her back; one hand is between her legs. Bits of her have been cut out and carelessly glued back on: A Working Landscape (in my dreams). But the 'L' could be an 'h' … Next to her, her own likeness demands:

Give it to me like a man I'll take it like a man.

The words, made with a needle and thread, have the naivety of a stitched sampler. Like the pictures of birds on branches sewn in pastel pinks and blues, these tender pieces of needlework are childlike in their execution and the messages they convey:

It could have been something very ugly but I thought about you.

The larger prayer blankets come from someone a bit older, not yet a woman, the stroppy self-obsessed teenage Emin.[79] Juxtaposing pastel pink ribbons and rich red velvet, they tell stories of sweet flirtations and bloody abortion, of childhood games and teenage dreams, violent passion and bitter resentment:

Something really terrible.
No-one would beleave her.

Come unto me.

It's a spiral witch goes down.
Helter fucking skelter.

I find your attitude a little bit negative.

Always alert, always active
Volcano closed, both eyes open.

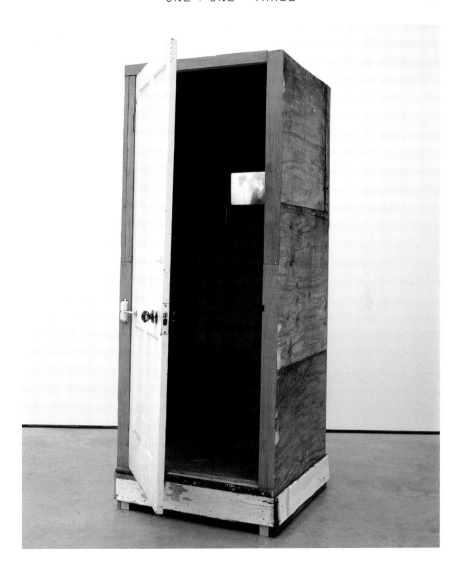

5
Tracey Emin, *The Bailiff* (2001). Wooden cabinet, DVD (shot on Mini-DV), monitor 261 × 82.5 × 91 cm. Duration: 4 mins 43 secs. © the artist. Courtesy: Jay Jopling/ White Cube, London.

Although *Self-portrait* occupies the centre of the rectangular gallery, with the three sculptural dialogues – *Conversation with my Mum*, *The Perfect Place to Grow* and *The Bailiff* – arranged around it, the helter-skelter does not hold the space centrifugally; nor do the other architectural works operate as self-contained objects. Rather the words and images contained within these artworks and arranged on the walls around the edge of the gallery create resonances across the room as a whole, where makeshift mends bind the rifts and tears to compose one tense and conflicted structure. Feminist art historian Rosemary Betterton has commented that in Emin's work: 'The repetition, fragmentation and layering of images and words across a range of diverse practices imply a more contradictory and ambiguous sense of self than can be held within a single, unified image.'[80] The subjective space produced in *You Forgot to Kiss my Soul* is not singular; it is not even double, nor yet a finite set of representations of separate dyadic relationships. Rather, it is composed of sets of threes, in which the position in which the third is placed varies. The references to childhood do not anchor the critic back into one version of Emin's past; instead multiple different Emins – hostile, playful, sentimental, gentle and furious – oscillate in shifting relations, a clear spatial correlate for the words of Susan Rubin Suleiman commenting on feminist autobiographical practice:

> … *the self is not a fixed entity but an evolving process, not something discovered (or passively 'remembered') but something made; which does not mean that it does not exist, but that its existence is always subject to revision (re-vision).*[81]

Although autobiographical work is often assumed to uncover the 'truth' beneath, through the act of performing the self, the intimate interior becomes a well-worn exterior.[82] I suggest that the confessional can be understood as a form of physic architecture, where the act of revealing transforms into one of concealing, and the details construct separations as well as openings between one and another.

Art critic Jennifer Doyle has described how Emin 'theatricalizes personal space' and generates 'an effect of intimacy' between artist, artwork and beholder.[83] She suggests, following the work of feminist critic Amelia Jones, who argues against 'the fantasy of the critical subject whose body is itself experienced as unmarked', and sets him/herself up as an authority on the object of his/her critique, that Emin's work disallows the critic to '[write] as though the boundaries between this self and the object of critical thought are solid, impenetrable',[84] and instead demands the kind of emotional rather than intellectual response that is usually considered out of place in art criticism. *You Forgot to Kiss my Soul* invites the critic to enter encounters between mother, father and child, conjuring up a space where it is hard not to reflect on one's own personal history, thus dissolving any easy boundary that might appear to separate the artist's life and work from the critic's own.

I argue that Emin's architecture provides three settings, each of which positions the critic in relation to certain psychic dyads she occupies. The importance of this composition of three sets of two is underscored in Emin's autobiographical text *Strangeland*. Structured into three topographies – 'Motherland', 'Fatherland' and 'Traceyland' – the book provides three different perspectives on the artist's history told in both the first and the third person. The three sculptures in *You Forgot to Kiss my Soul* also present her autobiography as a triadic construction through interactions between the artist and her mother, her father and herself. Each time the critic enters one of these dyads and occupies the position of third that is offered, the dyad is altered, since in engaging with Emin's particular version of the Oedipal triangle we are prompted to reconsider our own.

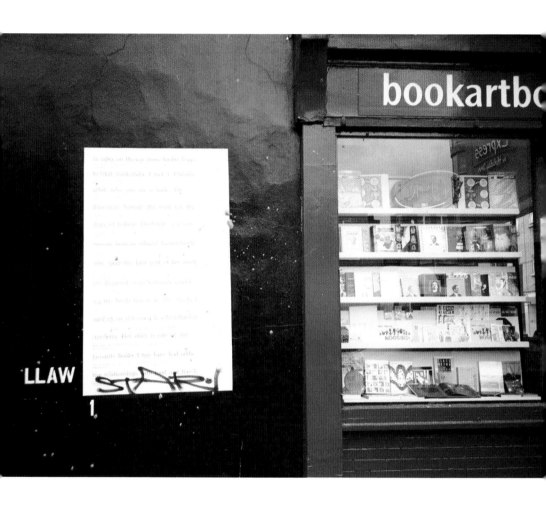

6
Jane Rendell, *Confessional Construction* (2002) *LLAW*, curated by Brigid McLeer, BookArtBookShop, London. Photograph: Jane Rendell, 2002.

Confessional Construction

At the BookArtBookShop in London, on the corner of Charles Street and Pitfield Street, Brigid McLeer was invited to curate one of the outside walls as a project called LLAW. She asked me to write a 'page' that would be pasted to the wall for a month.[85] McLeer's interest was in the physical construction of the text and the ways in which I might explore my position within the space of writing. How would the public placing of a 'page' on a wall influence what and how I might write?

Anticipating those public passers-by who might come across the text and read in distraction, rather than choose to immerse themselves in the pages of a book in a private quiet place, a new way of working emerged that changed the manner in which I would normally have considered the layout of the text on the page and my place within it. A main statement – an autobiographical detail, perhaps a confessional – was interwoven with more critical reflections upon what it means to confess. I placed the footnotes down the side of the page, numbered from bottom to top, to read upwards as one builds a wall.[86] They contained specifications by an architect friend, Deborah Millar, concerning the detailing of walls and openings. These careful instructions for physically constructing the boundary between inside and outside, precisely the site in which this page was located, touched upon my own developing interests in the confession as a construction rather than a revelation of the self.

When I read out my 'confessional construction', pasted to the wall of the BookArtBookShop, as one would read a page – from left to right, from top to bottom – I transformed my relation to the page and its three

voices. What has been created through this process, by accident it seems, are a series of blockages, which obstruct the smooth flow of an autobiographical confession.

In 1989, on the way from Austin, Texas

FACEWORK:
Protect against damage and disfigurement, particularly arrises of openings and corners.

I've always considered autobiographical writing to be confessional, part of a process of revelation, one that uncovers the truth beneath. 1 But recently

14

to Santiago Atitlan, Guatemala, I met a Chicano

BASIC WORKMANSHIP:
Store bricks/blocks in stable stacks clear of the ground. Protect from inclement weather and keep clean and dry.

I've come to realize that a confessing is not a revealing, but a constructing (of ourselves). 2 Writing about myself is a making of myself. 3 Although

13

artist, who gave me a book, *The*

POLYETHYLENE DAMP PROOF COURSE:
Joint sheets with continuous strips of mastic between 150 mm overlaps and seal with tape along the edge of the upper sheet, leaving no gaps. Ensure that sheets are clean and dry at the time of jointing.

the writing professes, confesses, to be a window or an opening to an

If sheets cannot be kept dry, double welted joints may be used, taped to hold in position prior to laying concrete.

interior, 4 it might better be described as a mask, 5 or a wall, 6 a boundary

12

Passionate Nomad. The book was the

Lay neatly and tuck well in angles to prevent bridging. Form folded welts at corners in upstands.

between myself and another. 7 As such it is a form of physic architecture.

11

diary of Isabelle Eberhardt, a young

SECOND-HAND LONDON STOCK FACING BRICKWORK:
Bricks: Second-hand London Stock bricks, to match existing, free from deleterious matter such as mortar, plaster, paint, bituminous materials and organic growths. Bricks to be sound, clean and reasonably free from cracks and chipped arrises. Some bricks can be salvaged from demolitions C10/5–7. As far as possible these should be reused for making good reveals to same, in order to achieve best possible colour match.

Sometimes I draw others into my stories – my father, my mother, even my lover. 8 Sometimes it is without their consent. 9 They are an integral part of

10

ALTERATIONS/EXTENSIONS:
Except where a straight vertical joint is specified, new existing facework in the same plane to be tooth bonded together at every course to give continuous appearance.

woman from an affluent French family

Where new lintels or walling are to support existing structure, completely fill top joint with semi-dry mortar, hard packed and well rammed to ensure full load transfer after removal of temporary supports.

my confessional construction. 10 If they are the building materials, then who is

9

the architect?

ALTERATIONS/EXTENSIONS
Arrange brick courses to line up with existing work.
Brick to brick: 4 courses high at 8 course centres.
Brick to block, block to brick or block to block: Every

who spent the later part of her short

alternate block course.
Bond new walling into pockets with all voids filled solid.

8

My love of writing is generated through a desire for encounters. I often tell stories about myself to make a place to meet my reader.

FIRE STOPPING:
Fill joints around joist ends built into cavity walls with mortar to seal cavities from interior of building. Ensure a tight fit between brickwork and cavity barriers to prevent fire and smoke penetration.

life disguised as an Arab man wander-

7

In telling you about myself, I am revealing aspects of myself, making myself vulnerable. 11 But am I really revealing?

FACEWORK:
Keep courses evenly spaced using gauge rods/set out carefully to ensure satisfactory junctions and joints with adjoining or built-in elements or components.

ing the deserts of northern Africa. She died

6

Is it not that I am showing you my vulnerability, showing you who I am? 12

FACEWORK:
Select bricks/blocks with unchipped arrises. Cut with a masonry saw where cut edges will be exposed to view.

5

aged 28, on 21 October 1904, in a flash flood at

TIMBER WINDOWS:
To BS 644: Part 1
Manufactured by a firm currently registered under the British Woodworking Federation Accreditation Scheme.
Materials generally: To BS EN 942.

Are my stories walls or windows? 13

When no predrilled or specified otherwise, position fixings no more than 150 mm from each end of jamb, adjacent to each hanging point of opening

lights and at maximum 450 mm centres.

4

Ain-Sefra. Her diary is one of my

BASIC WORKMANSHIP:
Bring both leaves of cavity walls to the same level at
– Every course containing rigid ties.
– Every third tie course for double triangle/butterfly ties.
– Courses in which lintels are to be bedded.

*What does psycho-analysis say about boundaries? * What do walls say about*

Do not carry up any one leaf more than 1.5 m in one day unless permitted by the CA.

self-protection?

3

favourite books. I too have had addictive

BASIC WORKMANSHIP:
Build walls in stretching half lap bond when not specified otherwise.
Lay bricks/blocks on a full bed of mortar; do not furrow. Fill all cross joints and collar joints: do not tip and tail.
Rake back when raising quoins and other advance work. Do not use toothing.

Are architectural and psychic elements, processes and structures analogous? 14

2

relationships.

All specifications from Deborah Millar architect.

* On the corner of Charles Street and Pitfield Street, she found a bookshop, one that she had not noticed before. She walked in. On the left-hand wall, lying on the floor, quite close to the wall, she saw a book. When she bent down to pick it up, she saw it was a copy of Sigmund Freud, *The Essentials of Psycho-analysis* (London: Penguin Books, 1986). She turned to page 117. Crouching there, close to the floor, head almost touching the wall, she started to read: 'Our hypothesis is that in our mental apparatus there are two thought-constructing agencies ...' She read for twenty-six seconds.

Configuration 2

To and Fro

Frontier Creatures

Our hypothesis is that in our mental apparatus there are two thought-constructing agencies, of which the second enjoys the privilege of having free-access to consciousness for its products, whereas the activity of the first is in itself unconscious and can only reach consciousness by way of the second. On the frontier between the two agencies, where the first passes over to the second, there is a censorship, which only allows what is agreeable to it to pass through and holds back everything else. According to our definition, then, what is rejected by the censorship is in a state of repression.[1]

Starting out with the quote from Sigmund's Freud 'On Dreams' found at the end of *Configuration 1: Triangular Structures with Variable Thirds* on the floor by the wall of the BookArtBookShop, *Configuration 2: To and Fro* explores the role of the frontier of boundary as a place of crossing in Freud's two triadic models, which describe developments in his understanding of the structure and processes of the psychical apparatus. The first topography consisted of the agencies of the conscious (Cs), preconscious (Pcs) and unconscious (Ucs) and was most clearly articulated in 'The Interpretation of Dreams' (1900). The second topography outlined in 'Beyond the Pleasure Principle' (1920) and also in 'The Ego and the Id' (1923) included the ego, id and superego. For André Green, in Freud's first topography the three agencies are defined in terms of their relation to consciousness.[2] While the preconscious is susceptible to becoming conscious, the unconscious is never revealed by observation and can only be deduced, for example by slips of the tongue, parapraxes, acts of forgetting, dreams, phantasies,

symptoms, transference and so on. The unconscious can only be spoken about *après coup*, after the event.[3]

A key aspect of the shift from the first to the second topography involved Freud's conceptualization of repression and the nature of the boundary condition between conscious and unconscious. The two are of course connected: Freud uses the term repression to describe 'a process affecting ideas on the border between the systems Ucs. and Pcs. (Cs.)'.[4] In psychoanalysis repression is linked to repetition. Freud's account of the compulsion to repeat is located in 'Beyond the Pleasure Principle', where he argues that from an economic rather than a topographic or dynamic point of view the pleasure principle's aim is to reduce agitation and return to an inorganic state, but that the compulsion to repeat works against this.[5] In their commentary on Freud's work, Jean Laplanche and J.B. Pontalis posit that the 'defining property of the symptom' can be located in the manner in which it reproduces 'in a more or less disguised way' elements of past conflict, and the ways that 'the repressed seeks to "return" in the present, whether in the form of dreams, symptoms or acting-out'.[6]

For literary critic Robert Rogers, Freud's concept of repetition has become a central strand of critical thinking. Rogers outlines how Freud describes repetition as a 'source of information for the purposes of psychoanalytic interpretation, and as a signifying process'.[7] He distinguishes between 'Beyond the Pleasure Principle', where Freud relates repetition to discomfort, and elsewhere, for example in 'Remembering, Repeating and Working Through' (1914), where he focuses on the positive aspects of repetition.[8]

Rogers then turns to examine in detail the fascination Freud's concept of '*fort/da*' has held for Jacques Derrida and Jacques Lacan. In 'Beyond the Pleasure Principle', Freud tells the story of a game invented by his grandson at the age of one and a half, where he would throw objects away from him, including a wooden reel, saying 'ooo', and then pull them back, saying '*da*'. Freud understood him to be saying '*fort*' and '*da*', the German words for 'gone' and 'there', and theorized his actions as a way of dealing with the absence of his mother to whom he was very attached.[9] Rogers discusses how, in 'Coming into One's Own' (1978), Derrida focuses on Freud's self-analysis and his own position in the text, examining how what is reported has a bearing on the one who reports it, noting that Freud is playing a game of *fort/da* with himself as his own object,[10] and stating that 'every autobiography is the going out and the coming back of the *fort:da*'.[11] Derrida describes how this kind of writing has the structure of an abyss, the *mise en abyme*, where identical elements fold into themselves through repetition, creating an abyss of meaning. Rogers notes that Derrida seems to miss the point – that he himself is also located in the game, identifying with Freud as well as his grandson.

Rogers goes on to explore how a 'lack of attention to difference also characterizes Lacan's discussion of repetition'.[12] He refers to Lacan's focus on the similarity rather than the difference between the first and

second scene in his seminar on Edgar Allan Poe's short story from 1845, 'The Purloined Letter'.[13] Rogers turns to feminist literary critic Shoshana Felman's commentary, agreeing with her reading – that it is the fact that the second scene is a repetition which allows it to provide an analysis of the first – and argument – that the analyst's effectiveness springs from his 'position in the (repetitive) structure'.[14]

Repetition can be understood as a conscious, but not necessarily knowing, acting out of repressed feelings stored in the unconscious. The temporal structure of deferred action, *nachträglichkeit* in the German original, *après coup* in the French translation, provides one way of understanding the distinction between conscious and unconscious, in terms of their division and then interaction over time, how one is separated from, but returns in the other. Laplanche has chosen the neologism 'afterwardsness' as his preferred English translation as he finds that this term is better able to embrace the double temporal direction – the 'to and fro' – of retrogressive and progressive actions, as well as the processes of detranslation and retranslation that he holds are central to the concept of *nachträglichkeit*.[15]

The relation between conscious and unconscious is spatial as well as temporal. From his earliest research Freud used diagrams to communicate his understanding of the various components and processes of the psychical apparatus, to highlight the topographical condition of psychic entities as well as movements between them across territories, boundaries and edges. One of the earliest diagrams drawn by Freud is 'Psychological Schema of the Word Concept',[16] originally published in 1891 in his work on aphasia. It shows the conscious and unconscious as two complexes – 'word-' and 'object-associations'. This representation shows the division between conscious and unconscious in terms of two main branches of a tree, whereas in a later drawing, 'Schematic Diagram of Sexuality' (1894),[17] a line is used, sometimes dashed, to differentiate between two territories, one unnamed located inside the boundary, and another labelled 'the external world' situated outside. The line of the boundary also marks a channel of flow between what Freud names 'the sexual object' and 'the spinal column'. Crossing the territory encircled by this boundary are two further lines: a vertical line, the 'ego boundary', crossed by a horizontal line, the 'somat.psych Boundary'.

In a subsequent diagram, 'The Architecture of Hysteria' (1897),[18] Freud represents the relationship between inner and outer worlds differently. The drawing's architect has changed his/her viewpoint, and rather than a plan or section, where all the elements are drawn at the same scale, the various zones in this drawing – labelled I, II, III, IV – appear to recede into the distance like a perspective. The zones are linked by two layers of triangulated lines – one dashed, the other not – both of which diminish in size as they move away from the viewer.

Another three years later, in 'The Interpretation of Dreams', Freud developed his visual representation of the passage of communication between inside and outside through series of schematic diagrams

comprising vertical bands, similar to an architect's cross-section through a substance. The final version showed perception (Pcpt.) at one end and the preconscious (Pcs.) at the other, with movement occurring from Pcpt. to Pcs. across a series of mnemic traces followed by a dotted arc swinging under the vertical band representing the unconscious.[19] Later on in the written text, Freud supplemented his topographical account of the nervous system and the psyche, where the conscious, preconscious and unconscious were located in different places, with a dynamic one, where he argues a particular 'agency' is able to influence the structure.[20] Using the metaphor of a telescope, Freud likens the operation of the psychical system to the way in which beams of light are refracted to form an image when they enter a new medium.[21]

The operation of spatial metaphors to explain the arrangement of psychical structures and processes also appears in Freud's 'Introductory Lectures' of 1917. Here he uses architecture to position the role of censorship on the threshold between two rooms – conscious and unconscious – guarded by a watchman:

> *Let us therefore compare the system of the unconscious to a large entrance hall, in which the mental impulses jostle one another like separate individuals. Adjoining this entrance hall there is a second, narrower, room – a kind of drawing-room – in which consciousness, too, resides. But on the threshold between these two rooms a watchman performs his function: he examines the different mental impulses, acts as a censor, and will not admit them into the drawing-room if they displease him.*[22]

Freud develops his understanding of the roles played by both the topographic and the dynamic models of the psyche in his 1915 paper 'The Unconscious', something I discuss in more detail in *Configuration 3: A Rearrangement*.[23] At the start of Part IV 'Topography and Dynamics of Repression', he employs the term repression or *Verdrängung*, which can also be translated as displacement, to describe 'a process affecting ideas on the border between the systems Ucs. and Pcs. (Cs.)'.[24] In 'The Ego and the Id' (1923) Freud goes on to articulate activities on this boundary in terms of the ego – a 'frontier-creature' who 'tries to mediate between the world and the id'.[25] 'The Ego and the Id' contains a diagram, which repositions the territories of the conscious, preconscious and unconscious spatially with respect to the three new entities of ego, superego and id. Freud places the ego below the preconscious and above the id, circumscribed in a blob-like shape. Outside the blob's boundary, at the top of the diagram, next to the preconscious, the 'pcpt.–cs.' is located, to its left a box named 'acoust.' and to the right a passage providing direct access to the id, under the ego, circumventing the preconscious.[26]

Ten years later, in 1933, in 'The Dissection of the Psychical Personality', Freud drew together these two triadic structures – 'the three qualities of the characteristic of consciousness [*sic*]', the conscious, preconscious and

unconscious, and 'the three provinces of the mental apparatus', the ego, superego and id – into one socio-spatial analogy using a geographical and cultural metaphor:

> *I am imagining a country with a landscape of varying configuration – hill-country, plains, and chains of lakes –, and with a mixed population: it is inhabited by Germans, Magyars and Slovaks, who carry on different activities.*[27]

The paper also includes a final diagram, a reworked version of the one from 'The Ego and the Id', this time including the superego to the left of the ego in the position previously occupied by 'acoust.', and the unconscious placed between the ego and the id. In this version the encircling boundary has an opening at the bottom, but the entry to the passage of repression is sealed.[28] Taken together, these various diagrams indicate Freud's reliance on drawing as well as writing for representing his changing understanding of his models – in particular topographic – of the psyche, but they also demonstrate the inadequacy of such systems of meaning for articulating interpsychic and intersubjective space.

Psychoanalyst Didier Anzieu and feminist philosopher Elizabeth Grosz have shown great interest in the role that the skin plays as external boundary in Freud's construction of the psyche. Anzieu's concepts of the skin-ego and psychic envelope draw together the skin's role as a physical organ and its psychic function in establishing a boundary between inside and outside realities. He comments on how Freud's formulations of the ego from 'The Project' of 1895 are energetic, whereas in 'The Ego and the Id' of 1923 the energetic functions of the ego are 'transformed in order to discover the functions of the psychic envelope'.[29]

> *This three layered psychic envelope delimits a triple frontier … a frontier with the internal space of external objects, a frontier with the internal space of internal objects, and a frontier with the perceptual world.*[30]

Anzieu argues that for thirty years the 'dissymmetrical double-tree',[31] originating in his work on aphasia, remains an implicit model of Freud's conceptualizations and practice. But 'Beyond the Pleasure Principle' (1920) and 'The Ego and the Id' (1923), Anzieu maintains, mark a break with this schema. The double-tree structure gives way to the image and notion of a vesicle, an outer envelope, representing the psychical apparatus. The accent shifts from conscious and unconscious psychical contents to the role of the psyche as container, but no ordinary container – one that is inscribed with signs:

> *The skin ego is at once a sac containing together the pieces of the self, an excitation-screen, a surface on which signs are inscribed, and guardian of the intensity of instincts that it localizes in a bodily source, in this or that sensitive zone of the skin.*[32]

Following Anzieu, Grosz describes how the information provided by the surface of the skin is 'both endogenous and exogenous, active and passive, receptive and expressive'.[33] From an examination of two Freudian texts, 'On Narcissism: An Introduction' (1914) and 'The Ego and the Id' (1923), she explores how the ego is a 'mapping of the body's inner surface, the surface of sensations, intensities, and affects', but that since it is derived from two kinds of 'surface' it is also able to provide a 'double sensation':

> On the one hand, the ego is on the 'inner' surface of the psychical agencies; on the other hand, it is a projection or representation of the body's 'outer' surface.[34]

But rather than a single thin screen or boundary, Green stresses that in Freud's work from 1924 it is possible to 'conceive of the whole psyche as an *intermediate formation* between soma and thinking',[35] extending the notion of the screen or boundary into an extended passage which encompasses a number of different transitions.

> We are now in possession of a complete system which starts with the psychical representations of the drive, closely linked to the body, opens out into thing- or object-presentations (unconscious and conscious), links up in consciousness with word-presentations, and finally joins the representatives of reality in the ego, implying relations with thought.[36]

However, in Anzieu's view, it is Freud's paper of 1925, 'Note upon the "Mystic Writing Pad"', which completes his detailed description of the topographical structure of this outer envelope.[37] Here Freud utilizes a more complex metaphor; that of the writing process itself, to describe the process of inscription and re-inscription. He describes the components and mode of operation of the 'mystic writing pad', an artefact available at the time, in great detail: how an upper layer of transparent celluloid and a lower of thin translucent waxed paper are laid over a slab of dark brown wax or resin, and that marks inscribed by a metal stylus can be seen while the two layers are in contact with each other and the wax, but when separated just a trace remains, embedded in the wax, visible only in certain light:

> Thus the Pad provides not only a receptive surface that can be used over and over again, like a slate, but also permanent traces of what has been written, like an ordinary paper pad: it solves the problem of combining two functions by dividing them between two separate but interrelated component parts or systems. But this is precisely the way in which … our mental apparatus performs its perceptual function.[38]

•

The configuration that follows traces the journey – the repetitions and differences – in a writing, which moves to and fro across the boundary between inner and outer worlds, private and public territories. The text started out as 'Travelling the Distance/Encountering the Other', where I wove reflections on my childhood in the Middle East with a more theoretical commentary on spaces of encounter in academic and intellectual life, from teaching through to criticism. I returned to these childhood memories and extended them in connection to themes of threshold and sanctuary for 'To Miss the Desert', a piece of art criticism produced in response to Nathan Coley's *Black Tent* (2003). When I was asked to write an essay for an exhibition, *(Hi)story* (2005), including works by four artists – Jananne Al-Ani, Tracey Moffatt, Adriana Varejão and Richard Wentworth – I took phrases from 'To Miss the Desert' and re-made them as refrains, in response to Al-Ani's *The Visit* (2004), as part of a longer essay entitled 'You Tell Me', which explored the theme of topological fictions.

In what is perhaps a final transformation, this time for *An Embellishment: Purdah*, a two-part text installation for an exhibition, *Spatial Imagination* (2006), I selected short extracts from 'To Miss the Desert' to create twelve 'scenes' of equal length, laid out in the catalogue as a grid, to match the twelve panes of glass in the gallery window where I wrote the word *purdah* repeatedly. From a hybrid essay combining theory and autobiography, into one piece of art criticism, then another, finally to be recomposed as a diptych – a text installation with one part sited in a book and the other in a window – this process of transformation could be described as a 'site-writing', where the repeated processes of writing and re-writing take place in response to the demands of changing sites, making patterns to and fro across the frontier between inside and outside.[39]

Travelling the Distance/ Encountering the Other

The distances we travel are physical and psychic. The others we meet on route take the form of places, objects and people. They may be our children, critics, friends, lovers, parents, readers, teachers or students. But often that most distant other encountered in travel turns out to be a lost part of ourself.[40]

The Games We Never Played

Home is that place which enables and promotes varied and everchanging perspectives, a place where one discovers new ways of seeing reality, frontiers of difference.[41]

For most of my life, travel has been a certainty rather than a question … travel was unavoidable, indisputable, and always necessary for family, love, and friendship as well as work.[42]

PO Box 1606, Riqa, Dubai, Trucial States, Arabian Gulf
PO Box 387, El Fascher, Darfur Province, Sudan
PO Box 1570, Kabul, Afghanistan
PO Box 86, Mekele, Ethiopia
22 Wells Close, Harpenden, Hertfordshire, AL5 3LQ
15 Mayfield Road, Girton, Cambridge, CB3 OPH

22 Collegiate Crescent, Sheffield, S10 2BA
15 Filey Street, Sheffield, S10 2FF
3 St Quintins Avenue, London, W10 6NX
12 Mogg Street, Bristol, BS2 9TZ
22 Barony Street, Edinburgh, EH3 6PE
18 Eyre Crescent, Edinburgh, EH3 5EU
60 Lillieshall Road, London, SW4 OLP
2a French Place, London, E1 3JB
48 Enfield Cloisters, Fanshaw Street, London, N1 6LD
60 Cotswold Court, Gee Street, London, EC1V 3RX

I was born in Al Mahktoum hospital, Dubai, in the 'Middle East'. As a girl I lived in Sudan, Afghanistan and Ethiopia. My movements followed the pattern of my father's work. Unlike many children in similar situations, I was not put into a boarding school at the age of eleven, but came back to live in England with my mother and sister. I say 'came back'. The phrase implies that I was returning to somewhere I had already been. But I had never lived in England before. It was my father's country of origin, not mine.

Once the women were back at home, my father continued to traverse the drier areas of the globe. He is a hydrogeologist – a man who looks for water and brings it to the surface for people to wash in and to drink. He does this in lands that are not his own, that he was not raised in, that are strange to him and with people whose languages and customs are not kin, but that he has had to learn anew.

Secretly I have always been rather relieved in confessional conversations around the academic dinner table that my relationship with colonization involves acts of kindness. My father had skills that allowed him to locate water under a brittle crust, and so he used his knowledge to help. He is a gentle and unassuming man who seldom takes the high ground. So why am I uneasy?

I remember nights spent capturing insects on cold stone floors. Our house was not grand. In western terms, it was a shack, but unlike many other houses we had lived in it had a stone floor, running water and a tin roof that seldom leaked. While my parents were out, a Tigreanean man stood at our gate. He was our watchman. I was uncomfortable around this tall black man with his hardened feet and long white robe and stick. My younger sister played with him, but I kept myself at a distance.

At that time all westerners had guards positioned at their gates. Was it because a western family had recently been ambushed nearby by Tigreanean rebels? Or was it to suggest that we were important enough to protect? I am still embarrassed by the fact that we employed Africans as servants to look after our house and us. 'Why?' I ask my parents now. 'It was the custom then,' they say.

If it is a custom, it is one that shames me. I never played with the watchman. I never travelled that distance. Do the games we never played make me a colonizer too?

Feminist Academics Come with Baggage

The nomad does not stand for homelessness, or compulsive displacement; it is rather a figuration for the kind of subject who has relinquished all idea, desire, or nostalgia for fixity.[43]

Writing is the passageway, the entrance, the exit, the dwelling place of the other in me – the other that I am and am not, that I don't know how to be, but that I feel passing, that makes me live – that tears me apart, disturbs me, changes me …[44]

Gloria Anzaldúa
Rosi Braidotti
Judith Butler
Hélène Cixous
Diane Elam
Elizabeth Grosz
bell hooks
Luce Irigaray
Caren Kaplan
Julia Kristeva
Doreen Massey
Elspeth Probyn
Gillian Rose
Janet Wolff

My early childhood made me into a traveller. For years I travelled physically all the time. My work simply provided money for a trip. And I never went to the same place twice. Recently I have been moving frequently, but have not been travelling in the same way. I go on journeys with purposes. I give papers at conferences. I visit buildings, artworks, and friends with new babies. No longer do I meander off with no purpose other than to lose myself. Yet still I do get lost – it is just that my body stays still. Through reading, writing and teaching I lose myself in other people's heads. In my office with students streaming through the door, or in the library with my head in a book, or at home with my fingers on the keyboard, I am endlessly on the move.

Moving is not strange to me; both physically and emotionally, I am most comfortable in transit. Being in motion provides a sense of stability – to have already left but not yet to have arrived. This place has a familiar feel and it seems I am not alone. Postmodern feminism is full of stories of women's travels. Their written work speaks of displacement. But there is much at stake. Movements vary in political dimension. Not all journeying is to be celebrated.

First in one place then in another, I find it easier to make connections in strange places. I like to take my baggage across the frontier into a new land – to unpack among strangers. Only to find the things I have brought have lost their intended purposes and have to be imagined anew.

This situation describes my experience of working between disciplines, relating to another. Many feminist academics I know seem to be drawn to the unknown territories of new areas of study. To be interdisciplinary is to be between places. But how exactly is the 'inter' constituted? Is the interdisciplinary operator the one who maps the tears and mends the rifts, the places where things have come apart, who sews the overlaps and fixes the joins, the places where things come together? Or has she arrived from elsewhere, as a foreigner in town? Does she aim to alter the values of here to match those of there, or allow herself to be changed by her new surroundings? To travel the distance is to transform as well as transgress.

Caress

> *Critical work is made to fare on interstitial ground … critical strategies must be developed within a range of diversely occupied territories where the temptation to grant any single territory transcendent status is continually resisted.*[45]

> *The caress is an awakening to intersubjectivity, to a touching between us which is neither passive nor active; it is an awakening of gestures, of perceptions which are at the same time acts, intentions, emotions. This does not mean that they are ambiguous, but rather, that they are attentive to the person who touches and the one who is touched, to the two subjects who touch each other.*[46]

critic
exile
migrant
nomad
refugee
storyteller
teacher
tourist
traveller
writer

For me, the critic is a travel writer, always going far from home, invited as a guest into someone else's place. To enter the territory of another necessitates movement out of one's own – it involves trust on both parts. To engage with something imagined by another is also to journey, from what is already known towards what is as yet unknown. To encounter another requires a willingness to connect, but also to let go, to take risks. Some critics travel like tourists, crossing vast territories but remaining unchanged. Others are constantly pulled out of the familiar towards the strange, impelled by a desire for transformation – a total immersion in the other – in order to return anew to the self.

Does the varying distance between a critic and her objects make different subjects? Can shifting subjectivities influence the space of criticism? The 'correct' critical viewpoint is commonly assumed to be one of objective judgement, requiring a distinction between the critic and the object she is critiquing and implying that distance is sufficient to establish disengagement. 'Subjective' is a pejorative term; it accuses the critic of having lost her sense of judgement, to have become so engaged in the other, so close, that distance, and thus objectivity, has collapsed.

But criticism can be a form of writing, which negotiates the very space of the distance between one and another. It is a working between at least two sites: one is already known while the other is yet to be explored. As I travel the distance towards you, I turn around to look back at myself and see that I have already disappeared from view.

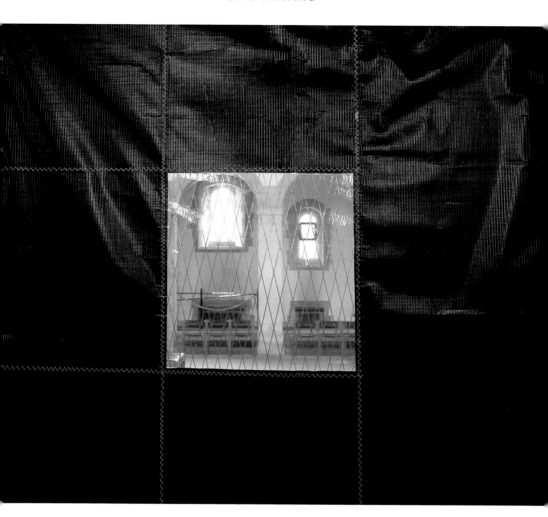

7
Nathan Coley, *Black Tent* (2003). Reproduced by kind permission of the artist and
Haunch of Venison Gallery, London.

To Miss the Desert

Around the Centre

Surrounding her house is a moat of flints with furrows running through it at regular intervals like a ploughed field. When you run up and down these slopes, you can lose your footing and slip, and that is when you know the sharp-looking stones really can cut your knees. Still, it is safer here than beyond the walls in the waste-ground of dry bushes and stinging insects, where hyenas cry in the night.

A hallway forms the centre of the house. It has a tiled floor, hard and shiny; at night she comes here to catch insects. Many creatures skulk across it, ants and spiders, and some more sinister, whose names she does not yet know. But as long as she is careful to catch them under her glass jar with its smooth edge, the one that meets the marble without making any gaps, she is safe to sit and watch the trapped insects inside.

14 Floor Finishes
Location G6
Lay new flooring 300 mm × 300 mm terracotta unglazed tiles with sandstone colour grout 10 mm wide joints.
All tiles to be laid out from centre line.
Finished floor level to match G5.

A small pig and a spider; the tin roof drums with yet more rain. The rains have come early this year, and they are heavy. She lies tucked up in

bed, reading about Charlotte and her web. Her tummy aches. It is swollen, a bit yellow, and worse still, it sticks out. Today she has had her tenth injection, thankfully the final one. Each time the fat needle went into her it made another mark, making a circle around her tummy button, first at mid-day, then at six o'clock, then at three o'clock, then at nine o'clock, and then all the way around again, until she felt bruised and sore.

Big injections had been talked about ever since Bobby the dog got a tick on the rim of his eye. The tick would not come free, not even with a burnt match and ghee. Poor Bobby, with his sad eyes and velvet brown ears, got sicker and sicker. He lay on his side in the shade, panting, his ribs heaving in and out. Sometimes his tummy shook. Finally, he was taken away to the vets' and never came back.

They kept on talking about big injections. No one seemed to know why Bobby had been sick – was it from tick fever or rabies? Tick fever was not a worry, they said, but rabies certainly was. It turned you mad, frothing at the mouth and running screaming from water, until it got you in the end. Everyone agreed it was the vets' fault; they had burnt Bobby's body. Anyone knows that you should keep the head and take a slide from the brain before burning it. Only then, when you look at that slide, can you tell whether or not the dog had rabies.

Had Bobby licked her hands, they wanted to know. They looked at all the scratches. She always had cuts on her hands from stone-hunting and mud-pie baking, she told them. Of course Bobby had licked her hands, especially when she tried to comfort him at the end, poor Bobby.

On an Ethiopian airlines plane, a DC3, with their '13 Months of Sunshine' posters, all the way from Addis Ababa, came the special cool box. She knew the route well; it took you past Gondar, Lalibella and the place beginning with D. You could get out there for a bit to play on the grass by the lake. For eating your snack of bread and jam, the stewardess gave you a bright orange cushion.

The cool box was delivered right to her door by the nice Dutch doctor. It was packed with jars of a plum-coloured syrup and big plastic syringes, 'horse syringes', the doctor said and laughed. To keep them cold, everything else had to be taken out of the fridge.

I swing to and fro, higher and higher, watching my dark shadow on the dirt. As mid-day approaches, my shadow grows smaller, and then it disappears. Everything is grey but it is not a shade I have seen before. It is not a dull grey, like the light on a cloudy day when shadows cover up the sun, but bright and dazzling, a grey that hurts my eyes. I look up. The sun has disappeared. Instead there is a black hole. Around the centre is a halo of white light.

Along the Edge

The bathroom has a floor of polished marble, black, interwoven with white veins. Perched on the toilet, with her feet dangling off the ground, she traces the white lines with her gaze. She keeps alert for cockroaches; at any time an intruder might crawl through the cracks along the edge of the room and into the blackness.

Inside her house all the floors are marble, smooth and cool, laid out in careful grids, except for the big golden rug. In the evening when the sun is in the west, the rug glows. At this time of day she likes to follow the intricate patterns with her feet, like paths around a secret garden. But if you dance along the edge of the squares, you must be careful not to fall in – who knows what could lie in wait for you in such an enchanted place?

> Our initial proposal is for a one-storey building with a courtyard at the centre and the accommodation along the edge of the site. This means that the building will be fully accessible without the additional cost of a lift and there will be no problems of overlooking. The main entrance leads to a central courtyard, covered and top lit. All the other facilities are to be accessed off this space.

Along one edge of the garden are the homes of two men. Gullum is tall and fair-skinned, with light hair and green eyes; and Kareem shorter, stockier, darker. They have fought each other in the past, and will again when the Soviets come to Kabul, and then again, when her own people search the Hindu Kush to wipe out all evil. But for now, there is no fighting; once the sun has gone down, they sit and eat together.

On weekday mornings she has to wait by the gate for the yellow school bus. She goes to a Catholic school, but the Italian priest who teaches her has not noticed yet that she never reads the Bible. They call him a real revolutionary, a man who fights for the people of Afghanistan. On days when she does not have to go to school, she swims in the streams of the Hindu Kush, looks at blue pots in Istalif, wooden chests in Peshawar, plastic boots in the Kabul bazaar, and one day, she goes south, to visit Kareem's home.

He is a man with property: land and wives. Inside the walls of his house are sunlit orchards full of dark purple fruit. Among the trees his wives sit. Dressed in shades of red, some of the women have covered their faces; others have painted their toenails pink. From a distance, the women watch them arrive, disappearing inside as they draw closer.

The guests are taken upstairs to a long veranda overlooking the garden. The only furniture here is the carpet laid out in a long line down the middle of the room. Men in turbans sit cross-legged along the edge and eat from the dishes laid out in front of them. They are invited to sit down and eat, the only women – her mother, her sister, herself.

After the meal, as they walk back down through the dark house to leave, she sees a pair of eyes watching her from behind a screen. The eyes belong to a girl, a girl with the hands of a woman, a woman who glints with silver. Later she learns that this is Kareem's youngest wife, once a nomad, who carries her wealth in the jewels on her fingers.

My own dress is set with tiny mirrors and a handsome square of embroidery at the front. It is hard work to get on, with no fastenings and a fabric so thin it could rip. In this dress I feel just like all the other Afghan girls. Except that they wear their dresses a bit softer, sometimes black. I wonder whether it is to match the black around the edges of their eyes.

At the Threshold

A hot tent, the swathes of sheet are close enough to make me sweat. I rush headlong into the redness, with sultry breath and a swollen tongue. Down and down, round and round … swirling in the shallows. The waves rise up and over me. I sink into a world beneath the sand. Towards me, staggering, comes a soldier, left, right, left, right … I open my eyes. I am in a palace of lilac silk, a cool object is on my chest and something metal in my mouth. A smooth brown hand holds mine.

Her mother tells her a story of how she taught the sheik's niece English. She was allowed to go inside the harem, and saw that underneath their *burqas* the women wore make-up and perfume. For her labours, she was offered a gift. She asked for a gold leaf *burqa*, the costume only the wives of the sheik can wear.

Her mother's labour is not easy; she refuses to come out. Her mother walks the dunes along the creek, to and fro, past the apartment block where she lives, but still she waits inside, for a night and a day. The chance of infection is high. There is no glass in the hospital windows. A caesarian section might kill them both, one of them for sure, certainly her mother if she turns out to be carrying a son.

Fortunately there is a woman who is willing to take a chance. On the second night of her mother's labour, the hospital is almost empty; everyone who can has gone, to feast, to break the fast. A nurse runs a drip to encourage her out. But she holds her ground. The nurse turns the drip up. Still she refuses to budge. The drip is turned up again, faster, until she has no choice but to leave her warm waters and enter the world.

For her entrance, and her mother's bother, the sheik sends his apologies. 'Sorry,' he said, 'so sorry it isn't a boy.' For a boy he would have sent a watch, but for the girl, a tiny gold coffee pot on a gold chain.

8
Nathan Coley, *Black Tent* (2003). Reproduced by kind permission of the artist and Haunch of Venison Gallery, London.

9
Nathan Coley, *Black Tent* (2003). Reproduced by kind permission of the artist and
Haunch of Venison Gallery, London.

14 Floor Finishes
Location 1.5 and G5
Forbo Nairn lino sheeting 1.5 mm to be laid on 6 mm wbp ply
sub floor.
Ply and lino to run under appliances and around kitchen units.
Colour tba by client.
Aluminium threshold at junction with G2, G6 and 1.1.

Born on the eve of the haj, I am a hajia. I will never have to make the journey to Mecca.

In the Middle

Two concrete paths lead away from the gate, with a long line of zenias in the middle. A small girl in an orange dress comes here often in her search for special stones. Before she crouches down to pick one out, she checks for scorpions.

On the window cill is a row of large tins that have once contained milk powder. Now they hold a collection of carefully chosen and prized items. She takes her stones out and covers them in water so that they glisten. Then she sorts them according to their colour. Her favourites form the most important group, seven in number, one for each colour of the rainbow. She puts them in a safe place, on a small piece of cloth on the table next to her bed. On certain days she takes the stones out into the garden and lays them on a soft patch in the rough grass. Right in the middle she places the violet one. Put right there, it will bring her luck when looking for four-leafed clovers.

She has been told to always shake her shoes out before putting them on, in case a scorpion might be hiding in the toes. And she must make sure to check for them too beneath the ground sheet of tents. Scorpions like nothing better than a warm dark place to nest.

Once when she was small, she and her mother went to camp with her father as he checked wells. They slept in a tent, with their daughter between them. Later as they broke camp, under the ground sheet, right in the middle, a large yellow scorpion was found.

They say the way to make a scorpion suffer is to build a circle of fire, place the insect in the middle and watch the poor thing sting itself to death.

There is an option of making a partition in the middle, between the crèche and the café, a flexible one. The partition we have suggested would be half-hour fire resisting and provide equivalent acoustic separation to that of a standard brick wall.

One hot day, she takes the lids off the tins and pours out her stones over the floor. There is a scuttling sound. She stands firm and watches; in the

warm moist interior of the tins, a family of yellow scorpions has hatched and is coming to the surface. She screams. Kareem comes running. He kills each scorpion calmly with the bare of his heel.

She hates camping, almost as much as she hates churches. She finds them both boring. But the soft black of a Bedouin tent, that is different …

It is a scorching hot day in San Francisco. Anyone with any sense is on a rooftop or in a park. Instead I force myself through the modern art collection. The gallery is badly lit; each room is a different shade of grey. They say they are going to renovate soon. I stop at another tedious canvas square. This time it is black. I stare hard. Nothing happens. Then I scrunch up my eyes and look out to the middle distance from between the fringes of my lashes. And remember what it feels like, to miss the desert.

•

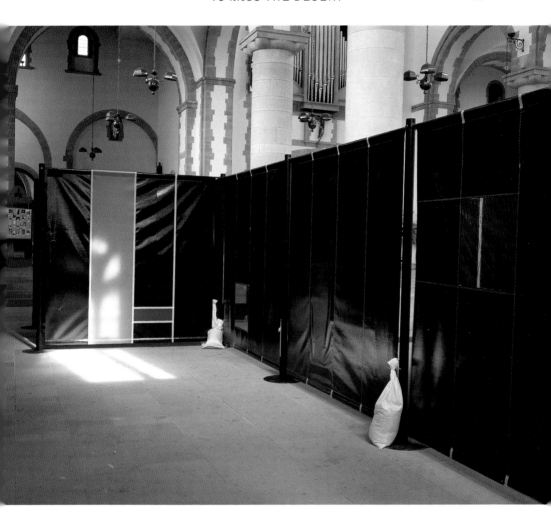

10
Nathan Coley, *Black Tent* (2003). Reproduced by kind permission of the artist and
Haunch of Venison Gallery, London.

Endnote

'To Miss the Desert' is an essay written in relation to Nathan Coley's *Black Tent* (2003), a work curated by Gavin Wade for *Art and Sacred Spaces*.[47] *Black Tent* had developed out of Coley's interest in religious structures in general but particularly the evocative and precise description of the construction of the tabernacle given in the Bible.[48] Wade had read a piece of my writing, where I questioned whether it was possible to 'write architecture', rather than 'write about architecture', and so he asked me to 'write a tabernacle'.[49] The essay I wrote in response reworks in writing Coley's *Black Tent* in both form and content.

Black Tent consists of a flexible structure, a number of steel-framed panels with black fabric screens stretched across them. Several coloured panels and small square transparent 'windows' criss-crossed with stitching are inserted into the screens.[50] *Black Tent* moved to a number of sites in Portsmouth, including two in the cathedral, reconfiguring itself for each location.

My essay investigates the changing position of the subject in relation to material details and psychic experiences of safety and danger. It places personal memories of home next to professional descriptions of architectural spaces. The main narrative remembers a childhood spent settling into various nomadic cultures and countries in the Middle East. A second type of spatial description taken from the design of contemporary sanctuaries, specifically a series of community buildings for different minority groups, intervenes. These texts, set as quotations, derive from written proposals and construction specifications that I was, when working as an architectural designer, closely involved in producing. The two modes of representation are pitched against one another to create a dynamic between private and public sanctuary. One draws on memories to conjure up spaces of security; the other adopts a professional tone to describe various sanctuaries at different scales and stages of the design process.[51] The narrative itself is also spatial; like the squares, it has two sides, two voices. Predominantly written in the third person, it is punctuated at intervals by short interjections in the first person that aim to change the reader's relation to the sites described.

Structured into several sections, each one composed around a different spatial condition, such as 'around the centre' and 'along the edge', my essay, like Coley's work, explores the nature of boundary conditions: specific and generic, political and personal, material and psychic.[52] Paralleling Coley's interest in the bounded site of the religious sanctuary, my central spatial motifs are the secular sanctuaries of home and refuge.[53] The two forms of variation in the composition of my essay – the separate sections divided according to spatial thematics and the varying combinations of text and voice within each section – echo aspects of the siting of *Black Tent* – the changing position of the work in relation to its shifting location and the differing configuration of the panels of the piece itself depending on their situation.[54]

11–14
Jananne Al-Ani, *Echo, The Visit* (2004). A work in two parts: Stills from *Echo* (1994–2004) VHS transferred to DVD, 10 mins, four-channel projection. 30 × 30 cm each. Commissioned by Film and Video Umbrella and Norwich Gallery. Courtesy: the artist.
15 (pages **88–9**)
Jananne Al-Ani, *Muse, The Visit* (2004). A work in two parts: Production stills from *Muse* (2004), 16 mm film, transferred to DVD, 15 mins, single-channel projection. 190 × 300 cm. Photographs: Effie Paleologou. Courtesy: the artist.

You Tell Me

'You Tell Me' is a topography which writes the sites of a series of thresholds, the boundary space of my engagement with four artists – Jananne Al-Ani, Tracey Moffatt, Adriana Varejão and Richard Wentworth – whose work invited me in, drawing me close to tell me stories of places.[55] Some I entered through my imagination, others by remembering, travelling back to my childhood in the Middle East. These were journeys both external and internal; they took me outside myself, offering new geographies, new possibilities, but they also returned me, altered, to myself, to my own biography.

The writing is configured as a travelogue that takes place at the frontier dividing inside and outside. It moves across this critical distance, the sites of private and public which separate and join critic and work, relating this motion to previous encounters to and fro. Voices from 'Travelling the Distance/Encountering the Other' and 'To Miss the Desert' return as repetitions, as echoes.

•

They tell each other stories, to and fro. From behind their hands the words slip like cherries, full and glossy. They pass them from one to another.

Along the horizon he paces, to and fro, a tiny figure, smoking.

Once the women were back at home, my father continued to traverse the drier areas of the globe.

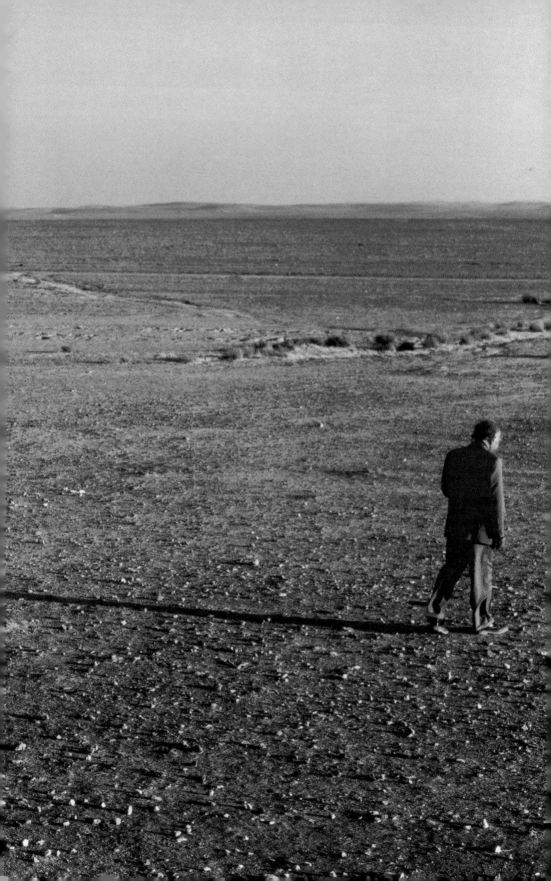

They speak of an absent man.

A tiny figure, smoking, on the dry crust of the earth.

He is a hydrogeologist – a man who looks for water and brings it to the surface for people to wash and drink. He does this in lands that are not his own, that he was not raised in, that are strange to him and with people whose languages and customs are not kin, but that he has had to learn anew.

Lips part and then come together. Words blow, in gusts.

On the dry crust of the earth, lacerated with cracks, scarred by the sun.

He is a man with property: land and wives. Inside the walls of his house are sunlit orchards full of dark purple fruit. Among the trees his wives sit. Dressed in shades of red, some of the women have covered their faces, others have painted their toenails pink. From a distance, the women watch them arrive, disappearing inside as they draw closer.

Hands flicker. The patterns they gesture echo the flutter of speech.

Scarred by the sun, as the day shortens, his shadow grows longer.

The guests are taken upstairs to a long veranda overlooking the garden. The only furniture here is the carpet laid out in a long line down the middle of the room. Men in turbans sit cross-legged along the edge and eat from the dishes laid out in front of them. They are invited to sit down and eat, the only women – her mother, her sister, herself.

Or so she tells me.

•

When I look at you, I see only a curtain of black obscuring your face.

I tell you a story *of how she taught the sheik's niece English. She was allowed to go inside the harem, and saw that underneath their burqas the women wore make-up and perfume. For her labours, she was offered a gift. She asked for a gold leaf burqa, the costume only the wives of the sheik can wear.*

I watch as you brush your hair. You drag the brush through the long dark strands, again and again.

For her entrance, and her mother's bother, the sheik sends his apologies. 'Sorry,' he said, 'so sorry it isn't a boy.' For a boy he would have sent a watch, but for the girl, a tiny gold coffee pot on a gold chain.

I cannot see you, but from behind your veil of hair, you can see me.

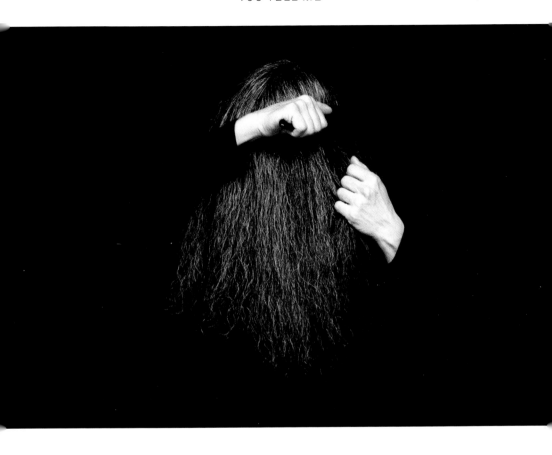

16
Jananne Al-Ani, *Untitled* (2002). Production still from *Untitled* (2002), DVCam transferred to DVD, 3 mins, single-channel projection. Dimensions variable. Commissioned by Terra Incognita. Courtesy: the artist.

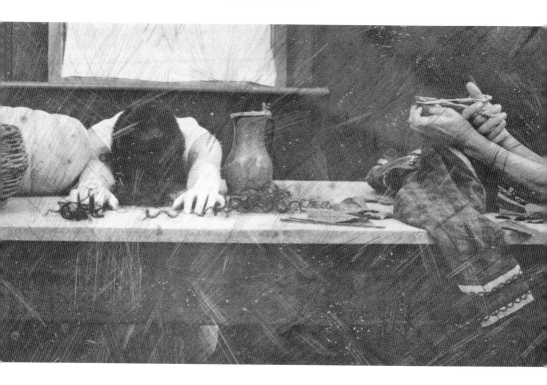

17
Tracey Moffatt, *Laudanum* (1998). Tone gravure prints on 250 g Arches Cover White
100% acid-free rag paper. Series of nineteen images. 76 × 57 cm. Edition of sixty.
(TM 01 16/60). Copyright: the artist and the Roslyn Oxley9 Gallery, Sydney.
18 (pages **94–5**)
Richard Wentworth, *Spread* (1997). Ceramic. 6 m diameter. Courtesy: the artist and
Lisson Gallery, London.

Born on the eve of the haj, I am a hajia. I will never have to make the journey to Mecca.

Or so I tell you.

•

I can see a man in the distance on the horizon. He approaches me to ask if he might be the odd man out. 'Why,' I ask, 'do you think you are the odd man out? Is it because you are only one man among so many women?' 'No,' he says, 'I think it is because I speak without words: objects have their own stories to tell; once found, they can speak for themselves.' 'You are not the odd man out,' I tell him. 'Two of these women also tell stories without words, they tell each other stories through places.'

You tell him your story.

How you served her on your knees; buffed the wooden banister, brushed the stone steps, polished the tiled floor at the bottom of the staircase, until your hands bled.

How she took your brown cheeks between her white hands and ripped at the flesh. In her too-tight crinoline, she held you down, and beat you until you crumpled. Then she hacked your hair off. Clumps of black silk, slits on the white tiles.

You streamed out, escaped to far away, to the palace of your imaginings. The lilac winds of the laudanum desert blew you upwards. You hovered over ceramic-scapes, discs of blue and primrose, tiles of white and red. Soon this was all there was to see, endless surfaces smooth and empty: saunas, hospitals, prisons and mortuaries – all that was outside was inside.

You tell me of a room awash with blood. Where the tiles meet, red seeps; where water dilutes, vividness floats.

I tell you of *a hot tent, the swathes of sheet are close enough to make me sweat. I rush headlong into the redness, with sultry breath and a swollen tongue. Down and down, round and round … swirling in the shallows. The waves rise up and over me. I sink into a world beneath the sand. Towards me, staggering, comes a soldier, left, right, left, right …*

You tell me of a room pristine square, threatened with ragged tears. Behind the surface flesh runs thick, squeezing through incisions sliced into the tilework. The slits are dark, alive to touch and fit to burst, lined with grease, torn from limbs laced with fat.

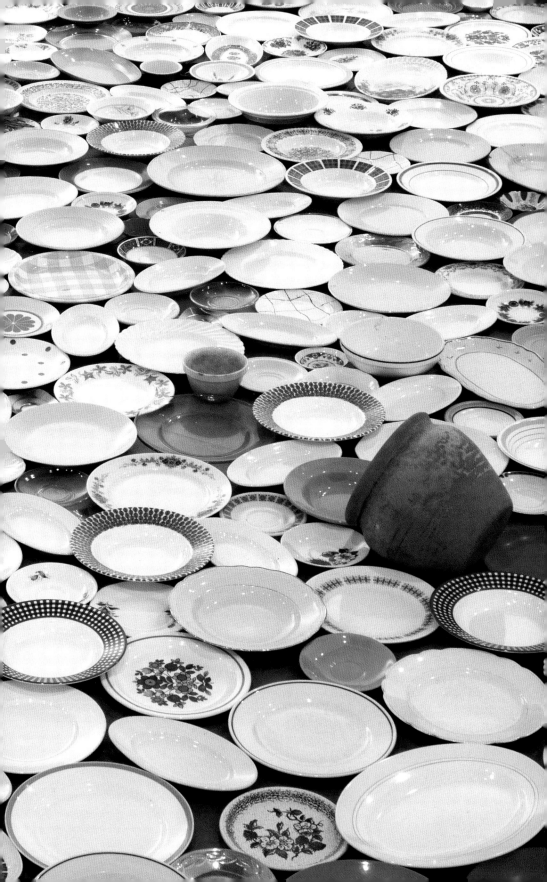

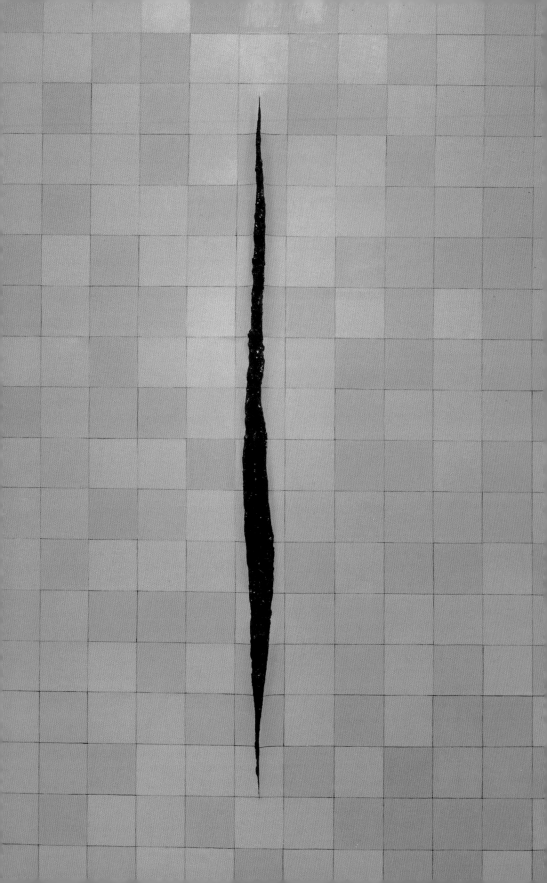

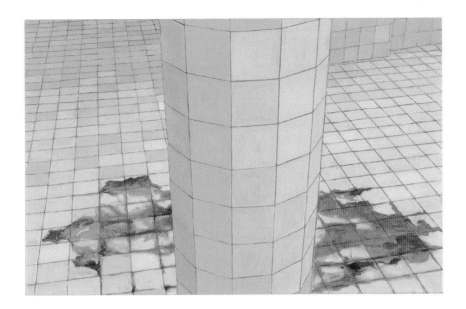

19 (opposite)
Adriana Varejão, *Parede con Incisão a la Fontana 3* (2002). Oil on canvas. Courtesy of the Victoria Miro Gallery, London. Copyright: the artist.
20
Adriana Varejão, *The Guest* (2004). Oil on canvas. 70 × 50 cm (ADV 1330). Courtesy of the Victoria Miro Gallery, London. Copyright: the artist.

I open my eyes. I am in a palace of lilac silk, a cool object is on my chest and something metal in my mouth. A smooth brown hand holds mine.

You tell me of a ruin where the walls have been turned inside out, their patterned interiors laid bare to the wind, ripped open to expose their raw edge.

Or so you tell me.

•

In *On Histories and Stories*, writer A.S. Byatt examines her fascination with 'topological fictions', fictions where the term topological means 'both mathematical game-playing, and narratives constructed with spatial rather than with temporal images'.[56] She names certain works by Primo Levi, Italo Calvino and Georges Perec as the most interesting examples of this kind of writing. For me, these authors have different ways of making topological fictions: while Calvino often uses combination and permutation as strategies for constructing the shape of stories, Levi might draw on existing empirical structures, such as the elements, to determine the narrative, and Perec's detailed taxonomies of actual places are frequently re-organized to produce fictional spaces.[57] In discussing his own interest in 'topological fictions', Calvino refers to a review by Hans Magnus Enzensberger of labyrinthine narratives in the work of Jorge Luis Borges and Robbe-Grillet, where Enzensberger describes how, by placing narratives inside one another, these authors make places where it is easy to get lost.[58]

The theme of topological fiction is apparent in the works of Jananne Al-Ani, Tracey Moffatt, Adriana Varejão and Richard Wentworth, selected for the exhibition *(Hi)story* (2005) but in ways concerned with topography, the description of place, in addition to topology, the study of geometric properties. Wentworth's interest, made evident in *Making Do & Getting By* and *Occasional Geometries* (1975–2005), is in seeking out and paying attention to those animate objects that already articulate but that have somehow been ignored. In works such as *List (15 months)* (1994) and *Spread* (1997) (see image 18), he positions combinations of things – buckets and spades, ceramic plates – in ways that allow them to both communicate with one another and 'speak' directly to the viewer.[59]

Varejão also lets matter speak for itself, but in her art stories are told through spaces as well as objects. These works describe relations of power – destruction and appropriation – between colonized and the colonizer with specific reference to the unfinished time of Brazilian history, anthrophagy or anthropophagy, the Brazilian-based concept of the cultural devouring of the other and the 'absolute interior' of the Baroque.[60] In *Azulejaria Verde em Carne Viva* (2000) and *Parede con Incisão a la Fontana 3* (2002), dark flesh interiors are revealed through narrow incisions in tiled surfaces, whereas in

works such as *Linda da Lapa* (2004) and *Linda do Rosário* (2004) the tension between tiled surface and fleshy interior takes the form of fragments of ruins, where coils of riotous intestines threaten to rupture the smooth gridded geometry in which they are contained (see image 19).[61]

In other pieces, the threat of the disturbance to the ceramic grid of culture is no less disturbing but aesthetically more subtle, like the red stain, which spreads across the white-tiled interior of *The Guest* (2004) (see image 20).[62] In *O Obsceno* (2004) and *O Obsessivo* (2004) the tiled surface is transformed from exterior shell to a seemingly endless series of interior spaces with no reference to the outside.[63] The interiors of this empty labyrinthine architecture suggest an interest in the relationship between particular spatial configurations and specific psychic states, especially those associated with perversion and claustrophobia, as well as Varejão's fascination with what has been called the 'echo chamber' of the Baroque, a space in which discontinuity prevails, and where echo may precede voice.[64]

There is an exploration of the spatial qualities of emotional tension and interpersonal communication through voice and echo in Al-Ani's work. *The Visit* (2004) relates *Muse*, where an isolated and mute male figure inhabits a flat desert plane, to *Echo*, the fragmented weave of four separate female voices (the artist and her three sisters),[65] a place where *he* is referred to, yet absent from (see images 11–15). In *She Said* (2000) a phrase exchanged, whispered behind cupped hands, along a chain of five women, is rendered different through repetition, transformed through miscommunication, pointing to the gaps in listening and slips in speaking.[66] Here the presence of another sounded through speech serves again as a reminder of what or who is not there.[67]

In several other works, Al-Ani also focuses on spaces – those chasms and frontiers – that bind and separate individuals.[68] In *Portraits* (1999) the women who cover their mouths with their hands sever lines of communication. A veil of hair brushed by the subject of the image in *Untitled* (2002) articulates the visual boundary or screen that occupies the place between the viewer and the brushing subject (see image 16).[69]

In Moffatt's work there is also an engagement with the emotional qualities of certain types of space – not the barrier between self and other that fascinates Al-Ani, or the internal typologies and psychologies that intrigue Varejão, but in the juxtapositions of inside and outside, shack and desert, typical of her native Australia.[70] In her work, both film and phototableaux, Moffatt challenges narrative as single and linear and examines instead its constructed nature and situated possibilities.[71] The shifting possibilities of narrative are explored, for example, through the meeting of aboriginal and white cultures in a shantytown in the outback in the series of twenty-five sepia-toned photolithographs comprising *Up in the Sky* (1997).[72] Interweaving close-up shots and landscape vistas, this work questions the usual representation of the desert as an empty mythic scene occupied by a lone male and shows it instead as a location inhabited by a diverse range of people.[73]

In *Laudanum* (1998), another phototableau, this time comprising nineteen images using the technique of photogravure, there is also a central spatial motif, in this case, a staircase. This metaphor of transition, whose form suggests a dynamic tension, allows connections to be made between upper and lower levels, but also between the physical qualities of materials and the altered mental space of drug-induced hallucinations.[74] The charged erotic sites of the sado-masochistic relationship between the two female characters in the scenes, a white woman and her dark-skinned maid, are caught somewhere between violent physical conflict and an opiated dream state[75] (see image 17).

In this increasingly globalized and conflicted world, the stories many artists and writers have been telling recently concern travel and the difficulties of movement and exchange: they tell us where they have come from, where they are going and what it is like along the way. These are stories about lives, yet despite the often powerful autobiographical elements, told as journeys; the narratives take spatial forms, actively referencing special places, generating situated dynamics through various voices, and inviting the reader or viewer to take up particular yet often ambiguous and changing positions in relation to the work.

•

This red book has been read in parts, read then left, left then read. Objects slipped in between the pages mark the pauses. How long will it be, I ask, before you open a page and tell me another story?

You tell me.

21 (opposite)
Richard Wentworth, *The Red Words (Die Roten Worte)* (1997). Aluminium foil, copper, wood and plastics. 41.5 × 53 cm. Courtesy: the artist and Lisson Gallery, London.

An Embellishment: Purdah

For *An Embellishment: Purdah*,[76] a two-part text installation for an exhibition, *Spatial Imagination* (2006), I selected twelve short extracts from 'To Miss the Desert' and rewrote them as 'scenes' of equal length, laid out in the catalogue as a grid, three squares wide by four high, to match the twelve panes of glass in the west-facing window of the gallery looking onto the street. Here, across the glass, I repeatedly wrote the word *purdah* in black kohl in the script of Afghanistan's official languages – Dari and Pashto.[77]

The term *purdah* means curtain in Persian and describes the cultural practice of separating and hiding women through clothing and architecture – veils, screens and walls – from the public male gaze. The fabric veil has been compared to its architectural equivalent – the *mashrabiyya* – an ornate wooden screen and feature of traditional North African domestic architecture, which also 'demarcates the line between public and private space'.[78] The origins of *purdah*, culturally, religiously and geographically, are highly debated,[79] and connected to class as well as gender.[80] The current manifestation of this gendered spatial practice varies according to location and involves covering different combinations of hair, face, eyes and body.

In Afghanistan, for example, under the Taliban, when in public, women were required to wear what has been termed a *burqa*, a word of Pakistani origin. In Afghanistan the full-length veil is more commonly known as the *chadoree* or *chadari*, a variation of the Persian *chador*, meaning tent.[81] This loose garment, usually sky-blue, covers the body from head to foot. The only part of the woman to be seen are her eyes, the rims outlined with

Her mother tells her another story, this time of her own life before she was born. She taught the Sheik's sister's daughter English, so she was allowed to go inside the hareem. Inside, under their burqas, she saw that the women wore make-up and perfume. For her labours, the sheik offered her a gift. She asked for a gold leaf burqa, the costume only the wives of the sheik can wear.

Her mother's labour is not easy; she refuses to come out. She walks the dunes along the creek, back and forth, past the apartment block where she lives, but still she waits inside, for a night and a day. The chance of infection is high. There is no glass in the hospital windows. A caesarian section might kill them both, one for sure if she was carrying a son.

Fortunately there is a woman who is willing to take a chance. On the second night of her labour, the hospital is almost empty, everyone who can has gone, to feast, to break their fast. A nurse runs a drip to encourage her out. But she holds her ground. The nurse turns the drip up. Still she refuses to budge. The drip is turned up again, faster, and again.

For her labours, the sheik sends her mother a gift along with his apologies. Sorry, he said, so sorry it isn't a boy. For a boy I would have sent you a watch, but here, with my condolences, is a gift for the girl, a gold coffee pot on a gold chain. She is a hajia, born on the eve of the haj: she will never have to make the journey to the east, to Mecca.

Surrounding her house is a moat of flints with furrows running through it at regular intervals like a ploughed field. When you run up and down these slopes, you can loose your footing and slip, and that is when you know the sharp-looking stones really can cut your knees. Still it is safer here, than beyond the walls in the waste-ground of dry bushes and stinging insects, where hyenas cry in the night.

The hallway cuts the house in half, and ties it together, with rooms leading off on both sides. The tiled floor is hard and shiny, at night she comes here to catch insects. Many creatures skulk across it, ants and spiders, and some more sinister whose names she doesn't yet know. Trapped under her glass jar with its smooth edge that meets the marble without making gaps, she is safe to watch them.

Inside her house all the floors are marble, smooth and cool, laid out in careful grids, except for the big golden rug. In the evening, when the sun is in the west, the rug glows. At this time of day, she likes to follow the intricate patterns with her feet, like paths around a secret garden. But if you dance around the edge of the squares, you mustn't fall in, who knows what lies waiting in the enchanted garden?

Around the edge of the garden are the homes of two men, one tall and fair skinned, with light hair and green eyes; the other shorter, stockier, with darker skin, hair and eyes. They have fought each other in the past, and will again when the Soviets come to Kabul, and again, when her own people search the Hindu Kush to wipe out all evil. But for now, there is no fighting, once the sun has gone down, they sit and eat together.

He is a man with property: land and wives. Inside the walls of his house are sunlit orchards full of dark purple fruit. Among the trees his wives sit. Dressed in shades of red, some of the women have covered their faces, others have painted their toenails pink. From a distance, the women watch them arrive, disappearing inside as they draw closer.

The guests are taken upstairs to an empty veranda overlooking the garden. The only furniture here is a carpet laid out in a long line down the middle of the room. Men sit cross-legged in turbans around the edge of the carpet and eat from the dishes laid out in front of them. They are invited to sit down – the only women – her mother, her sister and herself.

After the meal, as they walk through the dark house to leave, she sees a pair of eyes watching her from behind a screen. The eyes belong to a girl her own age but whose hands glint with silver like a woman. Later she learns that this is his youngest wife, once a nomad, who carries her wealth in the jewels on her fingers.

Her own dress is set with tiny mirrors and a handsome square of embroidery at the front. It is hard work to get on, with no fastenings and a fabric so thin it could rip. In this dress she feels just like all the other Afghan girls. Except that they wear their dresses a bit softer, sometimes black. She wonders whether it is to match the black around the edge of their eyes.

22

Jane Rendell, 'An Embellishment', Peg Rawes and Jane Rendell (eds), *Spatial Imagination* (London: The Bartlett School of Architecture, UCL, 2005), pp. 34–5, p. 35. Designed by Penelope Haralambidou and reproduced with her kind permission.

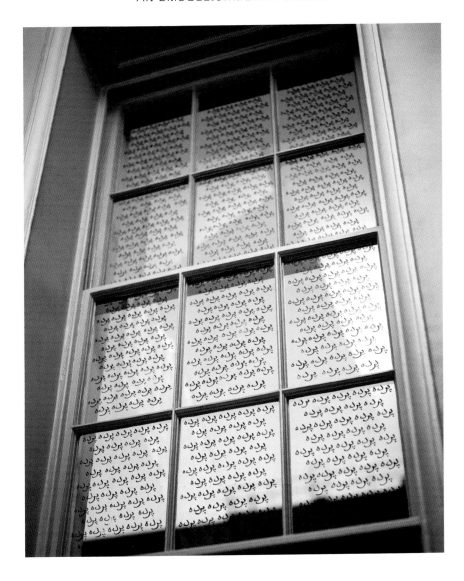

23
Jane Rendell, *An Embellishment: Purdah* (2006) *Spatial Imagination*, domoBaal
contemporary art, London. Photograph: Cornford & Cross, 2006.

black kohl (perhaps only in a westerner's imagination) looking out through the window of an embroidered screen.

Although in 1959 the Prime Minister of Afghanistan, Muhammad Daoud, had abolished veiling and seclusion for women, when the Taliban took over Kabul in September 1996 they issued edicts prohibiting women from working outside the home, attending school, or leaving the home unless accompanied by a close male relative as chaperone – *mahram* (husband, brother, father or son). In public women had to cover themselves in a *chadari* – a body-length covering with only a mesh opening through which to see and breathe. Women were not permitted to wear white shoes or socks – the colour of the Taliban flag – nor shoes that made a sound when they walked. Houses and buildings with women present in public view were to have their windows painted.[82]

It is understandable, then, that discussions around the veil provoke much controversy, especially in feminism, and it is worth briefly outlining the issues at stake.[83] In an account of arguments for and against the veil raised in early twentieth-century Egypt in response to the publication in 1899 of Qassim Amin's *Tahrir Al-Mar'a* (The Liberation of Woman), Leila Ahmed argues that in identifying the veil as a tool of female oppression, feminism has, perhaps unwittingly, along with anthropology, played the role of 'handmaid' to colonialism.[84] In using the veil to represent Muslim culture as backward, the aim of unveiling women in order to liberate them from repression has operated as the mode of justification for one patriarchal culture to possess another. This is an attitude and practice witnessed historically, for example, in the French colonization of Algeria, where, as Ahmed quotes from Franz Fanon's *A Dying Colonialism* (1967), 'the occupier was bent on unveiling Algeria'.[85] More recently unveiling was given as one of the reasons to justify the invasion of Afghanistan by today's crusaders – the United States, the United Kingdom and their allies – to depose a regime, which, as well as supporting terrorists, also oppressed women through its use of the veil.

The repression of woman has been used as a reason for colonizers to invade countries, especially Muslim ones, repeatedly. An interest in acts of colonial and neo-colonial oppression returns in my autobiography through an acknowledgement of how my own childhood involvement in colonialism has been repressed. Repetition is the acting out of that which has been repressed in the unconscious. Artist Sharon Kivland has pointed out that:

> *Repetition, for Freud, is the incessant exposure to horrible or upsetting events and circumstances, the compulsion to repeat an act when its origins are forgotten. Unless one remembers the past, if events are suppressed, something is returned in one's actions.*[86]

In re-writing the word *purdah* across the glass, the embellishment of the window surface is an act of repetition. It is also one of separation and

connection. Calligraphy has been used as a screening device by artists such as Mona Hatoum in her *Measures of Distance* (1988), where video images of the artist's mother are overlaid with the Arabic text of the letters she sent to her daughter from Beirut. This image is accompanied by a two-part soundtrack, in which the artist reads a clear translation of the letters in English, while in the background a playful but indistinguishable interchange takes place in Arabic between two women.[87] In her photographs of women covered with calligraphy, Lalla Essaydi focuses on how this Islamic art form has been made inaccessible to women, whereas the use of henna as a form of adornment is considered 'women's work'.[88] Describing how under the Taliban regime, in Shia areas such as Herat, in western Afghanistan, women's lives were the most oppressed, Christina Lamb's *The Sewing Circles of Heart* discovers how, in order for women writers to read, share ideas and study banned foreign literature, they had to meet under the guise of sewing groups, such as the Golden Needle Sewing Circle.[89]

In taking the form of an embellishment, repetition, as a kind of remembering, can also be linked to reminiscence. For *An Embellishment: Purdah*, in repeatedly writing the same word, focusing on its precise formation, again and again, I recalled my school days writing out sentences, aiming to make my handwriting as small as possible so that, as a left-hander, I did not smudge the ink. In trying not to spoil the perfect letters formed of liquid kohl, I realized that I was writing from left to right, writing against the flow of an Arabic or Persian text.

Kivland's account of repetition continues:

> *And while the analytic process may not aim at reliving past experience, at feeling the same emotions of the past, this still happens. In reminiscing, stories are embellished, made better or worse, and so occupy a register of the imaginary.*[90]

I imagined that for *An Embellishment: Purdah* when the sun set the writing would, like a rug, form a pattern on the gallery floor, where the viewer's shadow, facing west (away from Mecca), would be cast behind him/her. In early January, the time of year that the work was installed, the sun was too low in the sky to create the intended shadow, yet other unexpected effects were produced which resonated with the concerns of the piece. To perform the writing I had to stand in the window, my face screened by my writing, occupying a position behind a veil that I had not imagined. As night fell, light from inside the gallery illuminated my body.

Iranian director Moshen Makhmalbaf's film *Kandahar* (2001) tells the story of an Afghan woman journalist living in Canada, who travels back to Afghanistan when her sister writes from Kandahar to say she is going to kill herself before the next solar eclipse. The female protagonist's journey is at times filmed from behind the *burqa* she is wearing, offering western audiences a view out from the inside of the veil, so reversing the usual media representation of the camera imaging a covered faceless figure.[91] And it is the disguise offered by the veil in Yasmina Khadra's *The Swallows*

of Kabul that allows the central characters – two Afghan women – to change positions unnoticed and dramatically alter the narrative as agents of their own history.[92]

The rise in interest in the veil through cultural forms – film and literature – has increased dramatically since the western invasion of Afghanistan and Iraq.[93] But these stories told from 'behind the veil' are often authored by those who have not experienced this reality directly, extending the problem of the western-dominated representation of the veil in the media, which, in Christina Noelle-Karimi's opinion, has rendered Afghan women faceless and voiceless:[94] the veil obscures their faces, while others tell their stories. The author of *Swallows*, for example, is a male Algerian army officer, Mohammed Moulessehoul, who took a feminine pseudonym to avoid submitting his manuscripts for army approval. Khaled Hosseini, author of another story that focuses on an allegiance forged between two very different Afghan women, left Kabul in the 1970s.[95] *Beneath the Veil* (2001), a documentary famous for showing the execution of a woman under the Taliban regime, was made by Saira Shah, a woman of Afghan descent, but raised in the United Kingdom,[96] while *The Kabul Beauty School* (2004) and *Afghan Ladies' Driving School* (2006), both documentaries showing women's lives in Kabul, have also been made by those from the west.[97]

An Embellishment: Purdah does not make a judgement on the veil; rather it wishes to show how things seem quite different depending on where you are. From inside the gallery and outside on the street – by day and by night – the work changes according to the position occupied. Sometimes transparent, at other times opaque, revealing then concealing, this embellishment or decorative covering invites the viewer to imagine beyond the places s/he can see.

•

Nathan Coley's *Black Tent* offered me an enigmatic message. I replied with one of my own in the form of a piece of criticism, an essay, 'To Miss the Desert'. In selecting and reconfiguring 'scenes' from the essay into two complementary parts – one a text in a book and the other in a window – *An Embellishment: Purdah* was a response to two sites, *Black Tent* and domoBaal contemporary art, London. While *Black Tent* uses black squares to mark the boundary of newly created sanctuaries, and 'To Miss the Desert' is structured according to spatial conditions, such as 'Along the Edge' and 'At the Threshold', *An Embellishment: Purdah* responds to the specific quality of the window as an edge or threshold, marking the frontier between inside and outside, one and another.

Throughout *Configuration 2: To and Fro* the distance between one and another is articulated through repetition. When phrases from both 'To Miss the Desert' and 'Travelling the Distance/Encountering an Other' return in 'You Tell Me' and *An Embellishment: Purdah*, they recur as echoes of earlier voices. The aesthetic effect of repetition and its relation to

repression – division and displacement – has been a key concern in this configuration of *Site-Writing*. *To and Fro* repeats in words – back and forth across the threshold – the interest in echo and screens in works by Al-Ani, Coley, Moffatt and Varejão. Like an enigma, *An Embellishment: Purdah* employs the gendered trope of the veil in an ambiguous way, offering a message that appears to require deciphering, yet at the same time recognizing that cultural position and linguistic difference determine different understandings of words and things.

Configuration 3

A Rearrangement

Word-Presentations and Thing-Presentations

As you know, I am working on the assumption that our psychic mechanism has come into being by a process of stratification: the material present in the form of memory traces being subjected from time to time to a rearrangement in accordance with fresh circumstances – to a retranscription.[1]

Configuration 3: A Rearrangement, extends the exploration of Sigmund Freud's understanding of the relation between the exterior world and interior psyche initiated in *Configuration 2: To and Fro*, but specifically through his evolving concept of the workings of memory, of how external events registered or inscribed in the subject are translated and/or repressed, and are later recalled or re-emerge. In his 1915 paper 'The Unconscious', Freud put forward two hypotheses for how the unconscious and the conscious are related, one topographical and the other dynamic:

When a psychical act (let us confine ourselves here to one which is in the nature of an idea) is transposed from the system Ucs. into the system Cs. (or Pcs.), are we to suppose that this transposition involves a fresh record – as it were, a second registration – of the idea in question, which may thus be situated as well in a fresh psychical locality, and alongside of which the original unconscious registration continues to exist? Or are we rather to believe that the transposition consists in a change in the state of the idea, a change involving the same material and occurring in the same locality? ... With the first, or topographical, hypothesis is bound up that of a topographical separation of the systems Ucs. and Cs. and also the possibility that an idea may exist

simultaneously in two places in the mental apparatus – indeed, that if it is not inhibited by the censorship, it regularly advances from the one position to the other, possibly without losing its first location or registration.[2]

Jean Laplanche, in his critical development of Freud's work, has suggested that of the two hypotheses, the topographical or 'reification' model correlates with the 'impressions given by analytic work', where through recognition unconscious elements are available to the preconscious and conscious systems, whereas the functional one is the 'most convenient' for giving an account of repression, where conscious impressions become unconscious.[3] Judy Gammelgaard has further elaborated how these processes – repression and recognition – explained by the two hypotheses 'run contrary' to one another, without being 'symmetrical or identical', stating:

> *The hypothesis of registration in two locations is suitable for illustration of the process of becoming-conscious, while the hypothesis of functional change of cathexis is more appropriate when describing the process of repression.[4]*

Alain Gibeault argues that it is to 'help overcome the difficulties inherent in topographical and economic hypotheses' that Freud turns, in 'The Unconscious' (1915), to his concepts of word-presentations and thing-presentations, formulated in his work on aphasia from 1891.[5] Gibeault posits that Freud's aim in this earlier research was 'to relate such differences, not to varied forms of aphasia, but rather to distinct mental systems'.[6] The English translation of the aphasia work from 1953 includes the diagram 'Psychological Schema of the Word Concept', which shows two complexes – 'word-' – an open network including 'visual image for print', 'visual image for script', 'kinaesthetic image' and 'sound image' – and 'object-associations' – a closed network comprising 'visual', 'tactile' and 'auditory'.[7] This diagram, included as 'Appendix C: Word and Things' along with a written extract from the 1891 text, is labelled slightly differently in James Strachey's 1957 translation of 'The Unconscious'.[8] Its new title, 'Psychological Diagram of a Word-Presentation', uses the term 'presentation' instead of 'concept', and the open network, now captioned 'word-[presentations]' (*Wortvorstellungen*), consists of 'reading-image', 'writing-image', 'motor-image' and 'sound-image'.[9] Strachey notes that in 'The Unconscious', rather than the term 'object-associations' used in his work on aphasia, Freud refers to 'thing-presentations' (*Ding/Sachvorstellungen*). While the unconscious comprises only thing-presentations, consciousness is made up of both 'thing-presentations' and 'word-presentations', which together comprise an 'object-presentation' *(Objektvorstellungen)*, a third term missing from the aphasia work.[10]

> *The conscious presentation comprises the presentation of the thing plus the presentation of the word belonging to it, while the unconscious presentation is the presentation of the thing alone.[11]*

André Green maintains that 'the canonical couple thing-presentation–word-presentation' is 'at the heart of the Freudian problematic of representation', stressing how visual associations are for the object what sound-images are for the word.[12] Laplanche also emphasizes this distinction, describing how the word-presentation is of an acoustic nature, 'made of words able to be uttered', whereas the thing-presentation, a 'more or less mnemic image' characteristic of the unconscious, consists of visual elements.[13] Laplanche notes that up until 'The Ego and the Id' of 1923, Freud connects verbal residues and acoustic perceptions on the one hand, optical residues and things on the other.[14] For Freud, word-presentations are mnemic residues of words that have been heard, while optical mnemic residues are of things.[15]

As Laplanche and Pontalis discuss, the notion of a mnemic image or memory trace derives from Freud's early work. They highlight how in *The Studies on Hysteria* (1893–95) Freud explores the way in which mnemic or memory traces are stored in an archival fashion according to several methods of classification, including chronology, position in chains of association and accessibility to consciousness.[16] This means that a single event might be stored in various places: perceptual, mnemic and connected with the presentation of ideas or *Vorstellung*.[17]

In 'The Project' (1895) Freud differentiated between perceptual cells and mnemic cells,[18] perceptual images (*Wahrnehmungsbild*) and mnemic images (*Erinnerungsbild*).[19] Following Josef Breuer, Freud reasoned that it was not possible for the same system to operate in terms of perception, as the 'mirror of a reflecting telescope', *and* in terms of memory, as a 'photographic plate', and instead he suggested that separate systems of registration existed.[20] He explained his thinking on this to Wilhelm Fliess in his letter of 6 December 1896:

> *As you know, I am working on the assumption that our psychic mechanism has come into being by a process of stratification: the material present in the form of memory traces being subjected from time to time to a rearrangement in accordance with fresh circumstances – to a retranscription. Thus what is essentially new about my theory is the thesis that memory is present not once but several times over, that it is laid down in various kinds of indications. I postulated a similar kind of rearrangement some time ago (Aphasia) for the paths leading from the periphery [of the body to the cortex]. I do not know how many of these registrations there are – at least three, probably more.[21]*

A diagram indicates how one event may be registered in different 'mnemic systems', showing the three key terms Wz [*Wahrnehmungszeichen* (indication of perception)], the first registration of perceptions; Ub [*Unbewusstsein* (unconsciousness)], the second registration arranged according to causal relations and linked to conceptual memory; and Vb [*Vorbewusstsein* (preconsciousness)], the third transcription attached to word presentation and corresponding to the ego.[22] This system of successive layers of

registration was reworked in 'The Interpretation of Dreams' (1900) and represented through a set of three diagrams.[23]

Laplanche outlines how, in his Leonardo study, also dating from 1900, Freud compares the way in which the individual stores up memory to two different kinds of history writing: the work of chroniclers who make continuous day-to-day records of present experience, and the writers of history, where accounts of the past are re-interpreted in the present.[24] Freud juxtaposes a person's conscious memory of ongoing events with the writing of a chronicle, and the memories a mature person has of their childhood with the writing of history, 'compiled later and for tendentious reasons'.[25]

Examining how memories could be falsified retrospectively to suit current situations, Freud went as far as to state in his 1899 paper 'Screen Memories' that:

> *It may indeed be questioned whether we have any memories at all from our childhood: memories relating to our childhood may be all that we possess.*[26]

While this paper considered the screening of a later event by an early memory, in 'The Project' Freud had looked at a reverse type of screen memory, the screening of an early memory by a later event.[27] With reference to the case history of Emma, Freud investigated how the laughter of the shop assistants in a later scene 'aroused (unconsciously) the memory' of the grin of the shopkeeper who had 'seduced' her in an earlier one.[28] This later 'resurfacing' of the traces of childhood events, not registered consciously at the time, is developed subsequently by Freud into the two-phase model of trauma, *Nachträglichkeit*, where, as Green describes, 'Trauma does not consist only or essentially in its original occurrence (the earliest scene), but in its retrospective recollection (the latest scene)'.[29] Laplanche comments:

> *What is subject to the work of distortion and rearrangement in memory are not the childhood events (intrinsically inaccessible), but the first traces of them … The result of the secondary elaboration which is Freud's interest here is the conscious memory: very precisely, the 'screen memory'. But to evoke this term (*Deckerinnerung*) is to indicate that it both covers over and presents the resurgence of something: precisely, the repressed.* [30]

Freud distinguished between these two types of screen memory in 'The Psychopathology of Everyday Life' (1901), defining '*retro-active* or *retrogressive*' displacement, where the screen memory from childhood replaces events from later in life, and 'screen memories that have *pushed ahead* or been *displaced forward*', where the later memory covers an earlier one. He also adds a third possibility, '*contemporary* or *contiguous*' screen memories, 'where the screen memory is connected with the impression that it screens not only by its content but also by contiguity in time'.[31]

For Laplanche, Freud's fascination with the term trace – traces in the memory (*Gedachtnisspuren*) or mnemic traces (*Erinnerungsspuren*) – indicates

his interests in the preservation of the unconscious, and how the trace left by memory, as the result of repression, is somehow of more importance to him than 'memorization itself'.[32] Laplanche suggests that Freud's theory of memory involves both conscious memory, such as screen memory, which is closer to history, and unconscious memory, which is closer to archaeology. However, according to Laplanche, in archaeology each new construction involves a prior deconstruction, whereas in psychoanalysis the opposite is the case; all is preserved in the 'hyperarchaeology' of the human subject.[33] In examining how psychoanalytic and historical methods of interpretation differ, in particular concerning notions of truth, fact and the role of the subject in constructing the historical object, Laplanche's position relates to a debate that took place in the 1970s. Countering the views of psychoanalyst Serge Viderman,[34] Laplanche argues that Freud's aim was not to restore historical continuity by reintegrating lost memories, but rather to produce a history of the unconscious. In this history – one of discontinuity, burial and resurgence – the difference is that the turning points or moments of transformation are internal rather than external, described in terms of 'scenes' as opposed to the 'events' of history.[35]

The major scenes of childhood, according to Laplanche's reading of Freud, are present consciously in memories and memories of dreams, 'scattered, fragmented and repeated', their repressed aspects located inaccessibly in the unconscious.[36] The scene is the principal form of reminiscence: a kind of memory cut off from its origins and access routes, isolated and fixed, and reduced to a trace.[37] Breuer and Freud linked the symptomatic repetitions of hysterics, who were said to 'suffer mainly from reminiscences',[38] to the memory of psychical traumas, described by Breuer as the 'forcible entrance' of a 'foreign body'. It seems that Laplanche picks up on this language, when he describes the unconscious as an:

> *'Internal foreign body', 'reminiscence': the unconscious as an alien inside me, and even one put inside me by an alien.*[39]

Critical of the way Freud opposes thing-presentations and word-presentations,[40] and the unresolved opposition of his topographical and dynamic hypotheses,[41] Laplanche proposes a process of translation-repression comprising two phases. The first involves 'inscription' or the 'implanting' of what he calls 'enigmatic signifiers', messages from the mother that contain aspects of her unconscious, and the second entails the reactivation of certain traumatic signifiers which the subject attempts to bind or symbolize.[42] Failure to do this results in the repression of residue elements that are not capable of signifying or communicating anything but themselves. Laplanche calls these untranslatable signifiers 'thing-like presentations' (*représentation-chose*) in order to show that the unconscious element is not a representation or trace of an external thing. 'Thing-like presentations' are not representations *of* things, but representations that are *like* things.

For Laplanche, 'the passage to the unconscious is correlative with a loss of referentiality'.[43] It is an effect of the process of repression, 'a partial and failed translation', that the 'preconscious presentation-of-the-thing (*Sachvorstellung, représentation de chose*) is transformed into an unconscious presentation-as-a-mental-thing (*représentation-chose*) or thing-like presentation, a designified signifier'.[44] Laplanche describes this unconscious residue as having a 'reified and alien materiality'.[45] As a message it signifies 'to' rather than 'of', since despite the loss of its signified, this thing-like presentation can still communicate to an addressee, verbally and non-verbally, through gesture.[46] As John Fletcher maintains, Laplanche's model of translation-repression rethinks the problem of unconscious representation by understanding repressed elements, not as memories or copies of past events, but as remainders or 'waste' products of translations.[47]

The configuration that follows arranges and rearranges a set of 'scenes' presented as words and things. The first part consists of twelve scenes composed in response to a Welsh dresser owned by my great aunt. Presentations of objects made in words and images – dictionary definitions and photographs – describe the dresser in an objective mode. They are accompanied by another set of more subjective presentations – a series of written childhood memories associated with the dresser. But the distinctions made between objective and subjective, word and image, are not binary. The dictionary definition of a word often contains an element which has been suppressed, a meaning seldom used, sometimes related to the forgotten linguistic origin of that word. These lost etymological traces provide clues to alternative ways of considering the object, that on the one hand lead back to the subject, allowing another scene to surface, and on the other produce trajectories pointing away from her memories. The notes track these trajectories, describing a parallel account of how these scenes might be constructed as events from a historiographical perspective.

After the death of my great aunt I dreamt of her living room: a mirror set over the mantelpiece in a room shrouded in white linen offered a reflection full of plants – alive and green. The 'coming to life' dream of 'White Linen' is one of a tripych of related scenes, including 'Moss Green' and 'Bittersweet', both of which describe 'dead' or abandoned buildings visited in spring. These word-presentations were inserted into 'Longing for the Lightness of Spring', an essay written in response to Elina Brotherus's *Spring* (2001). This artwork, installed in the disused pump house of the Wapping Project, comprised its own arrangement of life and death: a photographic image of moss-covered lava meeting grey skies overhead was placed on the roof, set against London's horizon, while a video triptych anticipating spring was located in the dark pump room.

My triptych was translated into Korean, for a work that included both written and spoken texts, along with three photographs and three things associated with the sites. The audio recordings were retranslated back into written English for an installation in Los Angeles, comprising

a rearrangement of the word-presentations where the spoken voices – sound-images – were inserted at the point where sight fails and the pairs of texts – writing-images or reading-images – could not be read. Just as they slipped out of the reader's sight, the words became audible, but in another language.

The triptych was reworked as a third rearrangement: three word-presentations – each pair comprising the original text and its Korean translation returned to English through retranslation – were accompanied by three thing-presentations, objects associated with each site. Taken together, these word-presentations and thing-presentations can be understood as object-presentations, rearrangements of the scenes of childhood memory, made in response to an artwork. This brings to mind a beautiful paragraph from the writer Virginia Woolf, who describes her own process of scene-making like this:

> *These scenes, by the way, are not altogether a literary device – a means of summing up and making a knot out of innumerable little threads. Innumerable threads there were; still, if I stopped to disentangle, I could collect a number. But whatever the reason may be, I find that scene making is my natural way of marking the past. A scene always comes to the top; arranged, representative. This confirms me in my instinctive notion – it is irrational; it will not stand argument – that we are sealed vessels afloat upon what it is convenient to call reality; at some moments, without a reason, without an effort; the sealing matter cracks; in floods reality; that is a scene – for they would not survive entire so many ruinous years unless they were made of something permanent; that is a proof of their 'reality'.*[48]

The Welsh Dresser

In encountering a Welsh dresser inherited by my mother and the various things contained within it, I found myself remembering my childhood.[49] I decided to focus on one object at a time, to photograph it and write down the memories that came to mind. Influenced no doubt by Joseph Kosuth's *One and Three Chairs* (1965), I later added dictionary definitions of the objects (included in the quotations),[50] and finally reflected upon them from a historiographical perspective (indicated by the series of 'notes').

In invoking a mode of analysis rather than contemplation, the photograph has been considered a counterpoint to the work of art.[51] Here, however, I position the photograph as a point of contemplation between several modes of writing, two apparently objective – a series of dictionary definitions and theoretically inflected notes; and another typically subjective – scenes of childhood memory, in order to question the nature of the photograph as evidence. Often taken as an undisputed empirical fact and one used to illustrate reality, the photograph – as a trace of the now invisible lives of the past – can instead operative suggestively, constructing an argument visually by bringing to mind a set of possible narratives and extended reflections.[52] The view close up reduces the frame of reference, but this focus paradoxically broadens the perspective, requiring one to try to look more deeply into the object, so allowing a wider constellation of memories and associations to emerge. In the site-writing that follows, the material of the archive rearranges childhood memories in the present – autobiography becomes topography; the space of a life becomes the life of a space.[53]

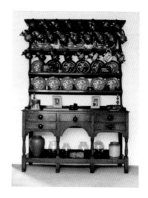

The Welsh Dresser

Dresser: A sideboard or table in a kitchen on which food is or was dressed.
A kind of kitchen sideboard surmounted by rows of shelves on which plates,
dishes, etc. are ranged (1552).
One who dresses.
One who attires another (1625).
One who attires himself (or herself) elegantly or in a specific way (1679).
A surgeon's assistant in a hospital, whose duty it is to dress wounds, etc. (1747).

The Welsh dresser was constructed in the 1830s and has been in the family for at least five generations. In my childhood, it occupied one wall of the dining room in my great aunt's house in Cwmgors, a small mining village near the Black Mountain (Y Mynydd Du) in South Wales. The dining room was one of two rooms that faced the street; both were immaculate, seldom used and always cold. The Welsh dresser stood opposite the window, obscured by a layer of net and a pair of heavy velvet curtains, always drawn back, slightly faded at the points where the fabric met the light. Hung with gorgeous antique jugs that could never be touched, and that rattled every time a coal lorry passed by on the road outside, the Welsh dresser was a difficult thing.

Note: *Initially interested in challenging the traditional mode of architectural history and its preoccupations with genius, style, form and taste, critical architectural historians have examined instead the production of the built environment. Over the past twenty years this work has evolved into a consideration of the ways in which architecture is a setting for everyday life, both as a scene for the reproduction of social relations, and also for the consumption of architecture through occupation, use and experience.*[54]

24
'The Welsh Dresser'. Photograph: Jane Rendell, 2003.

Lustre Jugs

Lustre: the quality of shining by reflected light; sheen, refulgence; gloss.
Appearances of lustre (1614).
A composition used to impart a lustre to manufactured items (1727).
Luminosity, brilliancy, bright light (1549); a shining body or form (1742).
Radiant beauty or splendour (of the countenance, of natural objects, etc.) (1602).
Brilliance or splendour of renown; glory (1555).
Something that adds lustre; a glory (1647).
External splendour (1674).
To render illustrious.
To illustrate.
To make specious or attractive (1644).

The Welsh dresser gleamed through my childhood, through Christmas dinners and Sunday lunches, through rice puddings, cherry corona, beetroot chutney, faggots and chips. As things fade into the distance, they gain a glossy sheen. The fairy lights on the Christmas tree still twinkle. My mother's hair always shines. The surface, polished bright by nostalgia, provides a perfect view of the past.

Note: *Cultural geographer Doreen Massey has written rather disparagingly of nostalgia as a longing for a perfect past. She describes how, on a visit back home to her parents, she longed for her mother's chocolate cake, but the taste of it did not live up to her expectation. Massey argues that nostalgic attitudes work to trap those close to us in our romanticized memories of them. Writing more positively of nostalgia as a longing for something better, Frederic Jameson, with reference to Walter Benjamin's work on allegory, has pointed out that looking back to a past because it appears to be better than the problems of the present is not necessarily regressive, especially if 'nostalgia as a political motivation … conscious of itself' can be used to change the future.*[55]

25
'Lustre Jug'. Photograph: Jane Rendell, 2003.

Cuttings

The action of cut in various senses.
An intersection, also a section (1726).
A piece cut off; esp. a shred made in trimming an object for use.
A small shoot bearing leaf-buds cut off a plant, and used for propagation (1664).
A piece cut out of a newspaper etc. (1856).

Tucked in between the lustre jugs were smaller pots and tins that held many useful things: needles, threads, elastic bands, but also a selection of yellowed local newspaper cuttings registering key events in the family. Reading them places emphasis. It allows me to think of my motherland, not the country of my own birth, but that of my mother and her family. It brings to mind the coming together of the family around the dining table, on ordinary days, at special times of the year and for big occasions – births, deaths and marriages.

Note: *The Annales School of Historians were critical of positivist and empirical history that focused on grand narratives, political events and the lives of famous men. They argued for the importance of social and economic history, the relevance of a wide range of sources, including maps and folklore, a long-term view of history and a study of the mindset of groups. Michelle Perrot, for example, states that 'the history of private life is more than anecdotal; it is the political history of everyday life'.*[56]

26
'Cuttings'. Photograph: Jane Rendell, 2003.

Two Keys

Key: An instrument, usually of iron, for moving the bolt or bolts of a lock forwards or backwards, and so locking or unlocking what is fastened by it.
The representation of a key, in painting, sculpture, etc. (1450).
In pregnant sense, with reference to the powers implied by the possession of the keys of any place; hence as a symbol of office, and the office itself.
Something compared to a key, with its power of locking and unlocking; that which opens up, or closes, the way to something; that which gives opportunity for, or precludes, an action, state of things, etc.
A place which gives its possessor control over the passage into or from a certain district, territory, inland sea, etc. (1440).
That which serves to open up, disclose, or explain what is unknown, mysterious or obscure.
An explanatory scheme for the interpretation of a cipher etc., a set of solutions of problems, a translation of a text, etc. in a foreign language for the use of learners, and the like.

The Welsh dresser is made of light oak in a form typical of dressers of its age from South Wales. The superstructure has an open rack with three shelves, a base with four side drawers and a short centre drawer with a shaped apron beneath.[57] The open potboard base has four turned front legs, terminating in block feet. It is an archive, a key to the past, my past, the past of 96 Heol-y-Gors, Cwmgors, Dyfed, South Wales, a place where it always rained in the holidays. The drawers of the dresser smell of the practical items they still contain – a wooden ruler, pencils with rubber tops, dry thick-bound notebooks, tailor's chalk and red die.

Note: *According to Jacques Derrida, the originators of the archive were those who held the keys to the place that housed the documents of the past.*[58]

27
'Two Keys'. Photograph: Jane Rendell, 2003.

Red Die

Die: A small cube, having its faces marked with spots numbering from one to six, used in games of chance by being thrown from a box or the hand.
An engraved stamp (often one of two) for impressing a design or figure upon some softer material, as in coining money, striking a medal, embossing paper.
Of man and sentient beings. To lose life, cease to live, suffer death; to expire.

The table had six settings; my place was next to the dresser, between my sister and great aunt, facing my mother, and diagonally opposite my grandfather, with a chair by the window for my father, which was only sometimes occupied. In the scene I am poised cautiously on a turquoise cushion, nervously waiting for that moment when it slips sideways on the polished surface of my wooden chair and I fall to the floor.

Note: *At a moment when feminists and others were turning away from the master narratives of history to uncover new forms of evidence and construct alterative modes of interpretation reliant on personal experience, feminist historian Joan W. Scott raised her objections – epistemological and ontological – concerning 'the evidence of experience'.*[59]

28
'Red Die'. Photograph: Jane Rendell, 2003.

Random Buttons (in a Bag with Needle and Thread)

*Button: A small knob or stud attached to any object for use or ornament.
A knob or stud of metal, bone, etc., sewn by a shank or neck to articles of dress,
usually for the purpose of fastening one part of the dress to another by passing
through a button-hole: but often for ornament.*

Buttons are odd things. Each one is of little interest, yet as a collection they fascinate. Singular and unattached, they are seemingly insignificant, but sewn in a row onto a garment they hold things together. I find looking at one and then another a meditative act that parallels the ability of storytellers to describe the world by making connections between occurrences. In sequence and in juxtaposition, things look different when they are next to one another. As my grandfather, the butcher, faced up from his dark coffin, tea and tongue sandwiches were served from the Welsh dresser in the room next door.

Note: *Visual critic Mieke Bal has pointed out that: '"Memory" is an act of "vision" of the past, but as an act it is situated in the memory's present. It is often a narrative act: loose elements come together and cohere into a story so that they can be remembered and eventually told. But, as is well-known, memories in relation to the fabula are unreliable, and when put into words, are rhetorically overworked so that they can connect to an audience, for example to a therapist. The "story" the person remembers is thus not identical to the one that happened. This "discrepancy" becomes dramatic, and in the case of trauma, incapacitating.'* [60]

29
'Random Buttons (in a Bag with Needle and Thread)'. Photograph: Jane Rendell, 2003.

Coins

Coin: A corner-stone; also, a wedge-shaped stone of an arch.
A corner, angle (1658).
A wedge (1779).
A die (? wedge-shaped), for stamping money; the device stamped upon money (1682).
A piece of metal of definite weight and value, stamped with an officially authorized device; a piece of money.
To make (money) by stamping metal.
To make (metal) into money by stamping pieces of definite weight and value with authorized marks.
To make, devise, produce.

My grandfather had a favourite joke. At Christmas, having bathed the pudding with brandy and set fire to it, he would cut slices, placing one in each dish and then distribute the portions around the table. On discovering a copper coin in my own pudding, I would be delighted, thinking I was the lucky one. My grandfather would search in his own dish and, feigning surprise, would pull out a piece of folded foil. On unwrapping it, a pound note would be discovered. As disappointment registered across my face, he would laugh and hand the note over to me as a generous gift. After his stroke, when he failed to find the words he required – objects were still able to speak for themselves.

Note: *For a Marxist historian, history has redeemable qualities only when it writes against the grain; storytelling lies dangerously close to the 'once upon a time' mode of history. For an exhilarating and unorthodox account of Marxist historical methodology which prioritizes the material of history itself, see the work of Walter Benjamin.*[61]

30
'Coins'. Photograph: Jane Rendell, 2003.

Hook without Eye

Hook: A length of metal or piece of other material, bent back, or fashioned with a sharp angle, adapted for catching hold, dragging, sustaining suspended objects, or the like.
To lay hold of with a hook; to make fast, attach, or secure with or as with a hook or hooks; to fasten together with hooks, or hooks and eyes (1611).

As I stand in front of the Welsh dresser now, each object I take out and hold tells me something particular about my mother, her history, our Welsh-ness. A single object can remain mute, or it can provoke a response in me, in you. What is a hook without an eye (I)? My spinster aunt loved detective stories. She left behind her a mystery surrounding an unworn engagement ring.

Note: *To attach one event to another and explain the relevance and implication of making such a connection is the job of the historian, but the relation of fact to interpretation, object to subject, remains history's most contested territory, with battles fought concerning the various crimes of idealism, positivism and empiricism.*[62] *Writing history by engaging with a series of objects gives a spatial structure to the usual chronology and a material twist to interpretation.*

31
'Hook without Eye'. Photograph: Jane Rendell, 2003.

Diary

Diary: a daily record of events or transactions, a journal; specifically, a daily record of matters affecting the writer personally.
A book prepared for keeping a daily record; also, applied to calendars containing daily memorabilia (1605).
Lasting for one day; ephemeral (1610).

My aunt taught needlework and cookery; not a day passed without her asking me to go from the kitchen to the Welsh dresser to fetch something useful for some kind of domestic task. These trips were fraught with anxiety. The Welsh dresser was unsteady on its feet, and as you pulled them out, the drawers stuck a little, causing the fragile jugs dangling above to sway a little and clink. The delicate sound raised uncertainty – the jugs were very carefully positioned next to one another – dislodge one and a whole row might smash.

Note: *For a feminist historian, the question of autobiography or life-writing is vexed. In resisting institutional narratives and the stories of victors, everyday details do have an important role to play in critical history, but there is a wariness of placing too much value on irrelevant anecdotes. At a talk at the Institute of Contemporary Arts, London, in the late 1990s, Susan Rubin Sulieman described the often painful process of re-reading personal stories she has told. With hindsight she felt they did not resonate, were not a microcosm of a greater whole, nor a detail that referenced a larger pattern, did not illustrate in a concrete fashion a complex theoretical idea: they were simply personal outpourings. Perhaps the personal is political only when it writes one life in relation to another.*[63]

32
'Diary'. Photograph: Jane Rendell, 2003.

Tailor's Chalk

Tailor's chalk: Hard chalk or soapstone used in tailoring and dressmaking for marking fabric as a guide to fitting.

Tailor's chalk makes marks for action, which have a certainly short life span. Like chalk on a blackboard, these marks will be rubbed out. Unlike chalk on a blackboard, they are marks for another making, for a line of cutting, folding or sewing, which will partially erase the first. After my aunt stopped teaching, she suffered from depression, a form of agoraphobia that prevented her from leaving the house. After years spent leading such a busy life, running a grammar school, and looking after her ailing brother and sister, she was alone. I remember arriving early on one visit to find her sitting in the dark in front of an unlit fire, the horizons of her world shrunk down to the contours of her dining room.

Note: *For cultural critic bell hooks, it is the lack of distinction between 'fact and interpretation of fact' in her remembering of the past that has influenced her thinking about autobiography. She discusses how 'Experimental memoirs have become the cultural sites for more imaginative accountings of an individual's life'. As precedent, she describes how Audré Lourde 'introduced to readers the concept of biomythography to encourage a move away from the notion of autobiography as an exact accounting of life. Encouraging readers to see dreams and fantasies as part of the material we use to invent the self'.[64] I misremembered Lourde's term 'biomythography' as 'biomorphology', or the shape a life takes, reflecting my own preoccupation with the topographical aspects of autobiography.*

33
'Tailor's Chalk'. Photograph: Jane Rendell, 2003.

My Junior Jet Club Badge

Badge: A distinctive device, emblem, or mark, but now worn as a sign of office, employment, membership of a society.
A distinguishing sign (1526).
A sort of ornament near the stern of small vessels, containing either a sash or the representation of one (1769).

My mother sometimes regrets how far she travelled from home. How she left Cwmgors for Aberystwyth, Aberystwyth for London, Wales for England. When she married my father, she went to live in the Middle East. Pregnant with me, she arrived alone at night on a desert airstrip. My Junior Jet Club badge is my reward for travelling far, with her.

Note: *The genres of autobiography and travel-writing are interwoven. While on the one hand much recent autobiographical writing tells stories of journeying, displacement and exile, on the other, many travelogues question political and theoretical discussions concerning subjectivity and location.*[65]

34
'My Junior Jet Club Badge'. Photograph: Jane Rendell, 2003.

Will

Will: Desire, wish, longing; inclination, disposition (to do something).
The action of willing or choosing to do something; the movement or attitude of
the mind which is directed with conscious intention to (and, normally, issues
immediately in) some action, physical or mental.
A person's formal declaration (usu. in writing) of his intention as to the disposal
of his property or other matters to be performed after his death; commonly the
document in which such intention is expressed.

The Welsh dresser tells the story of my mother's family. A traveller, with
more than one home, it has made several journeys, from a farm, to a house
in the next Welsh village, and then to my mother's home in England. From
mother to daughter, the Welsh dresser travels between women. My aunt
never married so the Welsh dresser went to her eldest niece. Tradition has
it that one day the Welsh dresser will be mine.

Note: *Luce Irigaray has paid attention to the need to reassert female genealogies in*
general and in particular the political and cultural importance of mother–daughter
relations.[66]

35
'Will'. Photograph: Jane Rendell, 2003.

36
Elina Brotherus, *Rain, The Oak Forest, Flood* (2001), *Spring,* The Wapping Project, London.
37 (pages **136–7**)
Elina Brotherus, *Horizon 8* (2000), *Spring,* The Wapping Project, London. Chromogenic colour prints on Fuji Crystal Archive paper. Mounted on anodised aluminium and framed. Edition 6 (3A + 3B). A 105 × 130 cm/B 80 × 100 cm. Courtesy: the artist and gb agency, Paris.

Longing for the Lightness of *Spring*

I had spoken to Elina Brotherus once briefly on the phone before meeting her. I was in a rush. She told me of her timetable – Helsinki, Walsall, Toulouse, Brussels, London. So was she. Even as I was speaking to her, the doorbell rang; I could hear children running in and laughing. But Brotherus sounded calm. The day I went to meet her, I was running late. I had only an hour to talk, before catching a return train from Walsall to London. Given her busy timetable I was a little anxious that I had kept her waiting. But like her work she approached me: precise, clear and still.[67]

The Culmination of all Longing and Desire

Elina Brotherus's photographs are all about time – emotional time, time spent loving, time spent remembering, time spent mourning, time spent yearning. Much of the work is a recording of what has happened, rather than what is to happen. This is why *Spring* (2001), a piece of work commissioned by Jules Wright for The Wapping Project, London, is unusual for Brotherus.[68] As well as using video, a medium seldom used in her practice, the work looks forward rather than backwards, described in her own words as: 'the culmination of all longing and desire'.

Spring is composed of two installations: a video triptych *Rain, The Oak Forest, Flood* (2001) (see image 36) in the boiler house and a back-lit image *Untitled* (2001), 3 m × 8 m (see image 37) reflected in the water tank on the

38
Jane Rendell, 'Moss Green' (2001). Photograph: Jane Rendell, 2001.

roof of Wapping. *Untitled* shows an illuminated horizon that divides sky from earth. Like the scene in the distance, where a dark and dense London meets light cloud overhead, the pale grey sky of Iceland floats above once-viscous lava now covered in green moss. Brotherus requested that the work be time-specific. *Spring* opened as Wapping entered winter, just after the autumn equinox in the northern hemisphere.

Moss Green

The house is beautiful – a one-storey building, with a square plan – born at the birth of modernism in the aftermath of the First World War. It embodies the values of early English modernism, of the Arts and Crafts movement: 'truth to materials' and honest craftsmanship. From the road it looks a little unloved, in need of some care and attention. Up close it is clearly derelict, almost in ruins. We enter a room with windows at each end. Curtains are falling away from the runners. The fabric has been soaked overnight and is drying in the spring afternoon sunshine. On the window cill and spilling over onto the floor are piles of old magazines. The pages are stuck together and disintegrate if you try to pull them apart. There are some photographs of buildings. One is particularly damp; the corners are soft, the surface is wrinkled. It shows a tower block, just completed, empty and pristine, a moss green utopia, the modernist dream dispersing as it soaks up spring rain.

Rain, The Oak Forest, Flood (2001)

Brotherus told me how much she hates the darkness of the Finnish winter and yearns for spring each year. It was no different when she moved to Paris, perhaps worse because she felt trapped in an urban setting with no view of the horizon. In search of spring, she left the city and went to Brittany and the Loire Valley.[69] The videos make up a triptych, projected on screens hung from the ceiling, *Rain, The Oak Forest, Flood*. In the first, rain streams down outside, as the viewer sits indoors, protected. The second shows an oak forest after the rain has stopped, but when drops, still heavy, continue to fall to the ground – John Betjeman's 'second rain'. The third is of a flood, a forest of elegant trees rising silver from a pane of shining water.

Rain has a different 'time' in each piece. Each piece has a different duration. The ever-changing combination of raining, rained and rain over means that the viewer never sees the same combination of rain and time.

In Finland, the skylark is the earliest bird to sing; its song heralds the coming of spring one month away. Like Jane Mulfinger's poignant piece *Nachtigall, 3.00 Uhr, Berlin Stadtmitte* (1996), where the artist recorded the song of a nightingale, which sang all night in the city, until dawn broke and his song was slowly drowned out by traffic noise, Brotherus's waterlogged

39
Jane Rendell, 'White Linen' (2001). Photograph: Jane Rendell, 2004.

spring landscape recalls the delicate beauty of this stifled birdsong. For Brotherus *Spring* is about beauty, yet given what we know of climate change, it is also somehow prophetic.

White Linen

I dreamt of the house last night, my mother's home in Cwmgors, South Wales. When I was a child, it was the place where it always rained in the holidays, but now, as it slips away from me, it is the place that I already begin to miss. I was in the dining room; the house was empty except for this one room. The furniture was far too big and was covered in linen. The air was thick with silence. With the curtains drawn, it was dark, but the linen glowed white. As I went towards the mantelpiece to take a look at myself in the mirror, I saw for the first time, in the reflection, that the room was full of plants, so alive I could smell the moisture still on their leaves.

Depicting a Sentiment

When curator Wright first showed me Brotherus's work, I was drawn immediately to the series called *Suites françaises 2*. These are photographs of Brotherus's home when she first arrived in France from Finland. On strategically placed Post-it notes, Brotherus's script precisely yet gently, names each object she sees in her new tongue, as well as parts of herself and her emotions[70] (see image 40). Brotherus says these are images 'depicting a sentiment'. She looks straightforward, childlike in her directness, yet the simple naming operation demonstrates the inability of words to connect.[71] To paraphrase artist Gillian Wearing, 'signs don't say what we want them to say'. Could it be that Jacques Lacan was right after all, that we are not in control of language, that on the contrary, language makes us?

Much of Brotherus's earlier work deals with intimate and personal subject matter – the death of her parents, the break up of her marriage, the desperation at the end of an affair. The photographs show Brotherus experiencing intense emotions.[72] For her, these images 'tell it as it was' – they are not set-ups. We see her genuinely distraught, we feel for her. But she is also capable of standing back. In many, for example in *Love Bites II* (1999), we are shown the artist holding the mechanism used to take the photograph[73] (see image 41). Here, she is both the image's subject and its maker. In showing herself as the producer of the artwork, Brotherus reassures us she is all right. She breaks the magic, the illusion of the image, and in so doing takes charge of her own emotional life.

Brotherus trained as an analytic chemist before becoming an artist. The chemist is still there, looking carefully, patiently breaking things down into their components and recording with exactitude life as it occurs.[74] When we

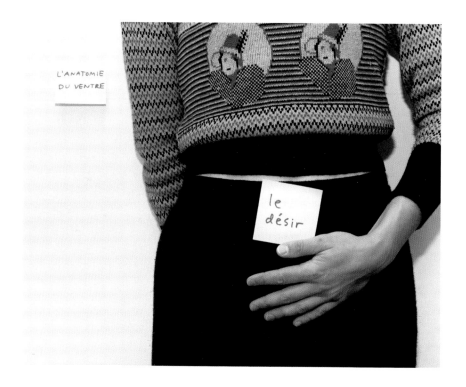

40

Elina Brotherus, *L'anatomie du ventre* (1999) *Suites françaises 2*. Tryptich of chromogenic colour prints on Fuji Crystal Archive paper. Mounted on anodised aluminium and framed. Edition 6, 40 × 50 cm each (× 3). Courtesy: the artist and gb agency, Paris.

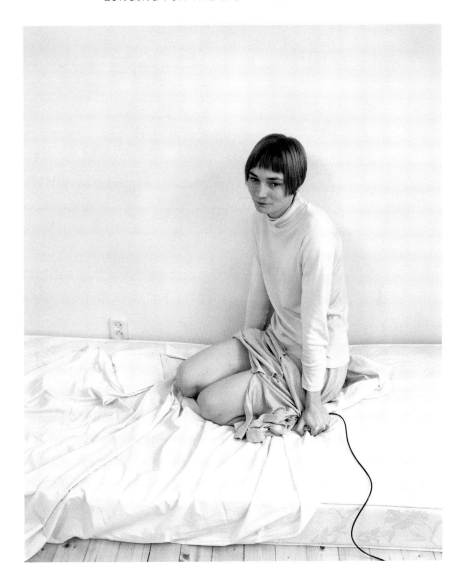

41
Elina Brotherus, *Love Bites II* (1999). Chromogenic colour print on Fuji Crystal Archive paper. Mounted on anodised aluminium and framed 70 × 57 cm. Courtesy: the artist and gb agency, Paris.

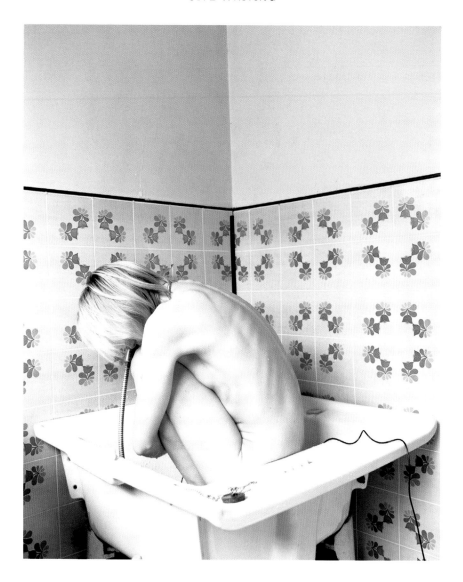

42
Elina Brotherus, *Femme à sa toilette* (2001), *The New Painting*. Chromogenic colour print on Fuji Crystal Archive paper. Mounted on anodised aluminium and framed. Edition 6, 80 × 66 cm. Courtesy: the artist and gb agency, Paris.

met we spoke of our mutual love of precision. Brotherus drew one hand down the centre of her face. She sees herself as split down the middle – the analytic chemist and the artist – the rational and the intuitive, the objective and subjective.[75] It emerges that she has been working away from the personal towards the general: the 'Post-it note phase' is right in between.[76]

To be Able to See Far

In 2000 Brotherus began a new phase of work entitled *The New Painting*, after a comment made by a critic on the current state of photography.[77] This work references classical work in its titles as well as its formats of landscapes and portraits. The portraits that feature people as subject matter are quite different from her earlier work. In *Femme à sa toilette* (2001) (see image 42) and *Homme derrière un rideau* (2000), for example, the figures are real people, Brotherus and a male lover, but the titles frame them as models 'acting' in a scene.[78] If these are attempts to capture the moment, they do so as part of series of critical explorations of certain motifs and genres in classical painting. A series of five images entitled *Le Mirroir* (2001) shows the artist in a bathroom filled with steam, facing a mirror above a basin. In each successive image, read from left to right, the steam slowly evaporates and Brotherus's face comes into focus in the mirror. Steam is a fascinating material, marking so briefly the moment of transformation from thick liquid to ephemeral gas – rather like that fleeting instance in the mirror, when we hope that in catching sight of our reflection we will recognise ourselves.[79]

For another group of work within *The New Painting* focusing on landscapes rather than the human figure, Brotherus produced a set of horizons: *Horizons*, *Low Horizons*, *Very Low Horizons* and *Broken Horizons*.[80] Following *Landscapes and Escapes*, her earlier landscape series, these works shift standpoint from a perspective view to flatter, more abstract images.[81] There are scenes cut in half by horizons: ice and sky, stone and sky, earth and sky. In some the ground line is barely visible; there is just sky, it seems, and then, barely perceptible, no more than a smudged line along the bottom of the image, it is possible to discern a thin slice of land. The horizon is important to Brotherus – she needs 'to be able to see far'.[82]

The New Painting works with the same colour palette and distribution of tones. There are the darks, blacks, blues and greens; and the lights, whites, pinks and greys; but not a lot in between.[83] There is a strength and simplicity to this contrast that corresponds to the juxtaposition of old and new at Wapping, the silver steel and rich brick. The differences in weight between these sombre colours resembles the differences between those material qualities that distinguish the elements – fire and earth, air and water.

43
Jane Rendell, 'Bittersweet' (2001). Photograph: Cornford & Cross, 2001.

Bittersweet

In Palafrugell, a small town north of Barcelona on the Costa Brava, is a derelict cork factory with a clock tower in front. The tower is a handsome steel structure, elegant and robust, but the clock on top has stopped. Inside, the floor is covered in dust and pieces of furniture: lamp-stands, chairs and old printing machinery. There are words everywhere, scattered all over the floor: burnt orange, turquoise, black and white, bittersweet. We stay in the factory a long time. We do not speak, we just walk and look. Later, once we have left the building, he brings something to show me. It is a white sign with carefully painted black letters: 'Bittersweet'. I reach into my bag and pull out a clear square-section rod; along one side of it letters printed onto cardboard are embedded in the perspex. From the top it is out of focus, but from the side you can read it: 'Bittersweet'.

If matter has a weight, does emotion?[84]
If space has a colour, does time?
What is the colour of longing, longing for the lightness of spring?

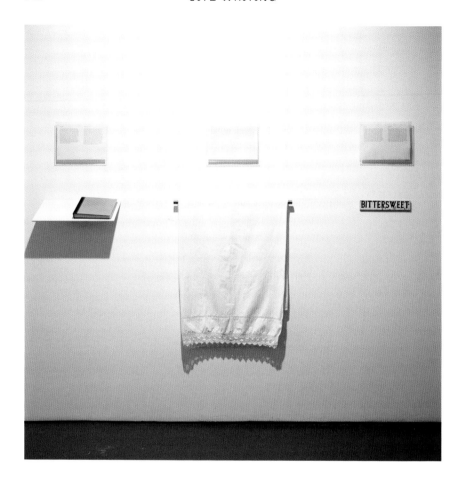

44
Jane Rendell, *Les Mots et Les Choses* (2003) *Material Intelligence*, Entwistle Gallery, London.
Photograph: Entwistle Gallery.

Les Mots et Les Choses

When Jules Wright from the Wapping Project asked me to write an essay about the work of artist Elina Brotherus, I found myself writing about places that corresponded visually with her photographic images, responding to the inscription of feeling in her landscapes with emotional scenes of my own. I started to wonder how including a memory or dream from a critic's life might question the usual distinctions made between art and criticism. Rather than writing directly about an artist's work, it might be possible to consider the work from the vantage point of another remembered or imagined place.

My essay made spatial, material and visual associations with Brotherus's *Spring*: specifically, the tri-partite structure of the triptych, the texture of moss, the time-freezing quality of lava and the monochrome colour palette. 'White Linen' resembled the vast pale skies in Brotherus's images, but referred to the sense of yearning in her work. My own fascination with the backwards gaze of nostalgia and the interest in Brotherus's *Spring* in anticipation as a melancholic desire that looks forward, allowed me to consider her work in relation to three sites connected with colours of longing.

The temporal correspondences created also draw out patterns of life and death, and construct juxtapositions between rejuvenation and decay. A work that anticipates the end of winter, Brotherus's *Spring* opened in Wapping just after the autumn equinox in the northern hemisphere and the start of the long decline into winter. 'Moss Green' describes a derelict house in London's green belt where in spring we found photographs of

a brave new world of modernist high-rise housing. Just after the autumn equinox, just after her death, I dreamt of the shrouded home of my Welsh great aunt. 'White Linen' recalls the presence of life in the form of plants in this dream, while 'Bittersweet' remembers another spring visit, this time to an abandoned cork factory in Catalunya where we found the name of the colour of longing, of yearning, abandoned on the floor.

Wapping is located in a disused pumping station on the north bank of the Thames, in London, adjacent to the Shadwell Basin. The building is constructed out of red brick with a timber and iron trussed roof and a stone floor. It is composed of two large masses placed at an angle to each other, linked by a corridor with a store and mess room. One is the engine house for the steam pumps with a turbine house and accumulator tower. The other is the boiler house with a coal store, filter house, two water tanks and a chimney. Wapping was built by the London Hydraulic Power Company in 1890 and operated as a steam-generated pumping station until the 1950s, when it switched to electricity. After closing in 1977, the pumping station lay empty until its discovery by Wright of the Women's Playhouse Trust. In October 2000 Wapping reopened, this time as an international arts venue with performance areas, gallery spaces and a restaurant.

Change over time is particularly pertinent with regard to Wapping, a building that depends for its very existence on elemental transformation and flow. As a steam-powered hydraulic pumping station, its purpose was to transform liquid water into gaseous air. Water from a well was circulated between rooftop tanks, underground reservoirs and the pumps through a complex system of pipes connecting Wapping to four other pump houses and 8,000 machines across London. The defunct status of the building inspired the descriptions of two other derelict sites: an Arts and Crafts cottage in England, and a derelict cork factory in Catalunya.

For its expedition to Seoul, as *What is the Colour of Memory?* (April 2002), each text was translated into Korean and accompanied by its 'object': an album of photographs found at the 'Moss Green' house, a white linen cloth, and a sign containing the word 'Bittersweet' found in the cork factory. The texts were translated back into written English from the Korean audio recordings for their journey to Los Angeles as *The Voice One Cannot Control* (November 2002). For *Concrete Feedback* at SYARC, curated by artist Brandon LaBelle, the three pairs of texts or word-presentations were placed along a corridor, with one either side of each of the three columns. Three audio installations positioned the Korean voice at the point were the written texts could no longer be read together. In moving, the words were translated from English to Korean and back again, from writing to speaking and back again.[85]

When the work changed location again, this time moving to the Entwistle Gallery in London as *Les Mots et Les Choses* (March 2003) for *Material Intelligence*, the three objects were re-inserted, sited in the slippage in language produced through translation and displacement (see image 44). In *Les Mots et Les Choses* (1966), translated into English as *The Order of*

Things,[86] historian and philosopher Michel Foucault explores the ordering of relationships between different cultural elements, for example, those that are real, those that represent, those that resemble, those that can be imagined. Between words and things, between writing and speaking, between one place and another, this site-writing is a two-way inscription, dreamed and remembered, of sites written and writings sited.

Configuration 4

That Which Keeps Coming Back

Déjà Vu

To put it briefly, the feeling of 'déjà vu' *corresponds to the recollection of an unconscious phantasy. There exist unconscious phantasies (or day-dreams) just as there exist conscious creations of the same kind which everybody knows from his own experience.*[1]

Configuration 4: Déjà Vu examines the spatial structure of unconscious hiding or folded memory. Like the concept of screen memory introduced in *Configuration 3: A Rearrangement*, *déjà vu* is a substitute memory used in order to aid repression and to cover up something secret. For Sigmund Freud, *déjà vu* – 'the recollection of an unconscious phantasy' – is 'a category of the uncanny'.[2] Analogous to *déjà raconté* and to *fausse reconnaissance*, the term *déjà vu* is used for the first time in 1907, in an addition to 'The Psychopathology of Everyday Life' (1901). Here Freud discusses the experience of a thirty-seven-year-old patient, who recalls how, on a visit made when she was twelve and a half to childhood friends in the country whose only brother was very ill, she felt she had been there before. Freud comes to understand that this visit reminded his analysand of the recent serious illness of her own only brother, but that this memory was associated with a repressed wish – that her brother would die, thus allowing her to be an only child. For Freud, it was in order to prevent the return of this unconscious and repressed wish that her feeling of remembering was 'transferred' onto her 'surroundings'.[3]

In 1909, Freud turned his attention to *déjà vu* in dreams, describing in an addition to 'The Interpretation of Dreams' (1900) how: 'In some

dreams of landscapes or other localities emphasis is laid in the dream itself on a convinced feeling of having been there once before.'[4] He asserted that: 'These places are invariably the genitals of the dreamer's mother; there is indeed no other place about which one can assert with such conviction that one has been there once before.'[5] And one year later, Freud altered his theory of *déjà vu* previously advanced in 'The Psychopathology of Everyday Life' in order to acknowledge the understanding of *déjà vu* in dreams that he had gleaned from Sandor Ferenczi – that memories of unconscious wishes may derive from night dreams as well as day dreams.[6] In 1914, he returned to 'The Interpretation of Dreams' to insert another sentence which identified the feeling of 'having been there once before' in dreams as a specific kind of *déjà vu*: 'Occurrences of *"déjà vu"* in dreams have a special meaning.'[7]

In the same year, 1914, in his paper '*Fausse Reconnaissance ("Déjà Raconté")* in Psycho-Analytic Treatment', Freud describes *fausse reconnaissance* and *déjà vu* as analogous and compares them both to *déjà raconté*, a feature of psychoanalytic treatment where the analysand believes erroneously that s/he has already told the analyst something. Acknowledging for the first time the contribution made by Joseph Grasset in his paper of 1904, Freud outlines the feeling of *déjà vu* as 'an *unconscious* perception', which later 'makes its way into consciousness under the influence of a new and similar impression'. He also comments on the views of other 'authorities' for whom *déjà vu* is a recollection of something that has been dreamed and then forgotten.[8] Freud states that what such opinions have in common is the 'activation of an unconscious impression' in *déjà vu*.[9] Revisiting his earlier consideration of the *déjà vu* experience of his thirty-seven-year-old analysand, Freud now emphasizes the activating role of her *déjà vu* experience, which, he argues, was 'really calculated to revive the memory of an earlier experience'.[10] He underscores how, because the analogy between her repressed wish that her sick brother should die and the dying brother in the house she was visiting could not be made conscious, the perception of this analogy was 'replaced by the phenomenon of "having been through it all before"', so dislocating the identity of the common element onto the geographical location – the house itself.[11]

Much later in his life Freud turned his attention to the allied phenomena of 'derealization' and 'depersonalization'.[12] In his 1937 paper 'A Disturbance of Memory on the Acropolis', Freud recounts a visit to the Acropolis made with his brother. He focuses on the odd sense of depression they shared in Trieste when it was first suggested that they might make the visit, followed by an analysis of his own response once at the Acropolis – his surprise that it *really did exist*. Through a series of careful reflections, Freud slowly uncovers what he believes is at stake here: that what he felt as a child was not so much disbelief that the Acropolis existed as disbelief that he would ever get to visit it. This insight allows him to understand that the depression both he and his brother felt in Trieste was in fact guilt – a guilt that they would do the forbidden thing, surpass their father and

visit the Acropolis (a destination for cultured travellers of the upper- and upper-middle classes) as he never had.

Freud goes on to interpret the phenomenon of derealization as a kind of defence – a need to keep something away from the ego.[13] He connects these derealizations, where 'we are anxious to keep something out of us', to what he calls their 'positive counterparts' – *fausse reconnaissance*, *déjà vu*, *déjà raconté* – which he describes as 'illusions in which we seek to accept something as belonging to our ego'.[14] This description of *déjà vu* as illusion sits uncomfortably with his earlier work, where in 1907 Freud had specifically argued that it was erroneous to understand feelings of *déjà vu* as illusions: 'It is in my view wrong to call the feeling of having experienced something before an illusion. It is rather that at such moments something is really touched on which we have already experienced once before, only we cannot consciously remember it because it has never been conscious.'[15] This change of mind over the illusory nature of the *déjà vu* cover-up constructed in order to prevent the return of memories repressed in the unconscious is something that Freud, frustratingly, never returns to resolve.

Other commentators though, have looked at how *déjà vu* might be considered an illusion, a diversion from that which is always coming back. Eli Marcovitz describes *déjà vu* as 'an illusory fulfilment of a wish that one could repeat some previous experience so that one could make the outcome accord better with a desire'.[16] Arguing that both are false experiences, Marcovitz compares *déjà vu* and hallucination: 'hallucination is a wish projected and falsely experienced as a perception, *déjà vu* is a wish directed into the past and falsely experienced as a memory'.[17] J.A. Arlow also maintains that since *déjà vu* 'resembles the wish-fulfilling complementation of the data presented by perception', it is closely allied to illusion.[18] Unlike Marcowitz, however, he suggests that although both aim to reassure the ego, in *déjà vu*, unlike hallucination, there is no 'falsification of perception'.[19]

In positing that the *déjà vu* reaction is 'the expression of a wish to have a second chance', Arlow believes that Marcovitz overlooks the defensive function of the *déjà vu* reaction and its 'uncanny, disconcerting, unpleasant, anxiety tinged affects'.[20] For Arlow, 'The false judgment, "I have seen or experienced this before", contains the expression of a wish, not a wish from the id, but a wish from the side of the ego.'[21] In his view *déjà vu* is not a compromise formation or symptom constituted as a substitute for an 'unachieved instinctual gratification', in other words an id impulse, but rather a 'transitory, circumscribed disturbance of a specific ego function'.[22] Arlow explains how it is by offering the current situation 'as a substitute for the original memory or fantasy in an effort to keep that memory or fantasy in repression' that 'the dynamic situation in *déjà vu* is similar to the use of screen memories as substitutes in order to aid the defense of repression'.[23] As screen memory 'also involves unconscious wishful falsification of memory', Marcovitz too relates it to *déjà vu*.[24]

In a fascinating cultural history, Peter Krapp develops this connection between *déjà vu* and screen memory. Krapp considers *déjà vu* in terms of the 'recurring structures of the cover up and the secret',[25] stressing how, in his first published account of parapraxis from 1898, Freud discusses the 'psychical mechanism' as parallel to what he calls 'unconscious hiding'.[26] This spatial emphasis on the structure of concealing and revealing is a focus which Krapp continues to explore through his understanding of screen memory as 'no mere counterfeit, but the temporal folding of two "memories": it presents as the memory of an earlier time data that in fact are connected to a later time, yet are transported back by virtue of a symbolic link.'[27] Yet the form of the fold is more complex than Krapp acknowledges, since it does not always occur in the same direction. As I noted in 'Word-Presentations and Thing-Presentations', the introduction to *Configuration 3: A Rearrangement*, Freud put forward three different temporal models for screen memory: one where an earlier memory screens a later one, explored in his paper 'Screen Memories';[28] another, which he referred to most often in subsequent work, where a later memory screens an earlier one; and a third where the screen memory and the memory screened come from the same period in a person's life.[29]

These folds – including the gaps, oversights, repeats and returns – are the strangest aspects of Freud's own work on *déjà vu*. The most obvious is the fact that, despite describing *déjà vu* as included in 'the category of the miraculous and the "uncanny"' in his 1907 addition to 'The Psychopathology of Everyday Life', Freud omits the term from his 1919 essay 'The "Uncanny"'.[30] In 'The "Uncanny"' Freud's main argument is that the return of the repressed – the homely (*heimisch*)[31] returning as the unhomely (*unheimlich*) – is located in the memory of the mother's body:

> *It often happens that neurotic men declare that they feel there is something uncanny about the female genital organs. This unheimlich place, however, is the entrance to the former* Heim *[home] of all human beings, to the place where each one of us lived once upon a time and in the beginning. There is a joking saying that 'Love is home-sickness' and whenever a man dreams of a place or a country and says to himself, while he is still dreaming: 'this place is familiar to me, I've been here before', we may interpret the place as being his mother's genitals or her body. In this case too, then, the* unheimlich *is what was once* heimisch, *familiar; the prefix* 'un' ['un-'] *is the token of repression.*[32]

Through a careful examination of the etymology of the German term *heimlich*,[33] and discussion of examples of the uncanny in literature, especially the relation between animate and inanimate, alive and dead, in E.T.A. Hoffmann's story *The Sand-Man* (1817), Freud shows how the uncanny is 'the opposite of what is familiar' and is 'frightening precisely because it is *not* known and familiar'.[34] But he is careful to stress that not everything unknown and unfamiliar is uncanny; rather, and here Freud follows F.W.J. Schelling, the *unheimlich* is everything 'that ought to have remained secret

and hidden but has come to light'.[35] It is striking that in his 1909 and 1914 additions to 'The Interpretation of Dreams', where Freud discusses the recall of the mother's body in very similar terms, he connects this phenomenon to *déjà vu* rather than the uncanny.[36]

The relation between *déjà vu*, the uncanny and the mother has also been explored by Christopher Bollas but with a rather different emphasis. A psychoanalyst who developed certain aspects of D.W. Winnicott's work, particularly his concept of the transitional object and the mother as a facilitating environment,[37] Bollas argues that in constantly altering the infant's environment to meet his/her needs, the mother is experienced as a form of transformation, what he calls a 'transformational object'.[38] Bollas suggests that later, with the creation of the 'transitional object', the transformational process gets displaced from the mother-environment onto countless subjective-objects.[39]

Bollas links this first creative act to aesthetic experience, describing the 'aesthetic moment' as one where an individual feels a 'deep subjective rapport with an object'.[40] This feeling of fusion is, Bollas suggests, uncanny because it has the 'sense of being reminded of something never cognitively apprehended, but existentially known'.[41] In a later articulation of this concept Bollas rephrases his argument using the term *déjà vu* to describe what he calls 'a non-representational recollection conveyed through a sense of the uncanny':[42]

> *I have termed the early mother a 'transformational object' and the adult's search for transformation constitutes in some respects a memory of this early relationship. There are other memories of this period of our life, such as aesthetic experience when a person feels uncannily embraced by an object.* [43]

Literary critic Elizabeth Wright has noted that the uncanny has become an important term in 'postmodern aesthetics' because it acts as a 'challenge to representation', one which makes us see the world not as 'ready-made' but in the constant process of 'construction, destruction and reconstruction'.[44] Following Wright's comment, my aim in this configuration is to explore how the spatial aspects of the psychoanalytic concept of *déjà vu*, as a category of the uncanny, operate as a fold or cover-up, fabricated to prevent the return of repressed memories. I explore how this spatial arrangement can inform, not the analysis of an artwork, but the experience of encountering particular kinds of artwork, as well as specific situations engaged with in the writing of criticism.

Through an extended investigation of a set of works by Cristina Iglesias shown at the Whitechapel Art Gallery in 2003, I examine how one artist has employed her understanding of *déjà vu*, in terms of 'some things you see will remind you of others', to shape the viewer's experience through folds in time. Performing this spatial figure, the essay is constructed as a journey through the exhibition, where descriptions of one work reappear in another, and a spatial response to the work framed by the artist's aesthetic

intentions is disturbed by strangely familiar phrases in the text, where words from previous Configurations in this book 'come back' – make an unexpected return.

Drawing on Iglesias's *Passages*, the final piece in the exhibition, as a space of unconscious memory, transition and transformation, I focus in the following part of the configuration on how the uncanny aspect of *déjà vu* as the repressed feminine has informed investigations of arcades, particularly artist Sharon Kivland's voyages that trace the urban passage of women. Taking its title 'She is walking about in a town which she does not know' from a work by Kivland, derived in turn from Freud's discussion of his analysand Dora's second dream, the configuration ends with a piece of art criticism. Here I explore the difficulties posed by a commission that requested that I write about works not yet in existence to be located in a town which I did not know. Furnished with photographs and maps of the location and images and texts describing the works in process, this site-writing imagines walking through the completed works, disturbed by feelings of *déjà vu* conjured up by my earlier glimpses of both town and work through visual and textual representations.

'Some Things You See Will Remind You of Others': *Déjà Vu* in the Work of Cristina Iglesias

To gaze at any one piece is to carry the vision of the previous one …[45]

This construction encloses an image. That image is sometimes a detail of the interior of another piece.[46]

… a memory that keeps coming back.[47]

When Cristina Iglesias introduced her solo show at the Whitechapel, London, in April 2003,[48] she described the exhibition in terms of *'déjà vu'*, saying 'some things you see will remind you of others'.[49] My discussion navigates the spaces of *déjà vu* – the folds in time created through perceptions and illusions, dreams and memories – produced by the seven artworks in this show. I examine how these *déjà vu*-like experiences relate to the psychoanalytic qualities of the psychic feeling described by Freud.

Connections between Iglesias's work and the uncanny, but not necessarily *déjà vu*, have been made by numerous other art critics. Michael Newman, for example, describes the 'gap [between the mould and the object that is made from it]' in Iglesias's work as 'an uncanny interval in which the distinction between life and death is undecidable',[50] while for Marga Paz the uncanny is present in the 'unusual combinations' of 'more-or-less familiar material'.[51] Iwona Blazwick, curator of the Whitechapel Art Gallery, in discussing the work of a group of contemporary European and American artists to whom she argues Iglesias belongs, suggests that in offering an actual environment to enter which is symbolically separated

from the world, these artists present a '*döppleganger*' with its qualities of the 'uncanny and speculative'.[52] Focusing on the role of the detail in the *Vegetation Rooms*, whose patterns are both familiar and strange, and the *Celosia* screens and silk-screened copper plates with their secret, hidden aspects, curator and writer Michael Tarantino locates the sense of the uncanny in works by Iglesias in 'the way in which she plays on our notions of what is familiar, making us experience different types of space or objects in a way we are normally unaccustomed to'.[53]

The unsettling effect of *déjà vu* can occur through the discovery of one thing in the place of another or the unexpected return of a detail or feature. Iglesias uses a number of aesthetic strategies like these to produce *déjà vu*: for example, 'illusionistic *mise en scene*'[54] and 'visual, phantasmatic projection'.[55] Although in psychoanalysis, as noted above, an understanding of *déjà vu* as illusion has been contested, for Iglesias the intention is precisely to create an illusion in order to break it: 'I use a lot of materials that lie,' she says.[56] In Iglesias's practice the creation of illusion operates architecturally and, as Paz has argued, the role of the image 'play[s] a fundamental role in the spatial and conceptual structure that makes up the work'.[57] Through her 'models or "pavilions": spaces of the imagination',[58] Iglesias investigates what Paz calls 'the subjective dimension of space' and its 'irrational, symbolic, metaphorical and allegorical' qualities, in particular 'blind' forms such as labyrinths, skylights and *jalousies* or screens.[59] According to Tarantino her work puts the 'notion of architecture itself in crisis: between past and present, real and imagined, her spaces challenge us to fix the spatial co-ordinates ourselves. Iglesias's rooms feature a kind of floating architecture, in which our position is never stable.'[60]

By inserting moments of illusion which appear, disappear and then reappear, depending on the scale, distance and sequence of viewing, Iglesias disturbs our usual relationship with architecture, questioning normative binary logics of structure and construction, for example open and closed,[61] inside and outside,[62] transparent and opaque,[63] physical and mental,[64] and fabricated and natural.[65] Drawing on memory and imagination, her work challenges the ways in which material objects and spaces are perceived. In the manner of previous surrealist writings and artworks, Iglesias confuses the separations traditionally held between the strange and familiar, using devices such as inverting, screening, returning, defamiliarizing, reflecting, repeating and passing (through). Turning the viewer upside-down, back-to-front and inside-out, Iglesias offers new worlds to enter, yet holds them away, presenting spaces that at first appear to be one thing yet are subsequently discovered to be quite another.

Inverting
Untitled (Tilted Hanging Ceiling) (1997) and *Untitled* (1997–2000)

A roof suspended in any space delineates or configures a room. This was my first idea in constructing that piece. Once she is under the roof, the spectator looks up and finds herself in other world. It could be the bottom of the sea – you may be standing upright but you are looking down.[66]

… I am interested in that play between the perception of an extreme illusionism in which you believe in that space and that other moment in which the piece itself reveals the trick to you.[67]

Metal rivets holding the decrepit ceiling plaster together shone at night like stars.

The plane suspended above her at an angle is not quite a canopy – it has the qualities of the ground not the air – a density and heaviness. Patterned with what look like sea urchins and shells, its underside might be a fossilized section of the ocean floor. But on closer inspection, the repetitive striations and fanned undulations appear to be the undersides of decaying forest mushrooms.[68]

This viewing position offers two sets of inversion, one emerging out of the other: an impossibility perceived at a distance becomes reformulated as a paradox up close. Initially the work invites her to stare up at a surface that at a glance appears to be one she would normally look down at – the marine floor. Then, as the surface reveals itself differently through the detail, she realizes that the pattern might instead be composed of repeated sections of the fluted underside of mushrooms, offering again a reversal of a usual viewing position. Unless preparing a meal, she is accustomed to looking down, not up, onto the tops, not the undersides, of mushrooms.

The canopy is encircled by dark glossy images depicting a deserted labyrinthine world of fragile ramshackle structures and sand floors.[69] On first impression her wish is to pass through the wall of the gallery and explore this copper-shadowed no-man's-land.[70] But on a more detailed examination the occasional glimpse of printed letters reveals the scale of the structures – these are cardboard boxes, some of them wine cases, complete with their barcodes and labels. The copper plates placed on the floor are door height; like a series of openings they lead her out of the gallery and into the surrounding deserted twilight, yet the letters contained within the photographs silk-screened onto them indicate the magnification of the boxes in the image, destroying her illusion of entry.

To inhabit these magical shanty towns she has to imagine herself otherwise. Similar to the wonderland Alice was able to access by going down a rabbit hole and later passing through the looking glass, this impossible territory also resembles those places occupied by the Borrowers, whose tiny-ness allowed them to experience the ordinary

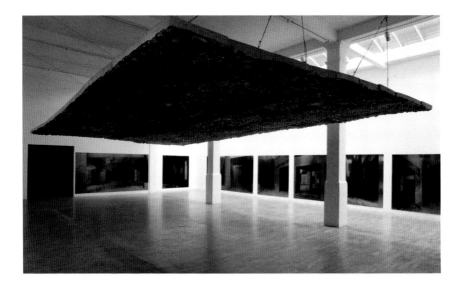

45
Cristina Iglesias, *Untitled (Tilted Hanging Ceiling)* (1997). Private Collection. Courtesy of the artist, Donald Young Gallery and galeria elba benitez. Installation view at Whitechapel Art Gallery (2003). Photograph: Ben Johnson. Reproduced with kind permission of the Whitechapel Gallery Archives.

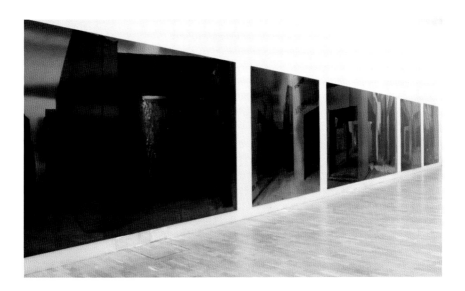

46
Cristina Iglesias, *Untitled (Polyptych III)* (1999). Silkscreen on copper 200 × 400 × 0.5 cm. Private collection. Courtesy of the artist, Donald Young Gallery and galeria elba benitez. Reproduced with kind permission of the Whitechapel Gallery Archives.
47 (page **167**)
Cristina Iglesias, *Untitled (Celosia I)* (1996). Wood, resin, bronze powder 260 × 220 × 250 cm. Collection Dexia Bank, Brussels. *Untitled (Celosia VII)* (2002). Wood, resin, bronze powder 260 × 220 × 250 cm. Courtesy of the artist, Donald Young Gallery and galeria elba benitez. Installation view at Whitechapel Art Gallery (2003). Photograph: Ben Johnson. Reproduced with kind permission of the Whitechapel Gallery Archives.

domestic world differently, and Flat Stanley who, squashed overnight by a bulletin board, was able to alter his reality and embark on adventures of all kinds – flying as a kite for his brother, visiting friends by travelling in an envelope and catching thieves while masquerading as a painting.[71]

For Iglesias the process of silkscreening 'erases' the trace of the photograph and *turns* the image into something else.[72] And the copper plate, too, has been described as playing a role as an unstable 'middleman' or messenger amplifying the transformative potential in the work.[73] Iglesias has described how she is able to use the same motifs repeatedly since they alter when the 'container' or setting is changed.[74] In this particular configuration at the Whitechapel, the copper plates perforate the wall with windows, alluding to, yet refusing, entry into another world, while the new ceiling suggests a ground plane that turns the space of the gallery upsidedown.[75]

Screening
Untitled (Celosia I) (1996) and *Untitled (Celosia VII)* (2002)

> *The invention of a room that has never existed, inside another room we are capable of describing … The fragmentation of the text imposes an extended, expanded time that is difficult to follow or even endure. This would occur if we were shut up in a room with hieroglyphics all over the walls.*[76]

She sees a pair of eyes watching her from behind a screen.

From under the tilted ceiling, she looks ahead to the rest of the exhibition, and notes that framed within the point of entry to the next room is an intricately carved screen. On approaching she sees that there are in fact two separate structures both composed of screens of just above head height. In one, the screens have been arranged in a roofed enclosure; the other is laid out in a form that invites entry.

In Spanish *celosia* has two meanings, as does *jalousie*, its French counterpart. These words refer both to the architectural space of slatted blinds and the psychical space of jealousy. Alain Robbe-Grillet's 1957 novel *Jealousy*, 'which centres on notions of shuttered surveillance whereby one watches others without being clearly visible oneself', was in part an inspiration for the work.[77] Jealousy can be described as a trap – a blind emotion where one is unable to look beyond the self.

Her perception of the two structures – the one that can be entered, and the other that cannot – and the difference between them changes upon interaction. The self-contained sculpture invites imaginative projection, hovering between a refuge of protection and a site of entrapment. In denying physical entry, it remains a place of mystery and speculation. Its companion piece is also made of intricate latticework, configured as a series

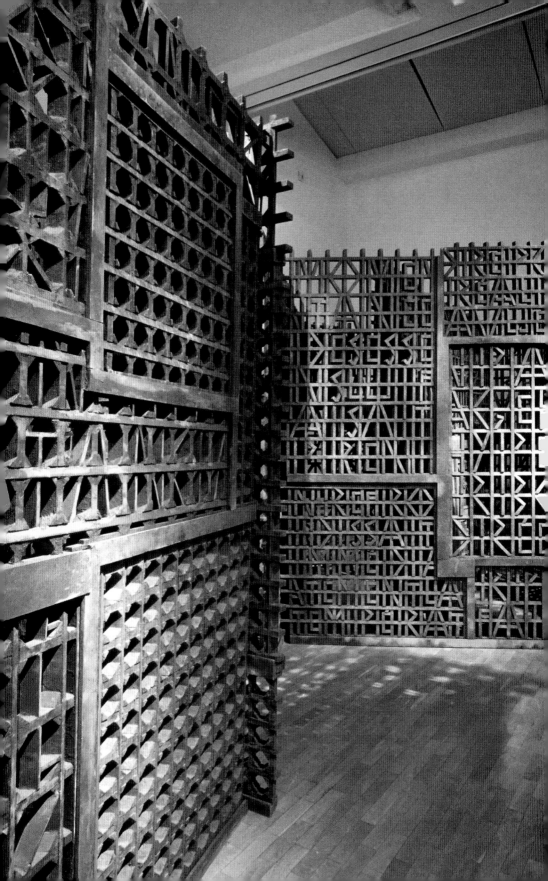

of screens forming a U-shaped enclosure. As she moves into it, her point of view changes; from this hidden position she is offered a secret view back through to the gallery and the works within it that she has just seen, which from behind the screen appear familiar, yet somehow different.

Iglesias has been described as 'relish[ing] the play of resistance and permeability in architectural surfaces', while her screens are understood to be 'architectural versions of the veil in clothing'.[78] The ornate screen, with its intricate architectural motifs, is a particular feature of Moorish art, setting up, as described in *Configuration 2: To and Fro*, a gendered dialectical space. A visual tension exists not just between the screen and the screened, but in the relations of looking, between those located behind the screen on the inside, enclosed and hidden, who *can* see out, and those situated on the outside, free and visible, but who *cannot* see in.

The disguising feature of the veil is reinscribed in the materials used to construct the screens. From a distance the *Celosia* appear to be made of metal, bronze perhaps. But up close the sculpture seems to be of varnished wood,[79] described by the artist as 'veiled in copper'.

Once intimate with the work it becomes apparent that the screens incorporate written passages. But without reading the accompanying notes, it is not possible to decipher what the texts say or to know that the words are taken from Raymond Roussel's *Impressions of Africa* (1910) and Joris-Karl Huysmans's *Against Nature* (1884), both of which describe imaginative space in great detail:

> *Darriand, calling for the public's attention with a few words, had just tilted the white wall backwards in order to show all the onlookers the interior of the overhanging ceiling, which was entirely covered with reddish plants, giving it the appearance of an upturned flower stalk.*[80]

> *Like those Japanese boxes that fit one inside the other, this room had been inserted into a larger one, which was the real dining-room planned by the architect.*[81]

The presence of words produces an experience that oscillates between looking and reading: between what can and what cannot be seen, between what can and what cannot be read. This hybrid form of viewing – spatial and textual – brings into play a relationship between the patterns of the structure and those of the words, indicating a divergence between 'what is being said and what is being seen'.[82] A labyrinth is constructed between the material spaces of the signifier and the virtual spaces of the signified, interweaving the illusions produced through phenomenological encounters across the alternating opacity and transparency of the two screened constructions, and the imagined spaces described in the words of two authors relocated by the artist.

Roussel developed a particular way of writing concerned with creating association, linking words that sounded like one another, and inventing structures where sequence was determined through chance rather than

narrative. Such a mode of operation structures the *Celosia* itself where: 'Even the use of prepositions, like *à* (to) take on an importance that is central to the chain of significations: the space that links one idea TO another.'[83] This 'to' or bridge of association is also the organizing principle that links the works in the exhibition to one another, as Iglesias describes: 'The pieces often follow from one another like lines from the same text. But this text is complex and is played out in different registers.'[84]

Returning
Guided Tour (1999–2002)

> *… from film and the way it uses montage and sequence to structure looking, to the experience of walking in a maze … I am interested in that serendipitous imposition that … conditions the urban landscape. To use it like a system of signs you can decipher like hieroglyphs.*[85]

> From the close-up to the glance, from the caress to the accidental brush, criticism can draw on spaces as they are remembered, dreamed and imagined, as well as observed.

She retreats from the *Celosia*, and turns towards an image of what seems to be the same screen but illuminated in a dark room behind her. *Guided Tour* (1999–2000) is a short film, a ten-minute loop that Iglesias produced in collaboration with documentary film-maker Caterina Borelli. The film moves between the cities of New York and Madrid – streets and corridors, formal gardens and glimpses of wild countryside; and through the work – mazes lined with vegetation, trellis-works embedded with text. Shot with a hand-held camera, just above the ground, architectural details and natural foliage rush past and into one another. The work frames the city and the city frames the work, both providing guides to one another.

The guided tour is usually a specifically choreographed sequence, which asks the visitor to pause at various points in order for specific details in the context to be pointed out – visual features of the urban fabric, sites of future interventions, important moments and stories in the making of a place. As the journey unfolds over time through space, an alternative narrative may evolve for the viewer, a passage between inner and outer, promoting the chains of thought psychoanalysis describes as free association, where external objects prompt internal reflections. In introducing the works and their settings, *Guided Tour* performs the mode of Iglesias's practice, taking this viewer *from* the work, shown as its content, and returning her *to* the work, displayed in the surrounding gallery.

Repeating

Untitled (Vegetation Room VIII) (2002) and *Untitled (Vegetation Room X)* (2002)

> *A vegetable bas-relief is an impenetrable screen. It generates an illusion of depth that adds a sense of intrigue: what lies behind it? ... The spaces of a labyrinth are created by walls. These interstitial spaces, these intervals, are significant places in my work. In many cases the sculptures are presented as artifice, as an illusionist façade.*[86]

> ... who knows what could lie in wait for you in such an enchanted place.

She exits the dark cinema and climbs the stairs; at the top she is immediately plunged into a narrow passageway,[87] surrounded on both sides by proliferating patterns of flora and fauna – lilies and octopi – reminding her of a tilted surface previously encountered. The claustrophobic atmosphere suggests the experience of a maze or labyrinthine structure. It is easy to imagine that the density of the organic matter continues deep into the room, conjuring up images of the fantastic worlds from which these creatures and foliage derive.

At first it appears that the screens are composed of an infinite range of fabulous matter, but a closer look reveals that the pattern of imprints is invented rather than found. The *bas relief* comprises panels, which themselves consist of repeated elements.[88] Iglesias describes the *Vegetation Rooms* as carrying 'the motif of an inverted nature'; the elements are 'pure fiction', she says, constructed by mixing motifs from nature in impossible combinations, or with 'elements and impressions alien to nature'.[89] In copying or reproducing nature, it has been argued that these works 'challenge not only our concept of "nature", but the "natural" itself'.[90]

That the patina is treated as if it were solid metal, when it is made of resin impregnated with bronze, copper or iron powder, highlights Iglesias's interest in the manipulation of appearance, 'the skin of things',[91] and her tendency to favour materials that are ephemeral and fictive.[92] The work frustrates the detailed gaze that would love to reveal secrets but only uncovers more of the surface. Yet it is through a close examination of this surface that one illusion – the difference in the repetition of the *bas relief* – that suggests a never-ending natural proliferation of the pattern, is broken and replaced by a more nightmarish one – the infinite extension of the artificial and unnatural space of repetition.

It is precisely at this point, where the work brings together the live and the dead, the animate and inanimate, that the uncanny is located – between, as has been noted, the cast and its anthropological connection with the death mask and the imprint as a proliferation that connects with the self-perpetuation of life.[93] Iglesias has suggested a different twist to the theme of repetition in her work, positing that these works are about the construction of echoes; the repetitions which here operate through

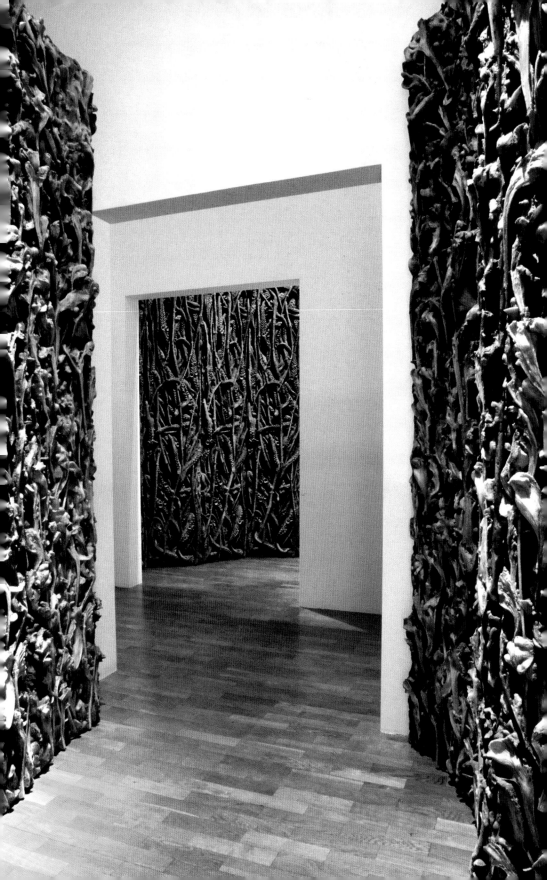

motifs – decorative and ornamental – can be found in other spaces, at other times, in other works.

Defamiliarizing
Untitled (Alabaster Corner III) (1993)

> *The detail of the veined surface of the alabaster, the time that passes looking at the light shining through it, the closeness to the corner, these are elements that the siting of the piece make possible.*[94]

> It is not a dull grey, like the light on a cloudy day when shadows cover up the sun, but bright and dazzling, a grey that hurts my eyes. I look up.

She emerges from the dense foliage of vegetation, to enter an almost empty room. In the corner is a shelter, a place inviting her to come underneath it. Its canopy is made of a geometrical steel grid, which holds pieces of white alabaster run through with grey veins. A material usually used for flooring, and thought of as opaque, its translucent qualities are revealed, as the light 'trespasses the stone'.

Yet this work is not only about the literal experience of illumination, with Iglesias; she knows she is entering not only a physical relationship with an architectural space, but also a conceptual and emotional one. The passage of light through alabaster refers to the space beyond the wall, but also makes strange the conventional use of this material as an impenetrable substance, suggesting as well that the corner may be a site of covering and caring. The perception of *Alabaster Corner* does not remain stable – from a distance it appears an insignificant object compared to the larger space of the gallery, but up close it is the architecture of the gallery that slips into the background.[95]

Reflecting
Untitled (1993–97)

> *You are not reflected in the mirror, the structure of the piece does not permit it. The reflection of the landscape and the pattern of the tapestry continue, constructing a larger field without it being possible to penetrate it.*[96]

> As I went towards the mantelpiece to take a look at myself in the mirror, I saw for the first time in the reflection, that the room was full of plants, so alive I could smell the moisture still on their leaves.

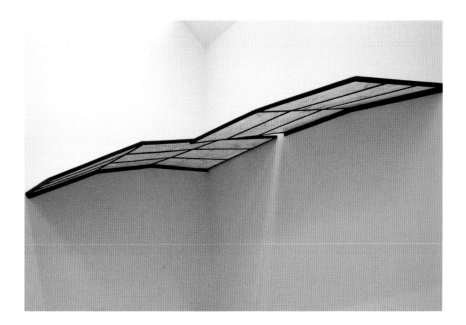

48 (page **171**)
Cristina Iglesias, *Untitled (Vegetation Room VIII)* (2002). Resin, marble powder, pigment.
Untitled (Vegetation Room X) (2002). Resin and bronze powder. Courtesy of the artist,
Donald Young Gallery and galeria elba benitez. Installation view at Whitechapel Art
Gallery (2003). Photograph: Ben Johnson. Reproduced with kind permission of the
Whitechapel Gallery Archives.
49
Cristina Iglesias, *Untitled (Alabaster Corner III)* (1993). Iron and alabaster. Variable
dimensions. Collection of the artist, Madrid. Courtesy of the artist, Donald Young
Gallery and galeria elba benitez. Photograph: Ben Johnson. Reproduced with kind
permission of the Whitechapel Gallery Archives.

From a distance the rectangular concrete slabs propped against the gallery wall appear to be one thing – dull, static and inanimate. They become quite another as she passes close by. From a particular angle, she is invited to enter a place where the surface has been peeled back to disclose a secret interior. At one end the concrete slab is close to the wall; at the other it is bent away, revealing its underside reflected in an aluminium panel on the wall.[97] In the distorted reflection she glimpses the gentle colours of a blurred arcadian scene. Yearning to see more, she leans into the gap created and discovers a pastoral hunting image represented in a faded eighteenth-century tapestry, but the exposed part cannot be seen directly; her body is blocked by the gallery wall, disallowing any further attempt to feast her eyes on the remainder of the image lying covered by the concrete.

Iglesias's secret 'pockets' appear at first generous, surprising her with their offer of an unexpected space to occupy. They reveal a sensual underside to concrete – intimate, colourful, delicate and textured – not quite what she imagined from such a brutally dull material. In the space, which promises to open further as she looks in closer, an alternative landscape appears, reminding her of one she has earlier encountered in the reflective copper plates. But her enjoyment of the illusion is momentary. Too soon she realizes this is but a reflection, and in trying to get in closer, to grasp the original, she is faced with her own disappointment. This interlocking gesture of enticement and prohibition draws on the tension engendered by utopia's imaginary status between the provocation of arcadia and, almost simultaneously, the thwarting of desire for its inhabitation.

Passing (through)
Untitled: Passage I (2002)

> *I am working on a piece in which a series of mats, hung from the ceiling, configure a passage. … A light illuminates the piece from above, throwing shadows of texts on the ground. The mats are superimposed to form a canopy beneath which we walk; at the same time the shadows of the texts fall at our feet; we are above and beneath the work at the same time.[98]*

> Through its fragile structure this house physically embraced my need for transience, and perhaps this is what made it feel like home to me.

Entering the final room of the exhibition, she walks beneath a mesh canopy suspended from the ceiling, made of a series of overlapping rectangular rush mats. They are constructed from esparto, a fibre native to southern Spain and northern Africa, used to make everyday objects, including the sunscreens found in street markets.[99] Like the screens she has previously hidden behind, these mats are embedded with words, whose shadows

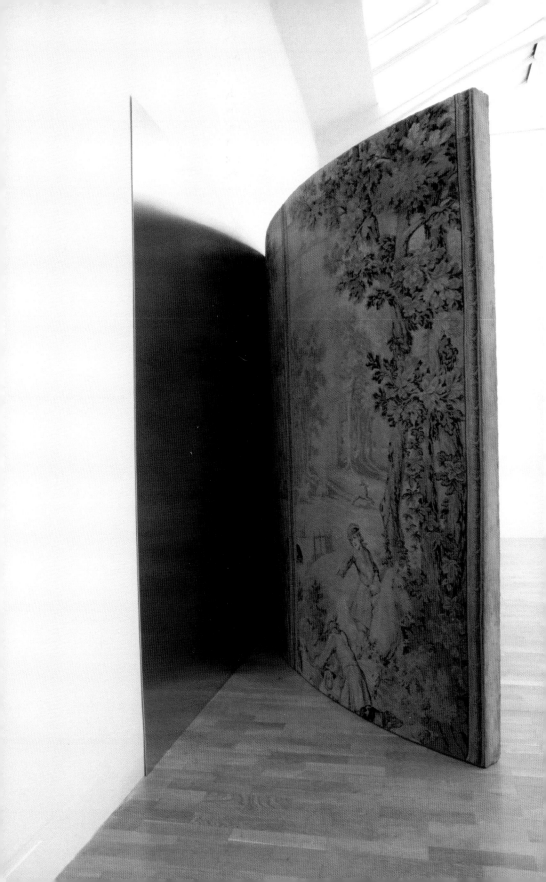

scatter letters onto her shoulders and down onto the floor below. As she bends her head back to look up and decipher the text, enigmatic signs fall across her face, and the rush of blood to her head makes her dizzy.

> *The palace named 'The delight of the Yetes', or 'The Support of Memory', was one entire enchantment, rarities, collected from every corner of the earth were there found in such profusion as to dazzle and confound, but for the order in which they were arranged, one gallery exhibited the pictures of the celebrated mani, and statues, that seemed to be alive.*[100]

Passage I positions the viewer in a place between two textual planes – one above and the other below – activated by light, shadow and movement. The architectural typology of the *passage*, or arcade in English, is a space both interior and exterior, an interpenetration of private and public. These narrow sky-lit corridors, which allow access into and through the interior of deep urban blocks, have provided not only a location for static consumption and display, but also a site of promenade and transition from one place to another.[101]

Walter Benjamin's major uncompleted work, the *Passagen-Werk*, or the *Arcades Project*, was a dialectical study of the arcades of Paris as places of collective dreaming.[102] According to Benjamin, as thesis the arcades 'flower' – they are palaces of commodity consumption and the wish-images of the dreaming collective of the early nineteenth century; as antithesis, in the early twentieth century, the arcades are in decline – they are ruins, 'are residues of a dream-world',[103] no longer desired by the consuming populace.[104] In the urban explorations of Benjamin's contemporaries, the surrealists Louis Aragon and André Breton, for example, the arcades were sites of the uncanny – the familiar made strange, providing opportunities for the urban wanderer to drift, excelling in what has been described as the 'art of losing one's way'.[105]

It has been argued that Iglesias's work is 'intricately connected with the notion of arcadia':[106]

> *Above all, arcadia is a place that is unnaturally protected, whether by the gods or by human engineering, an imaginatively constructed universe from which the 'outside' world has been banished. It is not merely one place. It is a mental space, intricately connected to the notion of the passage, of going from one place to another, of supposedly going to a 'better place' …*[107]

The idyllic landscape defined by arcadia and the dream space of the passage are linked through their position as places of transformation from one state to another.

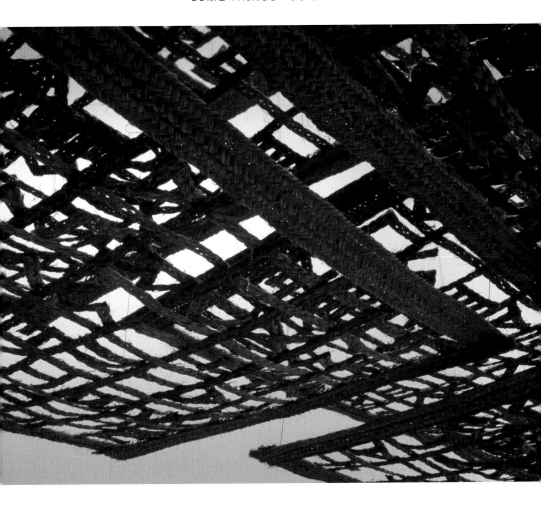

50 (page **175**)
Cristina Iglesias, *Untitled* (1993–1997). Fibrocement, iron, aluminium, tapestry 245 × 365 × 0.7 cm. Collection of the artist, Madrid. Courtesy of the artist, Donald Young Gallery and galeria elba benitez. Reproduced with kind permission of the Whitechapel Gallery Archives.

51
Cristina Iglesias, *Untitled (Passage I)* (2002). Raffia. Dimensions variable. Courtesy of the artist, Donald Young Gallery and galeria elba benitez. Installation view at Whitechapel Art Gallery (2003). Photograph: Ben Johnson. Reproduced with kind permission of the Whitechapel Gallery Archives.

La Passante

Sharon Kivland's *Le Bonheur des Femmes (The Scent of a Woman)* (2000)[108] consists of twenty-four photographs hung low on the gallery wall. Above them float the names of various famous perfumes: Allure, Fantasme, Knowing, Fragile, Dazzling and Sublime. The images all show women's feet and legs clad in black from the knees down. This is apparent. But another similarity is not. All the photographs were taken in the same kind of place – at the perfume counters of various shopping venues in Paris: *La Samaritaine, Galeries Lafayette, Au Printemps* and *Bazaar de L'Hotel de Ville.*

Kivland's images are caught up in a rhetoric of movement. At the moment these women are at rest, pausing; their feet are in touch with the ground, just. But it is inevitable that soon they will move on. This is not the first time moving women passing between one place and another have been present in Kivland's work. They are blurred, caught in motion in black and white in *Les Passages Couverts* (1998), and in colour in *Mes Péripatéticiennes* (1999), both series of photographs which capture women moving through the passages of Paris.

In Kivland's installation *La Valeur d'Échange*, two images face one another: one of the Paris Stock Market, the other of the *Passage des Variétés*.[109] Here the artists' door leads into the passage from the *Theatre of Variétés* where Emile Zola set Nana's 'triumph'.[110] Phrases from Zola's *Nana* (1880) describing her sensual form are written delicately across translucent pages, luscious like skin, interleaved with collaged paintings of nineteenth-century women, perhaps courtesans, in Kivland and Jeannie Lucas, *Parisiennes*.[111]

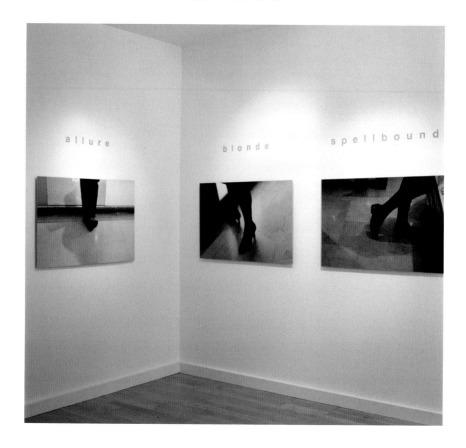

52
Sharon Kivland, *Le Bonheur des Femmes (The Scent of a Woman)* (2000), exhibited at
Portfolio, Edinburgh, 2000; also exhibited at VU, Quebec, Canada; La Centrale,
Montreal, 2001; and Le Triangle, Rennes, 2001. Twenty-four c-type photographs,
mounted on aluminium, each approx 100 × 75 cm, vinyl lettering. Photograph: Tim
Meara. Reproduced by kind permission of the artist.

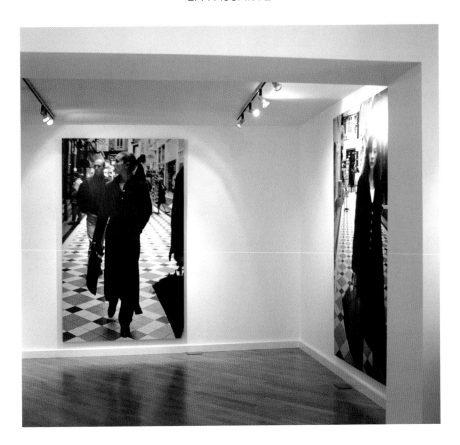

53
Sharon Kivland, *Mes Péripatéticiennes* (1999), Portfolio, Edinburgh, 2000; first exhibited
at The Economist Building, London, 1999. Four c-type colour photographs, mounted
on aluminium, each approx. 150 × 220 cm. Photograph: Tim Meara. Reproduced by
kind permission of the artist.

Moving urban women are also referred to in Kivland's *La Passante* (London, 1995), an artist's book that consists of proper nouns – London streets with women's names. The title of this work brings to mind Charles Baudelaire's sonnet 'A une passante' in *Fleurs du mal* (1857), referred to by Benjamin in his discussion of the poet's fascination with the urban crowd and with love 'at last sight'.[112] Like *Parisiennes*, Kivland's *La Passante* is dedicated to Jeanne Duval, Baudelaire's mistress. On the inner flap reads the following phrase:

> *Walter Benjamin notes of Baudelaire that the street is always his arena for amorous encounter, never the closed house, the 'maison de passe'. The streetwalker doesn't walk far, she inscribes her position on a short and wellworn route, easily recognised or remembered. The streets, one might say, are named for her…*

Kivland has been exploring the gendering of urban passage, particularly in Paris, in her work for a number of years. My own research into sites of consumption, display and exchange in early nineteenth-century London brought me into contact with similar spaces and figures: arcades and streets, ramblers and cyprians (the English equivalent of the French courtesan), with Benjamin, Freud, Luce Irigaray and Karl Marx, as well as with a complex set of thematics concerning the commercial activity of shopping, the conflation of the female shopper with the commodities she is purchasing, the exchange and use-value of femininity, and choreographies of looking and moving in public city spaces.[113]

Benjamin's *Passagen-Werk* is populated by a series of 'figures', both real-life and operational as dialectical images.[114] Haussmann, for example, builds the 'new phantasmagoria', Grandville represents it critically, Fourier's fantasies are 'wish-images, anticipations of the future expressed as dream symbols' and Baudelaire's images are 'ruins, failed material expressed as allegorical images'. Likewise, all the other more conceptual characters – the collector, ragpicker, detective, flâneur and gambler – are men, with a single exception, the female prostitute.[115] As seller and commodity in one, the prostitute occupies a pivotal position in Benjamin's thinking: she is an allegory of modernity – part of the 'oldest profession' and as new as a fleeting commodity.[116]

In Kivland's *La Passanta* (1996) five copper plates are engraved with the names of women written phonetically. The words ask to be spoken; they wish to be shaped by the mouth in order to be understood. Articulated verbally, they 'turn out to be street names in the former prostitution quarter of Rome'.[117] Kivland's artist's book, *La Forme-Valeur/The Value-Form*, constructs a two-way passage at the intersection of two tongues. One text can be read forward in French and the other backward in English. Both are written in search of 'a woman speaking' in Marx's *Capital*.[118]

In his materialist analysis of the commodity, Marx makes a distinction between exchange and use value. The use value of a commodity, he argues, is determined by physical properties, whereas when goods are produced for exchange in the market they are seen not only as articles of utility but as

inherently valuable objects with special mystical properties.[119] In making a distinction between the natural and exchangeable values of commodities, Marx uses the body of a woman as an exemplar of exchange.[120] Quoting from a satirical poem, 'Dit du Lendit', by the medieval French poet Guillot de Paris, Marx describes 'femmes folles de leur corps', or wanton women, as one of the commodities to be found at a fair.[121]

Irigaray's 'Women on the Market' reworks the Marxist analysis of commodities as the elementary form of capitalist wealth to show the ways in which women are the commodities of patriarchal exchange – the objects of physical and metaphorical exchange among men.[122] Like the commodity in Marxist analysis, the female body as a commodity is divided into two irreconcilable categories – women are utilitarian objects and bearers of value; they have use and exchange value, natural and social value. Irigaray outlines women's three positions in the patriarchal symbolic order as the mother who represents pure use value, the virgin who represents pure exchange value, and the prostitute who represents 'usage that is exchanged'.[123]

As well as providing a feminist critique of women's existing position in patriarchy, Irigaray's writing suggests an alternative and celebratory way of viewing female movement, from a position of feminine subjectivity, considered in terms of the 'angel'. For Irigaray, it is in order to deny the angel, or women's nomadic status, that men have confined women as and in the symbolic spaces of patriarchal law and language. Irigaray's angel cannot be represented within these structures since she rethinks their very spatial and temporal mode of organization. Like the passage, which combines real space and dream, and facilitates movement from one place to another, the angel is both transformational and transitional. She circulates as a mediator, an alternative to the phallus, who rather than cutting through, goes between and bridges.[124]

To be 'at' the perfume counter is to anticipate the application of a certain scent. This is a magical space, a place of enchantment where the air is dense with possibilities, played out again and again at the very point at which the scents are allowed to breath, to escape into the air. The placing of the names of perfumes – all words which suggest desire, intoxication and altered states – hovering just above the images of the grounded feet points 'to' the gap between who we are and who we might become.

'She is walking about in a town which she does not know'

The title of this piece of writing references an artwork by Kivland and an essay by cultural geographer Steve Pile. Kivland's *She is walking about in a town which she does not know* (1997) consists of two c-type photographs, from archive images of Anna Freud and Marie Bonaparte, and a glass panel engraved and silver-mirrored with a street map of the spa town Marienbad.[127] In her book *Hysteria*, which weaves together Dora's story and her own, Kivland explores Freud's discussion of his analysand's second dream.[128] Dora begins her own description by stating, 'I was walking about in a town which I did not know. I saw streets and squares which were strange to me.'[129] The interpretation drawn out by Freud was that the town in Dora's dream was most probably a German spa town whose photographs she had seen in an album sent by a potential suitor.[130]

The conflation of motion, vision and knowledge – the assumption that by travelling to and through a city one is able to see and therefore know it, as well as come to a better and deeper understanding of oneself – has been critiqued in contemporary discourse around the city.[131] Drawing on psychoanalysis, Pile's essay calls into question certain epistemological assumptions concerning urban space, turning to Freud's experience of the uncanny, prompted by his sight of prostitutes in a town he did not know, to explore how repressed elements of the city try to make themselves known.[132]

As I was walking, one hot summer afternoon, through the deserted streets of a provincial town in Italy which was unknown to me, I found myself in a quarter

*of whose character **I** could not long remain in doubt. Nothing but painted women were to be seen at the windows of the small houses, and **I** hastened to leave the narrow street at the next turning. But after having wandered about for a time without enquiring my way, **I** suddenly found myself back in the same street, where my presence was now beginning to excite attention. **I** hurried away once more, only to arrive by another* détour *at the same place yet a third time. Now, however, a feeling overcame me which **I** can only describe as uncanny, and **I** was glad enough to find myself back at the piazza **I** had left a short while before, without any further voyages of discovery.*[133]

The English word 'uncanny' is a translation of Freud's term *unheimlich*, which, as I have outlined earlier, he sets in opposition to the *heimlich* or familiar setting of home. For Freud, the uncanny is not a precise concept, but rather encompasses a wide range of feelings from slight uneasiness through to dread and outright fear. Not necessarily a property contained within an object or place, the uncanny is rather an aesthetic condition produced at the threshold of interchange between a subject and that object or place. Experienced as a palpable presence of the strange within the familiar, the uncanny can be understood in psychoanalytic terms as the return of the repressed, as the surfacing of buried childhood memories, including the unexpected recall of the mother's body, also described by Freud as *déjà vu*, and by Bollas as aesthetic in reviving the earlier transformations engendered by the mother.

When I was asked to write this essay for *Elles sont passées par ici*, a curated exhibition of seven artists due to take place in Loguivy de la Mer, Brittany, France, the artworks were not yet in existence. In their place I was sent a map and photographs of the small fishing village in which the artworks were to be installed as well as the artists' written statements and visual proposals. I used my encounter with these representations to create a fiction, structured as a walk through the sites in which the artists intended to locate their projects. In combining words from the artists (in italics), the map and photographs of the site (in bold) with those of my own, I invented a subject, a mermaid maybe, half-woman–half-fish, who arrives in a town which she does not know and in passing through finds that it feels familiar yet at the same time strange – uncanny perhaps. The coastal location provided an opportunity to reverse the gender and position of the siren – this mermaid remembers hearing a male voice calling to her from the land – it is his voice that draws her to this place.

The site-writing is located on the threshold which links and separates land and sea, as well as exterior and interior spaces. It draws upon the imagination to anticipate the artworks while at the same time writing a narrative that presents the site as a remembered place. The essay takes the reader on a journey through the works as a set of unexpected discoveries, suggesting that this is not the first visit to the town. Since the images and texts describing the preparatory work and the initial site visit recorded in photographs are not quite repeated, do not quite return, in the final

exhibition imagined in situ the site-writing conjures up a *déja vu* experience with uncanny undertones.

In writing the essay, I asked myself:

What does it mean to write a site that one has not visited, that can only be imagined, to know a place not with your feet, but with your eyes tracing lines on a map, words in a sentence, dots on a screen?

What does it mean to write of art that is not yet in existence, that at the time of writing is only envisaged, and to know of its possibilities through the words of seven artists, eight women, maybe nine?

What does it mean to meet them in a place that they once passed through?

•

54 (overleaf)
Map of Loquivy de la Mer, Brittany, France. Credit: Artevisa.

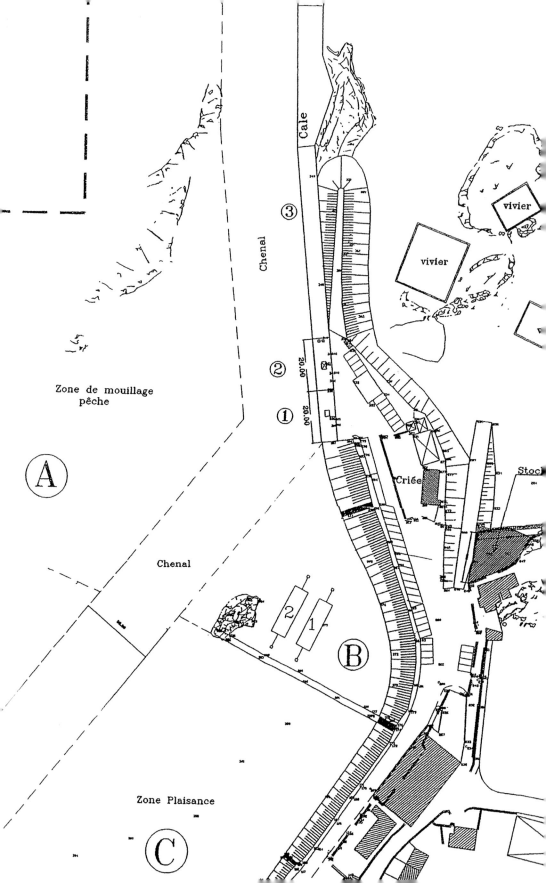

Zone de mouillage
pêche

Chenal

Cale

Chenal

③

②

①

vivier

vivier

Criée

Stoc

A

B

2 1

Zone Plaisance

C

She moves light through the white, skimming across a circumference visible just beneath the surface. This must be the circle of A, where she has been told that things begin to change, as they always do when water meets land. Life remains moist, but those who swim here do so in fear of the net.

She knows she is close now.

Zone de mouillage pêche

'Handscapes'

… an associative process, complex and intertwined, where I allowed my mind to flow from one thought to another. One could describe it as a labyrinth of interconnected thought, where one idea produced the next.

Close enough to touch the dashed line of the frontier that marks this outer side of the channel.

Chenal

Here is a treacherous crossing – not wide – but a channel deep and fast enough to have separated her twin sister A from her younger sister B and older sister C. The remaining sisters spin their gaze in circles slowly round the pleasure zone ensuring safe passage across the bay. Between the two of them lies the jetty, with the scribbled rock at its tip, jutting out towards the channel where from time to time sharp ledges emerge slyly from the waves.

… hyper-associative and imaginative thought in contemporary art practice and online virtual environments in comparison to experiences in dreaming …

Quick as a fish across the depths of the channel, towards the delights of immersion, she darts. The sisters signal and offer her welcome to warmer waters. Grey figures fleck the distance between them, indicating to strangers the distance from the tips of the waves to the heady depths of the marine floor.

55
Barbara Rauch,
Collaged Hands (2004).

Zone Plaisance

56
Loquivy de la Mer,
Brittany, France.

The ocean lies behind her now and beyond, the English shore. But here it starts to shallow; in front she can see the edge, a striated boundary, composed of widely spaced lines pointing towards her, and further away dark spikes, more narrowly spaced, which make it hard for her to squeeze between them as she exits the water. Up onto the beach she wades, and through the low tide finds her feet. She stands up straight for the first time in a long time, and sees this town, a place she has only seen from the sea, from a different perspective.

The wall to the beach is built of rock; in front boats perch on their keels in the wet sand. Gridded structures line the shore: tall boxes of grey iron, squat baskets sewn around with rope, low cages dangling with plastic bottles. To her left sit the four of them, each one square.

Viviers

Four-square they gather together and enclose space, cornering out the world. She must keep silent now. But they seem oblivious to her movements, their interest focused on the ponds where the fish they have trapped swim.

'Permutations'

57
Jenny Dunseath,
Gypsy (2005).

Directly in front of her, between the boats, blocking her route to the town, she spies an encampment seemingly abandoned on the mud. It is a tipsy wooden structure, with a ladder leading up to a platform, where a boat lies beached. Recognizable from its silhouette, the curved hull has slipped onto its side and rocks to and fro, threatening at any moment to topple off and flatten her.

... like the work of an engineer who has lost the master plan and is hoping to be guided by memoire involuntaire ...

She wriggles quickly underneath the unstable construction. On the other side two elegant lines of rock curve towards one another, edging the sand and turning seafarers inland. She follows the gap between them, up and over the bridge, into a stone-built gulley with glass holes for eyes.

An aromatic memory tempts her here, musky yet sweet; after years of fish, shells and salt, it takes a while for her to recall the scent exactly. When she does, the smell brings a longing for warmth and comfort.

Tabac
Stella Artois
Café de Port

Between two eyes is a closed door. If it were open a fraction, she could peer in and admire the interior lined with views of the sea: oil blue waves drench hunks of rock, sails of red and yellow blow in a water-coloured breeze. But the crowd would frighten her. And she might remind them. She would do better to move on. Before she is seen.

> *… what happens to our understanding and perception when an idea is transferred from one medium to another and when a particular sense or dimension is shifted by altering its original context.*

58
Loquivy de la Mer,
Brittany, France.

A light ripples from the inside. An image of water, reflected in a mirror? If she were to move in closer, would she be able to see her face in the glass and know a little more of the woman she has become?

A green cross sways over the street and beckons her on. Below its glowing sign she is offered a framed picture. Bottles and packets line the shelves, and perched at irregular intervals between them are intricate heads folded in paper. These seem somehow as familiar as the flickering glow lapping her feet. Fish stream through light, dance in water, glint silver in her direction. She can just see a tender-skinned swimmer among the shadows of their scales. Is that her? Or her twin sister? Who has she become, since she last passed this way?

59
Debbie Akam, *Immersed,*
There and Back (2002).

> *… a temporary immersion in a place implies that one will leave it …*

Remember, remember she is walking, walking about in a town which she does not know.

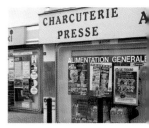

> *'Immersed' uses the motif of a journey to suggest the kind of temporary immersion experienced by tourists or visitors, as opposed to people who have a connection to a place …*

Total Gaz
Proxi
Ouest France
Charcuterie
Presse

60
Loquivy de la Mer,
Brittany, France.

By folding the paper, the arbitrary ink blot displays its symmetrical double and with it miraculously transforms into a shape to which we immediately respond (a butterfly, a floral motif … or a pornographic drawing by Cornelia Parker …)

More faces she half-recognizes. A wide pair of eyes stares out at her through the glass; unblinking, they gleam like moons in deep pockets of folded moist leather, a skin that offers an ambiguous surface, amphibian like her own.

Disconcerted, she steps backwards and trips. A yellow line helps provide orientation. She follows it past three pillars, waist high, reading glossy words positioned there at her cheek between faces cold as masks:

61
Karine Pradier,
Self-P n. 1 (2005).

Face-à-Face
Nouveau
Ici Paris

She is confused now, in this town, which she does not know. Has she been here before? Should she turn back before it is too late? Across the quiet, she takes a turn to the right, down past the silence, back towards the sea, over a wall, through a garden of sea cabbages. She must keep moving, but pass unseen. Over another wall, more slowly now for her feet are hurting, hugging close to the long side of a shadow.

> *'Around me'*
> *'Above me'*

A dark line falls across her shoulders. In the time she has been walking the night has turned white. A new dawn casts the steeple over her head. From the waist down, she starts to shimmer.

> *We have done this by casting and relocating shadows in plaster, by merging sound wave images with new audio tracks and projecting film into newly constructed sculptural sites.*

62
brook & black, *Here nor There* (2005).

Past the bulk of the church comes the sun-bright day. She looks to her right, as the east seeps a line of gold along the edge of the sand.

Criée

The line marks a sound she remembers.

Criée

Echoes of the crying one.

Criée

Across the years, over the waves, she heard those cries and came.

> *Trapped between two worlds, between a mass of falling vines and the bare space beneath, a lone, anonymous figure is recorded for a seemingly brief time in a perpetually unchanging situation.*

How long has she been here, with the cries echoing, the steeple falling, the line seeping gold across the bay?

Has she ever been away?

63
Johanna Love, *Catch Me as I Fall* (2004).

> *The drawing 'Sea' emerged from the disorientation associated with change. Marking paper with dots is a most simple intervention. This economy of means meant risking failure, yet it also provided stability and continuity. Observing lines and pattern appear was a cathartic process.*

Listen now, to the lines of the waves.
Look now, at the dots in the lines.
In the glittering spray, would you recognize me?

64
Aude Hérail Jäger, *Sea Drawing* (2004–06).

Configuration 5

Decentring/Recentring

The Copernican Revolution

We have reached the point that I consider is the essence of the Copernican revolution begun by Freud; the decentering, in reality, is double: the other thing (das Andere) *that is the unconscious is only maintained in its radical alterity by the other person* (der Andere): *in brief, by seduction.*[1]

The question asked at the end of *Configuration 4: Déjà Vu* of how it is possible to recognize another has been taken up as a pressing enquiry in feminist philosophy. Through discussions of both G.W.F. Hegel's account of the master–slave dialectic and Emmanuel Levinas's exploration of the face of the other, feminist theorist Judith Butler, for example, has drawn attention to the ethical aspects of the relation with the other. She suggests that certain accounts of Hegel argue that the subject 'assimilates' the other and explores instead, following Levinas and Hannah Arendt, the possibilities of a subjectivity created by exposure and vulnerability to the other.[2] Butler points to the work of Italian feminist philosopher Adriana Cavarero, who proposes that we are exposed to the other from the start, and it is this exposure which is the condition for political and social life. Cavarero states:

Autobiography does not properly respond to the question 'who am I?' Rather, it is the biographical tale of my story, told by another, which responds to this question.[3]

For Cavarero our desire to have our life story narrated by another demonstrates the role of a pre-existing other as foundational to the formation of the subject. Butler suggests that Cavarero turns around the usual progression from the early dyad to social relations, and instead 'ground[s] the social in the dyadic encounter'.[4] While Cavarero gives a philosophical account of how the external other situates us, Butler looks to the work of Jean Laplanche for a psychoanalytic perspective.[5]

For Laplanche, as I have already outlined in the Prologue, the elements inscribed in the first encounter between self and other are 'enigmatic messages', whose signifieds are unknown not only to their receiver but also to their sender. This first inscription, according to Laplanche, does not require a translation: 'it is a pure and simple implantation'.[6] These enigmatic messages are elements of perception; they do 'make a sign', but a sign whose signifier does not need to be transcribed, since it is already a 'signifier to', in other words this is a signifier *to someone* rather than a signifier *of something*.[7] Laplanche explains that he uses the term 'message' since it indicates the non-verbal as well as the verbal, and also because, unlike language, it does not 'efface the alterity of the other in favour of trans-individual structures'.[8]

In Laplanche's view, some aspects of the adult's enigmatic message are translated, while others are excluded and repressed, becoming unconscious.[9] In his account, repression – the negative side of the translation of the enigmatic message – produces dislocation:[10]

> *For in between the primary intervention of the other and the creation of the other thing in me, there occurs a process called repression – an extremely complex process comprising at least two stages in mutual interaction, and leading to a veritable dislocation/reconfiguration of (explicit and implicit-enigmatic) experiential elements.*[11]

For Laplanche, the result of this process of translation is that the ego and id are separated; the ego integrates that which can be translated, and that which cannot constitutes the id. During the process of repression, the initial Copernican relationship, where the centre of gravity is located in the other, radically alters to become a Ptolemaic one, centred on the self. According to Laplanche, once the ego is constituted as an agency, the psychic system shuts in on itself, and the external otherness of *der Andere* (the other person) undergoes primary repression to become the internal otherness of *das Andere* (the other thing).[12] In part resulting from the importance he assigns to the 'priority of the other in the construction of the sexual subject',[13] Laplanche's model has strong spatial characteristics, particularly in terms of the assymetrical situation he describes between adult and child,[14] and the dissymmetrical one that he argues exists between analyst and analysand.[15]

Laplanche argues that analysis is a return to the originary situation, which finds its 'immediate centre of gravity in the other' and aims

to 'make visible the gravitational pull exerted by the sun and stars of the unconscious'.[16] Since, for Laplanche, it is 'marked by the origin', psychoanalysis is sometimes able to maintain an 'opening-up', which can be 'transferred into other fields of otherness'. Laplanche calls this 'the transference of the transference … the transference of the relation to the enigma as such'.[17] For him, Ptolemaic transference is characterized as 'filled-out transference' – *en plein* – where the analysand's positive reproductions of childhood fill the hollowed-out space presented by the analyst, but where the analysand remains closed in on him/herself. However, when transference operates in its Copernican dimension, the gravitational pull changes, and the analysand reproduces the original relation to the enigma of the adult other:[18]

> *In the 'hollowed-out transference', the original dimension of the relation to the 'alien' resurfaces, a relation which is necessarily asymmetrical, non-complementary, and which tends to be masked by notions which are too adaptational, such as those of object-relation, reciprocity or interaction.*[19]

Laplanche understands transference – 'our interpellation by the enigma' – to exist before and outside analysis. Any outcome to analysis or to this re-opening to the other, 'cannot', he states, 'entail an end to that opening'.[20] To explain the 'cyclical character of the dynamics of transference', Laplanche uses a spiral, more precisely a helix, to represent the process of analysis. He distinguishes between a movement around the centre of a circle, which passes repeatedly through the same points on the circumference, and a journey which, by moving forward along the axis of a helix, passes through the same points but in different elaborations.[21] Laplanche compares the choosing of the moment for the end of analysis to the astronaut's option of possible 'windows' for take-off, where to miss a window is to be pulled back into the earth's gravity for one more turn.[22] The parameters at stake in analysis, he says, are no less complex, indeed even more conjectural and aleatory than interstellar navigation. The end of analysis involves not only internal dynamics (turns and windows) but also the external situation, which includes the provocation of the other.[23] Laplanche's 'conclusion' concerning 'the decentring revolution' is as follows:

> *Internal alien-ness maintained, held in place by external alien-ness; external alien-ness, in turn, held in place by the enigmatic relation of the other to his own internal alien …*[24]

In order to explore how Laplanche's understanding of Copernican and Ptolemaic movement informs art and culture, this final configuration is patterned by a series of decentrings and recentrings. In the first part, 'Somewhere Else She is Told', postcolonial accounts of the dislocatedness of cross-cultural encounters informed by the work of critics such as Homi

Bhabha and Susan Stanford Friedman set the frame for a discussion of three meetings that took place on a journey from Austin, Texas, to Santiago Atitlán, Guatemala, and back again, where experiences of foreign-ness or alien-ness produced aleatory trajectories.

In the second and third parts of this configuration, I examine how the critic can operate to both decentre and recentre his/her self in relation to an artwork. This is particularly pertinent when considered in connection to artworks, such as those of Do-Ho Suh, which are explicitly motivated by a desire to examine issues around home and displacement, and in galleries, such as domoBaal contemporary art, London, located in private homes, where it is possible to negotiate the 'position' of art at the boundary between domestic and gallery space. In the site-writing 'Everywhere Else' that I wrote for the group show *Ausland*, held at the gallery in 2002, comprising work by Martina Schmid, Silke Schatz and Jan Peters, I focus attention on the details of the curator's home, and the countries the artists have come from and those their artworks refer to, in order to dislocate the viewer's/reader's attention away from a discussion of the site of display in the gallery towards what could be described as 'everywhere else'.

The last part of this final configuration explores site-writing's key structuring mechanism – the tension between the critic's objective, as Ptolemaic subject, to position the work according to his/her own agenda, situating it around the centre s/he occupies, and the potential Copernican revolution provoked by a work and its setting, which sends the critic off on new trajectories. Through a series of *détournements*, the sculptures at the heart of London's Trafalgar Square, including Mark Quinn's *Alison Lapper* (2005), are decentred, relocating the critical gaze first to the 'other' within – the repressed acts of resistance which have taken place in this public place; then to the 'other' without – the sites of battle in colonial India to which a number of the sculptures refer; and finally to aspects of contemporary oil wars which are persistently being overlooked (the other without's other within) – sites of destruction in Iraq.

Somewhere Else She is Told

For the rest of her life, Isabelle would remain severely dependent on narcotics and on alcohol; in North Africa, she would function for days without sustenance, as long as she had enough kif and arak to stun herself with. Every last borrowed franc was spent on these habits, for she had the makings of a hardened addict – the loss of all will power, of all sense of reality and self-respect.[25]

In 1989, on the way from Austin, Texas, to Santiago Atitlan, Guatemala, I met a Chicano artist, who gave me a book, *The Passionate Nomad*. The book was the diary of Isabelle Eberhardt, a young woman from an affluent French family who spent the later part of her short life disguised as an Arab man, wandering the deserts of northern Africa. She died aged twenty-eight, on 21 October 1904, in a flash flood at Ain-Sefra. Her diary is one of my favourite books. I too have had addictive relationships.[26]

In her book *Mappings*, Susan Stanford Friedman summarizes the modes in which postcolonial theory discusses cross-cultural encounter. She outlines a number of tendencies: the use of stories of intercultural contact that focus on movement; the syncretist blending and clashing of difference; mimetic forms of cultural borrowing, assimilation, appropriation and parody; and bonds of connection and disconnection as well as reciprocal agencies in subject-to-subject encounters.[27] While listening to papers at 'Transcultural Architecture in Latin America',[28] stories came back to me concerning encounters that had taken place while I was travelling through Guatemala in 1989. The stories associated with this journey that I am now going to tell are not told in order to illustrate a previously held theoretical

position. It is rather the reverse. Having first sketched out my memories of each meeting, I then discovered resonances with the tendencies observed by Friedman:

> *These patterns of interaction ... arise out of a dialectical or dialogic oscillation between sameness and difference in the ethnographic encounter. Travel – a form of movement through space – brings about an engagement with the other or others in a liminal space materially, psychologically or culturally in between.*[29]

Encounter in a Church

I spend several hours in the church in the Guatemalan village of Chichicastenango, fascinated by how the colonized Mayans have appropriated the iconology of the Catholic church enforced upon them through subtle but repetitive day-to-day rituals. An elderly lady approaches me and engages me in conversation by pointing at a wooden image of a saint surrounded by fruit, flowers, incense and candles. I have previously been told that the Maya believe that sickness can be transferred from people to other animals, such as dogs, via eggs. A number of eggs are being 'blessed' this way in the church. I gesture towards this.

My new companion responds by taking me outside the church and then some way outside the village, to a hill-top grove, where she shows me a site of special stones marked with honey, flowers and candles. On the way we talk about Mayan religious rituals in broken Spanish. Following her instructions, keen to learn more, I set off to find some friends of hers in an isolated town. I catch a series of buses, but end up at the wrong end of a dead-end street in a town whose name I can no longer remember.

In 'Speaking in Tongues', literary critic Christopher Johnson discusses language and difference with reference to three scenes.[30] The first is of Pentecost, when those present are able to speak new languages and still understand one another; this Johnson calls 'the gift of foreign languages'. The second is taken from *Salammbô*, a historical novel by French writer Gustave Flaubert, published in 1862 but set after the first Punic War (264 to 241 BC).[31] Here the storyline is concerned with the 'unifying effect of the gift of tongues', but Johnson's interest is in the technical problems of translation. How can Flaubert speak like a third-century Carthaginian? Using indirect speech, Flaubert acts like a translator, assimilating the distance or difference of the other culture, an act that Johnson compares to the contemporary dubbing of foreign-language films.

The third scene is taken from a chapter in French anthropologist Claude Lévi-Strauss's autobiographical book *Triste Tropiques* (1955).[32] At one point Strauss recounts a scene from fieldwork conducted in Brazil with the Nimbikwara tribe, who do not write, but to whom he has given, as an experiment, pencils and paper. When they go on a visit to a neighbouring

village inhabited by a different tribe, the Nimbikwara chief manages the initial encounter by reading out a text that he has 'written' using the tools given to him by Strauss. In Johnson's view, the chief is performing an act of writing, indicating that he has understood the function of written language – 'to control and to manipulate'.[33] But here Johnson bemoans the lack of translation, which would at least have given us a glimpse into the mind of the chief, and an understanding of the role of writing from his perspective.

So first Johnson stresses the importance of speaking foreign languages in allowing us to communicate. Next he demonstrates the dangers of assimilation and appropriation if the act of translation replaces the original tongue. Finally he emphasizes the need for translation, not as a replacement, but as an addition. Instead of using translation to replace the original, by making a plea for subtitles rather than dubbing, like Walter Benjamin's 'The Task of the Translator', which considers the act of translation to be the creation of something new, rather than the production of a copy, Johnson argues for a situation where two languages can exist side by side.[34]

How do we understand my encounter in the light of these comments? In believing my companion was speaking Spanish I was performing an act of translation, which dubbed the original, replacing her indigenous language with my own imaginings of her voice in the language of her colonizer. If we follow Johnson's suggestion that we need translations in the form of subtitles to accompany the original, then to travel in the highlands of Guatemala I should perhaps have learnt the language of the Maya. But if we take a definition of translation from psychoanalyst Laplanche as 'the passage from a message to its understanding', an act that is not necessarily only interlingual, operating between languages, but intersemiotic, working between sign systems,[35] then it is possible to consider my linguistic (mis) understanding in another way – in relation to textual, material and spatial interactions. Had we been able to communicate in speech, then perhaps our encounter would have ended in the church and my companion would not have needed to show me the site of the ritual on the hill. In 'following' the itinerary she imparted to me, I ended up at the wrong end of a dead-end street. But in so doing I came to realize that, as a listener, I had performed an act of appropriative translation, shaped perhaps by my internalization of colonization. In focusing on the reappearance of indigenous rituals in conventional Catholic church iconography, I had failed to notice that her voice had also resisted eradication and remained resilient to the speech of her colonizer.

Encounter at the Market

Tired of the tourist trail, I hide on board a tiny ferry crossing Lake Panajachel to find a secluded place to stay. I choose a small wooden shed housing a concrete sleeping platform

with a stand-pipe and stone basin for washing. There is little to do in Santiago Atitlán except sit in the garden and write. Sometimes I go to the market and buy supplies – two tortilla instead of twenty. I get giggled at. I have sent most of my clothes back home by sea and prefer to wear a piece of Guatemalan cloth, wrapped around me like a skirt, in the way my Spanish language teacher, Rosa, has shown me. All the women here wear traditional costume, the weave of the fabric, the colours, and, in particular, the specific motifs in the embroidered patterns, indicate the village they come from. But the boys are more hybrid, they wear Pepsi cola t-shirts and Nike trainers with skirts woven out of village fabric. With my T-shirt and trainers my clothing makes me more boy than girl.

In the market I meet a man from California who has settled here, having married a woman from the village. I learn that this place is not as sleepy as it appears. Santiago Atitlán has seen a lot of trouble, past and present. There have been a number of disappearances and executions. Father Stanley Rother, a Catholic priest who served in the parish, sympathized with the Indians and made his views against the redistribution of land well-known: Rother was assassinated by a parliamentary death squad. His heart was removed and buried in the church. No one wants to talk about it. Santiago Atitlán was the first village in Guatemala to expel the armed forces. Extensive guerrilla activity to the north of the village gave the government a reason to establish a military base and raise accusations concerning the villagers' allegiances with the rebels. Throughout the 1980s hundreds of villagers were killed. No one wants to talk about this either. Instead the American guy wants to sell me his wife's clothes. He can make a lot of money that way. And I'll look more like a woman.

As noted in the *Prologue: Pre-Positions,* Kaja Silverman has talked about two modes of identification: 'heteropathic' identification, where the subject aims to go outside the self, to identify with something different, and 'cannibalistic' identification, where the subject brings something other into the self to make it the same.[36] This two-way street of identification – with its centripetal and centrifugal forces – suggests a 'rhetoric' of travel styled through the metaphor of eating. When we travel, are we aiming for difference, to transform ourselves by becoming other, or for more of the same, to remain intact by incorporating external things and places?

The cannibal metaphor was a key concept in the Brazilian *Antropofagia* Movement founded by Oswaldo de Andrade in the 1920s.[37] Here the cannibal is the colonized subject, the one who is able to appropriate and transform the colonizer by eating part of him or her. In this context, the potential offered by the cannibal is to be celebrated. 'Eating to make the same' can assimilate difference by making the other like the self, but it can also be emancipatory – an act of positive transformation – eating to make different. It is not then that a particular kind of act holds within it the seeds of oppression or the promise of liberation, but rather that the potential of an act can only be realized according to the distribution of power possible in a particular location at a specific moment of encounter.

In *The Location of Culture,* postcolonial theorist Homi Bhabha draws out an important distinction between cultural diversity and cultural difference.

In his opinion, cultural diversity is the 'recognition of pre-given cultural contents and customs', connected to liberal notions of multiculturalism, whereas the concept of cultural difference is more radical and allows new positions to arise. Bhabha notes how 'the problem of cultural interaction emerges only at the significatory boundaries of cultures, where meanings and values are (mis)read or signs are misappropriated'.[38] He suggests that 'the emergent sign of cultural difference' is 'produced in the ambivalent movement between the pedagogical and performative address'.[39]

The boy from Guatemala performs brands; the girl from England performs indigenous culture. He and I perform each other. But not quite; by retaining aspects of our own cultures, our performances are hybrid. And as Bhabha notes, hybridity may be both routine and transgressive,[40] but its possibilities depend on history and place.

For anthropologist Michael Taussig, the mimetic faculty is based on imitative play or the representational performance of the other.[41] When I wear a piece of fabric wrapped around me like a skirt, is it because I want to perform as a Guatemalan woman? If I choose to wear my skirt with a T-shirt and trainers is it because I wish to imitate a Guatemalan man, or rather to create a distance between myself and the Guatemalan woman, whose cloth I have bought? Is this mimicry, then, rather than mimesis, a self-knowing copy that desires to differ from the original? In wearing my Guatemalan fabric not quite like a skirt, am I performing myself as not quite like a woman and/or not quite like a Guatemalan?

Postcolonial critic Gayatri Spivak has argued that the 'subaltern cannot speak'; that there can be no representation of subaltern consciousness since each act of representation is always accompanied by an appropriation. For her, alienation is the price of representation.[42] As Nikos Papastergiadis has pointed out, Spivak advises against the well-meaning gesture of solidarity, the impossibly benign identification with the subaltern. For her, subalternity is not a condition to be desired. In Papastergiadis's view, Spivak 'warns against the presumption that subaltern experiences are texts that are available for translation' and instead focuses attention on what the 'work *cannot* say'.[43]

Encounter on a Bridge

On the last day of my journey, heading back through Mexico towards Texas, I am in the border town of Nuevo Laredo. As well as my rucksack, I am carrying a string bag clinking with bottles of Tequila. A clean-shaven middle-aged Latino approaches me and asks if he can help by carrying my bag. It is easier to say yes than no. We head through town towards the border control point on the bridge. On the way we make conversation – my journey home to England, his kids in Nuevo Laredo on the Mexican side, his brother, a hairdresser, in Laredo on the United States side. He is keen to introduce me to his brother, very keen.

At the checkpoint, I show my visa and passport. No problem. The border police nod towards my companion. They ask him some questions. He explains he is with me. No problem. Then he says something else, again in Spanish, but this time very fast, so fast I cannot follow. I keep quiet. I am keen to keep moving. They let us through. I expect now to be invited to visit the brother at the hairdressing salon. But I am mistaken. Once over the bridge, my companion is gone. I never meet up with his brother the hairdresser. Nor I suspect does he.

The German sociologist Georg Simmel writes of bridges as the height of human achievement in path-making. Like no other piece of construction, Simmel believes, bridges make visible our desire for making points of connection; they are unmatched in their ability to unify separateness.[44] To travel across a bridge is to connect one side to the other. To be halfway across is to be held apart, disconnected.[45] For me, there is a close relationship between this position and what feminist Diane Elam has called 'the politics of undecidability', her understanding of the political imperative of deconstruction.[46]

If the act of translation presupposes some kind of imbalance, demanding that one side be understood in terms of the other, the bridge presents the possibility of a balanced two-way conversation. Even dialogues composed of miscommunication are important forms of exchange for they focus on the critical possibilities offered by cultural and linguistic asymmetries. My gender gave my companion access to my nationality. (Would he have approached a *gringo* rather than a *gringa* and offered to carry *his* string bag?) With his proposition came the possibilities offered by my colonizer's easy mobility. But it was my lack of linguistic ability, not penis, that allowed my agile companion to fulfil a far more fruitful opportunity.

Jacques Derrida's deconstruction could be described as a defence of writing against speech, where he argues that speech has been prioritized at the expense of writing, for being closer to the presence of meaning. It is in writing that Derrida finds distance from presence and the potential for slippage in meaning to occur. Cultural critic Mieke Bal eloquently summarizes Derrida's position, outlined in *Dissemination*, as based on three tenets: 'intertextuality, entailing the dispersal of origins; polysemy, entailing the undecidability of meaning; and the shifting location of meaning, entailing the dispersal of agency'.[47] But for Mladan Dolar, Derrida's 'deconstructive turn deprives the voice of its ineradicable ambiguity by reducing it to the ground of illusory presence'.[48] Dolar suggests instead that in psychoanalysis the voice is not only one of self-presence but also the voice of the other, 'the voice that one cannot control'.[49]

I tell you. I tell of you. I tell to you. What do you tell to me?

When Bhabha talks of performative time, he argues that the subject is only graspable in the time between telling and being told. This emphasizes the temporal aspect of 'telling'; but there is also a spatial element. This is

a double scene, Bhabha says, which demonstrates that the very condition of cultural knowledge is the alienation of the subject.[50] Importance shifts for Bhabha from the one who is telling, or 'articulating', to *where* this articulation is taking place – the 'topos of ennunciation'.[51]

> *As narrator she is narrated as well. And in a way she is already told, and what she herself is telling* will not undo that somewhere else she is *told.*[52]

The suggestion is that the teller is 'already told' in the cultural narratives of which she is a part, but that the listener will also tell, again, somewhere else, dispersing the telling from a single point, even if a contingent one, to multiple sites, redefining the topography of telling through *différance* (spacing and deferral).

What did you tell? When did you tell? Where did you tell to me?

Los Encuentros

Certain forms of architecture – a path from a church to the hill-top behind it, a dead-end street, the clutter and colour of a market square, the two-way traffic on a bridge, a guarded gate – offer the storyteller patterns of space, as well as the social possibilities, for certain kinds of encounter to occur. Places loaded with cultural and historical significance, as well as those considered archetypal, suggest specific psychic forms and so prompt particular narrative arrangements. Literature frequently uses architecture metaphorically, but writing is also a place in its own right. Texts are spatial constructions in which writers interact with those they write of and those they write to. Some stories close down possibilities for discussion; others, situated at the crossroads of ongoing traffic, invite participation. *Los Encuentros* and *Los Quatro Caminos* were my favourite points along the *Carretera InterAmericana*, the main highway that runs through Guatemala, linking Panama in the south to Texas in the north. Their names mark the crossing of paths – confluences and divergences, meetings and partings.

North. South. East. West.

from Austin, Texas

North. South.

to Santiago Atitlán

South. North.

and back again.

Decentring/Recentring Do-Ho Suh

The work of Do-Ho Suh, a Korean-born artist now based in New York, explores concepts of home and dislocation. In her essay for his solo show at the Serpentine Gallery, London, in 2002, art critic Miwon Kwon took issue with notions of authenticity that could be ascribed to the work – not just the 'original' Korean home that Suh's travelling piece *Seoul Home/LA Home …* (1999) is a duplicate of, but the myth of the authenticity of mobility itself.[53] Although Kwon's critique of 'cosmopolitan homelessness' argues quite rightly that the movement experienced and described by the international art scene as a universal condition needs to be understood as an élite privilege enjoyed by very few, her own position in this context is not subject to address.

My own engagement with Suh's work (and Kwon's essay) took place just after I returned from a visit to Seoul.[54] In what follows I explore how my first-hand experience of South Korea operates to locate the work, to both decentre and recentre it.[55] I resist using autobiographical details of my visit to situate the work in relation to an 'authentic' Korea; nor do I argue that critics must experience the 'original' cultures that artworks might refer to and the 'actual' sites in which they are located. With the age of peak oil upon us, and given the vast amount of fossil fuel those from the minority world have already consumed in air miles, this would be an unethical position to advocate. I do, however, seek to draw attention to the specificity of the particular sites through which we engage with Suh's work, in my case Seoul and London. I question why autobiographical and biographical details are assumed to recentre, and wonder instead whether

they have the potential to decentre the critic's position with respect to the work, as well as the reader's relation to the critical essay.

Decentring and Recentring (and Decentring)

On entering the first room of Suh's solo show at the Serpentine Gallery, at first I was only aware of the presence of a glass floor, on which I had to step in order to continue my passage through the gallery. The walls seemed to have nothing on them; they appeared slightly coloured, but no more than off-white. Moving closer to inspect them more fully, I discovered that their surfaces were covered with thousands of tiny dots. Closer still, I saw that these dots were miniature faces in oval frames, all the same size, but each one different, a little like passport photographs in their ability to combine uniformity and variety.[56] Walking onto and looking down at the floor more carefully, I found myself standing on millions of tiny pairs of hands, which on a more detailed examination I realized belonged to figurines.[57] Unbending, the hands disappeared; moving back, the faces became invisible again. But I was left with the feeling that I was being silently watched, and that when I moved I should tread extremely lightly.

Much of the critical conversation about Suh's work has focused on the relationship the work has to minimalism,[58] and the emphasis it places on the perception of an artwork as a public rather than an intimate experience. Kwon argues that Suh's work 'extends the lessons of minimalism', but also, by 'creating intimate relations with his viewer', makes '*anti*-minimalist moves'.[59] For Kwon, *Who Am We?* (2000) and *Floor* (1997–2000) at first decentre the viewer because according to Kwon s/he only discovers the works once s/he is within them. Kwon asserts that the revelation of the detail then brings a privileged sense of knowledge gained, and with this a feeling of recentring.[60]

However, I am not sure the viewing experience is constructed so sequentially – decentring followed by recentring. The belated discovery that *Floor* consists of small figures with tiny hands, for example, positions the viewer in a powerful location, but the realization that s/he is crushing those who continue to support him/her brings with it discomfort and confusion, which I suggest might decentre rather than recentre the viewer. Kwon recognizes a double positioning in the work; indeed she argues that it is intentional on the part of the artist, and in her view its clear legibility produces resolution and thus pleasure, rather than displeasure, for the viewer. She mistrusts pleasure, because it undermines the 'disturbing undercurrents' of other works by Suh, such as *Some/One* (2001), a majestic military robe constructed out of thousands of army-style tags, and *High School Uni-Form* (1996), a single entity composed of multiple empty uniforms.[61]

65
Do-Ho Suh, *Who Am We? (Multi)* (2000) and Do-Ho Suh, *Floor* (1997–2000), Serpentine Gallery, London, 2002. Photograph: Stephen White. Reproduced with kind permission of Serpentine Gallery.

The view of the collective presented is ambivalent, but from whose perspective? It is not clear whether Suh's work asks the viewer to identify with the position of the worker represented, their resistance and/or collusion with dominant power structures,[62] or whether Suh wishes the viewer to consider whether he, the artist, is critiquing disciplinary regimes of power or affirming that individuality must be subsumed for the common good. Certainly for the viewer, the links that s/he presumes this Korean-born artist is making, between what Kwon calls the Eastern virtue of 'self-sacrifice in the name of a larger social or political entity' and the colonization of subjects, raises questions concerning whether the discipline of order comes from outside or within. Kwon asks whether 'we' in contemporary society are the agents of our own oppression or liberation.[63] But to which 'we' is she referring?

Resisting the tendency to use biographical details to 'explain' the qualities of Suh's work as she argues other critics have done,[64] Kwon chooses to produce a more theoretical interpretation, by exploring Michael Hardt's and Antonio Negri's discussion of 'the new global order of Empire', and their concept of the multitude rather than the people.[65] This allows her to reconsider pieces such as *Floor* and associate them with a degree of loss rather than the satisfaction of fulfilment with which she earlier connects this work.[66]

The vacancy or absence at the core of Suh's rendering of collectivity mitigates the nostalgic desire to reclaim a triumphant model of the people and registers an elegiac recognition of its passing.[67]

But where does biography end and theory begin? What does one reject by turning away from the biographical as a mode of explanation? Does a more theoretically astute mode of criticism require that no mention of an artist's life be made, even if the art, in the case of Suh, is based upon the artist's engagement with questions generated out of his own cultural mobility? How can a critic write theoretically when a work is conceptually derived from an artist's biography, in this case his physical trajectory? To avoid using the biographical to 'explain' the work, should we keep Korea and its culture out of the discussion?

On my visit to Seoul I learnt that Confucianism dominates Korean culture. In this ethical system, originating in China, a particular set of rules, based on respect, age, status and gender, govern the construction of social relations. To someone unfamiliar with this collective ethos the predetermined nature of relationships can appear rather oppressive, but perhaps no more so than global capitalism's myth of individual freedom. In Korean art practice there is a palpable tension between eastern and western values.

That Suh's father, Se-Ok Suh, is a well-known artist working in the traditional manner – ink on rice paper – and his mother, Min-Za Chung, is active in retaining Korean cultural heritage, are biographical details often

referred to in discussions of Suh's work. At Seoul National University, with its focus on traditional painting and sculpture, where Suh first studied, I met Insu Choi, Professor of Sculpture.[68] Although Choi studied in Germany, Karlesruhe, in the early 1980s, for him the birth of modernism brought with it the death of representative painting and figurative sculpture, and in his view such western traditions should not be forced on artists in Korea, but adopted through choice.[69] I also had many conversations with one of Suh's teachers, Yoon Young Seok, Professor at Kyungwon University. An artist who also trained in Germany, in Stuttgart, Yoon occupies a very different position from Choi. He embraced his western education and is currently engaged in the making of what he calls 'conceptual objects' located within a contemporary context that acknowledges the position of Korea in relation to the west, and vice versa.[70] A large number of Korean artists have studied in Germany and the United States. Some have returned to Korea, but others like Suh, have not. For many, the frictions between freedom and individuality that arise out of this particular East/West dislocation are generative impulses in their practice.

Is this information gleaned from informal conversations over dinner and my reflections upon it too (auto)biographical for inclusion here? What about the details concerning Suh's family? Are these only valid if they do not seek to explain? But whose biography precisely is the problem: the artist's or the critic's – Suh's, mine or Kwon's own?

Kwon is now based in the United States, but she grew up in Seoul. I found this out only recently by reading her 1998 article on Suh's work, where she refers to her own Korean childhood.[71] In a perceptive account of *Who Am We?* and *High School Uni-Form*, she eloquently describes how the 'destablizing conditions of cultural displacement', both chosen and forced, create a sense of longing connected with leaving. Here it is out of (auto)biographical details that a complex understanding of cultural and historical context emerges which, far from explaining, produces an informed exposition, subtle yet precise, of the work's ambiguities.

I wonder, then, whether the 'vacancy or absence' Kwon detects at the 'core' of Suh's work is not only to be connected to Hardt's and Negri's political theory, as she suggests, but also I propose to a loss of her own. Is it fear of the charge of sentimentality or nostalgia that makes Kwon remove her own history as well as Suh's in her second account of his work? It is hard to know. But paradoxically, the loss she finds described in political theory and which decentres her interpretation of Suh's work ends up recentring her in the role of intellectually astute art critic. Likewise, the knowledge I gained in Seoul, while decentred from my usual cultural habitat, serves to recentre my understanding of the decentring devices in Suh's work. What is the relationship between decentring and recentring in art criticism? Can (auto)biographical details operate to decentre rather than recentre a critic's relation to a work?

A Replica of a Replica of a Replica …

In 1999, when asked to exhibit at the Korean Cultural Centre in Los Angeles, Suh saw on display photographs of traditional nineteenth-century buildings in Korea. These images reminded him of his home in Seoul, based on parts of the Changdeokgung Palace.[72] For *Seoul Home/ L.A. Home/New York Home/Baltimore Home/London Home/Seattle Home* (1999), Suh fabricated a replica of his home in green silk. Conceived originally as 'custom-made clothing for a room',[73] this work is a development of an earlier one, *Room 516/516–I/516–II* (1994), where Suh made a copy of his studio in muslin.[74]

 Seoul Home … is a home, which is portable and has travelled around the world. With each new show, the work adds to its title the name of the town in which it has been exhibited, clearly marking its growing itinerary as well as Suh's increasing international recognition. Although generated through his interest in 'transportable site-specificity',[75] the physical substance of the work does not change; rather, it transports the specific site of his Seoul home to each new location. The work is altered in the way it addresses each of its new sites or homes. In Los Angeles, where it was placed on top of a central staircase, each viewer had to pass through the inside of the work before seeing it from the outside as an object in totality. In London, at the Serpentine Gallery, its floating position high up in the roof, produced comparisons with hot air balloons or parachutes. A tension between stasis and change is highlighted in the work's title, where the repetition of the word 'home', accompanied by a different town in each pair of words, can be understood to indicate either the transformation of Suh's Seoul home into a different one in each new location, or that despite its changing geography, home continues to refer back to the same origin.

 When in Seoul, I had, without knowing it, visited parts of Suh's home, in the form of Changdeokgung Palace.[76] This traditional Korean building is constructed of wood and rice paper, waxed to keep out the rain. The use of paper reduces the emphasis on vision that comes with glass, but this architecture is not a sealed box: it is porous to the environment. From inside you can hear and smell what is outside. Suh has discussed how his motivation to make the work came from being disturbed at night in his flat in New York and remembering how peacefully he had slept in his childhood home.[77] A strange reversal, then, that the key characteristic of the architecture of his childhood home – its permeability to light, smell and sound – should be remembered as a protecting envelope.

 As Kwon has noted, Suh's home is 'a replica of a replica of a replica'.[78] The artwork is a replica of a replica his father made of two nineteenth-century buildings – a library and master's house – from the palace complex. When some of these buildings were demolished to make way for new roads, Suh's father salvaged timbers to construct a house for his family, in which, as Suh describes, the original library became their family

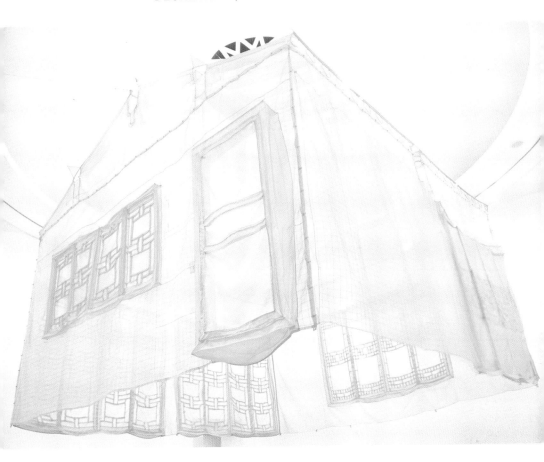

66
Do-Ho Suh, *Seoul Home/L.A. Home/New York Home/Baltimore Home/London Home/ Seattle Home* (1999), Serpentine Gallery, London, 2002. Photograph: Stephen White. Reproduced with kind permission of Serpentine Gallery.

kitchen and dining room.[79] But interestingly, the library and master's house were themselves replicas.[80] Suh outlines how, in 1828, King Sunjo made copies of 'civilian-style houses' in order to experience the life of 'ordinary people'.[81] However, the term 'commoner' used by Kwon[82] is a little misleading, for in the guidebook to Changdeokgung Palace it explains that the houses belonged to members of the yangban class of intellectuals, who although not members of the royal family were considered to be a 'largely hereditary aristocratic class based on scholarship and official position rather than wealth'.[83]

Between the Outside of the Inside and the Inside of the Outside

For *My Home is Yours, Your Home is Mine* (2000) at the Rodin Gallery in Seoul, Suh made a companion piece to *Seoul Home … the first of what has become a collection of replicas of his home in New York, of the apartment itself, 348 West 22nd Street, Apt. A, New York, NY 10011, at Rodin Gallery, Seoul/Toyko Opera City Art Gallery/Serpentine Gallery, London/Biennale of Sydney/Seattle Art Museum* (2000), made in grey nylon,[84] and the corridor, *348 West 22nd Street, Apt. A, New York, NY 10011 at Rodin Gallery, Seoul/Toyko Opera City Art Gallery/ Serpentine Gallery, London/Biennale of Sydney/Seattle Art Museum (Corridor)* (2001), fabricated in rose-pink nylon, added in subsequent exhibitions, such as the Serpentine Gallery, London, in 2002.[85] When exhibited together these two works have also been titled first *Perfect Home I*,[86] and then, when accompanied by part of the staircase from Suh's apartment block formed of yellow nylon, *Perfect Home II*.[87]

From the 1970s onwards, Seoul, the capital city of South Korea, has expanded massively horizontally and vertically, with new tower blocks constructed for all kinds of uses – housing, offices, shopping and entertainment, including twenty-four-hour twelve-storey markets with multi-storey underground car parks. On my visit, I was taken to see a scheme under construction by Samsung, one of five family-run corporations who finance development in Seoul. The 100-storey 'Tower Palace' contained apartments designed in so-called international-style architecture, sealed in by glass windows and fitted out with expensive fabrics imported from Italy. The view showed the rapidly changing city, with the urban edge just visible on the outskirts, and far below the last district of old housing soon to be demolished.

Korea is a country that has been invaded constantly in its history, and although this has produced a protective attitude towards cultural heritage, it is not one that opposes development. Looking down at the traditional buildings from the balcony of Tower Palace I expressed concern about their impending destruction, but my Korean companions conveyed their enthusiasm for the increased 'convenience' the new apartments offered. Perhaps it was a colonializing impulse in me, which reverted to the false

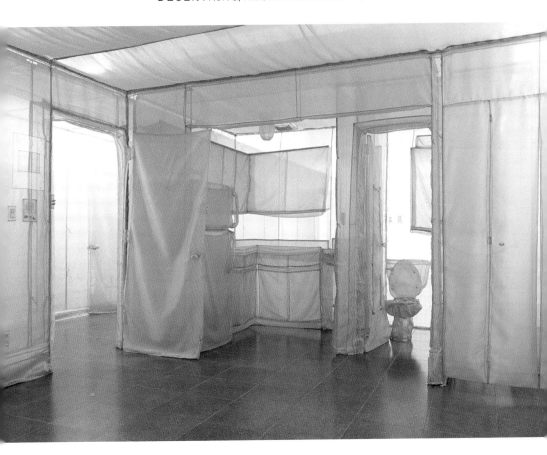

67
Do-Ho Suh, *348 West 22nd Street, Apt. A, New York, NY 10011 at Rodin Gallery, Seoul/ Toyko Opera City Art Gallery/Serpentine Gallery, London/Biennale of Sydney/Seattle Art Museum* (2000), Serpentine Gallery, London, 2002. Photograph: Stephen White. Reproduced with kind permission of Serpentine Gallery.
68 (overleaf)
Do-Ho Suh, *348 West 22nd Street, Apt. A, New York, NY 10011 at Rodin Gallery, Seoul/ Toyko Opera City Art Gallery/Serpentine Gallery, London/Biennale of Sydney/Seattle Art Museum* (*Corridor*) (2001), Serpentine Gallery, London, 2002. Photograph: Stephen White. Reproduced with kind permission of Serpentine Gallery.

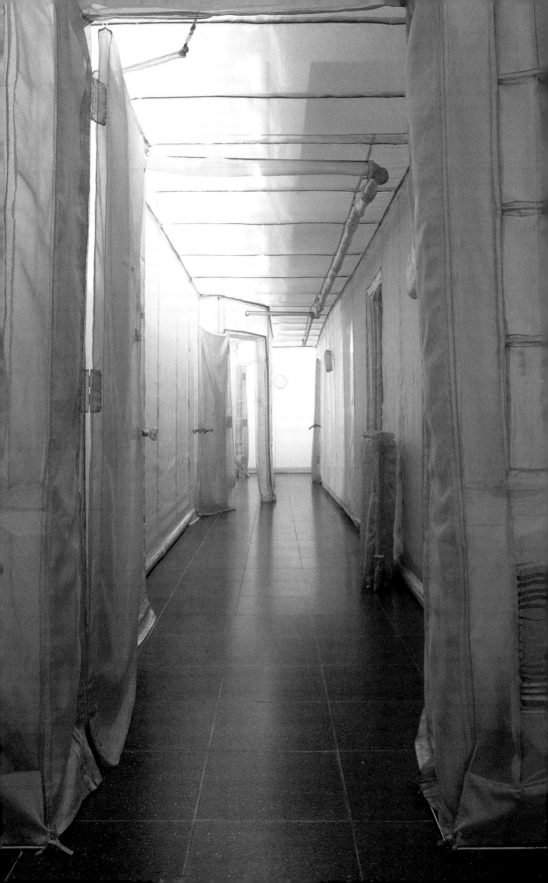

dualism, setting up on the one hand Korean architecture as traditional, and on the other international-style architecture as both western and modern. But South Koreans resist *and* embrace aspects of so-called western, especially north American, life, making their own decisions about the balance between traditional and modern from the inside rather than conforming to notions of what constitutes 'Korean-ness' determined from the outside.

At the Serpentine Gallery, Suh's two homes do not encounter one another directly. While *Seoul Home* ... floats down from the ceiling, allowing us to look up and into its beautiful interior, *348 West 22nd Street* ... is constructed from the ground up like a tent, with slightly sagging sides. In tracing an interior architecture at a scale of 1:1 and exploring the experiential qualities of absence, Suh's work raises comparisons with Rachel Whiteread's *House* (1993), her concrete cast of the interior of a Victorian house in London's East End.[88] But while Whiteread's casts turn inside out, Suh's linings face inwards, not outwards. His stitched lines are sewn twice, from inside *and* outside, suggesting that the structures are reversible;[89] however, if inhabiting the work from the inside clothes the viewer in an absent architecture, occupying the work from the outside is to be faced by an impossible object, one which decentres rather than recentres the viewer.

On the outside, trying to imagine the absent architecture to which I am being referred, I find myself located behind the interior paint finish of Suh's New York apartment, inside a solid brick wall or, depending on the construction technique, among the insulation, studwork and builder's rubbish commonly packed into the cavity. As I address the impossible position in which *348 West 22nd Street* ... places me, I realize I am right between the outside of the inside wall of Suh's apartment and the inside of the outside wall of the Serpentine Gallery. This is precisely how the 'at' in this work's title operates, where the insertion of a preposition suggests that, unlike *Seoul Home* ..., the meeting point between the site to which the work refers and the one in which it is located is not one of interaction – heteropathic or cannibalistic – but 'address'. *348 West 22nd Street, Apt. A, New York, NY 10011* at *Rodin Gallery* addresses itself to each gallery it visits. Rather than the self-referential movement of the 'signifer of', 'a metapsychology of the trace or of representation', which, as Laplanche would have it, 'remains irreducibly solipsistic', this 'at' is where home addresses gallery, and opens up a gap for the user to occupy, a 'signifier to' whose decentring message is enigmatic.[90]

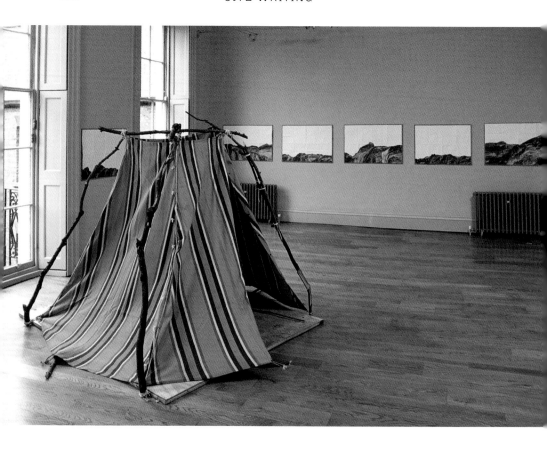

69
Foreground: Jan Peters, *Wie Ich ein Höhlenmaler wurde (How I became a Cave-Painter)* (2001).
16 mm, 38 min (co-production with Deutsches Schauspielhaus, Hamburg), *Ausland*
(2003), domoBaal contemporary art, London. Photograph: Andy Keate. Courtesy:
DOMOBAAL. Background: Martina Schmid, *Deep 1* (78 × 57 cm) and *Deep 2, 3, 4, 5*
(89.5 × 57 cm) (2003). Ink on folded paper. *Ausland* (2003), domoBaal contemporary
art, London. Photograph: Andy Keate. Courtesy: DOMOBAAL.

Everywhere Else

The cat's paw is large enough to cover the mountain crest; his tail is as long as the sunlit gully. But look more closely. You can see that the mountain top is the edge of a dense cluster of loops drawn on a sheet of cartridge paper, folded many times. And the cat, having walked across the mountain range, has been sent on his way, relieved that his paw did not leave a mark on the paper.

Three figures sit cross-legged on the floor in a room whose function is unclear. Two windows frame views onto a London street and the door in the wall opposite opens into a kitchen that stretches the width of the house. At the kitchen table a girl sits, her sulky head bent over a book. Mounted on the wall behind her is a piece of cartridge paper, folded many times, covered in hundreds, thousands of tiny little loops, drawn in ink. Beside the drawing, on the mantelpiece, is another drawing, smaller, perched this time rather than hung, made of tiny lines drawn in pencil over a painted surface. A horizon line splits the canvas, creating on the mantelpiece, in the foreground, a smoother profile, more hilly than the rugged mountain range that lurks behind in the alcove.

As she draws, she daydreams; different voices weave in and out, stories on the television, conversations in the room. She is in a state of almost mindless concentration; at any moment her attention might wander. She slips to a summer meadow high up in the German countryside, sitting there in the afternoon sunlight, just before the shadows of the surrounding mountain peaks fall across her lap. She wonders how she can feel a stranger in her own country. When the room comes into focus again, she

is in another place. The paper on her lap is covered in many patches of tiny loops. How will they ever meet? When the joins are invisible, you can lose yourself in the middle; when the upper edge is neat, you can journey along the horizon.

The walls in this room look like they are covered in loops too – but up close you can see that these are figures, lots and lots of small numbers. These financial indices that indicate specific quantities with particular functions appear here as surface ornament. In the corner, two sofas are placed at right angles to one another. On the floor between them sit three women, a cat and one half of a pair of shoes. On one sofa art catalogues and CVs spill across the cushions. Behind the other sofa is a long box containing a large drawing, rolled up. This is a drawing of another room, drawn by another hand, drawn from memory.

This is a room that matters, but of which she was never quite part. It was his room really, a room that he lived in before she entered his life, a room in which he may have loved others. To draw it is to conjure it into existence, to try to hold it down, to remember it as it was for her. The lines she draws are clear-headed and precise. She draws in a light hard pencil, sometimes in graphite, sometimes in colour. She draws in perspective with the certainty of an architect. But the point of convergence never holds still. From where she is looking, the room shifts in her memory, her focus changes. Looking back into the past, there are many places where eyes might have met.

Between the two sofas, a second door leads out into the hallway, where an elegant staircase winds its way upstairs, to a room overlooking the garden. This room will soon contain one of her large perspective drawings. There is talk of a tent filled with her cushions to be placed in the centre of the room, where you can lie back and watch him talk of his journey.

He travels hard, day after day, moving through corridor after corridor, to try and understand the geometry of the place. But no one on the inside will tell him where he is. If he does not know where he is, how will he know who he is? So he draws himself a map on the palm of his hand to remind him of where he has been, to remind him that 'he is in the house'.

She, too, has been on many journeys, back from where she has come. Sometimes she uses the folded paper as a diary, one square per day. To remember days and places, she makes marks, one after another, slowly filling up the paper. Sometimes she records a now distant journey, marking all the squares at once, with no sense of sequence. If you fold and unfold the paper you can read one place next to, rather than before or after, another. In the patches of light and shadow she has made over time, you can see the horizon of a mountain which you might have visited last summer.

In Hanover, this time, not London, three figures face a mirror. A man with wet hair is seated in the foreground. His head is bent downwards, only half his face is visible in the mirror. Behind him a woman leans forward with a pair of open scissors in her hand. She is cutting his hair. (Years down the line, cross-legged in the room full of numerical figures, we will see her

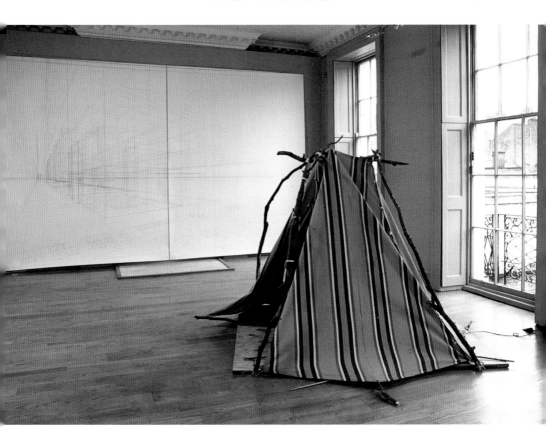

70
Foreground: Jan Peters, *Wie Ich ein Höhlenmaler wurde (How I became a Cave-Painter)* (2001). 16 mm, 38 min (co-production with Deutsches Schauspielhaus, Hamburg), *Ausland* (2003), domoBaal contemporary art, London. Photograph: Andy Keate. Courtesy: DOMOBAAL. Background: Silke Schatz, *Köln Weidengasse, Küche Wohn und Schlafraum (Weidengasse 63/65)* (2001). 300 × 477 cm (in two pieces). Pencil and colour pencil on paper. *Ausland* (2003), domoBaal contemporary art, London. Photograph: Andy Keate. Courtesy: DOMOBAAL.

profile again.) There is a third person, the face obscured by a camera; two hands adjust the lens – a photograph is taken. The photograph shows three artists, who today live somewhere else.

The light from the window hits her face in profile. She sits next to me on the floor, cross-legged. A third woman sits opposite, her back to a sofa. We talk of where we have come from. She was born in Russia, or was it Poland, or perhaps she said Australia. It is hard for me to remember her story, but it was also difficult for her to tell. She comes from somewhere between fact and fiction. I tell them I was born in Dubai, but have moved from place to place so many times that London is my home, simply because it is not everywhere else.

•

'Everywhere Else' questions the constitution of a legitimate subject or object for art criticism, and expands critical possibilities by looking elsewhere.[91] Each of the three artists included in the exhibition *Ausland* engages with forms of architectural and spatial representation – Martina Schmid produces foreboding mountainous landscapes on folded paper from doodles scribbled while daydreaming[92] and Silke Schatz draws large-scale architectural perspectives of places she remembers in fine coloured pencil,[93] while Jan Peters works in video presenting narratives of his experiences in labyrinthine buildings.[94] The text is written as a detailed empirical account, which retains the same voice to describe *what is seen* – that which is materially present – that it uses to recount those absent sites to which the works refer.

domoBaal contemporary art is a gallery located in a Georgian terraced house in London, a building that is the curator's home too. As a critic, you have access to the administration spaces 'supporting' the gallery, which are also the domestic rooms of the house, such as the kitchen and living room. Here curator, collectors, artists and critics meet, and as mother and wife, the curator cooks, eats and watches television with her family. Artworks can be found in a number of different settings, exhibited in the gallery, on the living room walls, stored behind sofas and propped up on the kitchen mantelpiece. In relocating its si(gh)tes to those remembered or imagined by the artists as well as these overlooked parts of the gallery, this site-writing seeks to decentre the gallery from its position at the centre of art criticism.

Trafalgar Square: *Détournements*

Détournement, *the reuse of preexisting artistic elements in a new ensemble, has been a constantly present tendency of the contemporary avant-garde, both before and since the formation of the SI. The two fundamental laws of* détournement *are the loss of importance of each* detourned *autonomous element – which may go so far as to completely lose its original sense – and at the same time the organization of another meaningful ensemble that confers on each element its new scope and effect.*[95]

The term *détournement* used by the Situationists refers to a particular critical strategy, where images produced by the spectacle are altered or subverted so that their meaning opposes rather than supports the status quo. In the following *détournement* of the public sculptures of Trafalgar Square, I take the reader on a tour interrupted by three detours.[96] Each detour, informed by the critical spatial practice adopted by a specific artwork, is in itself a *détournement*.[97] These detours interrupt and subvert the dominant operations of power in this urban place, working through site-writing to decentre the sculptures from their position in a square which aims to maintain itself at the centre of empire.

•

With the Palace of Westminster to the south, Whitehall to the east and Buckingham Place to the west, Trafalgar Square is situated at the symbolic seat of power and the centre of government. It is enclosed by structures of religious, imperial and cultural capital: on the north side, the National Gallery; on the east side, the church of St Martin-in-the-Fields and South Africa House; and on the west side, Canada House.

Trafalgar Square was built based on the architect Charles Barry's designs of 1840 for the site of the King's Mews.[98] A 5.5-metre statue of Admiral Nelson stands at its centre on top of a 46-metre granite column. The sandstone statue at the top, sculpted by E.H. Baily, a member of the Royal Academy, faces south towards the Palace of Westminster. The monument was designed by architect William Railton in 1838 and constructed by the firm Peto & Grissell between 1840 and 1843. The top of the Corinthian column (based on the Temple of Mars Ultor in Rome) is embellished with bronze acanthus leaves cast from British cannons. Four bronze panels, made from captured French guns, decorate the square pedestal and depict Nelson's four great battle victories: to the west, the Battle of St Vincent (1797); to the north, the Battle of the Nile (1798); to the east, the Battle of Copenhagen (1801); and to the south, the Battle of Trafalgar (1805), where the British navy defeated the French and Spanish to establish British naval supremacy, and in which Nelson lost his life.

Detour 1: *The Battle of Orgreave*

Jeremy Deller's *The Battle of Orgreave* (17 June 2001), commissioned by Art Angel, was a restaging of one of the most violent confrontations of the miners' strike that took place on 18 June 1984 in the town of Orgreave outside Sheffield in the United Kingdom.[99] Orgreave marked a turning-point in the strike, and the first use of military strategies by the police for settling resistance. Deller's apparent concern was with an accurate restaging of the events as they had occurred. He involved a battle enactment society to restage the battle: some miners chose to play themselves and some sons played their fathers, though only one policeman played himself.

By appearing to fall in line with the principles of re-enactment and the society's dogged desire for so-called historical accuracy in replaying the battle scenes, Deller's approach revealed a certain irony in pointing to its own obsession with historical facts. The presence of cameras filming the battle for broadcast as a documentary film directed for television by Mike Figgis enhanced the role-playing aspect of the event, prioritizing a consideration of the 'facts', not as they had occurred in the past but as they were being constructed in the present. In attempting to recreate a political struggle that took place at a specific moment, *The Battle of Orgreave* shows how an act of remembering the past can reconfigure a particular place as a critical space in the present. In so doing, it demonstrates the

revolutionary impetus offered by a specific historical moment and the importance repetition can offer in recognizing this potential and keeping it alive.

Trafalgar Square has been the site of rebellion since its construction. In 1848 100,000 Chartists occupied Trafalgar Square arguing for Universal suffrage for all men over the age of twenty-one, equal-sized electoral districts, voting by secret ballot, an end to the need for a property qualification for Parliament, pay for members of Parliament and the annual election of Parliament. The most violent demonstration in Trafalgar Square I can remember took place in 1990 against Prime Minister Margaret Thatcher's new policies for extracting a poll tax, an unjust form of tax which demanded a uniform fixed amount per individual regardless of income.

On 9 June 2007, the weekend after I delivered the first version of this text as a talk in the National Gallery overlooking Trafalgar Square, I was part of *Enough*, a protest against the occupation of Palestine. It took place in Trafalgar Square, a public space at the heart of the capital city of a democratic country, but one at war, with military strikes perpetrated by the British army along with its allies, namely the United States and Israel, not just in Palestine but also Afghanistan, Iraq and Lebanon. On that day, a message was delivered via video link-up from Ismail Haniya, a senior political leader of Hamas, and at that time the democratically elected Prime Minister of the Palestine National Authority. Less than a week later, on 14 June 2007, Palestinian President Mahmoud Abbas, member of the Fatah party, dismissed him from office. Haniya has refused to acknowledge this dismissal and continues to exercise *de facto* authority in the Gaza Strip.[100] His party, Hamas, is classified as a terrorist organization by the United States and European Union, but the government of the United Kingdom only places its military arm, Hamas Izz al-Din al-Qassem Brigades, in this category.[101]

•

Let us continue our tour of Trafalgar Square and take a look at some of the statues. Along the base of the National Gallery are three busts. First there is David Beatty, who took part in actions during World War I. He was appointed Admiral of the Fleet and served as First Sea Lord until 1927, when he was created 1st Earl Beatty, Viscount Borodale, and Baron Beatty of the North Sea and Brooksby. Next there is John Jellicoe, who was in command of the British fleet at the Battle of Jutland in 1916. He was made a Viscount in 1918 and became Governor General of New Zealand from September 1920 to November 1924. On his return to England in 1925, he was made an earl. And finally there is Andrew Cunningham, who was Admiral of the Fleet in World War II.

There are also a number of freestanding statues. To the south there is Charles I, put in place in 1676 before the square itself was built, removed by Cromwell and reinstated by Charles II. At the corners of the square are

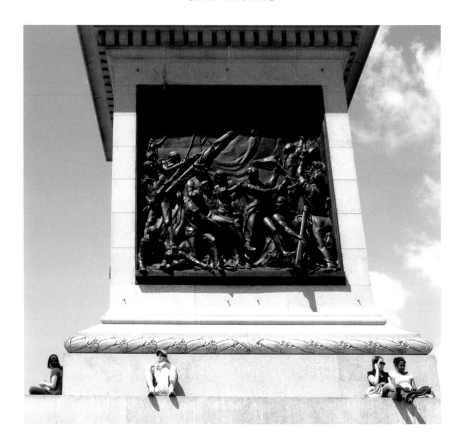

71
John Edward Carew, *The Battle of Trafalgar (1805)* (1838), Trafalgar Square, London.
Photograph: Cornford & Cross, 2007.
72 (opposite above)
Jeremy Deller, *The Battle of Orgreave* (2001), Sheffield. Commissioned and produced by
Artangel. Photograph: Martin Jenkinson.
73 (opposite below)
'Police arrest a rioter in Trafalgar Square during violence, which arose from a
demonstration against the poll tax, London, 31 March 1990.' Photograph: Steve
Eason/Hulton Archive/Getty Images.

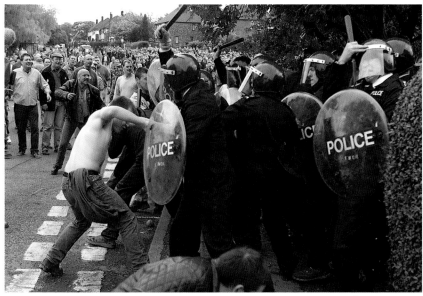

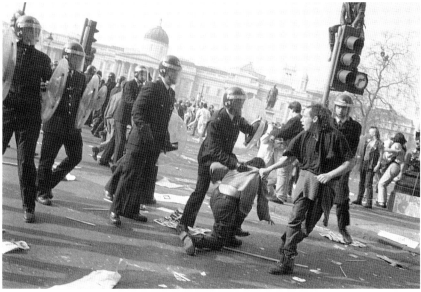

four plinths, three of which hold statues: to the north-east, there is George
IV from the 1840s; to the south-east, Major General Sir Henry Havelock,
made by William Behnes in 1861; and to the south-west, General Sir
Charles James Napier, made by George Cannon Adams in 1855.

Detour 2: *Better Scenery*

In 1965–66 Robert Smithson worked as a consultant artist for an
architectural firm called TAMS on designs for Dallas Forth Worth Airport.
The project prompted his consideration of how artworks might be viewed
from the air, but also how to communicate aspects of these exterior artworks
to passengers in the terminal building. This latter aspect he termed the
'non-site',[102] and his interest in the 'dialogue between the indoor and the
outdoor' led him to develop 'a method or a dialectic that involved … site
and non-site'.[103]

Smithson's radical gesture, which located the site of the work outside
the territory of the gallery and the gallery itself as the non-site where
the work is documented, has been recuperated today. The contemporary
commissioning process has established a new terminology that reverses
Smithson's dialectic. Many public art galleries term those works they
commission for sites outside the gallery 'off-site', reclaiming the gallery
position as the site of central importance to art.[104]

As part of a two-year 'off-site' programme, the Camden Arts Centre
invited Adam Chodzko to make a new work.[105] His intervention, *Better
Scenery* (2000), consisted of two signs, one located in the Arizona Desert
and the other in the car park of a new shopping centre, the O2 Centre, in
Camden.[106] The plain yellow lettering on the black face of each sign gives
clear directions for how to get to the other sign. Both sets of directions end
with the phrase: 'Situated here, in this place, is a sign which describes the
location of this sign you have just finished reading.'[107]

The two signs make no attempt to point to their immediate context,
only to each other. Their relationship is self-referential. In speaking about
where they are not, *Better Scenery*, described by Chodzko as 'an escapist
proposition', critiques the ethos of site-specificity and accessibility behind
many off-site programmes. If art is placed outside a gallery, why should it
be closely related to a particular site, which site and in what way?

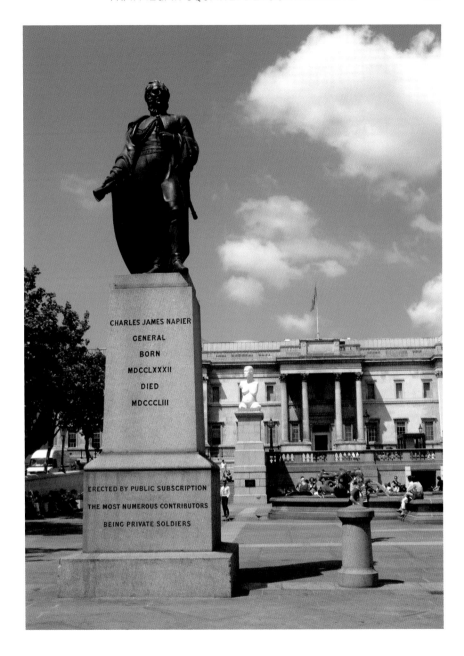

74
George Cannon Adams, *General Sir Charles James Napier* (1855). Photograph:
Cornford & Cross, 2007.

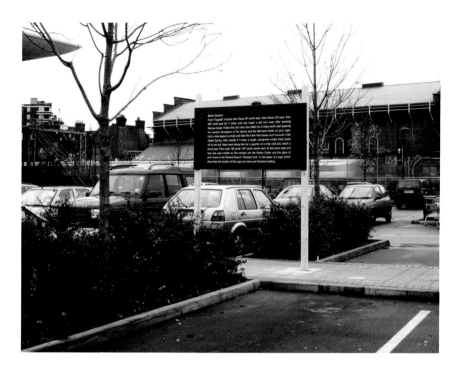

Adam Chodzko, *Better Scenery* (2000), London.

Better Scenery.

From Flagstaff, Arizona take route 89 northeast, then route 510 east, then 505 northeast for 7 miles until you reach a left turn soon after passing Maroon Crater. Follow this dirt track (the 244A) for 6 miles northeast passing the volcanic formations of The Sproul and the Merriam Crater on your right. Half a mile beyond a small well take the track that heads north towards Little Roden Spring. After exactly 6.7 miles a rough, overgrown cinder track leads off to the left. Head west along this for a quarter of a mile until you reach a fence post. Then walk 100 yards 160° south SE. At this point stop and face due east (visible on the horizon are the Roden Crater and the glow of pink rocks in the Painted Desert). Situated here, in this place, is a sign which describes the location of this sign you have just finished reading.

75
Adam Chodzko, *Better Scenery* (2000). A pair of installed signs, London and Arizona. Various dimensions and materials. Photograph: Adam Chodzko, 2000. Courtesy: the artist.

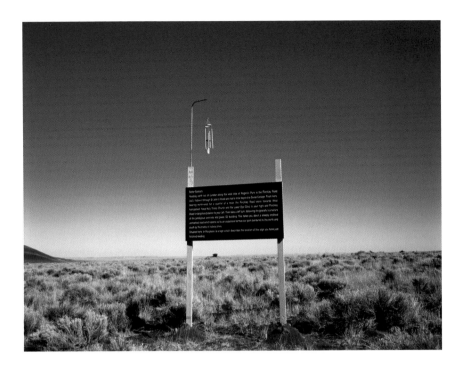

Adam Chodzko, *Better Scenery* (2000), Arizona.

Better Scenery.

Heading north out of London along the west side of Regent's Park is the Finchley Road (A41). Follow it through St John's Wood and half a mile beyond to Swiss Cottage. From here, bearing north-west for a quarter-of-a-mile the Finchley Road veers towards West Hampstead. Keep Holy Trinity Church and the Laser Eye Clinic to your right and Finchley Road Underground station to your left. Then take a left turn, following the graceful curvature of the prodigious, concrete and glass, O2 building. This takes you down a steeply inclined unmarked road which opens out to an expansive tarmac car park bordered to the north and south by the tracks of railway lines. Situated here, in this place, is a sign which describes the location of this sign you have just finished reading.

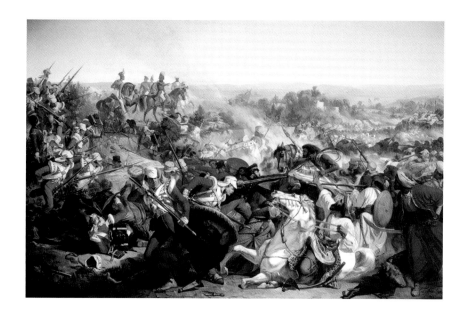

76
Edward Armitage, *The Battle of Meanee, 17 February 1843* (1847). Oil on canvas, 396.2
× 579.1 cm. Reproduced courtesy of The Royal Collection © 2009 Her Majesty
Queen Elizabeth II.

I'd like to return to General Sir Charles James Napier for a moment. Here is a short extract concerning a key moment in his life from Rodney Mace's *Trafalgar Square: Emblem of Empire*:

> *The two armies met at a dry river bed near the small town of Miari [sic] just south of the capital. The battle was fierce, but the Amir's force, armed only with sword and musket, were no match, despite their superior numbers, for the bayonet and cannon. At the end of the day, the battle was over. The Amir surrendered; 5,000 of their men were killed. The British casualties were 256. Undoubtedly Napier felt it had been a good day (he received £70,000 bounty for his success) and that history would be on his side. Was it not a law of nature 'that barbarous peoples should be absorbed by their civilized neighbours?' Within a few months the few remaining Amirs were crushed. By the middle of August 1843 Sind was formally annexed to the rest of British India.*[108]

Now let us continue our tour to the once-empty fourth plinth in the north-west corner of the square. This was intended to hold a statue of William IV, but owing to insufficient funds it initially remained empty, and later agreement could not be reached over which monarch or military hero to place there. In 1999, the Royal Society of Arts conceived the idea of the *Fourth Plinth Project*, which temporarily occupied the plinth with a succession of works commissioned from three contemporary artists, Mark Wallinger, Bill Woodrow and Rachel Whiteread. After several years in which the plinth stood empty, the new Greater London Authority assumed responsibility and started its own series of temporary exhibitions, starting with Marc Quinn's *Alison Lapper Pregnant* (15 September 2005).[109] Sculpted by an artist known at the time for his controversial self-portrait, *Self* (1991), a refrigerated cast of his own head made with nine pints of his own blood, his statue for the fourth plinth was a 3.6-metre white marble torso-bust of Alison Lapper. Lapper is also an artist, born with no arms and shortened legs owing to a condition called phocomelia, the visible effects of which are indistinguishable from those of individuals born to women who were given thalidomide during their pregnancies.

Lapper is the only female statue in Trafalgar Square; she is also the only non-military figure, with the exception of the mermaids, dolphins and lions, and of course the square's fleshly inhabitants. We might consider her an ordinary person, a civilian, but as a woman who is disabled but pregnant she is also extraordinary. Indeed we are encouraged to think of her inclusion in this square of monarchs, generals and admirals as a remarkable act, one that highlights the democratic nature of the government of the United Kingdom, its interest in culture and the promotion of equality. We might compare her disfigurement to Nelson's lost arm,[110] and note, as the artist himself does, how her perfect rendering and composure refigures the idea of beauty in contemporary art.[111] But I want to draw out another *figure* here and end with a final detour.

Detour 3: *Fallujah*

On 2 June 2007, the weekend before my talk at the National Gallery, after taking photographs in Trafalgar Square I walked down the Mall to the Institute of Contemporary Arts to see an exhibition called *Memorial to Iraq* (2007).[112] This included a work called *Fallujah*, designed by Studio Orta, written and directed by Jonathan Holmes. *Fallujah* is a piece of documentary theatre in which professional actors performed the events of the siege among the audience and the artefacts comprising the set in a disused brewery in London's Brick Lane. The publication of the script also includes material drawn from interviews carried out by the playwright Holmes, drawings of the set by Studio Orta, an essay by triple Nobel Prize nominee Scilla Elworthy, and testimony from those at the heart of the siege: Iraqi civilians, clerics, the United States military, politicians, journalists, medics, aid workers and the British army.[113]

The sieges of Fallujah in April and November 2004 are among the most extensive human rights violations of recent times. Breaching over seventy articles of the Geneva conventions, United States forces bombed schools and hospitals, sniped civilians (including children) holding white flags, and cut off water and medical supplies. Journalists were actively prevented from entering the city. There is evidence to show that chemical weapons, classified as weapons of mass destruction by the United Nations, whose production and stockpiling was outlawed by the Chemical Weapons Convention of 1993, were used in these attacks, including white phosphorus, napalm and depleted uranium.[114] Regarding their use in Fallujah, journalist, activist and writer George Monbiot reports:

> *Did US troops use chemical weapons in Fallujah? The answer is yes. The proof is not to be found in the documentary broadcast on Italian TV last week, which has generated gigabytes of hype on the Internet. It's a turkey, whose evidence that white phosphorous was fired at Iraqi troops is flimsy and circumstantial. But the bloggers debating it found the smoking gun.*

> *The first account they unearthed comes from a magazine published by the US Army. In the March 2005 edition of* Field Artillery, *officers from the 2nd Infantry's Fire Support Element boast about their role in the attack on Fallujah in November last year. On page 26 is the following text: 'White Phosophorus. WP proved to be an effective and versatile munition. We used it for screening missions at two breeches and, later in the fight, as a potent psychological weapon against the insurgents in trench lines and spider holes when we could not get effects on them with HE [high explosives]. We fired 'shake and bake' missions at the insurgents, using WP to flush them out and HE to take them out.'[115]*

White phosphorus is fat-soluble and burns spontaneously on exposure to the air. On contact with human skin, it chars and blackens the flesh, causing deep wounds, extreme forms of disfigurement and death.

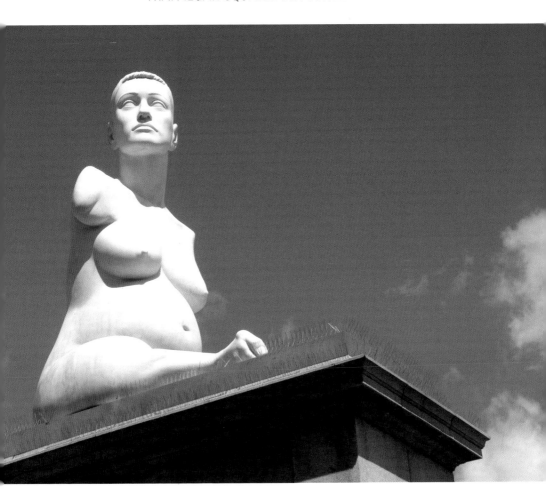

77
Marc Quinn, *Alison Lapper Pregnant* (2005). Photograph: Cornford & Cross, 2007.

The army of the United States declare that they only use white phosphorus to 'screen' the areas they attack. In so doing, they appropriate the symbolic role of white as a colour of peace and enlightenment, and instead its 'light' operates as a blinding mechanism, part of a contemporary Christian crusade to gain control over many Muslim countries of the Middle East and the oil or 'black gold' they contain. The sculptures in Trafalgar Square are all made of bronze, which over the years has darkened to become almost black; *Alison Lapper* stands out as an exception – female, naked and made of white marble. The public exhibition of her white disfigured body is displayed as a sign of democracy, while the black disfigured bodies of Iraqis, charred by white phosphorus attacks, are hidden from view, their very existence denied by a government who conducts its wars in the name of democracy.

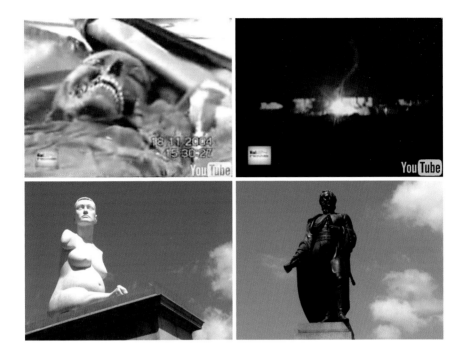

78

A composite image comprising top left and right: two stills from Sigfrido Ranucci and Maurizio Torrealto, *Fallujah: The Hidden Massacre*, shown in Italy on RAI on 1 November 2005, http://www.youtube/com/watch?v=WbuiHYdwU (accessed 21 June 2008), reproduced with kind permission of Sigfrido Ranucci; bottom left, Marc Quinn, *Alison Lapper Pregnant* (2005). Photograph: Cornford & Cross, 2007; bottom right: George Cannon Adams, *General Sir Charles James Napier* (1855). Photograph: Cornford & Cross, 2007.

Epilogue

Alien Positions

What does it mean to 'use' an object – a concept, an artwork, even an artist – rather than to relate to one? On reading Juliet Mitchell's discussion of the distinction D.W. Winnicott makes between relating and using an object, I started to think about how, in writing this book, I had approached my own objects.[1] In his 1968 paper 'The Use of an Object', Winnicott describes how 'relating may be to a subjective object, but usage implies that the object is part of external reality'.[2] For Winnicott, to use an object is to take into account its objective reality or existence as 'a thing in itself' rather than its subjective reality or existence as a projection. The change from relating to using is for him significant: it 'means that the subject destroys the object'; that the object stands outside the omnipotent control of the subject, recognized as the external object it has always been.[3]

In exploring how artists and critics use psychoanalytic theory, Mitchell discusses her own desire to 'use' theory rather then relate to it. To use a theory, she says, we have to destroy it; when it survives it 'will be in a different place',[4] one where it is independent of the artist/critic and is therefore charged with the capacity of a 'use-object'.[5] If one does not use theory, she argues, all one can do is apply it or question it 'within its own terms'.[6]

Reflecting on this, I wondered whether my choice of the preposition 'to' which had enabled me to write *to* the object rather than *about* it was still a way of relating to an object, even if differently, while the impulse to write the object, to reproduce it textually, was a form of use. In reworking Elina Brotherus's triptych *Spring* in my own three-part text installation *Les Mots et Les Choses* and Nathan's Coley's *Black Tent* in my scripted screen *An*

Embellishment: Purdah, had I, in Winnicott's sense, used these artworks? Did my reworking involve a form of destruction which allowed the artworks to exist 'in a different place' – independent of me? If so, then *Site-Writing* has gone some way to engage with how critics use artworks as I suggested in the *Prologue: Pre-Positions*, and perhaps even shown how using art might be rather different from viewing art. To use rather than view art still seems a rather 'alien' position for a critic to adopt given the optical terms of visual culture, but it does seem a more appropriate way to approach the spatial, and more specifically architectural, concerns of much contemporary art.

Now, moments away from completing the manuscript, I become aware that while I might, at times, have used art I have not 'used' psychoanalytic concepts in Winnicott's sense at all. Quite the opposite, in fact: I have used psychoanalysis to inspire the invention of a larger pattern, to act as a tool of enquiry, and in André Green's terms, coming from Sigmund Freud, to bind the work, to hold it together. It seems, as always, that I have needed theory – or my knowledge of psychoanalysis as a body of concepts – to inform my responses to the difficulties posed by this specific writing situation. These are first, that the writing of a book of many strands, some already formulated, some yet to be composed, all requiring radical transformation, raises issues of argument and structure; second, that the request from the publisher to focus on writing about the work of well-known artists sets up a dilemma of focus between two objects – the artwork and/or the writing of criticism itself; and finally, that the requirements of the Arts and Humanities Research Council (AHRC) as a funding body entail the production of research that has clear aims and objectives, a final destination, with no loose ends – a thesis, in effect.

In the face of demands often incompatible with my own desires, I have required psychoanalysis to hold its own, to steady me and allow me to invent a different way through the problem. Concepts have acted as guides, through the thicket of questions that the task of site-writing asked of me: How does being invited to write about an artwork deviate from choosing an artwork to write about? How to distinguish between writing for an artist or a curator, a public museum or a private gallery, about an artwork world-known or one apparently unheard of (yet)? How is a catalogue essay dissimilar to a discussion about the same artwork in a book that includes many other critiques? How does writing a text as a script for a guided tour of an exhibition diverge from writing an essay based on notes, drawings and memories of that tour? What difference does it make to meet the artist in person, visit the studio to see the artwork in progress, or the gallery to encounter the artwork on display? What if all you have of the artwork are some preparatory sketches or final photographs in a magazine?

Through all this and more, relating to psychoanalysis as a body of theory has helped me negotiate my engagement with the artworks and the questions this has posed. But at the same time as holding and guiding, psychoanalysis has, as a practice – a way of doing things – *suggested* to me; it has engendered situations where I have recognized configurations

present in artworks and imagined how my sites of engagement with these works might be written. Provoked by psychoanalysis – playing for me the muse that opens onto the enigma as Jean Laplanche indicates – my subjective object has not been destroyed; it remains intact, until this last moment.

For their exhibition at the Rijksmuseum in 2006, artists Bik Van Der Pol displayed one of the oldest items in the museum's collection, a piece of rock brought back to earth from the moon in 1969 by the crew of the first manned lunar landing mission, Apollo 11, in an exhibition space where visitors could come and reflect on this alien object.[7]

I started my writing commission by drawing connections between Laplanche's concept of 'alien-ness' and the moon rock. But it soon became clear that I could only communicate what I found so enlightening about this psychoanalyst's work to other art users by setting up a situation where both versions of alien-ness – Laplanche's and the moon's – could be brought together. To do this, I had finally to *use* the theory.

•

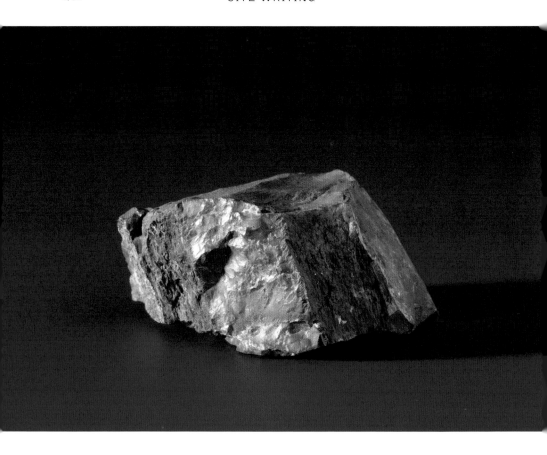

79
Moonrock brought to earth by Apollo 11 in 1969. Object Number: NG-1991-4-25.
Collection: Rijksmuseum, Amsterdam. Reproduced with kind permission of the
Rijksmuseum, Amsterdam.

Alien Positions

I look at the moon.
What do I see?
Who looks back at me?
What do they see?
The moon looks like a face to me.
What do I look like from the moon's point of view?

When I face another and the seemingly indecipherable mystery that they offer me, this is what I wonder. I try to turn things around and imagine myself from their point of view.

What me does this other see?
What does the other in me see?
What me does the other in this other see?
What other in this other does the other in me see?[8]

•

In his remarkable essay 'The Unfinished Copernican Revolution', Laplanche draws connections between astronomy and psychoanalysis, discussing the de-stabilizing effects of reversing the structures of relationships we take for granted socially, culturally and personally, from the macro-scale of the cosmos to the micro-scale of the psyche. Laplanche argues that the revolutionary move made by Copernicus in 1543, which demonstrated that the earth revolved around the sun, rather than the reverse, can be paralleled by Freud's discovery of an unconscious whose existence de-stabilized the central position of the ego in the formation of the subject. In Laplanche's view Freud did not pay proper heed to the possibilities inherent in his discovery, and went astray: 'the wrong path was taken each time there was a return to a theory of self-centering'.[9] This notion of 'going astray' Laplanche relates to astrology:

> *One cannot ignore the fact that the wandering stars* [planets asteres], *derive their name from the verb* [planao], *which means 'to lead astray, to seduce' ...*[10]

Laplanche writes of how the unconscious implanted in the subject by the enigmatic address of the other can be thought of as an internal foreign body: 'the unconscious as an alien inside me, and even one put inside me by an alien'.[11]

•

Alien Position One
Go to the Rijksmuseum, Amsterdam.
Find the fragment of the moon on exhibition in the gallery.
Stand in front of it.
Think about where it comes from.
Contemplate its strangeness.
Consider its alien-ness.

Ask yourself this: 'Is this alien really outside me?'

Alien Position Two
Ask the gallery attendant for a copy of Jean Laplanche's *Essays on Otherness*.
Return to the fragment of the moon.
Draw up a chair and sit down in front of it.
Turn to page 52 and start reading.
Read until you have completed 'The Unfinished Copernican Revolution'.

Ask yourself this: 'How does the moon see me?'

Alien Position Three
Find out the date and time of next full moon.
Take up a position where you can watch the full moon rise.
Wait until the moon is at its zenith.
Look at image 80.[12]

You are looking at an image of the earth taken from the moon.
Lift the book to the night sky with the image of the earth facing you.
Position the image of the earth so that you can see the moon at the same time.
Hold the images of the earth and moon together and wait …

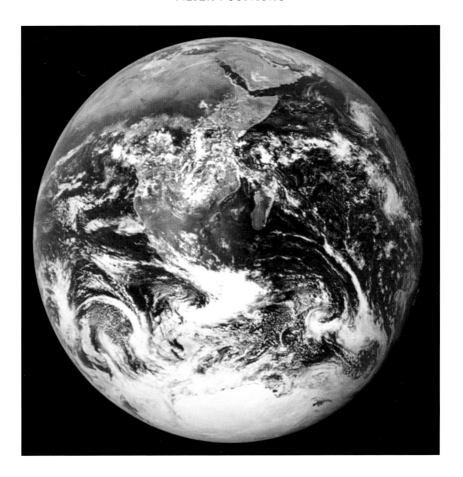

80

The Blue Marble. View of the Earth as seen by the Apollo 17 crew travelling towards the moon. This image was taken on 7 December 1972. NASA still images are not copyrighted. This image was reproduced from the NASA website: http://veimages. gsfc.nasa.gov/1597/AS17-148-22727_Irg.jpg (accessed 9 July 2008).

Notes

Prologue

1 Mieke Bal, *Louise Bourgeois's Spider: The Architecture of Art-Writing* (London and Chicago: University of Chicago Press, 2001), p. xii.
2 Bal, *Louise Bourgeois's Spider*, p. 2.
3 Mieke Bal, 'Earth Moves: The Aesthetics of the Cut', *Doris Salcedo, Shibboleth* (London: Tate Publishing, 2007), pp. 41–63.
4 See for example Jane Rendell, 'Critical Spatial Practice: Curating, Editing, Writing', in Judith Rugg and Michèle Sedgwick (eds), *Issues in Curating Contemporary Art and Performance* (Bristol, UK: Intellect, 2007), pp. 59–75, for an account of the relation between my individual and collaborative work.
5 Compare with Jane Rendell, *The Pursuit of Pleasure: Gender, Space and Architecture in Regency London* (London and New Brunswick, New Jersey: The Athlone Press/ Continuum and Rutgers University Press, 2002) and Jane Rendell, 'Writing in Place of Speaking', in Sharon Kivland and Lesley Sanderson (eds), *Transmission: Speaking and Listening* (Sheffield: Sheffield Hallam University and Site Gallery, 2002), vol. 1, pp. 15–29.
6 See Jane Rendell, *Art and Architecture: A Place Between* (London: I.B.Tauris, 2006).
7 For an earlier account of the conceptual framework that underpins my practice of 'site-writing' see Jane Rendell, 'Architecture-Writing', in Jane Rendell (ed.), *Critical Architecture*, special issue of *Journal of Architecture*, v. 10, n. 3 (June 2005), pp. 255–64, see http://www.informaworld.com (accessed 3 June 2009).
8 On art and site-specificity see for example Alex Coles (ed.), *Site Specificity: The Ethnographic Turn* (London: Black Dog Publishing, 2000); Nick Kaye, *Site-Specific Art: Performance, Place and Documentation* (London: Routledge, 2000); and Miwon Kwon, *One Place After Another: Site Specific Art and Locational Identity* (Cambridge, Mass.: The MIT Press, 2002).
9 See Irit Rogoff, *Terra Infirma* (London: Routledge, 2000) and Marsha Meskimmon, *Women Making Art: History, Subjectivity, Aesthetics* (London: Routledge, 2003). The work of Griselda Pollock has been central to the development of this strand of art criticism. See for example Griselda Pollock, 'Territories of Desire: Reconsiderations of an African Childhood', in Griselda Pollock, *Looking Back*

to the Future: Essays on Art, Life and Death (Amsterdam: G+B Arts International, 2001), pp. 339–69.

10 Donna Haraway's 'situated knowledges', Jane Flax's 'standpoint theory' and Elspeth Probyn's notion of 'locality' use 'position' to negotiate such ongoing theoretical disputes as the essentialism/constructionism debate. See Jane Flax, *Thinking Fragments: Psychoanalysis, Feminism and Postmodernism in the Contemporary West*, Berkeley (Los Angeles: University of California Press, 1991), p. 232; Donna Haraway. 'Situated Knowledges: The Science Question in Feminism and the Privilege of Partial Knowledge', *Feminist Studies*, v. 14, n. 3 (Fall 1988), pp. 575–603, especially pp. 583–88; and Elspeth Probyn, 'Travels in the Postmodern: Making Sense of the Local', in Linda Nicholson (ed.), *Feminism/Postmodernism* (London: Routledge, 1990), pp. 176–89, p. 178. See also Seyla Benhabib's critical articulation of 'feminism as situated criticism' in *Situating the Self: Gender, Community and Postmodernism in Contemporary Ethics* (Cambridge: Polity Press, 1992), pp. 225–8, and bell hooks's discussion of the margin in *Yearnings: Race, Gender, and Cultural Politics* (London: Turnaround Press, 1989). Sandra Harding has defined three kinds of feminist epistemology: feminist empiricism based on women's authentic experience, feminist stand-point based on a feminist angle of interpretation, and feminist postmodernism, a stance rejecting the possibility of any universal theory. See Sandra Harding, *The Science Question in Feminism* (Ithaca: Cornell University Press and Milton Keynes, UK: Open University Press, 1986).

11 See Rosi Braidotti, *Nomadic Subjects* (New York: Columbia University Press, 1994).

12 For Nicholas Bourriaud, in relational art, the work of art operates as a partial object, a vehicle of relation to the other producing open-ended conditions that avoid prioritizing the producer and instead invite the viewer to participate in the construction of the work. See Nicholas Bourriaud, *Relational Aesthetics*, trans. Simon Pleasance and Fronza Woods (Paris: Les Presses du Réel, 2002). Grant H. Kester examines artworks that are based on conversation through a theoretical framework developed in response to the writings of Emmanuel Levinas on 'face-to-face' encounter and the irreducible 'Other' as well as literary critic Mikhail Bahktin's work on how meaning is constructed between the speaker and the listener, rather than simply given. See Grant H. Kester, *Conversation Pieces: Community and Communication in Modern Art* (Berkeley: University of California Press, 2004).

13 See Umberto Eco, 'The Poetics of the Open Work' [1962], in Claire Bishop (ed.), *Participation: Documents of Contemporary Art* (London and Cambridge, Mass.: Whitechapel and The MIT Press, 2006), pp. 20–40.

14 More recently theorists have argued for works to be understood as produced by their users as well as their architects, and criticism to be considered a form of use. See Jonathan Hill, *Actions of Architecture: Architects and Creative Users* (London: Routledge, 2003) and Katja Grillner, 'Fluttering Butterflies, a Dusty Road, and a Muddy Stone: Criticality in Distraction' (Haga Park, Stockholm, 2004), in Jane Rendell, Jonathan Hill, Murray Fraser and Mark Dorrian (eds), *Critical Architecture* (London: Routledge, 2007), pp. 135–42.

15 Eco, 'The Poetics of the Open Work', pp. 39–40, n. 1.

16 Claire Bishop, *Installation Art: A Critical History* (London: Tate Publishing, 2005), p. 13 and p. 131.

17 Bishop, *Installation Art*, p. 133.

18 Bishop, *Installation Art*, p. 10.

19 Hal Foster, *The Return of the Real: The Avant-Garde at the End of the Century* (Cambridge, Mass.: The MIT Press, 2001), pp. 223–4.

20 Foster, *The Return of the Real*, pp. 225–6.

21 Isobel Armstrong, *The Radical Aesthetic* (Oxford: Blackwell Publishing, 2000), p. 87.

22 Armstrong, *The Radical Aesthetic*, p. 87.

23 Howard Caygill, *Walter Benjamin: The Colour of Experience* (London: Routledge, 1998), p. 34; see also p. 79.

24 Caygill, *Walter Benjamin*, p. 64.

25 Caygill, *Walter Benjamin*, p. 64.

26 Caygill, *Walter Benjamin*, p. 64.

27 Gavin Butt, 'Introduction: The Paradoxes of Criticism', in Gavin Butt (ed.), *After Criticism: New Responses to Art and Performance* (Oxford: Blackwell Publishing, 2005), pp. 1–19.

28 Butt, 'Introduction: The Paradoxes of Criticism', p. 3.

29 Butt, 'Introduction: The Paradoxes of Criticism', p. 7.

30 Amelia Jones and Andrew Stephenson, 'Introduction', in Amelia Jones and Andrew Stephenson (eds), *Performing the Body/Performing the Text* (London: Routledge, 1999), pp. 1–10, p. 8

31 Amelia Jones, 'Art History/Art Criticism: Performing Meaning', in Jones and Stephenson (eds), *Performing the Body/Performing the Text*, pp. 39–55.

32 Michael Schreyach, 'The Recovery of Criticism', in James Elkins and Michael Newman (eds), *The State of Art Criticism* (London: Routledge, 2008), pp. 3–25, p. 10.

33 Schreyach, 'The Recovery of Criticism', p. 6.

34 Schreyach, 'The Recovery of Criticism', p. 6.

35 See Irit Rogoff's discussion of Trinh T. Minh-ha's assertion in Irit Rogoff, 'Studying Visual Culture', in Nicholas Mirzoeff (ed.), *The Visual Culture Reader* (London: Routledge, 1998), pp. 24–36, p. 28.

36 Rogoff, 'Studying Visual Culture', p. 28. Gavin Butt also refers to how artist/writer Kate Love 'attempts to write with the experience of art'. See Butt, 'Introduction: The Paradoxes of Criticism', p. 15, and Kate Love, 'The Experience of Art', in Butt (ed.), *After Criticism*, pp. 156–75, p. 167.

37 Irit Rogoff, 'What is a Theorist?' in Elkins and Newman (eds), *The State of Art Criticism*, pp. 97–109, p. 104.

38 Rogoff, 'What is a Theorist?', pp. 97–8.

39 Jane Rendell with Pamela Wells, 'The Place of Prepositions: A Place Inhabited by Angels', in Jonathan Hill (ed.), *Architecture: The Subject is Matter* (London: Routledge, 2001), pp. 131–58. See also Rendell, *Art and Architecture*, pp. 150–1, where I discuss the potential of the phrase 'I love to you', deriving from the work of Luce Irigaray, for art criticism.

40 Luce Irigaray, 'The Wedding between the Body and Language', *To be Two* [1994], trans. Monique M. Rhodes and Marco F. Cocito-Monoc (London: Athlone Press, 2000), pp. 17–29, p. 19. See also Luce Irigaray, 'I Love to You', in *I Love to You: Sketch of a Possible Felicity in History* [1996], translated from the French by Alison Martin (London: Routledge, 1996), pp. 110–13.

41 Michel Serres, 'Winged Messengers', in *Angels: A Modern Myth* (Paris: Flammarion, 1995), pp. 139–49, pp. 140 and 147.

42 Rendell, 'Writing in Place of Speaking', p. 26.

43 'The Greening of Psychoanalysis: André Green in Dialogues with Gregorio Kohon', in Gregorio Kohon (ed.), *The Dead Mother: The Work of André Green* (London: Routledge, published in association with the Institute of Psycho-Analysis, 1999), pp. 10–58, p. 35.

44 Jessica Benjamin, *Shadow of the Other: Intersubjectivity and Gender in Psychoanalysis*

(London: Routledge, 1998), p. 80.

45 Benjamin, *Shadow of the Other*, p. xii.

46 Benjamin, *Shadow of the Other*, p. xii. See also Jessica Benjamin, 'An Outline of
 Intersubjectivity: The Development of Recognition', *Psychoanalytic Psychology*,
 v. 7 (1990), pp. 33–46, especially pp. 34–5, and Jessica Benjamin, 'Response to
 Commentaries by Mitchell and by Butler', *Studies in Gender and Sexuality*, v. 1 (2000),
 pp. 291–308.

47 Benjamin, *Shadow of the Other*, p. xiii and p. 90.

48 Andreina Robutti, 'Introduction: Meeting at a Cross-roads', in Luciana Nissim
 Momigliano and Andreina Robutti (eds), *Shared Experience: The Psychoanalytic
 Dialogue* (London: Karnac Books, 1992), pp. xvii–xxvi, p. xxv.

49 See for example Susan Stanford Friedman, *Mappings: Feminism and the Cultural
 Geographies of Encounter* (Princeton: Princeton University Press, 1998); Diane Fuss,
 Identification Papers (London: Routledge, 1995); Elizabeth Grosz, *Volatile Bodies:
 Toward a Corporeal Feminism* (Bloomington and Indianapolis: Indiana University
 Press, 1994); Rogoff, *Terra Infirma*; and Kaja Silverman, *The Threshold of the Visible
 World* (London: Routledge, 1996).

50 Steve Pile, *The Body and The City* (London: Routledge, 1999), p. 91. See also Grosz,
 Volatile Bodies, pp. 27–61.

51 Benjamin, *Shadow of the Other*, p. 25.

52 Fuss, *Identification Papers*, p. 3.

53 Fuss, *Identification Papers*, p. 2.

54 Silverman, *The Threshold of the Visible World*, pp. 23–4.

55 Cathy Caruth, 'An Interview with Jean Laplanche', © 2001 Cathy Caruth. See
 http://www3.iath.virginia.edu/pmc/text-only/issue.101/11.2caruth.txt (accessed
 3 May 2006). Laplanche notes that Freud uses the terms *der Andere* and *das Andere* to
 distinguish the other person from the other thing. See Jean Laplanche, 'The Kent
 Seminar, 1 May 1990', in John Fletcher and Martin Stanton (eds), *Jean Laplanche:
 Seduction, Translation and the Drives* (London: Institute of Contemporary Arts, 1992),
 pp. 21–40, p. 25.

56 Caruth, 'An Interview with Jean Laplanche'.

57 Jean Laplanche, 'Transference: Its Provocation by the Analyst' [1992], trans. Luke
 Thurston, in *Essays on Otherness*, ed. John Fletcher (London: Routledge, 1999), pp.
 214–33, p. 222. See also Jean Laplanche, *New Foundations for Psychoanalysis*, trans.
 David Macey (Oxford: Basil Blackwell Ltd, 1989), pp. 152–4.

58 Laplanche, 'Transference: Its Provocation by the Analyst', p. 222.

59 Laplanche, 'Transference: Its Provocation by the Analyst', p. 224.

60 Jean Laplanche, 'The Theory of Seduction and the Problem of the Other',
 International Journal of Psycho-Analysis, v. 78 (1997), pp. 653–66, p. 665.

61 Jean Laplanche, 'Sublimation and/or Inspiration', trans. Luke Thurston and
 John Fletcher, *New Formations*, v. 48 (2002), pp. 30–50, p. 49. See also Sigmund
 Freud, 'Creative Writers and Day-Dreaming' [1908], *The Standard Edition of the
 Complete Psychological Works of Sigmund Freud*, vol. 9 *(1906–1908): Jensen's 'Gradiva'
 and Other Works*, translated from the German under the general editorship of
 James Strachey (London: The Hogarth Press, 1959), pp. 141–54.

62 The work of Laplanche has recently been taken up in film, literary and art history.
 See Richard Rushton, 'The Perversion of *The Silence of the Lambs* and the Dilemma of
 The Searchers: on Psychoanalytic "Reading"', *Psychoanalysis, Culture & Society*, v. 10, n. 3
 (December 2005), pp. 252–68; Allyson Stack, 'Culture, Cognition and Jean Laplanche's
 Enigmatic Signifier', *Theory, Culture & Society*, v. 22, n. 3 (2005), pp. 63–80; and Mignon

Nixon, 'On the Couch', *October*, v. 113 (Summer 2005), pp. 39–76.

63 See for example Sigmund Freud, 'Delusions and Dreams in Jensen's *Gradiva*' [1907 [1906]], *The Standard Edition*, vol. 9, pp. 1–95, and Sigmund Freud, 'Leonardo da Vinci and a Memory of his Childhood' [1910], *The Standard Edition of the Complete Psychological Works of Sigmund Freud*, vol. 11 *(1910): Five Lectures on Psycho-Analysis, Leonardo da Vinci and Other Works*, translated from the German under the general editorship of James Strachey (London: The Hogarth Press, 1957), pp. 57–138.

64 Laplanche, 'Transference: Its Provocation by the Analyst', p. 222.

65 André Green, 'The Unbinding Process', in *On Private Madness* (London: The Hogarth Press and the Institute of Psycho-Analysis, 1986), pp. 331–59. In Green's view, psychoanalytic criticism – because it deals with unconscious processes – should only be carried out by those who have undergone analysis and worked with the unconscious. See p. 338: 'The interpretation of the text becomes the interpretation which the analyst must provide for the text but when all is said and done, it is the interpretation that he must give himself of the effects of the text in his own unconscious. That is why it matters so much that this exercise in self-analysis be preceded by an analysis performed by another or, if one prefers, by an analysis of the Other.'

66 Green, 'The Unbinding Process', p. 338.

67 Green, 'The Unbinding Process', p. 337.

68 André Green, 'The Double and the Absent' [1973], in Alan Roland (ed.), *Psychoanalysis, Creativity, and Literature: A French-American Inquiry* (New York: Columbia University Press, 1978), pp. 271–92, p. 272.

69 Green, 'The Double and the Absent', p. 278.

70 Green, 'The Double and the Absent', p. 278.

71 Laplanche, 'Sublimation and/or Inspiration', p. 50.

72 Sigmund Freud, 'On Beginning the Treatment (Further Recommendations on the Technique of Psycho-Analysis I)' [1913] *The Standard Edition of the Complete Psychological Works of Sigmund Freud*, vol. 12 *(1911–1913): The Case of Schreber, Papers on Technique and Other Works*, translated from the German under the general editorship of James Strachey (London: The Hogarth Press, 1958), pp. 121–44, p. 126 and p. 133. For a detailed description of Freud's consulting room, see Diana Fuss and Joel Sanders, 'Berggasse 19: Inside Freud's Office', in Joel Sanders (ed.), *Stud: Architectures of Masculinity* (New York: Princeton Architectural Press, 1996), pp. 112–39. For an extended discussion of the frame or scene of psychoanalysis in relation to contemporary art practice, see Nixon, 'On the Couch'.

73 Freud, 'On Beginning the Treatment', p. 134.

74 Freud, 'On Beginning the Treatment', p. 126.

75 D. W. Winnicott, 'Metapsychological and Clinical Aspects of Regression Within the Psycho-Analytic Set-Up', *International Journal of Psycho-Analysis*, v. 36 (1955), pp. 16–26, p. 20.

76 Winnicott, 'Metapsychological and Clinical Aspects of Regression', p. 21.

77 Luciana Nissin Momigliano, 'The Analytic Setting: A Theme with Variations', in *Continuity and Change in Psychoanalysis: Letters from Milan* (London and New York: Karnac Books, 1992), pp. 33–61, pp. 33–4. Momigliano points out that in Italy the term 'setting' is used in the Winnicottian sense to 'indicate a safe and constant framework within which the psychoanalytic process evolves', whereas in Anglo-Saxon language this is currently called the 'frame'.

78 José Bleger, 'Psycho-Analysis of the Psycho-Analytic Frame', *International Journal of Psycho-Analysis*, v. 48 (1967), pp. 511–19, p. 518.

79 The French term used is '*baquet*'. See Laplanche, 'Transference: Its Provocation by the Analyst', p. 226, n.

80 The French word used is *écrin*. See André Green, *Key Ideas for a Contemporary Psychoanalysis: Misrecognition and Recognition of the Unconscious* (London: Routledge, 2005), p. 33, n.

81 André Green, 'Potential Space in Psychoanalysis: The Object in the Setting', in Simon A. Grolnick and Leonard Barkin (eds), *Between Reality and Fantasy: Transitional Objects and Phenomena* (New York and London: Jason Aronson Inc., 1978), pp. 169–89, p. 180.

82 See Sigmund Freud, 'Two Encyclopedia Articles: (A) Psycho-Analysis' [1923], *The Standard Edition of the Complete Psychological Works of Sigmund Freud*, vol. 18 *(1920–1922): Beyond the Pleasure Principle, Group Psychology and Other Works*, translated from the German under the general editorship of James Strachey (London: The Hogarth Press, 1955), pp. 235–54.

83 Christopher Bollas, 'Freudian Intersubjectivity: Commentary on Paper by Julie Gerhardt and Annie Sweetnam', *Psychoanalytic Dialogues*, v. 11 (2001), pp. 93–105, p. 93.

84 Freud, 'On Beginning the Treatment', pp. 134–5.

85 Christopher Bollas, *Free Association* (Duxford, Cambridge: Icon Books Ltd, 2002), pp. 4–7.

86 Bollas, *Free Association*, p. 12.

87 Bollas, 'Freudian Intersubjectivity', p. 98.

88 André Green, 'Surface Analysis, Deep Analysis', *International Review of Psycho-Analysis*, v. 1 (1974), pp. 415–23, p. 418.

89 Elizabeth Wright, *Speaking Desires can be Dangerous: The Poetics of the Unconscious* (Cambridge: Polity Press, 1999), p. 19.

90 Sigmund Freud, 'Constructions in Analysis' [1937], *The Standard Edition of the Complete Psychological Works of Sigmund Freud*, vol. 23 *(1937–1939): Moses and Monotheism, An Outline of Psycho-Analysis and Other Works*, translated from the German under the general editorship of James Strachey (London: The Hogarth Press, 1963), pp. 255–70, p. 261.

91 Green, 'The Double and the Absent', p. 274.

92 Rebeccca Swift (ed.), *A.S. Byatt and Ignes Sodré: Imagining Characters: Six Conversations about Women Writers* (London: Chatto & Windus, 1995), p. 245.

93 Jean Laplanche, 'Narrativity and Hermeneutics: Some Propositions', trans. Luke Thurston and John Fletcher, *New Formations*, v. 48 (2002), pp. 26–9, p. 26.

94 Didier Anzieu, *A Skin for Thought: Interviews with Gilbert Tarrab on Psychology and Psychoanalysis* (London and New York: Karnac Books, 1990), p. 34.

95 T. J. Clark, *The Sight of Death: An Experiment in Art Writing* (New Haven and London: Yale University Press, 2006), p. 133. The first intensive period of research occurs over six months from January 2000, but Clarke returns periodically over the next two years.

96 Clark, *The Sight of Death*, p. 133.

97 Clark, *The Sight of Death*, p. 203. The realization that the hands belong to his mother takes place on 6 March 2001, see p. 202. It is not until 20 December 2001 that Clark states categorically that the face of death is his mother's on the mortuary slab, see p. 229.

98 Mary Jacobus, *Psychoanalysis and the Scene of Reading* (Oxford: Oxford University Press, 1999), p. 18. This is a point also made in a slightly different way by Shoshana Felman when she argues that the relation between psychoanalysis and literature

is one of 'interimplication'. Felman argues that the term 'application' locates one field exterior to the other, and suggests instead that the analyst is already inside the text. See Shoshana Felman, 'On Reading Poetry: Reflections on the Limits and Possibilities of Psychoanalytic Approaches', in Joseph H. Smith (ed.), *The Literary Freud: Mechanisms of Defense and the Poetic Will* (New Haven: Yale University Press, 1980), pp. 119–48, p. 145.

99 See David Carrier, *Artwriting* (Amherst: The University of Massachusetts Press, 1987) and David Carrier, *Writing about Visual Art* (New York: Allworth Press co-published with the School of Visual Art, 2003).

100 Carrier, *Writing about Visual Art*, p. 12.

101 Carrier, *Writing about Visual Art*, p. 13.

102 Carrier, *Writing about Visual Art*, p. 179.

103 Norman Bryson, 'Introduction: Art and Intersubjectivity', in Mieke Bal, *Looking in: The Art of Viewing* (Amsterdam: G+B Arts International, 2001), pp. 1–39, p. 12.

104 Bal, *Louise Bourgeois's Spider*, p. xii.

105 Italo Calvino, 'Literature as Projection of Desire', *The Literature Machine* (London: Vintage, 1997), pp. 50–61, p. 58.

106 Calvino, 'Cybernetics and Ghosts', *The Literature Machine*, pp. 3–27, p. 15.

107 Roland Barthes, 'Twenty Keywords for Roland Barthes' [1975], *The Grain of the Voice: Interviews 1962–1980*, trans. Linda Coverdale (Berkeley and Los Angeles: University of California Press, 1991), pp. 205–32, pp. 215–16. Here Barthes is referring to his own autobiography, *Roland Barthes by Roland Barthes* [1975], translated from the French by Richard Howard (London: Macmillan, 1977).

108 Emile Benveniste, *Problems in General Linguistics* [1966], trans. Mary Elizabeth Meek (Florida: University of Miami Press, 1971), p. 225.

109 See for example Stanford Friedman, *Mappings*, for a wonderfully rich discussion of such writers.

110 An exemplary text in this regard is Gloria Anzaldúa, *Borderlands/La Frontera: The New Mestiza* [1987] (San Francisco: Lute Books, 1999).

111 See for example Nancy K. Millar, *Getting Personal: Feminist Occasions and Other Autobiographical Acts* (London: Routledge, 1991) and Susan Rubin Suleiman, *Risking who One is: Encounters with Contemporary Art and Literature* (Cambridge, Mass.: Harvard University Press, 1994).

112 See Tess Cosslett, Celia Lury and Penny Summerfield, 'Introduction', in Tess Cosslett, Celia Lury and Penny Summerfield (eds), *Feminism and Autobiography: Texts, Theories, Methods* (London: Routledge, 2000), pp. 1–21, p. 13.

113 See Cosslett, Lury and Summerfield, 'Introduction', pp. 13–15.

114 I must thank Rosalyn Deutsche for bringing the work of Lynne Tillmann to my attention, and Brigid McLeer and Rob Holloway for pointing me in the direction of Jeanne Randulph and ficto-criticism. See for example Lynne Tillmann, *The Madame Realism Complex* (Columbia University: Semiotext(e), 1992) and Jeanne Randulph, *Psychoanalysis and Synchronized Swimming and other Writings on Art* (Toronto: YYX Books, 1991). The work of Rachel Blau DuPlessis combines theory, fiction and autobiography in her desire to challenge the neutrality of critical writing, specifically through the use of experimental writing strategies including collage, heteroglossia, and self-reflexivity. DuPlessis's work, however, does not focus on providing critical commentaries on art objects. See Rachel Blau DuPlessis, *The Pink Guitar: Writing as Feminist Practice* (London: Routledge, 1990), especially p. viii for a discussion of her approach.

115 See Bruce Grenville, 'Introduction', Randulph, *Psychoanalysis and Synchronized*

Swimming, pp. 12–17, pp. 12–13.

116 See for example Peggy Phelan, *Unmarked: Politics of Performance* (London: Routledge, 1993) and Peggy Phelan, 'To Suffer a Sea Change', *The Georgia Review*, v. 45, n. 3 (Fall 1991), pp. 507–25.

117 Della Pollock, 'Performing Writing', in Peggy Phelan and Jill Lane (eds), *The Ends of Performance* (New York: New York University Press, 1998), pp. 73–103.

118 Butt (ed.), *After Criticism*.

119 See for example Maria Fusco (ed.), 'The Dream that Kicks: Transdisciplinary Practice in Action', special issue of *a-n (Artists' Newsletter)* (London, 2006). See also *The Happy Hypocrite*, a new journal edited by Fusco.

120 See for example Brigid McLeer, 'From "A…" to "B…": A Jealousy', Peg Rawes and Jane Rendell (eds), *Spatial Imagination* (London: The Bartlett School of Architecture, UCL, 2005), pp. 22–3, and Ken Ehrlich and Brandon LaBelle (eds), *Surface Tension Supplement*, n. 1 (Copenhagen and Los Angeles: Errant Bodies Press, 2006).

121 For alternative strategies of critical writing by poets and others see for example Juliana Spahr, Mark Wallace, Kristen Prevallet and Pam Rehm (eds), *A Poetics of Criticism* (Buffalo, New York: Leave Books, 1994). For an account of critics exploring creativity in critical writing see Rob Pope, *Textual Intervention: Critical and Creative Stategies for Literary Studies* (London: Routledge, 1995).

122 See for example Iain Biggs, *Between Carterhaugh and Tamsheil Rig: A Borderline Episode* (Bristol: Wild Conversation Press, 2004) and Mike Pearson, *In comes I: Performance, Memory and Landscape* (Exeter: University of Exeter Press, 2007).

123 See for example the work of Carolyn Bergvall, Redell Olsen and Kristen Krieder. See Carolyn Bergvall, *Éclat* (pdf edition, ububooks, 2004) http://www.ubu.com/ubu/bergvall_eclat.html (accessed 15 July 2008); Carolyn Bergvall, *Fig*, (Cambridge: Salt Publishing, 2005); Redell Olsen, *Book of the Fur* (Cambridge: Rem Press, 2000); and Kristen Krieder, 'Toward a Material Poetics: Sign, Subject and Site' (University of London, unpublished PhD thesis, 2008).

124 See the work of Sue Golding (Johnny de Philo) and Yves Lomax. See Sue Golding (Johnny de Philo), 'Games of Truth: A Blood Poetics in Seven Part Harmony (this is me speaking to you)', an Inaugural Lecture delivered at the University of Greenwich, 27 March 2003; Yves Lomax, *Writing the Image: An Adventure with Art and Theory* (London: I.B.Tauris, 2000); and Yves Lomax, *Sounding the Event: Escapades in Dialogue and Matters of Art, Nature and Time* (London: I.B.Tauris, 2005).

125 I teach 'site-specific writing' as part of the MA in Architectural History at the Bartlett School of Architecture, UCL, as does Redell Olsen in the MA in Poetic Practice at Royal Holloway. See http://www.rhul.ac.uk/english/studying/Postgraduate-Study/MA/PoeticPractice.html (accessed 15 July 2008).

126 Mary Ann Caws, *A Metapoetics of the Passage: Architextures in Surrealism and After* (Hanover and London: University Press of New England, 1981), p. xiv.

127 See Guiliana Bruno, *Atlas of Emotion: Journeys in Art, Architecture and Film* (London: Verso, 2002).

128 See AKAD: The Academy for Practice-based Research in Architecture and Design) http://www.akad.se/progwri.htm (accessed 15 July 2008). See also Katja Grillner, 'The Halt at the Door of the Boot-Shop', in Katja Grillner, Per Glembrandt, Sven-Olov Wallenstein (eds), *01.AKAD* (Stockholm: AKAD and Axl Books, 2005), pp. 68–9; Katja Grillner, 'Writing and Landscape – Setting Scenes for Critical Reflection', in Jonathan Hill (ed.), *Opposites Attract*, special issue of *Journal of Architecture*, v. 8, n. 2 (2003), pp. 239–49; and Katja Grillner, *Ramble, Linger and Gaze: Dialogues from the Landscape Garden* (Stockholm: Axl Books, 2000). See also the work of Rolf Hughes

for a discussion of the role of writing in design. For example Rolf Hughes, 'The DROWNING METHOD: On Giving an Account in Practice-Based Research', in Rendell, Hill, Fraser and Dorrian (eds), *Critical Architecture*, pp. 92–102, and Rolf Hughes, 'The Poetics of Practice-Based Research', in Hilde Heynen (ed.), *Unthinkable Doctorates?*, special issue of *Journal of Architecture*, v. 11, n. 3 (2006), pp. 283–301. See also Katerina Bonnevier, *Behind Straight Curtains: Towards a Queer Feminist Theory of Architecture* (Stockholm: Axl Books, 2007) and Lilian Chee, 'An Architecture of Intimate Encounter: Plotting the Raffles Hotel through Flora and Fauna (1887–1925; 1987–2005)' (University of London, unpublished PhD thesis, 2006).

129 Karen Bermann, 'The House Behind', in Heidi J. Nast and Steve Pile (eds), *Places Through the Body* (London: Routledge, 1998), pp. 165–80.

130 Jennifer Bloomer, 'Big Jugs', in Arthur Kroker and Marilouise Kroker (eds), *The Hysterical Male: New Feminist Theory* (London: Macmillan Education 1991), pp. 13–27, and Jennifer Bloomer, *Architecture and the Text: The (S)crypts of Joyce and Piranesi* (New Haven and London: Yale University Press, 1993).

131 Bal, *Louise Bourgeois's Spider.*

132 Caygill, *Walter Benjamin.*

Configuration 1

1 André Green, 'The Intrapsychic and Intersubjective in Psychoanalysis', *Psychoanalysis Quarterly* v. 69 (2000), pp. 1–39, p. 3.

2 Gregorio Kohon (ed.), *The British School of Psychoanalysis: The Independent Tradition* (London: Free Association Books, 1986), p. 20. The British School of Psychoanalysis consists of psychoanalysts belonging to the British Psycho-Analytical Society. Within this society are three groups: the Kleinian Group, the 'B' Group (followers of Anna Freud) and the Independent Group.

3 Klein describes the early stages of childhood development in terms of different 'positions'. The paranoid schizophrenic position characterizes the child's state of one-ness with the mother, where he or she relates to part-objects such as the mother's breast as either good or bad, satisfying or frustrating. See Melanie Klein, 'Notes on Some Schizoid Mechanisms' [1946], in *Envy and Gratitude and Other Worlds 1946–1963* (London: Virago, 1988), pp. 1–24. This position is replaced by a depressive stage, where in recognizing its own identity and that of the mother as a whole person, the child feels guilty for the previous aggression inflicted on the mother. See Melanie Klein, *Love, Guilt and Reparation and Other Works 1921–1945* (London: The Hogarth Press and the Institute of Psycho-Analysis, 1981).

4 D.W. Winnicott, 'Transitional Objects and Transitional Phenomena: A Study of the First Not-Me Possession', *International Journal of Psycho-Analysis*, v. 34 (1953), pp. 89–97, see in particular pp. 89 and 94. See also D.W. Winnicott, 'The Use of an Object', *International Journal of Psycho-Analysis*, v. 50 (1969), pp. 711–16.

5 Winnicott discusses cultural experience as located in the 'potential space' between 'the individual and the environment (originally the object)'. In Winnicott's terms, for the baby this is the place between the 'subjective object and the object objectively perceived'. See D.W. Winnicott, 'The Location of Cultural Experience', *International Journal of Psycho-Analysis*, v. 48 (1967), pp. 368–72, p. 371. See also D.W. Winnicott, *Playing and Reality* (London: Routledge, 1991).

6 André Green, 'Potential Space in Psychoanalysis: The Object in the

Setting', in Simon A. Grolnick and Leonard Barkin (eds), *Between Reality and Fantasy: Transitional Objects and Phenomena* (New York and London: Jason Aronson Inc., 1978), pp. 169–89, p. 180.

7 André Green, 'The Analyst, Symbolization and Absence in the Analytic Setting (On Changes in Analytic Practice and Analytic Experience) – In Memory of D.W. Winnicott', *International Journal of Psycho-Analysis* v. 56 (1975), pp. 1–22, p. 12.

8 Green, 'Potential Space in Psychoanalysis', p. 180.

9 'The Greening of Psychoanalysis: André Green in Dialogues with Gregorio Kohon', in Gregorio Kohon (ed.), *The Dead Mother: The Work of André Green* (London: Routledge, published in association with the Institute of Psycho-Analysis, 1999), pp. 10–58, p. 29.

10 Michael Parsons, 'Psychic Reality, Negation, and the Analytic Setting', in Kohon (ed.), *The Dead Mother*, pp. 59–75, p. 74.

11 Parsons, 'Psychic Reality', p. 74.

12 'The Greening of Psychoanalysis', p. 53.

13 Parsons, 'Psychic Reality', p. 65. Parsons quotes from his own translation of André Green, 'Le langage dans la psychanalyse', *Langages: Rencontres Psychanalytiques d'Aix-en-Provence 1983* (Paris: Les Belles Lettres, 1984), pp. 19–250, p. 123.

14 'The Greening of Psychoanalysis', p. 53.

15 'The Greening of Psychoanalysis', p. 53.

16 Jessica Benjamin, *Shadow of the Other: Intersubjectivity and Gender in Psychoanalysis* (London: Routledge, 1998), p. 28, n. 5. Benjamin originally made this argument in Jessica Benjamin, 'The Omnipotent Mother: A Psychoanalytic Study of Fantasy and Reality', in *Like Subjects/Love Objects* (New Haven: Yale University Press, 1995), pp. 81–113, especially pp. 96–7.

17 Benjamin, *Shadow of the Other*, p. xiv.

18 Jessica Benjamin, 'Response to Commentaries by Mitchell and by Butler', *Studies in Gender and Sexuality*, v. 1 (2000), pp. 291–308, p. 302.

19 Benjamin, 'Response', p. 305.

20 Benjamin, 'Response', p. 306.

21 Benjamin, 'Response', p. 305.

22 Jessica Benjamin, 'Beyond Doer and Done To: An Intersubjective View of Thirdness', *The Third in Psychoanalysis*, special issue of *Psychoanalytic Quarterly*, v. 73, n. 1 (2004), pp. 5–46, p. 5.

23 The following text is based on Jane Rendell, 'Doing it, (Un)Doing it, (Over)Doing it Yourself: Rhetorics of Architectural Abuse', in Jonathan Hill (ed.), *Occupying Architecture* (London: Routledge, 1998), pp. 229–46, but radically shortened and reworked. See also another alternative version, Jane Rendell, '(Un)doing it Yourself: Rhetorics of Architectural Abuse', *The Journal of Architecture*, v. 4 (Spring 1999), pp. 101–10, see http://www.informaworld.com (accessed 3 June 2009).

24 Benjamin, *Shadow of the Other*, p. 80.

25 Audré Lourde, 'The Master's Tools will never Dismantle the Master's House' [1979], Jane Rendell, Barbara Penner and Iain Borden (eds), *Gender, Space, Architecture: An Interdisciplinary Introduction* (London: Routledge, 1999), pp. 53–5, p. 54.

26 Luce Irigaray, 'Any Theory of the "Subject" has always been Appropriated by the "Masculine"' [1974], *Speculum of the Other Woman*, translated by Gillian C. Gill (Ithaca, New York: Cornell University Press, 1985), pp. 133–46, p. 133.

27 See Pierre Bourdieu, *Distinction: A Social Critique of the Judgement of Taste* [1979], trans. Richard Nice (London: Routledge & Kegan Paul, 1984).

28 Hélène Cixous, 'Sorties' [1975], translated by Betsy Wing, in Susan Sellers (ed.),

The Hélène Cixous Reader (London: Routledge, 1994), pp. 37–44, p. 43.

29 For drawings and photographs see for example Juhani Pallasmaa with Andrei Gozak, *The Melnikov House, Moscow (1927–1929)*, trans. Catherine Cooke (London: Academy Editions, 1996).

30 Luce Irigaray, *Elemental Passions* [1982], trans. Joanne Collie and Judith Still (London: The Athlone Press, 1992), p. 47.

31 Cixous, 'Sorties' [1975], translated by Betsy Wing, p. 43.

32 Irigaray, *Elemental Passions*, pp. 63, 65 and 66.

33 Luce Irigaray, 'Volume-Fluidity' [1974], *The Speculum of the Other Woman*, trans. Gillian C. Gill (Ithaca, New York: Cornell University Press, 1985), pp. 227–40, p. 229.

34 Luce Irigaray, 'Sexual Difference' [1984], in *An Ethics of Sexual Difference* [1984], trans. Carolyn Burke and Gillian C. Gill (Ithaca, New York and London: Cornell University Press and Continuum, 1993), pp. 5–19, p. 11.

35 Hélène Cixous, 'Sorties' [1975], trans. Ann Liddle, in Elaine Marks and Isabelle de Courtivron (eds), *New French Feminisms* (London: Harvester Wheatsheaf, 1981), pp. 90–8, p. 95.

36 Cixous, 'Sorties' [1975], translated by Betsy Wing, p. 44.

37 Hélène Cixous, *Three Steps on the Ladder to Writing* [1990], trans. Sarah Conell and Sarah Sellers (New York: Columbia University Press, 1993), p. 5.

38 Irigaray, 'Sexual Difference', p. 15.

39 This piece was originally drafted directly after seeing Tracey Emin, *You Forgot to Kiss my Soul* (2001), White Cube, London. I have reworked it here in reference to the large body of criticism which has been written around Emin and her work in subsequent years.

40 All the text in italics which is set in from the margin but not as a quotation is taken from the words on the gallery walls of Tracey Emin, *You Forgot to Kiss my Soul* (2001). This includes artworks themselves, titles of artworks, captions and words within artworks made of diverse materials – textile, ink and neon.

41 Robert Preece, 'Exposed: A Conversation with Tracey Emin', *Sculpture* (November 2002), pp. 38–43, p. 40.

42 Tracey Emin, *You Forgot to Kiss my Soul* (2001), White Cube, London. Exhibition flyer.

43 Neal Brown, *TE: Tracey Emin* (London: Tate Publishing, 2006), pp. 83–6.

44 Jeanette Winterson, 'Foreword', in *Tracey Emin Works 1963–2006* (New York: Rizzoli, 2006), pp. 6–7, p. 6.

45 Tracey Emin's first public sculpture, *Roman Standard* (2005), also features a small bird cast in bronze on top of a four-metre-high column positioned in front of The Oratory, next to the Anglican Cathedral on Upper Duke Street. See http://www.bbc.co.uk/liverpool/content/articles/2005/02/17/capculture_traceyemin_feature.shtml (accessed 29 February 2008).

46 Mark Durden, 'The Authority of Authenticity: Tracey Emin', *Parachute*, n. 105 (January–March 2002), pp. 20–37, p. 35.

47 Brown, *TE*, p. 96.

48 Sarah Valdez, '*Tracey Emin* at Lehmann Maupin', *Art in America*, v. 94, n. 5 (May 2006), pp. 180–1, p. 181.

49 Valdez, '*Tracey Emin*', p. 181. The development of this use of dual materials to create psychological constructs has continued into the combination of 'neon and heavier materials' in *You Turn Me On* (2007) for *You Left Me Breathing* (2007), Gagosian, Beverly Hills, and *Borrowed Light* (2007), British Pavilion, Venice Biennale. See Shana Nys Dambrot, *Tracey Emin: You Left Me Breathing*, Art Review, n. 19 (February 2008), p. 121, and Tracey Emin, *Borrowed Light*, British Pavilion,

Venice Biennale (2007) (London: British Council, 2007), pp. 53–9, which includes sketches of tower-like structures made for the show.

50 See Tracey Emin, *Strangeland* (London: Hodder and Stoughton, 2005), p. 5.

51 Unlike the converted rice factory in Toyko where it was first shown, Emin felt the small room in the Lehmann Maupin Gallery in New York failed to make *My Bed* strange, to transform it from a familiar domestic object into art. See Preece, 'Exposed', p. 42. See also Carl Freedman interviewing Tracey Emin, 'Break on Through to the Other Side', in *Tracey Emin Works*, pp. 251–6, p. 252. Deborah Cherry notes that for *My Bed* (1998–99) the objects, such as a pair of suitcases, which accompany the bed, changed and were organized differently in each site. In Toyko the suitcases were distant from the bed, in New York they were absent and in London they reappeared close to the bed, on the other side of it, separated from the messy bedtime companions of vodka bottles, dirty knickers and bloody condoms. See Deborah Cherry, 'On the Move: My Bed, 1998 to 1999', in Mandy Merck and Chris Townsend (eds), *The Art of Tracey Emin* (London: Thames and Hudson, 2002), pp. 134–54.

52 Preece, 'Exposed', p. 42.

53 See sketches *Margate Harbour 16/5/95* (1995); *Light House 15/5/95* (1995); *Big Wheel 16/5/95* (1995); *Margate 15/5/95* (1995); and *The Lido 16/5/95* (1995), in *Tracey Emin Works*, pp. 187–91 and 326–33, positioned just after a photograph of *Self-portrait* (2001).

54 Rudi Fuchs, 'Tracey Emin: A Particular History', in *Tracey Emin: When I think about Sex … White Cube, 27 May – 25 June 2005* (London: Jay Joplin/White Cube, 2005), pp. 6–18, p. 6.

55 Preece, 'Exposed', p. 43. The catalogue for *This is Another Place* features a photograph of a collapsed pier (double spread), followed by scale models in white of *Knowing my Enemy* and paper spirals. See *Tracey Emin: This is Another Place* (Oxford: Modern Art Oxford, 2002).

56 The issue of transitory space is one explored by Deborah Cherry in relation to the changing configuration of *My Bed* (1998–99) across its three locations: Toyko, New York and London. This is important for Cherry, whose discussion of Emin's work draws attention to the legal framework of asylum and immigration being debated and reformulated in the UK at the same time as the display of *My Bed*. See Cherry, 'On the Move', especially pp. 138–9 for beds, suitcases and homelessness; p. 151 for connections to immigration; and p. 153 for a discussion of temporary structures.

57 As a bodily gesture in space, the out-of-place feeling you get after spinning around on the spot can be described as a feminine topography. The spiral and the spinning figure in Louise Bourgeois's work have been linked to Irigaray's essay 'Gesture in Psychoanalysis' [1985], in Luce Irigaray, *Sexes and Genealogies*, trans. Gillian C. Gill (New York: Columbia University Press, 1993), pp. 89–104. See Hilary Robinson, 'Louise Bourgeois's Cells: Gesturing towards the Mother', in Ian Cole (ed.), *Museum of Modern Art Papers*, vol. 1 (Oxford: Museum of Modern Art Oxford, 1996), pp. 21–30. In terms of form and content, it is hard not to draw comparisons between Louise Bourgeois and Emin. Indeed Emin refers to the influence of Bourgeois's work herself. See Preece, 'Exposed', p. 40. Both Bourgeois and Emin work at a monumental scale, use needlework and explore the complexities of their own emotional histories. Emin's various smaller-scale constructions correspond to Bourgeois's lairs and her *Femme Maison* (1947), and the larger sculptures allow spatial associations to be made with Bourgeois's web-like structures, with their references to spirals, for example *I do, I redo, I undo*

(2000), and spiders, for example, *Maman* (2000). See for example *Louise Bourgeois* (London: Tate Gallery Publishing, 2000); Mieke Bal, *Louise Bourgeois's Spider: The Architecture of Art-Writing* (London and Chicago: University of Chicago Press, 2001); and Mignon Nixon, *Fantastic Reality: Louise Bourgeois and a Story of Modern Art* (Cambridge, Mass.: The MIT Press, 2005).

58 Jennifer Doyle describes how 'Everyone is trying to "pick-up" Emin as if the use of props from her everyday life (like her bed) and personal experiences (like pregnancy and abortion) constitutes an invitation to think about Emin the artist as an always-already available sexual object …'. See Jennifer Doyle, 'The Effect of Intimacy: Tracey Emin's Bad Sex Aesthetics', *Sex Objects: Art and the Dialectics of Desire* (Minneapolis: University of Minnesota Press, 2006), pp. 97–120, p. 107.

59 'Transcript of *Conversation with my Mum* (2001)', *Tracey Emin Works*, pp. 302–15, pp. 307–8.

60 Emin's father gave her the small chairs. See Preece, 'Exposed', p. 40.

61 *Conversation with my Mum* can be compared with *The Interview* (1999) shown at Lehmann Maupin in 1999, along with *My Bed* (1998) and *The Hut* (1999) for *Every Part of Me's Bleeding. The Interview* (1999), 47 × 47 × 25 in, comprised a white video monitor placed on the floor, two white chairs and pairs of slippers. As in *The Bailiff* (2001), in *The Interview* one version of Tracey interviews another; they are seated at the two ends of a sofa, one in a hooded top, the other in a low-cut black dress smoking and drinking. *The Interview* prefigures two of the works in *You Forgot to Kiss my Soul: The Bailiff* in terms of subject matter and *Conversation with my Mum* in format.

62 Doyle describes how Emin's work invites the spectator to mimetically identify with the affect of the work. See Doyle, 'The Effect of Intimacy', p. 110.

63 See for example Sarah Wigglesworth, 'Critical Practice', in Jane Rendell (ed.), *Critical Architecture*, special issue of *Journal of Architecture*, v. 10, n. 3 (June 2005), pp. 335–46, especially pp. 139–42 and figures a, b, c and d on pp. 141–2.

64 Jean Wainwright, 'Interview with Tracey Emin', Merck and Townsend (eds), *The Art of Tracey Emin*, pp. 195–209, pp. 202–4.

65 Kim Chernin, *The Hungry Self: Women, Eating and Identity* (New York: Harper and Row, 1985), see pp. xiii, 130 and 201.

66 Many of these works come out of a long tradition of radical feminist artists in the United States in the 1970s exploring female sexuality and desire through an interest in materials and processes traditionally connected with women's work such as sewing and also storytelling. Rosemary Betterton has discussed this relationship in detail and draws attention to Emin's denial of any connection between her own work and this genre of feminist textile art, led by such artists as Janis Jeffries. See Rosemary Betterton, 'Why is my Art not as Good as Me? Femininity, Feminism, and Life-Drawing in Tracey Emin's Art', in Merck and Townsend (eds), *The Art of Tracey Emin*, pp. 22–39, especially pp. 34–7.

67 Benjamin, *Shadow of the Other*, pp. 30–1.

68 Michael Gibbs, '*Tracey Emin:* Stedelijk Museum, Amsterdam', *Art Monthly*, n. 262 (December 2002–January 2003), pp. 32–3, p. 35.

69 'The great question that has never been answered and which I have not been able to answer despite my thirty years of research into the feminine soul, is "What does a woman want?"', Sigmund Freud, letter to Marie Bonaparte, quoted in Ernest Jones, *The Life and Work of Sigmund Freud* [1953–57], edited and abridged in one volume by Lionel Trilling and Steven Marcus (London: Penguin Books in association with Hogarth Press, 1964), p. 474. For a discussion of the issues raised for feminist psychoanalytic critiques by this quote, see Shoshana Felman

in *What Does a Woman Want? Reading and Sexual Difference* (Baltimore, Maryland: John Hopkins University Press, 1993), p. 2, and Griselda Pollock, 'Thinking the Feminine: Aesthetic Practice as Introduction to Bracha Ettinger and the Concepts of Matrix and Metramorphosis', *Theory, Culture & Society*, v. 21, n. 1 (2004), pp. 5–64, see especially pp. 28–9 and 35–6.

70 http://www.tate.org.uk/btseries/bb/traceyemin/explore/shed_walkthru.htm (accessed 29 February 2008).

71 See Brown, *TE*, p. 96.

72 http://www.tate.org.uk/btseries/bb/traceyemin/explore/shed_walkthru.htm (accessed 29 February 2008). See also Carl Freedman interviewing Tracey Emin, 'The Turn of the Screw', in *Tracey Emin Works*, pp. 326–33, pp. 331–2.

73 Freedman interviewing Tracey Emin, 'The Turn of the Screw', pp. 331–2.

74 Brown, *TE*, pp. 37 and 44.

75 Durden, 'The Authority of Authenticity', p. 35

76 It is usually the mother who is referred to in relation to the *fort/da* game Freud describes his grandson playing with a cotton reel. I discuss this in more detail in *Configuration 2: To and Fro*. See Sigmund Freud, 'Beyond the Pleasure Principle' [1920], in *The Standard Edition of the Complete Psychological Works of Sigmund Freud*, vol. 18 *(1920–1922): Beyond the Pleasure Principle, Group Psychology and Other Works* (London: The Hogarth Press, 1955), pp. 1–64, pp. 14–15.

77 Doyle suggests that Emin invites the spectator to identify with her 'outsiderness'. See Doyle, 'The Effect of Intimacy', p. 119.

78 This text is taken and the layout slightly modified from 'Transcript of *The Bailiff* (2001)', *Tracey Emin Works*, p. 44.

79 These appliquéd banners have been compared to infant school display pieces, quilts, folk art, political and union banners and satchel art by Brown, and connected to female domestic labour and the Suffrage and peace banners of the women's movement by Betterton. See Brown, *TE*, pp. 37–44, and Betterton, 'Why is my Art', p. 37.

80 Betterton, 'Why is my Art', p. 29.

81 Susan Rubin Suleiman, *Risking who One is: Encounters with Contemporary Art and Literature* (Cambridge, Mass.: Harvard University Press, 1994), p. 3.

82 Connections can be drawn between the work of Emin and Sophie Calle owing to their shared interest in autobiography. However, while Emin's works from the late 1990s and early 2000s revel in the dramatic act of publicly exposing intimate details, Calle constructs versions of the self that are more self-consciously manipulated, for example *The Birthday Ceremony* (1998) and *Appointment with Sigmund Freud* (1999). The Venice Bienalle of 2007, with Emin representing Great Britain and Calle France, invited direct comparison between their practices. Calle's more intellectual and reserved approach is exemplified in *Prenez soin de vous* (Take Care of Yourself), which documents in elaborate detail the prelude and aftermath of the breakup of the artist's relationship but through the voices of others. Emin's *Borrowed Light* continues her shift of gear away from the bloody and visceral towards works which are more formal and restrained, favouring pastel colours and delicate, brittle materials, though the themes of emotional pain and sexual rejection remain the same.

83 Doyle, 'The Effect of Intimacy', p. 116.

84 Doyle, 'The Effect of Intimacy', p. 115.

85 This piece of work was originally installed as Jane Rendell, *Confessional Constructions* (2002), *LLAW*, curated by Brigid McLeer, BookArtBookShop, London. It was

then performed as part of a poetry reading at The Foundry, London, in 2003 and published as part of longer essays in Jane Rendell, 'Between Two: Theory and Practice', in Jonathan Hill (ed.), *Opposites Attract*, special issue of *Journal of Architecture* v. 8 (Summer 2003), pp. 221–37, see http://www.informaworld.com (accessed 3 June 2009); Jane Rendell, 'Architectural History as Critical Practice', in Elisabeth Tostrop and Christian Hermansen (eds), *Context: (theorising) History in Architecture* (Oslo: Olso School of Architecture, 2003), pp. 17–29; and Jane Rendell, 'From Architectural History to Spatial Writing', in Elvan Altan Ergut, Dana Arnold and Belgin Turan Ozkaya (eds), *Rethinking Architectural Historiography* (London: Routledge, 2006), pp. 135–50. I also described my performance of Jane Rendell, 'Travelling the Distance/Encountering the Other', in David Blamey (ed.), *Here, There, Elsewhere: Dialogues on Location and Mobility* (London, Open Editions, 2002), pp. 43–54; see *Configuration 2: To and Fro* of this book, as part of *taking place*, University of North London, November 2001, as a 'confessional construction'. See for example Katie Lloyd Thomas, Teresa Hoskyns and Helen Stratford, 'taking place', *Scroope: Cambridge Architecture Journal*, n. 14 (2002), pp. 44–8. A script of this performance was also published as part of Jane Rendell, 'How to Take Place (but only for so long)', in Doina Petrescu (ed.), *Altering Practices: Feminist Politics and Poetics of Space* (London: Routledge, 2007), pp. 69–87.

86 In the text that follows the main statements are in bold, the critical reflections in italics and the footnotes in regular font.

Configuration 2

1 Sigmund Freud, 'On Dreams' [1901], *The Essentials of Psycho-analysis*, trans. James Strachey (London: Penguin Books, 1986), pp. 81–125, p. 117. See also Sigmund Freud, 'On Dreams' [1901], *The Standard Edition of the Complete Psychological Works of Sigmund Freud*, vol. 5 *(1900–1901): The Interpretation of Dreams (Second Part) and On Dreams*, translated from the German under the general editorship of James Strachey (London: The Hogarth Press, 1953), pp. 629–86, p. 676.

2 André Green, *Key Ideas for a Contemporary Psychoanalysis: Misrecognition and Recognition of the Unconscious* (London: Routledge, 2005), p. 100.

3 Green, *Key Ideas*, p. 98.

4 Sigmund Freud, 'The Unconscious' [1915], *The Standard Edition of the Complete Psychological Works of Sigmund Freud*, vol. 14 *(1914–1916): On the History of the Psycho-Analytic Movement, Papers on Metapsychology and Other Works*, translated from the German under the general editorship of James Strachey (London: The Hogarth Press, 1957), pp. 159–215, p. 180. See also Sigmund Freud, 'Repression' [1915], *The Standard Edition*, vol. 14, pp. 141–58.

5 Sigmund Freud, 'Beyond the Pleasure Principle' [1920], *The Standard Edition of the Complete Psychological Works of Sigmund Freud*, vol. 18 *(1920–1922): Beyond the Pleasure Principle, Group Psychology and Other Works* (London: The Hogarth Press, 1955), pp. 1–64, p. 8.

6 Jean Laplanche and J.B. Pontalis, *The Language of Psycho-Analysis*, trans. Donald Nicholson-Smith (London: Karnac and the Institute of Psycho-Analysis, 1973), p. 78.

7 Robert Rogers, 'Freud and the Semiotics of Repetition', *Poetics Today*, v. 8, ns. 3–4 (1987), pp. 579–90, p. 582.

8 Sigmund Freud, 'Remembering, Repeating and Working Through' [1914], *The*

Standard Edition of the Complete Psychological Works of Sigmund Freud, vol. 12 *(1911–1913): The Case of Schreber, Papers on Technique and Other Works*, translated from the German under the general editorship of James Strachey (London: The Hogarth Press, 1958), pp. 145–56.

9 Freud, 'Beyond the Pleasure Principle', pp. 14–15.

10 See Jacques Derrida, 'Coming Into One's Own', trans. James Hulbert, in Geoffrey Hartman (ed.), *Psychoanalysis and the Question of the Text* (Baltimore: John Hopkins University Press, 1978), pp. 114–48.

11 Derrida, 'Coming Into One's Own', p. 136.

12 Rogers, 'Freud and the Semiotics of Repetition', p. 587.

13 See Jacques Lacan, 'The Purloined Letter' [1955], *The Seminars of Jacques Lacan, Book II: The Ego in Freud's Theory and in the Technique of Psychoanalysis 1954–1955*, trans. Sylvana Tomaselli, ed. Jacques-Alain Miller, with notes by John Forrester (London and New York: W.W. Norton and Company, 1991), pp. 191–205.

14 Rogers, 'Freud and the Semiotics of Repetition', p. 589. Rogers quotes from Shoshana Felman, 'On Reading Poetry: Reflections on the Limits and Possibilities of Psychoanalytic Approaches', in Joseph H. Smith (ed.), *The Literary Freud: Mechanisms of Defense and the Poetic Will* (New Haven: Yale University Press, 1980), pp. 119–48.

15 See Jean Laplanche, 'Notes on Afterwardsness' [1992], *Essays on Otherness*, ed. John Fletcher (London: Routledge, 1999), pp. 260–5, p. 265. This chapter is based on a conversation between Jean Laplanche and Martin Stanton that took place in 1991, later revised by Laplanche.

16 For a reproduction of the original image see Sigmund Freud, 'Zur Auffassung der Aphasien' [1891], Vienna, translated as Sigmund Freud, *On Aphasia: A Critical Study* (New York: International Universities Press, 1953), p. 77, fig. 8. An extract from the 1891 text including the drawing relabelled is reprinted as 'Appendix C: Word and Things', in Freud, 'The Unconscious', p. 214.

17 Sigmund Freud, 'Draft G. Melancholia' [1894], *The Complete Letters of Sigmund Freud to Wilhelm Fliess, 1887–1904*, trans. and ed. Jeffrey Moussaieff Masson (Cambridge, Mass.: Belknap Press of Harvard University Press, 1985), pp. 98–105, p. 100.

18 Sigmund Freud, 'Draft M. The Architecture of Hysteria, 25 May 1897' [1897], *The Complete Letters*, pp. 246–8, p. 247.

19 See figs 1–3 in Sigmund Freud, 'The Interpretation of Dreams (Second Part)' [1901], *The Standard Edition of the Complete Psychological Works of Sigmund Freud*, vol. 5 *(1900-1901): The Interpretation of Dreams (Second Part) and On Dreams*, translated from the German under the general editorship of James Strachey (London: The Hogarth Press, 1953), pp. 339–627, pp. 537, 538 and 541.

20 Freud, 'The Interpretation of Dreams (Second Part)', p. 610.

21 Freud, 'The Interpretation of Dreams (Second Part)', p. 611.

22 Sigmund Freud, 'Introductory Lectures on Psycho-Analysis' [1917], *The Standard Edition of the Complete Psychological Works of Sigmund Freud*, vol. 16 *(1916–1917): Introductory Lectures on Psycho-Analysis (Part III)*, translated from the German under the general editorship of James Strachey (London: The Hogarth Press, 1963), pp. 241–463, 'Lecture IX: Resistance and Repression', pp. 286–302, p. 295. Diana Fuss and subsequently Charles Rice have picked up on Freud's use of this domestic architectural metaphor to describe the relationship between the ego, superego and id, with Rice making the interesting point that it 'doubles the domestic situation experienced by Freud's clientele'. See Diana Fuss, *The Sense of an Interior: Four Rooms and the Writers that Shaped Them* (London: Routledge, 2004),

p. 6, and Charles Rice, *The Emergence of the Interior: Architecture, Modernity, Domesticity* (London: Routledge, 2007), pp. 39–40.

23 Freud, 'The Unconscious', pp. 173–6.

24 Freud, 'The Unconscious', p. 180. See also Freud, 'Repression', pp. 141–58.

25 Sigmund Freud, 'The Ego and the Id' [1923], *The Standard Edition of the Complete Psychological Works of Sigmund Freud*, vol. 19 *(1923–1925): The Ego and the Id and Other Works*, translated from the German under the general editorship of James Strachey (London: The Hogarth Press, 1961), pp. 1–308, p. 56.

26 Freud, 'The Ego and the Id', p. 24.

27 Sigmund Freud, 'The Dissection of the Psychical Personality' [1933], *The Standard Edition of the Complete Psychological Works of Sigmund Freud*, vol. 22 *(1932–1936): New Introductory Lectures on Psycho-Analysis and Other Works*, translated from the German under the general editorship of James Strachey (London: The Hogarth Press, 1964), pp. 57–80, p. 72.

28 Freud, 'The Dissection of the Psychical Personality', p. 78.

29 Didier Anzieu (ed.), *Psychic Envelopes*, trans. Daphne Briggs (London: Karnac Books, 1990), p. 51.

30 Anzieu (ed.), *Psychic Envelopes*, p. 48.

31 Didier Anzieu, *The Skin Ego: A Psychoanalytic Approach to the Self*, trans. Chris Turner (New Haven: Yale University Press, 1989), p. 75.

32 Didier Anzieu, *A Skin for Thought: Interviews with Gilbert Tarrab on Psychology and Psychoanalysis* (London: Karnac Books, 1990), pp. 65–6.

33 Elizabeth Grosz, *Volatile Bodies: Toward a Corporeal Feminism* (Bloomington and Indianapolis: Indiana University Press, 1994), p. 35.

34 Grosz, *Volatile Bodies*, p. 37.

35 Green, *Key Ideas*, p. 128.

36 Green, *Key Ideas*, p. 128.

37 Anzieu, *A Skin for Thought*, p. 43.

38 Sigmund Freud, 'A Note upon the "Mystic Writing-Pad"' [1925], *The Standard Edition*, vol. 19, pp. 225–32, p. 230.

39 Previous incarnations of this series of transformations have been published as Jane Rendell, 'Back and Forth', in Maria Fusco (ed.), *The Dream that Kicks: Transdisciplinary Practice in Action*, special issue of *a-n (Artists' Newsletter)* (2006), pp. 10–12, see www.a-n.co.uk/publications/topic/31022 (accessed 9 June 2009), and Jane Rendell, 'Site-Writing: Enigma and Embellishment', in Jane Rendell, Jonathan Hill, Murray Fraser and Mark Dorrian (eds), *Critical Architecture* (London: Routledge, 2007), pp. 150–62.

40 The following text is based on one first published as Jane Rendell, 'Travelling the Distance/Encountering the Other', in David Blamey (ed.), *Here, There, Elsewhere: Dialogues on Location and Mobility* (London: Open Editions, 2002), pp. 43–54 but radically shortened and reworked.

41 bell hooks, *Yearnings: Race, Gender, and Cultural Politics* (London: Turnaround Press, 1989), p. 148.

42 Caren Kaplan, *Questions of Travel: Postmodern Discourses of Displacement* (Durham, North Carolina: Duke University Press, 1996), p. ix.

43 Rosi Braidotti, *Nomadic Subjects* (New York: Columbia University Press, 1994), p. 22.

44 Hélène Cixous, 'Sorties' [1975], trans. Betsy Wing, in Susan Sellers (ed.), *The Hélène Cixous Reader* (London: Routledge, 1994), pp. 37–44, p. 42.

45 Trinh T. Minh-Ha, *When the Moon Waxes Red: Representation, Gender and Cultural Politics* (London: Routledge, 1991), p. 229.

46 Luce Irigaray, 'The Wedding between the Body and Language', in *To be Two*
 [1994], trans. Monique M. Rhodes and Marco F. Cocito-Monoc (London:
 Athlone Press, 2000), pp. 17–29, p. 25.

47 The following text is based on Jane Rendell, 'To Miss the Desert', in Gavin Wade
 (ed.), *Nathan Coley: Black Tent* (Portsmouth: Art and Sacred Spaces, 2003), pp. 34–
 43 but radically shortened and reworked.

48 Nathan Coley's fascination with places of religious worship runs through his
 practice. An early work, *Fourteen Churches of Münster* (2000), comprises a street plan
 and the view from a helicopter circling fourteen churches in the city: in the Second
 World War allied bomber pilots were issued with an order to target them. *The Lamp
 of Sacrifice, 161 Places of Worship, Birmingham* (2000) and *The Lamp of Sacrifice, 286
 Places of Worship, Edinburgh* (2004), consisting of cardboard models of all the places
 of worship in the towns listed in the *Yellow Pages*, have been argued to express the
 premise of Coley's work – that architectural forms remain empty until socially
 occupied. See Martin Herbert, 'Nathan Coley, Fruitmarket Gallery Edinburgh',
 Art Monthly, n. 278 (July–August 2004), pp. 35–7, p. 36. More recent projects, such
 as *There Will Be No Miracles Here* (2006), Mount Stuart, Isle of Bute, question the
 passivity of architecture especially in current religious conflicts. One part of the
 exhibition – *Camouflage Mosque, Camouflage Synagogue, Camouflage Church* – comprises
 three models covered in 'dazzle' camouflage, a technique applied to ships during
 both world wars as protection from attack. See Andrea Schlieker, 'Negotiating the
 Invisible: Nathan Coley at Mount Stuart' at http://www.haunchofvenison.com/
 media/4797/essay%20andrea%20schlieker.pdf (accessed 19 July 2009).

49 Jane Rendell, 'Writing in Place of Speaking', in Sharon Kivland and Lesley
 Sanderson (eds), *Transmission: Speaking and Listening*, vol. 1 (Sheffield: Sheffield
 Hallam University and Site Gallery, 2002), pp. 15–29, p. 26.

50 The use of black occurs in a number of other works by Coley from 2002, such as
 Black Maria, see n. 52 below, and *I Don't Have Another Land* (2002), in which a black-
 painted metal model of the M&S building in Manchester Arndale Centre, blown
 up by the IRA in 1996, is presented with a line from a Jewish folk song as its title
 and across the space where its windows should be.

51 Coley's work has examined the representation of architecture through different
 kinds of media simultaneously: for example, *Minster* (1998), an installation in the
 Tate Gallery Liverpool, consisted of slide-projected images of a non-conformist
 chapel in Liverpool's Toxteth, a recorded lecture of a guided tour of York Minster
 and an explanatory pamphlet describing the correct procedure for establishing
 a tabernacle or portable sanctuary. See Nick Barley (ed.), *Leaving Tracks:
 Artranspennine98, an International Contemporary Visual Art Exhibition Recorded* (London:
 August Media Ltd., 1999), pp. 78–81.

52 Coley's engagement with the politics of boundaries is apparent in a number of
 works. For *Lockerbie* (2003) Coley documented the trial of two Libyan suspects
 associated with bombing Pan Am Flight 103 over Lockerbie. Owing to the need for
 neutral ground, the trial took place at Kamp van Ziest in the Netherlands, where
 for legal reasons the court was designated Scottish territory, constituting what
 has been described as a 'legal fiction'. See Susanne Gaensheimer, 'The Politics
 of Space: Architecture, Truth, and other Fictions in the Work of Nathan Coley',
 in *Nathan Coley: There Will Be No Miracles Here* (Edinburgh and Newcastle: The
 Fruitmarket Gallery and Locus+, 2004), pp. 12–19, p. 12. In *Jerusalem Syndrome*
 (2005) Coley filmed sites of major religious significance for Islam, Christianity
 and Judaism, all located in Jerusalem: the Dome of the Rock on Temple Mount,

the Church of the Holy Sepulchre, and the Western (or Wailing) Wall. See Matt Price, 'Nathan Coley', *Flash Art* (July–September 2005), p. 119. Related work has examined the Israeli occupation of Palestine, the prefabs built in a single day in 1937 in *Tower and Wall (1937 prefabs)* (2005), and the more recent white modernist structures, which have been described as 'co-opt[ing]' Corbusian ideals 'into the Zionist project' in *Emanuel (1972 Settlement Offensive)* (2004). See Sumantro Ghose, 'Nathan Coley: Haunch of Venison', *Modern Painters* (March 2005), p. 103. Coley has also investigated the frontier between indigenous populations and occupying forces through the façades constructed in American 'westerns'. For *The Black Maria/Places Where Something Has Happened* (2002) in Christchurch, New Zealand, Coley produced a black-painted wooden replica of Black Maria, the first film studio built by Thomas Edison in 1893. See Kate Montgomery, 'Nathan Coley: The Black Maria/Places Where Something Has Happened', Christchurch, New Zealand, *The Physics Room Annual 2002* (December 2003). For his show at the Haunch of Venison, Berlin, 2008, Coley re-made another 1880s 'western' façade, at 80 per cent of its real size, as in film sets, with the words – WEALTH, BELIEF, LAND, MIND, LIFE (the five rights that every human is granted under Islam) written over the doors. See http://www.haunchofvenison.com/en/#page=berlin. exhibitions.2008.nathan_coley (accessed 3 July 2008).

53 Coley's interest in sanctuaries has been related to their role as places of refuge outside state control. See Nathan Coley, *Urban Sanctuary: A Public Art Work by Nathan Coley* (Glasgow: The Armpit Press, 1997), which comprised a series of interviews with eight people including a policeman and a feng shui practitioner, where the artist asked each person what the term 'sanctuary' meant to them and documented their answers.

54 Coley's *Show Home* (2003), curated by Locus + and commissioned by North Tyneside Council, a replica of a traditional rural cottage, also moved sites, this time in Tyneside over a three-day period – a marina, a suburban housing estate and a school playing field surrounded by security fences. See http://www.showhome. org.uk/ (accessed 3 July 2008) and Paul Usherwood, 'Nathan Coley: North Shields', *Art Monthly*, n. 268 (July 2003), pp. 46–7. Coley's interest in the potential significance of a work's location is present, for example, in the placing of *Show Home* on the roof of the City Arts Centre, Dublin, adjacent to the city's financial centre at a time when property prices were surging. For Coley's commentary on the position of his own practice with respect to the current discourse on art and site-specificity, see 'Nathan Coley in Conversation with Claire Doherty', Claire Doherty (ed.), *Thinking of the Outside: New Art and the City of Bristol* (Bristol: University of the West of England and Bristol Legible City in Association with Arnolfini, 2005), pp. 30–7, p. 31.

55 The following text is a reworked version of Jane Rendell, 'You Tell Me', an essay written for *(Hi)story: Jananne Al-ani, Tracey Moffatt, Adriana Varejão and Richard Wentworth* (2005), Kunstmuseum, Thun, n. p. The words in italics have been taken from 'Travelling the Distance/Encountering the Other' and 'To Miss the Desert', earlier parts of *Configuration 2: To and Fro*, and altered to fit their new site.

56 A.S. Byatt, *On Histories and Stories* (London: Vintage, 2001), pp. 139–41.

57 See for example Primo Levi, *The Periodic Table* (London: Penguin Books, 2000); Italo Calvino, *If on a Winter's Night a Traveller* (London: Vintage Classics, 1998); and Georges Perec, *Life: A User's Manual* (London: Collins Harvell, 1992).

58 Hans Magnus Enzensberger, 'Topological Structures in Modern Literature', *Sur* (May–June 1966), referred to by Calvino in Italo Calvino, 'Cybernetics and

Ghosts', in *The Literature Machine* (London: Vintage, 1997), pp. 3–27, p. 25.

59 For Simon Groom, Wentworth's work operates 'to tease out in public something more of the private life of a thing'. See Simon Groom, 'In Medias Res', in *Richard Wentworth* (Liverpool and London: Tate Liverpool and Tate Publishing, 2005), pp. 73–5, p. 74.

60 For commentaries on the influence of Brazilian history in Varejão's work see for example Santiago Olmo, 'Adriana Varejão', *Art Nexus*, n. 28 (May–July 1998), pp. 150–1; Stella Teixeira de Barros, 'Adriana Varejão: The Presence of Painting', *Art Nexus*, n. 34 (November–January 1999–2000), pp. 48–53; and Christine Frerot, 'Adriana Varejão: Cartier Foundation for Contemporary Art', *Art Nexus*, v. 3, n. 57 (June–August 2005), pp. 104–5.

61 For Varejão 'These ruins serve as metaphors for uncompleted time'. See '*Echo Chamber*: Adriana Varejão interviewed by Hélène Kelmachter', in *Adriana Varejão: Chambre d'echos* (Paris: Foundation Cartier pour l'art contemporain, 2005), pp. 79–99, p. 85.

62 Varejão describes the contamination of the blood that seeps through the cracks as a narrative. See *Echo Chamber*, p. 95. Critic Paolo Herkenhoff discusses the 'real space of the juncture between the tiles' as the 'return of the repressed'. See Paolo Herkenhoff, 'Saunas', *Adriana Varejão: Chambre d'echos*, pp. 23–5, p. 24.

63 In Claudia Laudanno's opinion, 'Varejão's figuration supports a multiplicity of visual games and geometric grids that expand over every surface and display horror vacuii, another principle of Baroque art.' See Claudia Laudanno, 'Adriana Varejão', *Art Nexus*, v. 5, n. 60 (March–May 2006), p. 150.

64 Varejão explains how the title of her show *Echo Chamber* was taken from a book on the Baroque by Severo Sarduy. See *Echo Chamber*, p. 81.

65 Al-Ani was born in Iraq to an Irish mother and Iraqi father. The importance of the autobiographical aspect of her work is something the artist expresses ambivalence towards, stating both that the inclusion of family snapshots is an attempt to bring the body and 'a more complex historical narrative into the events of the first Gulf War', but also that the work is not 'personal narrative' and that the 'biographic specifics' are not important. Al-Ani is interested in how narratives shift in relation to history and, as Angela Weight has commented, in recognizing that 'Memory is replete with lies and illusions'. See 'Richard Hylton interviews Jananne Al-Ani', *Jananne Al-Ani* (London: Film and Video Umbrella, 2005), n. p. and Angela Weight, 'After the Fog', *Jananne Al-Ani*, n. p. Claire Doherty compares Al-Ani's 'enigmatic use of her biography' literally and metaphorically to the veil. See Claire Doherty, 'The Triumph of Echo', *Jananne Al-Ani*, n. p.

66 Doherty describes how in *She Said* Al-Ani 'subverts linear narrative' and manipulates language to 'wrong-foot the narrative', and that her use of 'interruption, repetition and shifts in tone and expression' in the work prevents the story becoming sentimental. See Doherty, 'The Triumph of Echo', n. p.

67 Doherty notes that in Greek mythology Echo's punishment from Hera is that she will never again speak first, and that Echo is both audio receiver and transmitter. She argues that in Al-Ani's *Echo* 'the women can only refer *ad infinitum* to the absent male(s)'. See Doherty, 'The Triumph of Echo', n. p.

68 Maria Walsh discusses *The Visit* as 'a reflection on displacement' that positions the viewer in a 'liminal space between here and there'. She compares the 'temporal and spatial gaps' between *Echo* and *Muse* to 'barriers that can never be crossed'. See Maria Walsh, 'Jananne Al-Ani: Tate Britain, London', *Art Monthly*, n. 285 (April 2005), pp. 24–5.

69 The veil has been a recurrent theme in Al-Ani's work. She outlines her own interest in the veil as a 'visual device', which allows one to contemplate the 'returned gaze' of women. See 'Richard Hylton interviews Jananne Al-Ani', n.p. For Steven Bode, the veil in Al-Ani's work is a 'recurring formal device', which disguises and discloses. See Steven Bode, 'Foreword', *Jananne Al-Ani*, n. p. Doherty suggests that Al-Ani's fascination with the veil is as a 'metaphor for emotional candour and complex identity, rather than explicit cultural representation'. See Doherty, 'The Triumph of Echo', n. p. Al-Ani's interest in the veil is also evident in her role as co-curator of the exhibition *Veil*, with Zineb Sedira, David A. Bailey and Gilane Tawadros, shown at The New Art Gallery Walsall (2003), Bluecoat Gallery and Open Eye Gallery, Liverpool (2003) and Modern Art Oxford (2004) with an associated publication, David A. Bailey and Gilane Tawadros (eds), *Veil: Veiling, Representation and Contemporary Art* (inIVA and Modern Art Oxford, 2003).

70 See for example Jenni Sorkin, 'The Moving Images of Tracey Moffatt', *Modern Painters*, v. 19, n. 9 (November 2007), pp. 104–5.

71 Moffatt's use of narrative has been described as close to poetry – 'ambiguous, suggestive, open-ended'. See Deborah Hart, 'Andy and Oz: Parallel Visions', *Artonview*, n. 52 (Summer 2007–08), pp. 26–33. It has also been discussed as 'post-colonial', disjunctive and lacking in resolution. See Judy Annear, 'Be Careful What You Wish For – The Art of Tracey Moffatt', Paula Savage and Lara Strongman (eds), *Tracey Moffatt* (Wellington: City Gallery, 2002), pp. 10–15, pp. 10–11. Like Al-Ani's, Moffatt's work draws on her own biography. Of Aboriginal descent, she was born in Brisbane in 1960, and, along with three siblings, fostered out to a white family at the age of three. See Morgan Falconer, 'Silver Scream', *Art Review*, v. 53 (May 2001), pp. 48–9. Her work explores themes pertinent to her life, but in ways that, through the creation of tableaux and staged scenes, blend the autobiographical with the fictional, the unique personal story with broader cultural experience.

72 In *Up in the Sky* the use of narrative has been posited, not as single, but as differing and contested. See Isaac Julien with Mark Nash, 'Only Angels have Wings', *Tracey Moffatt: Free-Falling* (New York: Dia Center for the Arts, 1998), pp. 9–20, p. 20. Moffatt outlines how she 'twists' simple narratives. For example, in *Up in the Sky*, the storyline is without a beginning, middle and end, so can be changed by shifting the hanging order of the photographs. See Gerald Matt, 'An Interview with Tracey Moffatt', Michael Snelling (ed.), *Tracey Moffatt* (Brisbane: Institute of Modern Art, 1999), pp. 65–8, p. 66.

73 For an extended discussion of this work see Lynne Cooke, 'A Photo-Filmic Odyssey', *Tracey Moffatt: Free-Falling*, pp. 23–44, especially pp. 34–44 and 36.

74 Lara Strongman stresses that laudanum, cheaper than gin, was commonly available to working-class women, and also used to control female 'hysteria'. See Lara Strongman, 'Indolentia, or Freedom From Feeling', Savage and Strongman (eds), *Tracey Moffatt*, pp. 65–7, p. 65.

75 While Lisa Fischman argues that *Laudanum* (1998) is 'tightly staged and scripted' but 'narratively open-ended', Falconer maintains that the use of narrative in this work is oblique. See Lisa Fischman, 'Neither Win, Place nor Show: Tracey Moffatt discusses her recent series *Fourth*', *Art Papers*, v. 26, n. 4 (July–August 2002), pp. 12–13 and Falconer, 'Silver Scream', pp. 48–9. While the 'photo-drama' of *Laudanum* is 'theatrical, fictional' and not a '"real life" drama', Catherine Summerhayes suggests that 'the fiction is based on a "serious" story about how people can abuse each other under the obsessions of lust and power'. See Catherine Summerhayes,

The Moving Images of Tracey Moffatt (Miliano: Edizioni Charta, 2007), p. 221.

76　See Jane Rendell, *An Embellishment: Purdah* (2006), in *Spatial Imagination*, domoBaal contemporary art, London with an associated catalogue essay, Jane Rendell, 'An Embellishment', Peg Rawes and Jane Rendell (eds), *Spatial Imagination* (London: The Bartlett School of Architecture, UCL, 2005), pp. 34–5. In 2005–06 I directed a research cluster called *Spatial Imagination in Design*, which involved artists, architects and writers exploring the spatial imagination through the production of artefacts for an exhibition at domoBaal contemporary art, London. See www.spatialimagination.org.uk. (accessed 8 July 2008). See also Rendell, 'Site-Writing: Enigma and Embellishment'.

77　Afghanistan's official languages Dari, a version of Persian, and Pashto are written primarily in the Arabic alphabet. One report states that Dari is spoken by the Tajiks (25–30 per cent of the Afghan population) and Pashto by the Pashtuns (45–50 per cent of the Afghan population). See Physicians for Human Rights, *Women's Health and Human Rights in Afghanistan: A Population-Based Assessment* (31 December 2001), p. 17. However, another source holds that 'according to recent US government estimates, approximately 35 percent of the Afghan population speaks Pashto, and about 50 percent speaks Dari'. http://www.afghan-web.com/language/ (accessed 14 May 2008).

78　Quoting Malek Alloulla, David A. Bailey and Gilane Tawadros describe how the veil marks the closure of private space and its extension to public space where the viewer is to be found. See David A. Bailey and Gilane Tawadros, 'Introduction', Bailey and Tawadros (eds), *Veil*, pp. 16–39, pp. 22–3. Referring to the writings of Hamid Naficy on the poetics and politics of the veil in revolutionary Iranian cinema, Bailey and Tawadros suggest that veiling is not fixed or unidirectional, but that it is rather 'a dynamic practice in which both men and women are implicated', and that the relation between veiling and unveiling is dialectical.

79　See for example Leila Ahmed, 'The Discourse on the Veil', *Women and Gender in Islam: Historical Roots of a Modern Debate* (Yale: Yale University Press, 1993), pp. 144–68.

80　For example Ahdaf Soueif, in a discussion of the differing practices and terms for the veil in Muslim cultures across the world including Arab countries, focuses on the history of its use in Cairo, Egypt. He explains how in the early twentieth century the *tarha*, a thin material to cover the hair in white or black, and *yashmak*, a white veil worn across the face under eyes, were adopted by women of the aristocracy, while the *burqu'*, a rectangle of fishnet which hung under the eyes and fastened over the nose with a small decorative gold or brass cylinder – an *aroussa* – was worn by working-class women, and the *bisha*, which covered the whole face, was neutral in class terms. Between the 1920s and the 1960s, as part of the move to accept western culture, the veil was rejected, except the *bisha*, which continued to be worn by working-class women and more traditional women of all classes aged over fifty. The veil was taken up again as the *hijab* and the full *niqab* in the 1970s and more recently as a sign of resistance to the west. See Ahdaf Soueif, 'The Language of the Veil', first published in *The Guardian*, weekend supplement (8 December 2001), pp. 29–32, and reprinted in Bailey and Tawadros (eds), *Veil*, pp. 110–19.

81　Christina Noelle-Karimi discusses how the *chadari* was originally a town fashion, worn by middle-class women to show they did not work with their hands, and as a sign of distinction by women whose husbands had secured government employment. Rural women wore a head scarf or *chadar*, and reserved the *chadari* for trips to town. See Christina Noelle-Karimi, 'History Lessons: In Afghanistan's

Decades of Confrontation with Modernity, Women have always been the Focus of Conflict' (April 2002). See http://www.wellesley.edu/womensreview/archive/2002/04/highlt.html (accessed 14 May 2008).

82 See Physicians for Human Rights, *Women's Health and Human Rights*, p. 19 and p. 23. The reports states in a rather contradictory manner that the dress code of the *chadari* was particularly strict in Kabul, but less rigorously enforced in rural or non-Pashtun areas, see p. 19, n. 53, but also that there were more severe restrictions enforced in non-Pashtun areas, see p. 23.

83 Ahmed, 'The Discourse on the Veil', pp. 144–68.

84 Ahmed, 'The Discourse on the Veil', p. 155.

85 Ahmed, 'The Discourse on the Veil', p. 164.

86 Sharon Kivland, 'Memoirs', in Rendell, Hill, Fraser and Dorrian (eds), *Critical Architecture*, pp. 143–9, p. 145.

87 For a fascinating commentary on this work see Marsha Meskimmon, *Women Making Art: History, Subjectivity, Aesthetics* (London: Routledge, 2003), pp. 141–7. The exhibition *Veil*, co-curated by Al-Ani, Sedira, Bailey and Tawadros, included a number of works which critique the practice and representation of veiling. See for example Faisal Abdu'Allah, *The Last Supper* (1995); Kourush Adim, *Le Voile* (The Veil) (1999–2000); Shadafarin Ghadirian, *Qajar* series (1998); Majida Khattari, *Les Mille et Une Souffrances de Tchadiri (1001 Sufferings of Tchadiri) no 7* (2001); Shirin Neshat, *Rapture* (1999); and Zineb Sedira, *Self-Portraits of the Virgin Mary* (2000) – all shown in Bailey and Tawadros (eds), *Veil*.

88 See Lalla Essaydi and Amanda Carlson, *Converging Territories* (New York: powerHouse Books, 2005). *Veil* also included works which connect screening to pattern-making such as Henna Nadeem, *Screen* (1997) and Samta Benyahia, *Nuit du Destin* (2000), as well as writing, drawing and veiling, for example Ghada Amer, *Majnun* (1997); Ramesh Kalkur, *Untitled* (1996); and Shirin Neshat, *Allegiance with Wakefulness* (1994). See Bailey and Tawadros (eds), *Veil*. See also the work of Pakistani artist Aisha Khalid, *Ongoing Conversation* (2008), Pump House Gallery, London.

89 Christina Lamb, *The Sewing Circles of Heart: My Afghan Years* (London: HarperCollins Publishers, 2002), pp. 156–60.

90 Kivland, 'Memoirs', p. 145.

91 Samira's Makhmalbaf's *At Five in the Afternoon* (2003), made by Moshen Makhmalbaf's daughter, also focuses on the life of women in Afghanistan.

92 Yasmina Khadra's *The Swallows of Kabul* (London: Vintage, 2005) was first published in French as *Les Hirondelles de Kaboul* (Paris: Julliard, 2002).

93 Alison Donnell has drawn attention to the number of books that feature an image of a veiled woman on the cover. See Alison Donnell, 'Visibility, Violence and Voice? Attitudes to Veiling Post-11 September', Bailey and Tawadros (eds), *Veil*, pp. 122–35.

94 Noelle-Karimi, 'History Lessons'.

95 See Khaled Hosseini, *A Thousand Splendid Suns* (London: Bloomsbury, 2007). This is Hosseini's second novel; his first was *The Kite Runner* (London: Bloomsbury, 2003).

96 See Saira Shah, *Beneath the Veil* (2001), shown in the UK on Channel 4 on 26 June 2001. See for example http://www.channel4.com/life/microsites/A/afghanistan/ (accessed 3 June 2009). Her novel *The Storyteller's Daughter: One Woman's Return to Her Lost Homeland* traces her journey back to her family's lost homeland in Paghman. See Saira Shah, *The Storyteller's Daughter: One Woman's Return to Her Lost Homeland* (London: Michael Joseph, 2002). Both *Beneath the Veil* and *Kandahar* have been harshly critiqued by Martin Kramer, who states that Shah does not take

into account, for example, the fact that the woman executed had murdered her husband, and that the same executionary practice occurs in Saudi Arabia today without comment. See Martin Kramer, 'The Camera and the *Burqa*', *Middle East Quarterly* (Spring 2002), pp. 69–76.

97 See the documentary Liz Mermin, *The Beauty Academy of Kabul* (2004), shown in the UK on BBC4 on 23 January 2006. See http://www.bbc.co.uk/bbcfour/documentaries/storyville/beauty-academy-kabul.shtml (accessed 14 May 2008). See also Deborah Rodriguez, *The Kabul Beauty School: The Art of Friendship and Freedom* (London: Hodder & Stoughton, 2007). Sean Langan's *Afghan Ladies Driving School* was shown in the UK on BBC4 on 23 January 2006 http://www.bbc.co.uk/bbcfour/documentaries/features/afghan-driving-school.shtml (accessed 14 May 2008).

Configuration 3

1 Sigmund Freud, 'Letter from Freud to Fliess, 6 December 1896', *The Complete Letters of Sigmund Freud to Wilhelm Fliess, 1887–1904*, trans. and ed. Jeffrey Moussaieff Masson (Cambridge, Mass.: Belknap Press of Harvard University Press, 1985), pp. 207–14, p. 207.

2 Sigmund Freud, 'The Unconscious' [1915], *The Standard Edition of the Complete Psychological Works of Sigmund Freud*, vol. 14 *(1914–1916): On the History of the Psycho-Analytic Movement, Papers on Metapsychology and Other Works*, translated from the German under the general editorship of James Strachey (London: The Hogarth Press, 1957), pp. 159–215, pp. 174–5.

3 Jean Laplanche, 'A Short Treatise on the Unconscious' [1993], trans. Luke Thurston, *Essays on Otherness*, ed. John Fletcher (London: Routledge, 1999), pp. 84–116, pp. 88–9.

4 Judy Gammelgaard, 'The Unconscious: A Re-reading of the Freudian Concept', *Scandinavian Psychoanalytic Review*, n. 26 (2003), pp. 11–21, pp. 15–16. Although she does not explicitly say so, I presume that at this point Gammelgaard is following Laplanche, whose readings of Freud she refers to throughout her paper.

5 Alain Gibeault, 'Travail de la *pulsion* et représentations: Représentation de chose et représentation de mot', *Revue française de psychanalyse*, v. 49, n. 3 (1985), pp. 753–72. An English translation of a short part of this paper can be found at http://www.answers.com/topic/thing-presentation?cat=health\ (accessed 6 March 2008).

6 Gibeault, 'Travail de la *pulsion* et représentations'.

7 See Sigmund Freud, 'Zur Auffassung der Aphasien' [1891], Vienna, translated as Sigmund Freud, *On Aphasia: A Critical Study* (New York: International Universities Press, 1953), p. 77, fig. 8.

8 Freud, 'The Unconscious', p. 214.

9 Strachey explains that, rather than 'idea', the term *Vorstellung* is translated by 'presentation': '*Wortvorstellung*' is translated as 'word-presentation' rather than 'verbal idea' and '*Sachvorstellung*' as 'thing-presentation' rather than 'concrete idea'. See Freud, 'The Unconscious', p. 201, editor's note.

10 See Freud, 'The Unconscious', 'Appendix C: Words and Things', p. 209, editor's note.

11 Freud, 'The Unconscious', p. 201.

12 André Green, *Key Ideas for a Contemporary Psychoanalysis: Misrecognition and Recognition of the Unconscious* (London: Routledge, 2005), p. 125.

13 Laplanche, 'A Short Treatise', p. 89. Laplanche refers to Sigmund Freud, 'The Ego and the Id' [1923], *The Standard Edition of the Complete Psychological Works of Sigmund Freud*, vol. 19 *(1923–1925): The Ego and the Id and Other Works*, translated from the German under the general editorship of James Strachey (London: The Hogarth Press, 1961), pp. 1–308, pp. 20–1.

14 Laplanche, 'A Short Treatise', p. 89, n. 13.

15 Freud, 'The Ego and the Id', pp. 20–1.

16 Jean Laplanche and J.B. Pontalis, *The Language of Psycho-Analysis*, trans. Donald Nicholson-Smith (London: Karnac and The Institute of Psycho-Analysis, 1973), p. 247.

17 Laplanche and Pontalis, *The Language of Psycho-Analysis*, p. 41.

18 Sigmund Freud, 'Project for a Scientific Psychology' [1895], *The Standard Edition of the Complete Psychological Works of Sigmund Freud*, vol. 1 *(1886–1899): Pre-Psycho-Analytic Publications and Unpublished Drafts*, translated from the German under the general editorship of James Strachey (London: The Hogarth Press, 1966), pp. 281–391, p. 299. This was first published in German in 1950, and then in English four years later. See editor's notes p. 283.

19 'A qualification is called for here in the case of "*W*" and "*Er*". It will be found that these sometimes stand respectively for "*Wahmehmungsbild*" ("perceptual image") and "*Erinnerungsbild*" ("mnemic image") instead of for "*Wahrnehmung*" and "*Erinnerung*". The only way of deciding for certain on the correct expanded version depends on the fact that the longer terms are of neuter gender whereas the shorter ones are feminine. There is usually an article or an adjective to make the decision possible; but this is one of those cases in which the reader must depend on the editor's judgement ... ' See editor's note Freud, 'Project', p. 288. The word *Wahrnehmung* is translated into English as 'perception' and *Erinnerung* as 'memory'.

20 Josef Breuer, 'Theoretical' [1893], *The Standard Edition of the Complete Psychological Works of Sigmund Freud*, vol. 2 *(1893–1895): Studies on Hysteria*, translated from the German under the general editorship of James Strachey (London: The Hogarth Press, 1955), pp. 183–251, p. 188, n.

21 Freud, 'Letter from Freud to Fliess, 6 December 1896', p. 207.

22 Freud, 'Letter from Freud to Fliess, 6 December 1896', pp. 207–8.

23 Sigmund Freud, 'The Interpretation of Dreams (Second Part)' [1901], *The Standard Edition of the Complete Psychological Works of Sigmund Freud*, vol. 5 *(1900-1901): The Interpretation of Dreams (Second Part) and On Dreams*, translated from the German under the general editorship of James Strachey (London: The Hogarth Press, 1953), pp. 339–627, p. 538, see also fig. 1, p. 537; fig. 2, p. 538; and fig. 3, p. 541.

24 Laplanche, 'A Short Treatise on the Unconscious', p. 95.

25 See Sigmund Freud, 'Leonardo da Vinci and a Memory of his Childhood' [1910], *The Standard Edition of the Complete Psychological Works of Sigmund Freud* vol. 11 *(1910): Five Lectures on Psycho-Analysis, Leonardo da Vinci and Other Works*, translated from the German under the general editorship of James Strachey (London: The Hogarth Press, 1957), pp. 57–138, p. 84.

26 Sigmund Freud, 'Screen Memories' [1899], *The Standard Edition of the Complete Psychological Works of Sigmund Freud*, vol. 3 *(1893–1899): Early Psycho-Analytic Publications*, translated from the German under the general editorship of James Strachey (London: The Hogarth Press, 1962), pp. 299–322, p. 322.

27 James Strachey makes the point that the topic of memory distortion had preoccupied Freud since he started on his self-analysis in the summer of 1897.

Freud, 'Screen Memories', p. 302, editor's note.

28 Freud, 'Project', p. 354.

29 Green, *Key Ideas*, p. 175.

30 Laplanche, 'A Short Treatise on the Unconscious', p. 96.

31 Sigmund Freud, 'The Psychopathology of Everyday Life' [1901], *The Standard Edition of the Complete Psychological Works of Sigmund Freud*, vol. 6 *(1901): The Psychopathology of Everyday Life'*, translated from the German under the general editorship of James Strachey (London: The Hogarth Press, 1960), pp. vii–296, pp. 43–4.

32 Jean Laplanche, 'Interpretation between Determinism and Hermeneutics' [1992], trans. Philip Slotkin and revised for this volume by Jean Laplanche, *Essays on Otherness*, ed. John Fletcher (London: Routledge, 1999), pp. 138–65, pp. 152.

33 Laplanche, 'Interpretation', p. 150.

34 See Serge Viderman, 'La bouteille a la mer', *Revue française de psychanalyse*, n. 38 (1974), pp. 323–84, referred to by Laplanche. Some of the ideas from this paper as well as Serge Viderman, *La construction de L'espace analytique* (Paris: Denöel, 1970), have been incorporated into Serge Viderman, 'The Analytic Space: Meaning and Problems', *Psychoanalytic Quarterly*, n. 48 (1979), pp. 257–91.

35 Laplanche, 'Interpretation', p. 148.

36 Laplanche reworks Freud's discussion of the three kinds of material presented for analysis – as fragments of memories in dreams, ideas and actions – into memories and fragments of memories within which 'the major scenes are to be found', 'scattered, fragmented or repeated'; 'constructions or ideologies or theories representing the way the individual has synthesized *his* existence for *himself*'; and 'unconscious formations', inaccessible 'derivatives of the original repressed'. Laplanche, 'Interpretation', p. 161, and Sigmund Freud, 'Constructions in Analysis' [1937], *The Standard Edition of the Complete Psychological Works of Sigmund Freud*, vol. 23 *(1937–1939): Moses and Monotheism, An Outline of Psycho-Analysis and Other Works*, translated from the German under the general editorship of James Strachey (London: The Hogarth Press, 1963), pp. 255–70, p. 258.

37 Laplanche, 'Interpretation', pp. 152–3.

38 Josef Breuer and Sigmund Freud, 'On The Psychical Mechanism of Hysterical Phenomena: Preliminary Communication' [1893], *The Standard Edition*, vol. 2, pp. 1–17, p. 7.

39 Jean Laplanche, 'The Unfinished Copernican Revolution' [1992], trans. Luke Thurston, *Essays on Otherness*, ed. John Fletcher (London: Routledge, 1999), pp. 52–83, p. 65.

40 Laplanche, 'A Short Treatise', p. 92, n. 20.

41 Laplanche, 'A Short Treatise', p. 88.

42 Laplanche, 'A Short Treatise', p. 93.

43 Laplanche, 'A Short Treatise', p. 90.

44 Jean Laplanche, 'The Drive and its Source-Object: its Fate in the Transference' [1992], trans. Leslie Hill, *Essays on Otherness*, ed. John Fletcher (London: Routledge, 1999), pp. 117–32, pp. 120–1, n. 6.

45 Laplanche, 'The Drive', pp. 120–1, n. 6.

46 Laplanche, 'A Short Treatise', p. 91 and p. 91, n 18. John Fletcher notes that in 'signifying to' Laplanche is 'alluding to' Jacques Lacan, who distinguished between a signifier *of* something, a meaning or signified, and a signifier *to* someone, an addressee. See Laplanche, 'A Short Treatise', p. 91, n. 18, editor's comment. Laplanche refers explicitly to Lacan's model of language, but dismisses it as 'only

applicable to a perfect, well-made, univocal language' and takes up instead the 'full extension' Freud gives to language. Laplanche, 'A Short Treatise', p. 92. See also *Configuration 5: Decentring/Recentring*, n. 7.

47 John Fletcher, 'Introduction: Psychoanalysis and the Question of the Other', Jean Laplanche, *Essays on Otherness*, ed. John Fletcher (London: Routledge, 1999), pp. 1–51, p. 37.

48 Virginia Woolf, *Moments of Being* [1939–40], edited with an introduction and notes by Jeanne Schulkind (London: The Hogarth Press, 1985), p. 142.

49 The following text is based on Jane Rendell, 'The Welsh Dresser: An Atlas', in Ken Ehrlich and Brandon LaBelle (eds), *Surface Tension: Problematics of Site* (Errant Bodies Press, 2003), pp. 283–92, but radically shortened and reworked.

50 All text set as quotations comes from *The Shorter Oxford English Dictionary* (Clarendon Press: Oxford, 1991).

51 See Ralph Rugoff, *Scene of the Crime* (Cambridge, Mass.: The MIT Press, 1997).

52 Rather than use images to illustrate an argument made of words, Beatriz Colomina uses photographs to construct the history of the architecture of Adolf Loos, and in so doing explores the role of the photograph, as a trace of lived experience, in architectural history. See Beatriz Colomina, *Publicity and Privacy, Modern Architecture as Mass Media* (Cambridge, Mass.: The MIT Press: 1994).

53 A key inspirational reference here is Daniel Spoerri, *An Anecdoted Topography of Chance* (London: Atlas Press, 1995).

54 See for example Adrian Forty, *Objects of Desire: Design and Society, 1750–1980* (London: Thames and Hudson, 1986); Iain Borden, *Skateboarding, Space and the City: Architecture and the Body* (Oxford: Berg, 2001); and Jonathan Hill, *Actions of Architecture: Architects and Creative Users* (London: Routledge, 2003).

55 See Doreen Massey, 'Reinventing the Home', *Blueprint* (March 1999), pp. 23–5 and Fredric Jameson, *Marxism and Form: Twentieth-Century Dialectical Theories of Literature* (Princeton: Princeton University Press, 1971), p. 82.

56 See Michelle Perrot (ed.), *A History of Private Life* [1987], (Cambridge, Mass.: The Belknap Press of Harvard University Press, 1990), p. 5.

57 'Valuation' (26 February 1992), Auctioneers, Valuers and Estate Agents, 21 New Road, Llandeilo, Dyfed.

58 See Jacques Derrida, *Archive Fever: A Freudian Impression* [1995], trans. Eric Prenowitz (Chicago: The University of Chicago Press, 1995).

59 See Joan W. Scott, 'The Evidence of Experience', *Critical Enquiry*, v. 17 (Summer 1991), pp. 773–99.

60 See Mieke Bal, *Looking In: The Art of Viewing* (Amsterdam: G+B Arts International, 2001), pp. 47–8.

61 See in particular Walter Benjamin, 'One Way Street' [1928], trans. Edmund Jephcott, in Marcus Bullock and Michael W. Jennings (eds), *Walter Benjamin: Selected Writings*, vol. 1, *1913–1926* (Cambridge, Mass.: Harvard University Press, 2004), pp. 444–88, and Walter Benjamin, 'Theses on the Philosophy of History' [1940], trans. Harry Zohn, in *Illuminations*, edited and with an introduction by Hannah Arendt (London: Fontana, 1992), pp. 245–55.

62 See for example the discussion of fact, evidence and interpretation in E. H. Carr, 'The Historian and his Facts', *What is History?* [1961] (London: Penguin Books, 1990), pp. 7–30, and the postmodern version of the debate in Keith Jenkins, *Rethinking History* (London: Routledge, 1991), pp. 32–47.

63 For the work of Susan Rubin Suleiman see *Risking who One is: Encounters with Contemporary Art and Literature* (Cambridge, Mass.: Harvard University Press, 1994).

See also Nancy K. Millar, *Getting Personal: Feminist Occasions and Other Autobiographical Acts* (London: Routledge, 1991).

64 See bell hooks, *Wounds of Passion: A Writing Life* (London: The Women's Press, 1998), p. xix.

65 See for example Gloria Anzaldúa, *Borderlands/La Frontera: the New Mestiza* [1987] (San Francisco: Lute Books, 1999); Rosi Braidotti, *Nomadic Subjects* (New York: Columbia University Press, 1994); and bell hooks, *Yearnings: Race, Gender, and Cultural Politics* (London: Turnaround Press, 1989).

66 See for example Luce Irigaray, 'The Neglect of Female Genealogies', in Luce Irigaray, *Je, Tu, Nous: Towards a Culture of Difference* [1990], trans. Alison Martin (London, Routledge, 1993), pp. 15–22, and Luce Irigaray, *Thinking the Difference: For a Peaceful Revolution* [1989], trans. Karin Montin (London: The Athlone Press, 1994).

67 Patience is a quality evident in the artist and her work. For example, in an interview Brotherus comments: 'The technical part is not difficult but demands time and patience. One is simultaneously concentrated and relaxed. One is pragmatic and determined, and yet intuitive.' See 'Elina Brotherus interviewed by Sheyi Anthony Bankale', in Sheyi Anthony Bankale (ed.), *Elina Brotherus: The New Painting* (Next Level & Creative Scape and Thames and Hudson, 2005), pp. 71–3, p. 73. Critic Susanna Pettersson has described how 'Brotherus patiently awaits when she wants to capture a precise feeling in her work'. See Susanna Pettersson, 'Close to the Painting', in Bankale (ed.), *Elina Brotherus*, pp. 5–7, p. 7.

68 This essay was commissioned by Jules Wright of the Wapping Project, London, and originally published as Jane Rendell, 'Longing for the Lightness of Spring', in *Elina Brotherus* (London: The Wapping Project, 2001), pp. 19–26. The quoted comments are based on an interview conducted with Elina Brotherus on 28 September 2001. I have altered the essay slightly and supplemented the text with additional footnotes to position it in relation to other commentaries on Brotherus's work.

69 Pettersson notes that waiting for spring implies 'a special feeling for those who grew up in Nordic countries. Spring means painfully bright light, tentative warmth, and finally the greenness of the leaves on the trees.' See Pettersson 'Close to the Painting', p. 7.

70 For Brotherus, 'taking photographs is also, like naming things, a way of taking control of the world'. See 'The Enchantment of Reality: Discussion between Elina Brotherus and Jan Kaila, 31 August 2001', in *Decisive Days: Elina Brotherus: Photographs 1997–2001* (Oulo, Finland: Kunstannus Pohjoinen, 2002), pp. 127–41, p. 137.

71 In a commentary on Brotherus's work, critic Barry Schwabsky wonders whether the same word in a different language has a 'different emotional and cognitive valence'. See Barry Schwabsky, 'Real Jardin Botanico – Reviews – Elina Brotherus', *ArtForum* (October 2002), p. 161.

72 Brotherus comments: 'Up to 1999, I focused on emotions and was looking for emotional "decisive moments", something personal but at the same time recognisable to all, "the human condition".' See 'Elina Brotherus interviewed by Sheyi Anthony Bankale', p. 71.

73 This has been called an 'umbilical cord', one that 'attaches the subject/artist to the mechanism that makes the photograph'. See Craig Burnett, 'Magnetic North', *Modern Painters*, v. 14, n. 4 (Winter 2001), p. 104.

74 For Brotherus the aim of analytic chemistry is 'analysing what things contain'. See 'Elina Brotherus interviewed by Sheyi Anthony Bankale', p. 71.

75 Brotherus explains how when she first started studying photography she was still researching chemistry and strongly resistant 'to investigating my own emotional

life', but that when she completed her work in chemistry she was able to 'give up the scientific-analytical thinking required by that type of work and to concentrate on intuition and looking'. See 'The Enchantment of Reality', *Decisive Days*, p. 127.

76 '*Suites Françaises 2* (1999) has an autobiographical background, but the series' primary content, with its questions about understanding language, is something else.' For this reason Elina Brotherus sees *Suites Françaises 2* as 'a transition' or 'halfway between' the personal earlier photographs and the later work where autobiography is eliminated. See 'The Enchantment of Reality', p. 135.

77 This was 'Icelandic art ambassador' Edda Jonsdottir. See 'Elina Brotherus interviewed by Sheyi Anthony Bankale', p. 71.

78 A number of critics have subsequently argued that the figures in *The New Painting* series are models, marking a shift from the personal tone of Brotherus's early autobiographical mode to something more general or universal. See Andrea Holzherr, 'Of Landscape', trans. Emily Butler, in Bankale (ed.), *Elina Brotherus*, pp. 11–13, p. 11. Pettersson discusses *The New Painting* as 'a turning point and a move away from autobiographical portrayals … The essential thing is no longer depicting the model's inner world, but something more universal, more generally applicable.' See Pettersson, 'Close to the Painting', p. 5. These views reinforce Brotherus's own that 'with *The New Painting*, there was a profound shift: the formal visual qualities became the primary subject matter. My role in the image is that of a model, all personal narration is ruled out.' See 'Elina Brotherus interviewed by Sheyi Anthony Bankale', p. 71.

79 Schwabsky interprets the condensation on the mirror as a way of calling attention to the surface, and points to photography's 'limited ability to reflect reality'. See Schwabsky, 'Real Jardin Botanico', p. 161. The reflections, glass and mirrors that also feature in a later exhibition, *Model Studies* (2005), continuing the series *The New Painting*, have been described as 'powerful interpretive symbols, hinting at other, less obvious secrets concealed within these works'. See Paola Noe, '*Elina Brotherus* (5 March–9 April 2005), gb agency, Paris', trans. Rosalind Furness, *Modern Painters* (June 2005), p. 119.

80 Brotherus's work is organized according to series. She understands her search for 'organisation or clarity' in relation to her training as an analytic chemist. See 'Elina Brotherus interviewed by Sheyi Anthony Bankale', p. 71. She has also explained how the musical form or structural solution of 'theme and variations' appeals to her, and how she finds it an 'excellent form for serial pictorial work'. See 'The Enchantment of Reality', p. 131.

81 This series was part of *Suite Françaises 1*. Brotherus discusses how these landscapes are 'commas' or 'breathing spaces', initially made in response to the feeling of claustrophobia induced by a show of hers composed entirely of self-portraits. See 'The Enchantment of Reality', p. 131.

82 Brotherus likes bridges because 'you can't see to the other side', and curved hillsides or the horizons, because it is not possible to see beyond them; they are 'edges of the world'. See 'The Enchantment of Reality', p. 132.

83 For Brotherus the language of this work is 'ascetic and subdued', in response to the 'unpleasantness' of what she describes as 'over-intimate revelatory art'. It is part of her attempt to 'rise above the personal level to become universal'. See 'The Enchantment of Reality', p. 129.

84 Critic Andrea Holzherr has suggested that Brotherus 'is capable of transmitting an emotion into the landscape'. See Andrea Holzherr, 'Of Landscape', p. 11.

85 See also Jane Rendell, 'Site-Writing', in Sharon Kivland, Jaspar Joseph-Lester and

Emma Cocker (eds), *Transmission: Speaking and Listening*, vol. 4 (Sheffield: Sheffield Hallam University and Site Gallery, 2005), pp. 169–76.

86 Michel Foucault, *The Order of Things: An Archaeology of the Human Sciences* [1966], translated from the French (London: Routledge, 1992). Originally published in French under the title *Les Mots et Les Choses* by Editions Gallimard.

Configuration 4

1 Sigmund Freud, 'The Psychopathology of Everyday Life' [1901], *The Standard Edition of the Complete Psychological Works of Sigmund Freud*, vol. 6 *(1901): The Psychopathology of Everyday Life*, translated from the German under the general editorship of James Strachey (London: The Hogarth Press, 1960), pp. vii–296, p. 266.

2 Freud, 'The Psychopathology of Everyday Life', p. 265.

3 Freud, 'The Psychopathology of Everyday Life', pp. 266–7.

4 Sigmund Freud, 'The Interpretation of Dreams' [1900], *The Standard Edition of the Complete Psychological Works of Sigmund Freud*, vol. 5 *(1900–1901): The Interpretation of Dreams (Second Part) and On Dreams*, translated from the German under the general editorship of James Strachey (London: The Hogarth Press, 1953), pp. 339–628, p. 399.

5 Freud, 'The Interpretation of Dreams', p. 399.

6 Freud, 'The Psychopathology of Everyday Life', p. 268. Editor James Strachey states that this reference to Ferenczi was added as a footnote in 1910, and transferred to the text in 1924. Freud, 'The Psychopathology of Everyday Life', p. 267, n. 1.

7 Strachey notes that this point was interpolated in 1914. Freud, 'The Interpretation of Dreams', p. 399, n. 1. But it is one thing to propose that the repressed unconscious wish whose return *déjà vu* aims to circumvent through displacement has its origin in a dream, and quite another to suggest as Freud does that it is possible to experience *déjà vu* while dreaming. Strachey comments that the interpretation of *déjà vu* Freud advanced in his additions to the *Interpretation of Dreams* (1900), made in 1909 and 1914, is very different from the one he first made in 1907 and re-acknowledged in 1917. See Freud, 'The Psychopathology of Everyday Life', p. 268, n. 1.

8 Sigmund Freud, '*Fausse Reconnaissance* ("*déjà raconté*") in Psycho-Analytic Treatment' [1914], *The Standard Edition of the Complete Psychological Works of Sigmund Freud*, vol. 13 *(1913–1914): Totem and Taboo and Other Works*, translated from the German under the general editorship of James Strachey (London: The Hogarth Press, 1955), pp. 199–207, p. 203. The paper referred to is Joseph Grasset, 'La sensation du "*déjà vu*"', *Journal de Psychologie Normale et Pathologique*, v. 1 (1904), pp. 17–27. Three years later, in 1917, Freud adds an acknowledgement to Grasset's work to 'The Psychopathology of Everyday Life'. See Freud, 'The Psychopathology of Everyday Life', p. 268, n. 1.

9 Freud, '*Fausse Reconnaissance*', p. 203.

10 Freud, '*Fausse Reconnaissance*', p. 203.

11 Freud, '*Fausse Reconnaissance*', p. 204.

12 Sigmund Freud, 'A Disturbance of Memory on the Acropolis' [1936], *The Standard Edition of the Complete Psychological Works of Sigmund Freud*, vol. 22 *(1932–1936): New Introductory Lectures on Psycho-Analysis and Other Works*, translated from the German under the general editorship of James Strachey (London: The

Hogarth Press, 1964), pp. 237–48.

13 Freud, 'A Disturbance of Memory', p. 245.

14 Freud, 'A Disturbance of Memory', p. 245.

15 Freud, 'The Psychopathology of Everyday Life', p. 266.

16 Eli Marcovitz, M.D., 'The Meaning of Déjà Vu', *Psychoanalytic Quarterly*, v. 21 (1952), pp. 481–9, pp. 488–9.

17 Marcovitz, 'The Meaning of Déjà Vu', p. 484.

18 J.A. Arlow, 'The Structure of the Déjà Vu Experience', *Journal of the American Psychoanalytic Association*, v. 7 (1959), pp. 611–31, p. 628.

19 Arlow, 'The Structure of the Déjà Vu Experience', p. 628.

20 Arlow, 'The Structure of the Déjà Vu Experience', pp. 613–14.

21 Arlow, 'The Structure of the Déjà Vu Experience', p. 626.

22 Arlow, 'The Structure of the Déjà Vu Experience', p. 627.

23 Arlow, 'The Structure of the Déjà Vu Experience', p. 626.

24 Marcovitz, 'The Meaning of Déjà Vu', p. 484.

25 Peter Krapp, *Déjà Vu: Aberrations of Cultural Memory* (London and Minneapolis: University of Minnesota Press, 2004), p. xxiv.

26 Krapp, *Déjà Vu*, pp. 2–3. Krapp is referring to Sigmund Freud, 'The Psychical Mechanism of Forgetfulness' [1898], *The Standard Edition of the Complete Psychological Works of Sigmund Freud*, vol. 3 *(1893–1899): Early Psycho-Analytic Publications*, translated from the German under the general editorship of James Strachey (London: The Hogarth Press, 1962), pp. 287–97, which, as Krapp indicates, with certain changes in the sequence of argument, formed the basis for the opening chapter of Freud, 'The Psychopathology of Everyday Life'.

27 Krapp, *Déjà Vu*, p. 5.

28 Sigmund Freud, 'Screen Memories' [1899], *The Standard Edition of the Complete Psychological Works of Sigmund Freud*, vol. 3 *(1893–1899): Early Psycho-Analytic Publications*, translated from the German under the general editorship of James Strachey (London: The Hogarth Press, 1962), pp. 299–322, p. 322.

29 Freud, 'The Psychopathology of Everyday Life', pp. 43–4.

30 Freud, 'The Psychopathology of Everyday Life', p. 265. The strangeness of this omission is noted by Nicholas Royle. See Nicholas Royle, 'Déjà Vu', Martin McQuillan (ed.), *Post-Theory: New Directions in Criticism* (Edinburgh: Edinburgh University Press, 1999), pp. 3–20, p. 11.

31 Freud states that: 'The German word "*unheimlich*" is obviously the opposite of "*heimlich*" ["homely"], "*heimisch*" ["native"], …'. See Sigmund Freud, 'The "Uncanny"' [1919], *The Standard Edition of the Complete Psychological Works of Sigmund Freud*, vol. 17 *(1917–1919): An Infantile Neurosis and Other Works*, translated from the German under the general editorship of James Strachey (London: The Hogarth Press, 1955), pp. 217–56, p. 220. He also notes that: 'It may be true that the uncanny [*unheimlich*], is something which is secretly familiar [*heimlich-heimisch*].' See Freud, 'The "Uncanny"', p. 245.

32 Freud, 'The "Uncanny"', p. 245.

33 This investigation leads Freud from definitions of the word '*heimlich*' as an adjective meaning, 'belonging to the house, not strange, familiar, tame, intimate, friendly', to situations where it is used in the opposite way, as both an adjective and an adverb, to refer to things or actions that are 'concealed', 'kept from sight', 'withheld', 'deceitful' and 'secretive'. Freud, 'The "Uncanny"', pp. 222–5.

34 Freud, 'The "Uncanny"', p. 220.

35 Freud, 'The "Uncanny"', p. 225.

36 Strachey's note placed after the word 'body' in the quote above refers the reader back to Freud's earlier insertion into the 'The Interpretation of Dreams', where he 'labels' this experience *déjà vu*. See Freud, 'The "Uncanny"', p. 245, n. 1.

37 See D.W. Winnicott's account of transitional and subjective objects in D.W. Winnicott, 'Transitional Objects and Transitional Phenomena: A Study of the First Not-Me Possession', *International Journal of Psycho-Analysis*, v. 34 (1953), pp. 89–97, and D.W. Winnicott, 'The Use of an Object', *International Journal of Psycho-Analysis*, v. 50 (1969), pp. 711–16. It is interesting to note that Winnicott describes how 'transitional phenomena represent the early stages of the use of illusion'. See Winnicott, 'Transitional Objects and Transitional Phenomena', p. 95. Winnicott also discusses cultural experience as located in the 'potential space' between 'the individual and the environment (originally the object)'. In Winnicott's terms, this is the place where the baby has 'maximally intense experiences': '*in the potential space between the subjective object and the object objectively perceived*, between me-extensions and the not-me'. See D.W. Winnicott, 'The Location of Cultural Experience', *International Journal of Psycho-Analysis*, v. 48 (1967), pp. 368–72, p. 371.

38 Christopher Bollas, 'The Transformational Object', *International Journal of Psycho-Analysis*, v. 60 (1979), pp. 97–107, p. 97.

39 Bollas, 'The Transformational Object', p. 98.

40 Bollas, 'The Transformational Object', p. 98. Bollas also explored the notion of a 'maternal aesthetic' and its connection with later aesthetic experiences in his earlier paper, Christopher Bollas, 'The Aesthetic Moment and the Search for Transformation', *Annual of Psychoanalysis*, v. 6 (1978), pp. 385–94.

41 Bollas, 'The Transformational Object', p. 99.

42 Christopher Bollas, *The Shadow of the Object: Psychoanalysis of the Unthought Known* (London: Free Association Books, 1987), p. 32.

43 Bollas, *The Shadow of the Object*, p. 4.

44 Elizabeth Wright, *Speaking Desires can be Dangerous: The Poetics of the Unconscious* (Cambridge: Polity Press, 1999), p. 19.

45 Cristina Iglesias, in 'A Conversation between Cristina Iglesias and Gloria Moure', Iwona Blazwick (ed.), *Cristina Iglesias* (Porto, Dublin and London: Museu de Arte Contemporânea de Serralves, Irish Museum of Modern Art and Whitechapel Art Gallery, 2002–03), pp. 21–66, p. 23.

46 Iglesias, in 'A Conversation', p. 61.

47 All texts set in quotations but not in italics 'come back' from previous Configurations in this book.

48 I was invited to give a gallery talk about the exhibition *Cristina Iglesias* (7 April–1 June 2003), Whitechapel Art Gallery, London, and this text derives from my script for the guided tour. *Cristina Iglesias*, curated by Michael Tarantino, debuted at the Museu Serralves, Porto, 2002, and travelled to the Whitechapel Art Gallery, London, 2003, and the Irish Museum of Modern Art, Dublin, 2003.

49 Quotes from Cristina Iglesias that are not referenced are taken from notes I made of her verbal presentation at the opening of *Cristina Iglesias* (7 April–1 June 2003), Whitechapel Art Gallery, London.

50 Michael Newman, 'Imprint and Rhizome in the work of Cristina Iglesias', Blazwick (ed.), *Cristina Iglesias*, pp. 121–64, p. 125.

51 Marga Paz, 'Al Otro Lado Del Espejo' ('Through the Mirror'), trans. Alison Canosa, in *Cristina Iglesias* (Miengo, Cantabria, Spain: Sala Robayera, 1998), pp. 10–13, p. 13.

52 Iwona Blazwick, 'Introduction', Blazwick (ed.), *Cristina Iglesias*, pp. 9–17, p. 11.

53 Michael Tarantino, 'Cristina Iglesias: Between the Natural and the Artificial',

Blazwick (ed.), *Cristina Iglesias*, pp. 71–100 and 108.

54 Paz, 'Al Otro Lado Del Espejo', p. 12. Paz argues that Iglesias's landscapes are 'peculiar spatial forms whose *raison d'être* is to invent an imaginary architecture', of the kind that is found in fictitious or double spaces. Paz, 'Al Otro Lado Del Espejo', pp. 10–11. For Blazwick, the works 'offer a zone of experience, or *mise en scène*, which we enter by passing through a physical or virtual frame … Like Lewis Carroll's Alice, who climbs over a mantelpiece to enter a room reflected in a mirror, we are invited to enter a reflection of our world uncannily similar, yet subtly and disturbingly different.' Blazwick, 'Introduction', pp. 10–11.

55 According to Newman it is the use of phantasy, rather than phenomenology, which distinguishes Iglesias's work from minimalist sculpture. See Newman, 'Imprint and Rhizome', p. 125.

56 Iglesias, in 'A Conversation', p. 57.

57 Paz, 'Al Otro Lado Del Espejo', p. 12.

58 Blazwick, 'Introduction', p. 17.

59 Paz, 'Al Otro Lado Del Espejo', p. 13.

60 Michael Tarantino, 'Enclosed and Enchanted: Et in Arcadia Ego', *Enclosed and Enchanted* (Oxford: Museum of Modern Art, 2000), pp. 19–32, p. 24.

61 Curator Ulrich Wilmes explores how Iglesias's 'concept of the sculptural work has an inherent dialectic of closed form and open interpretation, perceived as both real and fictitious at the same time'. See Ulrich Wilmes, 'The Dramatization of Space: Cristina Iglesias: *Three Suspended Corridors*, 2005', *DC: Cristina Iglesias: Drei Hängende Korridore (Three Suspended Corridors)* (Köln: Museum Lüdwig and Verlag der Buchhandlung Walther König, 2006), p. 16–21, p. 19.

62 For Tarantino: 'The discrepancy that lies between exterior and interior is central to Cristina Iglesias' wall pieces …' See Tarantino, 'Enclosed and Enchanted', p. 24. Curator Penelope Curtis suggests that 'Iglesias collides the interior and the exterior'. See Penelope Curtis, 'Cristina Iglesias', in Penelope Curtis (ed.), *Gravity's Angel: Asta Groting, Kirsten Ortwed, Cristina Iglesias, Lili Dujourie* (Leeds: Henry Moore Institute, 1995), pp. 28–37, p. 31.

63 Paz describes how the works are 'marked by the physical imprint of other previous objects' and, noting Nancy Princenthal's discussion of Iglesias, argues that 'in reference to the Freudian term of "screen memories" as those whose opacity is imperfect, making it possible to discern fragments of previous experiences', nearly all the works can be defined as screens. See Paz, 'Al Otro Lado Del Espejo', p. 12.

64 Curtis maintains that Iglesias's works 'operate as a kind of passage or window between the physical and the mental'. See Penelope Curtis, 'Introduction', Curtis (ed.), *Gravity's Angel*, pp. 4–5, p. 5.

65 Curtis states that: 'She also collides the notions of the fabricated and the natural'. See Curtis, 'Cristina Iglesias', p. 31.

66 Iglesias, in 'A Conversation', p. 42.

67 Iglesias, in 'A Conversation', p. 42.

68 *Untitled: Tilted Hanging Ceiling* (1997) has been described as a '6-inch-thick slab of off-white resin, about 20 by 30 feet and covered in stone powder … suspended by wires from the ceiling'. See David Ebony, 'Beyond the Vanishing Point', *Art in America*, v. 94, n. 1 (January 2006), pp. 104–9, p. 108.

69 For Morgan Falconer, *Untitled* (1997–2000) is 'a series of large, gleaming copper plates silk-screened with photographs of a makeshift labyrinth or shanty town which the sculptor has constructed from cardboard boxes and sand'. See Morgan Falconer, 'Cristina Iglesias: Whitechapel Art Gallery, London', *Art Monthly*, n. 266

(May 2003), pp. 34–5.

70 Paz compares the work to the use of mirrors in the surrealist film *Orphée* (1950) by Jean Cocteau, which, combined with ruins or the 'unheimlich', created the marvellous, one of the emblems of surrealism. Paz argues though that although both create the 'atmosphere of "no man's land"', Igelias's landscapes are not ruins, but imaginary architectures. See Paz, 'Al Otro Lado Del Espejo', p. 10.

71 See Lewis Carroll, *Alice in Wonderland* [1865] (London: Constable and Co., 1998); Lewis Carroll, *Through the Looking-Glass, and What Alice Found There* [1871](London: Merrell, 2006); Mary Norton, *The Borrowers* [1952] (London: Puffin, 1993); and Jeff Brown, *Flat Stanley* [1964] (London: Egmont, 2003).

72 Iglesias, in 'A Conversation', p. 42.

73 This interesting point is one developed by Blazwick: 'The copper plate is essential to the traditional process of etching, playing the "middleman" in a process of transference from image to engraving on paper. Iglesias halts this process midway, stopping at the copper plate – the medium which was once used only as the messenger – printing a photograph directly onto its surface.' See Blazwick, 'Introduction', p. 17.

74 Iglesias, in 'A Conversation', pp. 30–1.

75 Iglesias describes her desire to create work that produces ambiguity and impossibility. See Cristina Iglesias, 'The Photograph as a Drawing' (1991), in Blazwick (ed.), *Cristina Iglesias*, p. 69, and Iglesias, 'A Conversation', p. 68.

76 Iglesias, in 'A Conversation', p. 50.

77 Ebony, 'Beyond the Vanishing Point', p. 106.

78 See Michael Bird, 'Cristina Iglesias: Whitechapel Art Gallery', *Modern Painters* v. 16, n. 2 (Summer 2003), p. 115.

79 This has been described as 'wood covered with resin and bronze powder' and 'wood and synthetic resin patinated with bronze powder'. See Ebony, 'Beyond the Vanishing Point', p. 106, and Wilmes, 'The Dramatization of Space', p. 17.

80 Fragment of text from Raymond Roussel, *Impressions of Africa* [1910], trans. Lindy Foord and Rayner Heppenstall (London: Calder, 1983), used in Cristina Iglesias, *Untitled: Celosia V* (2001) and *Untitled: Celosia VI* (2002). See Blazwick (ed.), *Cristina Iglesias*, p. 51.

81 Fragment of text from Joris-Karl Huysmans, *Against Nature* [1884], trans. Robert Baldick (Harmondsworth: Penguin, 1972), used in Cristina Iglesias, *Untitled: Celosia II* (1997). See Blazwick (ed.), *Cristina Iglesias*, p. 32.

82 Tarantino argues that: 'The structure itself creates a kind of symmetry: patterns of straight lines, ovals, diamonds, etc. The words create an asymmetry, each letter creating its own unity.' See Tarantino, 'Cristina Iglesias', p. 93.

83 See Tarantino, 'Cristina Iglesias', p. 79.

84 Iglesias, in 'A Conversation', p. 56.

85 Iglesias, in 'A Conversation', p. 50.

86 Iglesias, in 'A Conversation', p. 59 and p. 61.

87 Iglesias states that the configuration of the screens, 'the interior topography', varies according to location and the 'itinery' she has in mind; sometimes the passageway is blocked at the end, creating an 'ambiguous sensation'. See Iglesias, in 'A Conversation', pp. 65–6.

88 Iglesias, in 'A Conversation', p. 65.

89 Iglesias, in 'A Conversation', p. 65.

90 See Tarantino, 'Enclosed and Enchanted', p. 24.

91 Iglesias, in 'A Conversation', p. 57.

92 Iglesias, in 'A Conversation', p. 59.

93 See Newman, 'Imprint and Rhizome', p. 125.

94 Iglesias, in 'A Conversation', p. 43.

95 Iglesias, in 'A Conversation', p. 43.

96 Iglesias, in 'A Conversation', p. 31 and p. 37.

97 This work has been described as a reflective aluminium panel measuring about 8 × 12 ft and a curving concrete slab as approximately the same height and width, several inches thick. See Ebony, 'Beyond the Vanishing Point', p. 107.

98 Iglesias, in 'A Conversation', p. 26.

99 This sculpture has been described as a '25-foot-long, 10-foot-wide canopy' consisting of 'esparto mats suspended about 8 feet above the ground'. See Ebony, 'Beyond the Vanishing Point', p. 107. See also Wilmes, 'The Dramatization of Space', p. 17.

100 Fragment of text used in Cristina Iglesias, *Untitled (Passage)* (2002), from William Beckford, *Vathek* (1786–1987). See Blazwick (ed.), *Cristina Iglesias*, p. 27. See for example *An Arabian Tale (The History of the Caliph Vathek)*, from an unpublished manuscript by W. T. Beckford, translated from the French, with notes critical and explanatory by S. Henley (London: J. Johnson, 1786).

101 See for example Johann Friedrich Geist, *Arcades: The History of a Building Type* (Cambridge, Mass.: The MIT Press, 1983).

102 Walter Benjamin, *The Arcades Project (1927–1939)*, trans. Howard Eiland and Kevin McLaughlin (Cambridge, Mass.: Harvard University Press, 1999). For an account of the arcade as a dialectical image see for example Jane Rendell, *Art and Architecture: A Place Between* (London: I.B.Tauris, 2006), pp. 76–8.

103 Walter Benjamin, 'Paris: the Capital of the Nineteenth Century' [1935], trans. Quintin Hoare, in Walter Benjamin, *Charles Baudelaire: A Lyric Poet in the Era of High Capitalism* [1935–1939], trans. Harry Zohn (London: Verso, 1997), pp. 155–76, p. 176.

104 Walter Benjamin, 'Materials for the Exposé of 1935', in Benjamin, *The Arcades Project (1927–1939)*, pp. 899–918, p. 910.

105 See Anthony Vidler, 'Blind Alleys', in Blazwick (ed.), *Cristina Iglesias*, pp. 173–96, p. 176. See for example Louis Aragon, *Paris Peasant* [1926], trans. Simon Watson Taylor (Boston: Exact Change, 1994); André Breton, *Nadja* [1928], trans. Richard Howard (New York: Grove Weidenfeld, 1960); and André Breton, *Mad Love* [1937], trans. Mary Ann Caws (Lincoln, Nebraska, and London: University of Nebraska Press, 1987).

106 Tarantino, 'Cristina Iglesias', p. 73.

107 Tarantino, 'Cristina Iglesias', p. 73.

108 See the artist's book: Sharon Kivland, *Le Bonheur des Femmes* (The Scent of a Woman) (Trézélan: Filigranes Editions, 2002). See also Sharon Kivland, *Flair* (London: domoBaal Editions, 2004). For a longer discussion of this work see Jane Rendell, 'The Scent of a Woman: Between Flesh and Breath', *Portfolio*, v. 31 (2000), pp. 18–22.

109 Sharon Kivland, *La Valeur d'Échange* (Centre d'Art Contemporain de Rueil-Malmaison, 1999), n. p.

110 Jean-Marc Huitorel, 'Proper Nouns', trans. Stephen Wright, in Sharon Kivland, *La Valeur d'Échange* (Centre d'Art Contemporain de Rueil-Malmaison, 1999), n. p. See Emile Zola, *Nana* [1880], trans. George Holden (Harmondsworth: Penguin, 1972).

111 Sharon Kivland and Jeannie Lucas, *Parisiennes*, ed. Jean-Pierre Faur (Paris: Impression sur les Presses de Suisse Imprimerie, 2004).

112 Walter Benjamin, 'The Paris of the Second Empire in Baudelaire' [1938], trans. Harry Zohn, Benjamin, *Charles Baudelaire*, pp. 9–101, pp. 44–5.

113 See for example Jane Rendell, '"Industrious Females" and "Professional Beauties", or, Fine Articles for Sale in the Burlington Arcade', in Iain Borden, Joe Kerr, Alicia Pivaro and Jane Rendell (eds), *Strangely Familiar: Narratives of Architecture in the City* (London: Routledge, 1995), pp. 32–6; Jane Rendell, 'Subjective Space: An Architectural History of the Burlington Arcade', Duncan McCorquodale, Katerina Ruedi and Sarah Wigglesworth (eds), *Desiring Practices* (London: Black Dog Publishing, 1996), pp. 216–33; and Jane Rendell, 'Thresholds, Passages and Surfaces: Touching, Passing and Seeing in the Burlington Arcade', in Alex Coles (ed.), *The Optics of Walter Benjamin* (London: Black Dog Publishing, 1999), pp. 168–91.

114 See for example Benjamin, 'Materials for the Exposé of 1935', especially pp. 909–16.

115 Benjamin, 'Paris: the Capital of the Nineteenth Century'.

116 Benjamin, 'Paris: the Capital of the Nineteenth Century', p. 171.

117 Huitorel, 'Proper Nouns', n. p.

118 Sharon Kivland, *La Forme–Valeur/The Value-Form* (London: domoBaal Editions, 2006).

119 Karl Marx, *Capital: The Process of Production of Capital* (Harmondsworth: Penguin, 1976), p. 132.

120 Marx, *Capital*, p. 138.

121 Marx, *Capital*, p. 178, n. 1.

122 Luce Irigaray, 'Women on the Market', *This Sex Which Is Not One* [1977], trans. Catherine Porter with Carolyn Burke (Ithaca: Cornell, 1985), pp. 170–91, pp. 172, 176 and 185–7.

123 Irigaray, 'Women on the Market', p. 186. It is interesting to note that in the eighteenth and early nineteenth centuries, the word 'commodity' was used to refer to a woman's sex, and the term a 'public commodity' described a prostitute. See Francis Grose, *A Classical Dictionary* (London: S. Hooper, 1788), n. p., and Pierce Egan, *Grose's Classical Dictionary of the Vulgar Tongue* (London: Sherwood, Neely and Jones, 1823), n. p.

124 Luce Irigaray, 'Sexual Difference' [1984], *An Ethics of Sexual Difference* [1984], trans. Carolyn Burke and Gillian C. Gill (Ithaca, New York and London: Cornell University Press and Continuum, 1993), pp. 5–19, p. 15.

125 Michel Serres, *Angels: A Modern Myth* (Paris: Flammarion, 1995), p. 216.

126 Serres, *Angels*, pp. 140 and 147.

127 This catalogue essay was commissioned for *Elles sont passées par ici … Here nor There* (2005), a group show of eight women artists, Loquivy de la Mer, Brittany, France, originally published as Jane Rendell, 'She is walking about in a town she does not know', *Elles sont passées par ici … Here not There* (London: Artevisa, 2005), pp. 6–13, and subsequently republished as part of a longer article, Jane Rendell, 'Site-Writing: she is walking about in a town which she does not know', in Lesley McFayden and Matthew Barrac (eds), *Connected Spaces*, special issue of *Home Cultures* v. 4, n. 2 (2007), pp. 177–99.

128 Sharon Kivland 'She is walking about in a town which she does not know', Sharon Kivland, *A Case of Hysteria* (London: Book Works, 1999), pp. 177–86, and *She is walking about in a town which she does not know* (1997). The work is reproduced in the artist's book by Sharon Kivland with Shelagh Wakely and Michelle Naismith, *Fascinum* (London: 1997), and in Sharon Kivland, *La Valeur d'Échange* (Centre d'Art Contemporain de Rueil-Malmaison, 1999). See also Sharon Kivland, 'Aphoria', in Sharon Kivland, *Aphoria* (Saint-Fons: Editions Centre d'Art Plastiques de

Saint-Fons, 1994), n. p.

129 For Freud's account of Dora's second dream, referred to by Kivland, see Sigmund Freud, 'Fragment of an Analysis of a Case of Hysteria' [1905 [1901]], *The Standard Edition of the Complete Psychological Works of Sigmund Freud*, vol. 7 *(1901–1905): A Case of Hysteria, Three Essays on Sexuality and Other Works*, translated from the German under the general editorship of James Strachey (London: The Hogarth Press, 1953), pp. 1–122, p. 94.

130 Freud 'Fragment of an Analysis of a Case of Hysteria', pp. 95–6.

131 See for example Elizabeth Wilson, 'The Invisible Flaneur', *The New Left Review*, v. 191 (1992), pp. 90–110, and Janet Wolff, 'The Invisible Flaneuse', *Theory, Culture and Society*, v. 2, n. 3 (1985), pp. 37–46. My work has developed these arguments within architectural history. See Jane Rendell, *The Pursuit of Pleasure: Gender, Space and Architecture in Regency London* (London and New Brunswick, New Jersey: Continuum and Rutgers University Press, 2002).

132 Steve Pile, 'The Un(known) City … or, an Urban Geography of what Lies Buried below the Surface', in Iain Borden, Jane Rendell, Joe Kerr with Alicia Pivaro (eds), *The Unknown City: Contesting Architecture and Social Space* (Cambridge, Mass.: The MIT Press, 2001), pp. 263–79. See also Freud, 'The "Uncanny"', referred to by Pile.

133 Freud, 'The "Uncanny"', p. 237.

Configuration 5

1 Jean Laplanche, 'The Unfinished Copernican Revolution' [1992], trans. Luke Thurston, *Essays on Otherness*, ed. John Fletcher (London: Routledge, 1999), pp. 52–83, p. 71. Fletcher explains that Laplanche's neologism *étrangereté* has been translated as 'alien-ness' rather than 'strangerness' in order to denote the irreducible strangeness of the alien's external origin, as opposed to the subjective and more relative term 'strange'. See p. 62, n. 21.

2 See Judith Butler, 'Giving an Account of Oneself', *Diacritics*, v. 31, n. 4 (Winter 2001), pp. 22–40.

3 Adriana Cavarero, *Relating Narratives: Storytelling and Selfhood* [1997], translated by Paul A. Kottman (London: Routledge, 2000), p. 45.

4 Butler, 'Giving an Account of Oneself', p. 24.

5 Butler, 'Giving an Account of Oneself', p. 33.

6 Jean Laplanche, 'A Short Treatise on the Unconscious' [1993], trans. Luke Thurston, *Essays on Otherness*, pp. 84–116, p. 97.

7 Laplanche, 'A Short Treatise', p. 91, n. 18.

8 Laplanche, 'The Unfinished Copernican Revolution', p. 73. Both Didier Anzieu and André Green have taken issue, like Laplanche, with Jacques Lacan's formula: 'the unconscious is structured like a language'. Anzieu, following Freud's formulation that 'the unconscious is the body', argues that the unconscious is structured like the body: 'source of the first sensory-motor experiences'. See Didier Anzieu, *A Skin for Thought: Interviews with Gilbert Tarrab on Psychology and Psychoanalysis* (London and NY: Karnac Books, 1990), p. 43. Green posits that the unconscious 'is structured like an affective language, or like an affectivity having the properties of language'. Green's position, again following Freud's, is that if the unconscious, opposed to the pre-conscious, is constituted by thing-presentations as Freud suggests then what is 'related to language can only belong to the pre-

conscious'. See André Green 'Potential Space in Psychoanalysis: The Object in the Setting', Simon A. Grolnick and Leonard Barkin (eds), *Between Reality and Fantasy: Transitional Objects and Phenomena* (New York and London: Jason Aronson Inc., 1978), pp. 169–89, p. 186, and 'The Greening of Psychoanalysis: André Green in Dialogues with Gregorio Kohon', Gregorio Kohon (ed.), *The Dead Mother: The Work of André Green* (London: Routledge, published in association with the Institute of Psycho-Analysis, 1999), pp. 10–58, p. 24.

9 Laplanche, 'A Short Treatise on the Unconscious', p. 97.

10 Laplanche, 'A Short Treatise on the Unconscious', p. 104.

11 Laplanche, 'The Unfinished Copernican Revolution', p. 71, n. 37. Here the reader is referred to Jean Laplanche, *New Foundations for Psychoanalysis* [1987], trans. David Macey (Oxford: Basil Blackwell Ltd., 1989), pp. 130–3.

12 Jean Laplanche, 'The Aims of the Psychoanalytic Process', trans. Joan Tambureno, *Journal of European Psychoanalysis*, v. 5 (Spring–Fall 1997), pp. 69–79, p. 75.

13 Jean Laplanche, 'Transference: its Provocation by the Analyst' [1992], trans. Luke Thurston, *Essays on Otherness*, pp. 214–33, p. 228.

14 Laplanche, 'A Short Treatise', p. 92.

15 Laplanche, 'Transference: Its Provocation by the Analyst', p. 228.

16 Laplanche, 'The Unfinished Copernican Revolution', p. 83.

17 Jean Laplanche, 'Sublimation and/or Inspiration', trans. Luke Thurston and John Fletcher, *New Formations*, v. 48 (2002), pp. 30–50, p. 50.

18 Laplanche, 'Sublimation and/or Inspiration', p. 50.

19 Jean Laplanche, 'The Theory of Seduction and the Problem of the Other', *International Journal of Psycho-Analysis*, v. 78 (1997), pp. 653–66, p. 663.

20 Laplanche, 'Transference: Its Provocation by the Analyst', p. 230.

21 Laplanche, 'Transference: Its Provocation by the Analyst', p. 231.

22 Laplanche, 'Transference: Its Provocation by the Analyst', pp. 231–2, see figs 1 and 2.

23 Laplanche, 'Transference: Its Provocation by the Analyst', p. 232.

24 Laplanche, 'The Unfinished Copernican Revolution', p. 80.

25 Rana Kabbani, *The Passionate Nomad: The Diary of Isabelle Eberhardt* (Boston: Beacon Press, 1987), p. vi.

26 The following text is based on Jane Rendell, 'From Austin, Texas to Santiago Atitlán, and back again', Felipe Herandez (ed.), *Transculturation in Latin America and Architecture*, special issue of *Journal of Romance Studies*, v. 2, n. 3 (Winter 2003), pp. 89–100, but radically shortened and reworked. I would like to thank the editors of Berghahn Journals for permission to reproduce some sections of the article. The article was subsequently republished as Jane Rendell, 'From Austin, Texas to Santiago, Atitlán and back again', in Felipe Hernandez, Mark Millington and Iain Borden (eds), *Architecture and Transculturation in Latin America* (New York and Amsterdam: Rodopi, 2006), pp. 43–58.

27 Susan Stanford Friedman, *Mappings: Feminism and the Cultural Geographies of Encounter* (Princeton: Princeton University Press, 1998), p. 143.

28 'Transcultural Architecture in Latin America', organized by Felipe Hernandez, Mark Millington and Iain Borden, Institute of Romance Studies, University of London (2001).

29 Friedman, *Mappings*, p. 143.

30 Christopher Johnson, 'Speaking in Tongues', Inaugural Lecture, University of Nottingham (8 June 2000).

31 Gustave Flaubert, *Salammbô* [1862] (London: Everyman's Library, 1931).

32 Claude Lévi-Strauss, *Tristes Tropiques* (Paris: Librarie Plon, 1955).

33 Johnson, 'Speaking in Tongues'.

34 Walter Benjamin, 'The Task of the Translator' [1923], trans. Harry Zohn, in *Illuminations*, edited and with an introduction by Hannah Arendt (London: Fontana, 1992), pp. 70–82.

35 Laplanche, 'Sublimation and/or Inspiration', p. 28.

36 Kaja Silverman, *The Threshold of the Visible World* (London: Routledge, 1996), pp. 22–7.

37 For an account of the 'Brazilian-derived metaphor of anthropophagy' as it emerged in the work of Haroldo de Campus in the 1960s, see for example Else Vieira, 'Liberating Calibans: Readings of Antropofagia and Haroldo de Campos Poetics of Transcreation', Susan Bassnett and Harish Trivedi (eds), *postcolonial Translation: Theory and Practice* (London: Routledge, 1999), pp. 95–113.

38 Homi K. Bhabha, *The Location of Culture* (London: Routledge, 1994), p. 34.

39 Bhabha, *The Location of Culture*, p. 163.

40 Friedman, *Mappings*, p. 86.

41 Michael Taussig, *Mimesis and Alterity: A Particular History of the Senses* (London: Routledge, 1993), p. 19.

42 Gayatri Chakravorty Spivak, 'Can the Subaltern Speak?', in Patrick Williams and Laura Chrisman (eds), *Colonial Discourse and Post-Colonial Theory: A Reader* (Hemel Hempstead: Harvester Wheatsheaf, 1993), pp. 66–111.

43 Nikos Papastergiadis, 'Tracing Hybridity in Theory', in Pnina Werbner and Tariq Modood (eds), *Debating Cultural Hybridity: Multi-Cultural Identities and the Politics of Anti-Racism* (London: Zed Books, 1997), pp. 257–81, p. 276.

44 Georg Simmel, 'Bridge and Door' [1909], trans. Mark Ritter, in Neil Leach (ed.), *Rethinking Architecture: A Reader in Cultural Theory* (London: Routledge, 1997), pp. 66–9.

45 See Jane Rendell, 'Imagination is the Root of all Change', in *Bridges* (a book accompanying three films on bridges by Lucy Blakstad) (London: August Publications, 2001), pp. 30–7.

46 Diane Elam, *Feminism and Deconstruction: Ms. En Abyme* (London: Routledge, 1994).

47 Mieke Bal, *Looking In: The Art of Viewing* (Amsterdam: G + B Arts International, 2001), p. 67. See Jacques Derrida, *Dissemination* [1972], trans. Barbara Johnson (London: The Athlone Press, 1981).

48 Mladen Dolar, 'The Object Voice', in Renata Salacl and Slavoj Zizek (eds), *Sic 1: Gaze and Voice as Love Objects* (London and Durham, North Carolina: Duke University Press, 1996), pp. 7–31, p. 16.

49 Dolar, 'The Object Voice', p. 15.

50 Bhabha, *The Location of Culture*, p. 150.

51 Bhabha, *The Location of Culture*, p. 162.

52 Interestingly, this quote comes not from Bhabha himself, but from Bhabha quoting Lyotard and Thébaud. See Bhabha, *The Location of Culture*, p. 150 and p. 267, n. 31. See also J.K. Lyotard and J.L. Thébaud, *Just Gaming*, trans. W. Godzich (Manchester: Manchester University Press, 1985), p. 41.

53 Miwon Kwon, 'The Other Otherness: The Art of Do-Ho Suh', *Do-Ho Suh* (London: Serpentine Gallery, 2002), pp. 9–25, p. 23. For an extended discussion of site-specificity and dislocation see Miwon Kwon, *One Place After Another: Site Specific Art and Locational Identity* (Cambridge, Mass.: The MIT Press, 2002).

54 I participated in an art and architecture workshop in Seoul, Korea, organized by Junghee Lee in April 2002.

55 I was invited to give a gallery talk about the exhibition, Do-Ho Suh (23 April–26 May 2002), Serpentine Gallery, London, and this text derives from my script for the guided tour. *Do-Ho Suh*, curated by Lisa G. Corrin and Mary Shirley, debuted at the

Serpentine Gallery, London, 2002, and travelled to the Seattle Art Museum and
Seattle Asian Art Museum, Seattle, 2002.

56 Do-Ho Suh, *Who Am We? (Multi)* (2000). The 37,000 images of faces are taken
 from high school yearbooks of Suh and his friends. For a critical commentary see,
 for example, Miwon Kwon, 'The Other Otherness: The Art of Do-Ho Suh', *Do-
 Ho Suh* (London: Serpentine Gallery, 2002), pp. 9–25, p. 9.

57 Do-Ho Suh, *Floor* (1997–2000). This work consists of 180,000 figures cast from six
 different moulds. The figures differ from those in *Doormat: Welcome (Amber)* (2000),
 also exhibited at the Serpentine Gallery, and *Doormat: Welcome (Green)* (1998),
 described by Katie Clifford as less defined, apparently because Suh wanted them
 to appear as if they had been rubbed away by people stepping on them. See Katie
 Clifford, 'A Soldier's Story', *Art News* (January 2002), pp. 102–5, p. 104.

58 See for example Janet Kraynak, 'Travelling in Do-Ho Suh's World', *La Biennale
 di Venezia/Korean Pavilion: Do-Ho Suh* (Seoul: The Korean Culture and Arts
 Foundation, 2001), pp. 41–2.

59 Kwon, 'The Other Otherness', p. 12.

60 Kwon, 'The Other Otherness', p. 12. In a similar vein, artist Tom Csaszar has
 commented that Suh's work often 'inverts or suspends expectations', but he does
 not argue that the inversion is then itself overturned. See Tom Csaszar, 'Social
 Structures and Shared Autobiographies: A Conversation with Do-Ho Suh',
 Sculpture, v. 24, n. 10 (December 2005), pp. 34–41, p. 40.

61 Other critics have also drawn out the more threatening aspects of *Some/One* and
 High School Uni-Form. For example, Frances Richard connects *Some/One* with 'enigma
 and threat' and *High School Uni-Form* as well as *Who Am We?* with 'an oppressive
 sameness', in distinction to what she calls the 'collective strength' of *Floor*. See Frances
 Richard, 'The Art of Do-Ho Suh', *Art Forum* (January 2002), pp. 115–17, p. 117.
 High School Uni-Form has been described by Clifford as 'militaristic', a comment
 made in connection to an article in which she frames Suh's work in relation to his
 time in military service. See Clifford, 'A Soldier's Story', p. 104. Audrey Walon
 has stated that *Some/One* 'bring[s] out the military strength of the collective' in a
 more confrontational way than other pieces by Suh, an interpretation formulated
 in response to the installation of this work at the heart of the capitalist corporation
 Philip Morris. See Audrey Walen, 'Do-Ho Suh: Whitney Museum at Philip
 Morris', *Sculpture*, v. 20, n. 8 (October 2001), pp. 72–3, p. 72.

62 Glenn Harper asks whether the figures in the Suh's *Floor* are 'oppressed masses' or
 the 'workers who support the world'. See Glenn Harper, 'Do-Ho Suh: Lehmann
 Maupin', *Sculpture*, v. 20, n. 1 (January–February 2001), pp. 62–3, p. 62.

63 Kwon discusses all these ambiguities. See Kwon, 'The Other Otherness', p. 13.

64 Kwon refers particularly to Clifford, 'A Soldier's Story'. See Kwon, 'The Other
 Otherness', p. 13.

65 Kwon, 'The Other Otherness', pp. 13 and 16. See also Michael Hardt and
 Antonio Negri, *Empire* (Cambridge, Mass.: Harvard University Press, 2000).

66 Kwon, 'The Other Otherness', p. 17.

67 Kwon, 'The Other Otherness', p. 17.

68 My understanding of Insu Choi's views comes from a conversation with him where
 Junghee Lee acted as an informal translator. The inaccuracies in this articulation
 of his position are my own.

69 Choi places a strong emphasis on Taoist tradition and meditative practice in his own
 work. In the winter he draws lines on paper in response to the length of his breath and
 in the summer he rolls clay. For Choi, the hand is a tool, which in the act of shaping

integrates spirit and matter. See for example Insu Choi, Nigel Hall, Christain Herdeg and Paul Isenrath, *Beyond the Circle* (The Moran Museum of Art, 2000).

70 See for example Young Seok Yoon, *Temple of Time* (Seoul, Korea: TOTAL Museum of Contemporary Art, 1999). See also Young Seok Yoon's *Piggy Plantation* (2002), shown at PS1 and the Clock Tower Gallery, New York.

71 See Miwon Kwon, 'Uniform Appearance', *frieze*, n. 38 (January–February 1998), pp. 68–9.

72 Lisa G. Corrin, 'The Perfect Home: A Conversation with Do-Ho Suh', *Do-Ho Suh* (London: Serpentine Gallery, 2002), pp. 27–39, p. 27.

73 Corrin, 'The Perfect Home', p. 27.

74 Corrin, 'The Perfect Home', p. 28.

75 Corrin, 'The Perfect Home', p. 27.

76 See for example the photographs and short texts describing Yeon-Gyeongdang (House), including the Husband's Quarters, the Housewife's Quarters, the Inner Servants' Quarters and Seonhyangjae (Library) in Jong-Soon Yoon, *Changdeokgung (Palace)* (Seoul: Sung Min Publishing House, 2000), pp. 46–51.

77 Corrin, 'The Perfect Home', p. 28.

78 Kwon, 'The Other Otherness', p. 25, n. 19.

79 Clifford, 'A Soldier's Story', p. 105.

80 Kwon, 'The Other Otherness', p. 17.

81 Corrin, 'The Perfect Home', p. 29.

82 Kwon describes how 'The original building was itself designed to mimic a commoner's home …' See Kwon, 'The Other Otherness', p. 25, n. 19.

83 Yoon, *Changdeokgung (Palace)*, p. 46.

84 The grey has been described as 'dust-coloured', see Richard, 'The Art of Do-Ho Suh', p. 116; and also as generic in contrast to the culturally specific 'celadon' green of *Seoul Home* …, see Kwon, 'The Other Otherness', p. 17.

85 Critics have drawn attention to the colouring of the work; some argue that it articulates the functional zoning of architectural design emphasized in the colour coding of drawings. See C. K. Ho, 'Do-Ho Suh: Lehmann Maupin Gallery', *Modern Painters*, v. 16, n. 3 (August 2003), pp. 122–3, p. 122. Others suggest the choice of colours is emotive, with the pink of the corridor considered to be indicative of the 'rose-tinted', 'idealized' and 'fantasized connection' between the different elements of the piece; see Richard, 'The Art of Do-Ho Suh', p. 116.

86 For example when installed in the Seattle Art Museum and Seattle Asian Art Museum, Seattle, 2002. See Anon., 'Do-Ho Suh: The Perfect Home', *Fiberarts*, v. 29, n. 3 (November–December 2002), pp. 22–3.

87 For example when installed at the Lehmann Maupin Gallery, New York, 2003. See http://www.lehmannmaupin.com/#/exhibitions/2003-05-30_do-ho-suh/ (accessed 14 June 2008).

88 See for example James Lingwood (ed.), *Rachel Whiteread: House* (London: Phaidon Press, 1995).

89 Kwon, 'The Other Otherness', p. 25, n. 20.

90 Laplanche, 'Sublimation and/or Inspiration', p. 45.

91 This essay was commissioned by Domo Baal of domoBaal contemporary art, London, and originally published as Jane Rendell, 'Everywhere Else', *Ausland*, comprising artists Jan Peters, Silke Schatz and Martina Schmid (London: domoBaal contemporary art, 2003), pp. 2–5. It has also been republished as part of a longer essay, Jane Rendell, 'Critical Spatial Practice: Curating, Editing, Writing', in Judith Rugg and Michèle Sedgwick (eds), *Issues in Curating Contemporary*

Art and Performance (Bristol, UK: Intellect, 2007), pp. 59–75.

92 See Martina Schmid, *Deep 1–6* (2003), ink on paper. See also the artist's books, Martina Schmid, *Landed* (London: domoBaal contemporary art, 2002), edition of 500, and Martina Schmid, *Thirteen Collected Lands* (London: domoBaal contemporary art, 2002), edition of 500, as part of the solo exhibition, Martina Schmid, *Land or Reason* (2001), domoBaal contemporary art, London.

93 See for example Silke Schatz, *Köln, Weidengasse* (2001), Fluchtpunktstudie, Blei- and Buntstift auf Papier, 83.4 × 114 cm, and *A Force for Good* (2001), Blei- and Buntstift auf Papier, 190 × 240 cm. Silke Schatz has had three solo shows at the Wilkinson Gallery London. The most recent, *Private and Public* (2006), deals with subjectivity and architecture through the disturbance of memory; reviewed by Roy Exley, 'Silke Schatz: Wilkinson Gallery', *Flash Art*, v. 36 (September–October 2006), p. 120.

94 Jan Peters, *Wie ich ein Höhlenmaler wurde (How I became a Caveman)* (2001), 16 mm, 38 min.

95 Guy Debord, 'Détournement as Negation and Prelude' [1959], *Situationist International Anthology* [1989], edited and translated by Ken Knabb, revised and expanded edition (Berkeley, California: Bureau of Public Secrets, 2006), pp. 67–8, p. 67. For the distinction between '*minor détournements* and *deceptive détournements*', where the former involves the recontextualization of an insignificant element, and in the latter a significant element 'derives a different scope from the new context', see Guy Debord and Gil J. Wolman, 'User's Guide to Détournement' [1956], *Situationist International Anthology*, pp. 14–21, p. 16. Debord and Wolman stress that '*the main impact of a détournement is directly related to the conscious or semiconscious recollection of the original contexts of the elements*', p. 17. Debord also notes how the theory of *détournement* stresses that situationist art, including unitary urbanism, must be not only critical in content but also self-critical in form: 'It is a communication which, recognizing the limitations of the specialized sphere of established communication, "is now going to contain *its own critique*".' See Guy Debord, 'The Situationists and the New Forms of Action in Politics and Art' [1963], *Situationist International Anthology*, pp. 402–7, p. 407.

96 This text was originally written as a talk commissioned by the National Gallery, London, and delivered on 6 June 2007. As part of Architecture Week, a number of architectural historians were invited to talk about the architecture depicted in various paintings in the gallery; because of my work on public art, it was suggested that I might discuss the sculptures in front of the gallery in Trafalgar Square. This contextual detail is important because it locates the site of the delivery of the talk – the National Gallery, overlooking Trafalgar Square. A new version of the talk was later delivered as a paper at *Power and Space*, University of Cambridge, 5–7 December 2007, and has been further developed here.

97 For a more detailed discussion of these works and my understanding of how public art can operate as a 'critical spatial practice', see Jane Rendell, *Art and Architecture: A Place Between* (London: I.B.Tauris, 2006).

98 All details of the history of the art and architecture of Trafalgar Square are taken from Rodney Mace, *Trafalgar Square: Emblem of Empire* (London: Lawrence and Wishart, 2005).

99 See Gerrie van Noord (ed.), *Off Limits, 40 Artangel Projects* (London: Artangel, 2002), pp. 190–195, and Jeremy Deller, *The Battle of Orgreave* (London: Artangel, 2002). See also Dave Beech, review of Jeremy Deller, 'The Battle of Orgreave', *Art Monthly* (July–August 2001), pp. 38–9 and Rendell, *Art and Architecture*, pp. 61–3.

100 See for example http://en.wikipedia.org/wiki/Ismail_Haniyeh (accessed 8 June 2008).

101 See http://security.homeoffice.gov.uk/legislation/current-legislation/terrorism-act-2000/proscribed-terrorist-groups?version=1 (accessed 8 June 2008).

102 Robert Smithson, 'Towards the Development of an Air Terminal Site' [1967], Jack Flam (ed.), *Robert Smithson: The Collected Writings* (Los Angeles: University of California Press, 1996), pp. 52–60. See also Suzaan Boettger, *Earthworks: Art and the Landscape of the Sixties* (Los Angeles: University of California Press, 2002), pp. 55–8.

103 Robert Smithson, '*Earth* Symposium at White Museum, Cornell University' [1969], Flam, *Robert Smithson*, pp. 177–87, p. 178.

104 See Rendell, *Art and Architecture*, pp. 23–40.

105 This programme included Anna Best, *MECCA*, State Mecca Bingo Hall; Felix Gonzalez-Torres, *Untitled (America) (1994–95)*; Maurice O'Connell, *On Finchley Road*; and Orla Barry, *Across an Open Space*. Other artists worked with participants at Swiss Cottage library and the Royal Free NHS Trust.

106 See Adam Chodzko, *Plans and Spells* (London: Film & Video Umbrella, 2002), pp. 40–1, and Adam Chodzko, 'Out of Place', John Carson and Susannah Silver (eds), *Out of the Bubble; Approaches to Contextual Practice within Fine Art Education* (London: London Institute, 2000), pp. 31–6.

107 Chodzko, *Plans and Spells*, pp. 40–1.

108 Mace, *Trafalgar Square*, pp. 115–16. Mace quotes from T. R. E. Holmes, *Four Famous Soldiers* (London: 1889), p. 28.

109 See http://www.london.gov.uk/fourthplinth/ (accessed 20 June 2008).

110 See http://www.24hourmuseum.org.uk/nwh_gfx_en/ART30597.html (accessed 8 June 2008).

111 Charles Darwent, 'The Battle of Trafalgar', *Independent on Sunday* (4 September 2005). See http://findarticles.com/p/articles/mi_qn4159/is_20050904/ai_n15331791/pg_1?tag=artBody;col1 (accessed 8 June 2008).

112 *Memorial to Iraq* (23 May – 27 June 2007), Institute of Contemporary Arts, London. See for example http://www.ica.org.uk/Memorial%20to%20the%20Iraq%20War+13499.twl (accessed 8 June 2008).

113 See Jonathan Holmes (ed.), *Fallujah: Eyewitness Testimony from Iraq's Besieged City* (London: Constable and Robinson Ltd, 2007).

114 See http://justice4lebanon.wordpress.com/2007/04/26/use-of-napalm-like-white-phosphorus-bombs-in-lebanon/ (accessed 2 December 2007) and http://www.csmonitor.com/2005/1108/dailyUpdate.html (accessed 2 December 2007).

115 George Monbiot is quoting from Captain James T. Cobb, First Lieutenant Christopher A. LaCour and Sergeant First Class William H. Hight, 'TF 2-2 in FSE AAR: Indirect Fires in the Battle of Fallujah', *Field Artillery* (March–April 2005), p. 26. See George Monbiot, 'War without Rules', in Holmes (ed.), *Fallujah*, pp. 107–12, pp. 107–8, originally published in *The Guardian*, 15 November 2005. See also http://www.globalsecurity.org/military/library/report/2005/2-2AARlow.pdf (accessed 11 July 2008).

Epilogue

1 Juliet Mitchell, 'Theory as an Object', *October*, v. 113 (Summer 2005), pp. 29–38. In her paper Mitchell refers to D.W. Winnicott, 'The Use of an Object', *International Journal of Psycho-Analysis*, v. 50 (1969). pp. 711–16.

2 Winnicott, 'The Use of an Object', p. 715.

3 Winnicott, 'The Use of an Object', p. 713.

4 Mitchell, 'Theory as an Object', p. 32.

5 Mitchell, 'Theory as an Object', p. 33.

6 Mitchell, 'Theory as an Object', p. 29.

7 Bik Van Der Pol, *Fly Me To The Moon* (2005), Rijksmuseum, Amsterdam. The project was commissioned by Het Mieuwe Rijksmuseum as part of the arts programme 'a contemporary view of the Rijksmuseum' during the renovation of the building. Bik Van Der Pol commissioned a range of writers – Jennifer Allen, Wouter Davidts, Frans Von der Dunk and myself – to respond to the moon rock. See Bik Van Der Pol, *Fly Me To The Moon* (Amsterdam: Rijksmuseum and Sternberg Press, 2006). See also http://www.sternbergpress.com/index.php?pageId=1156&l=en&bookId=56&sort=year (accessed 21 June 2008); http://www.rijksmuseum.nl/pers/tentoonstellingen/fly-me-the-moon?lang=en (accessed 21 June 2008); and http://www.bikvanderpol.net/ (accessed 21 June 2008).

8 This essay was originally published as Jane Rendell, 'Alien Positions', in Bik Van Der Pol, *Fly Me To The Moon* (Amsterdam: Rijksmuseum and Sternberg Press, 2006), pp. 49–55 and 163–8.

9 Jean Laplanche, 'The Unfinished Copernican Revolution' [1992], trans. Luke Thurston, *Essays on Otherness*, ed. John Fletcher (London: Routledge, 1999), pp. 52–83, p. 60.

10 Laplanche, 'The Unfinished Copernican Revolution', p. 54, n. 6.

11 Laplanche, 'The Unfinished Copernican Revolution', p. 65.

12 This is an image of the earth taken on 7 December 1972 as the Apollo 17 was travelling towards the moon. Reproduced from the NASA website: http://veimages.gsfc.nasa.gov/1597/AS17-148-22727.jpg (accessed 14 July 2008).

Select Bibliography

Leila Ahmed, 'The Discourse on the Veil', *Women and Gender in Islam: Historical Roots of a Modern Debate* (New Haven: Yale University Press, 1993), pp. 144–68.

Jananne Al-Ani (London: Film and Video Umbrella, 2005), n. p.

Gloria Anzaldúa, *Borderlands/La Frontera: the New Mestiza* [1987], (San Francisco: Lute Books, 1999).

Didier Anzieu, *The Skin Ego: A Psychoanalytic Approach to the Self*, trans. Chris Turner (New Haven: Yale University Press, 1989).

Didier Anzieu, *A Skin for Thought: Interviews with Gilbert Tarrab on Psychology and Psychoanalysis* (London: Karnac Books, 1990).

Didier Anzieu (ed.), *Psychic Envelopes*, trans. Daphne Briggs (London: Karnac Books, 1990).

Isobel Armstrong, *The Radical Aesthetic* (Oxford: Blackwell Publishing, 2000).

David A. Bailey and Gilane Tawadros (eds), *Veil: Veiling, Representation and Contemporary Art* (inIVA and Modern Art Oxford, 2003).

Mieke Bal, *Looking In: The Art of Viewing* (Amsterdam: G+B Arts International, 2001).

Mieke Bal, *Louise Bourgeois's Spider: The Architecture of Art-Writing* (London and Chicago: University of Chicago Press, 2001).

Roland Barthes, 'Twenty Keywords for Roland Barthes' [1975], in *The Grain of the Voice: Interviews 1962–1980*, trans. Linda Coverdale (Berkeley and Los Angeles: University of California Press, 1991), pp. 205–32.

Roland Barthes by Roland Barthes [1975], translated from the French by Richard Howard (London: Macmillan, 1977).

Scyla Benhabib, *Situating the Self: Gender, Community and Postmodernism in Contemporary Ethics* (Cambridge: Polity Press, 1992).

Jessica Benjamin, 'An Outline of Intersubjectivity: The Development of Recognition', *Psychoanalytic Psychology*, v. 7 (1990), pp. 33–46.

Jessica Benjamin, *Like Subjects/Love Objects* (New Haven: Yale University Press, 1995).

Jessica Benjamin, *Shadow of the Other: Intersubjectivity and Gender in Psychoanalysis* (London: Routledge, 1998).

Jessica Benjamin, 'Beyond Doer and Done To: An Intersubjective View of Thirdness', *The Third in Psychoanalysis*, special issue of *Psychoanalytic Quarterly*, v. 73, n. 1 (2004), pp. 5–46.

Walter Benjamin, 'The Task of the Translator' [1923], in *Illuminations*, trans. Harry Zohn, edited and with an introduction by Hannah Arendt (London: Fontana, 1992), pp. 70–82.

Walter Benjamin, *The Arcades Project (1927–1939)*, trans. Howard Eiland and Kevin McLaughlin (Cambridge, Mass.: Harvard University Press, 1999).

Walter Benjamin, 'One Way Street' [1928], trans. Edmund Jephcott, in Marcus Bullock and Michael W. Jennings (eds), *Walter Benjamin: Selected Writings*, vol. 1, *1913–1926* (Cambridge, Mass.: Harvard University Press, 2004), pp. 444–88.

Walter Benjamin, *Charles Baudelaire: A Lyric Poet in the Era of High Capitalism* [1935–39], trans. Harry Zohn (London: Verso, 1997).

Walter Benjamin, 'Theses on the Philosophy of History' [1940], trans. Harry Zohn, in *Illuminations*, edited and with an introduction by Hannah Arendt (London: Fontana, 1992), pp. 245–55.

Homi K. Bhabha, *The Location of Culture* (London: Routledge, 1994).

Bik Van Der Pol, *Fly Me To The Moon* (Amsterdam: Rijksmuseum and Sternberg Press, 2006).

Claire Bishop, *Installation Art: A Critical History* (London: Tate Publishing, 2005).

Iwona Blazwick (ed.), *Cristina Iglesias* (Porto, Dublin and London: Museu de Arte Contemporânea de Serralves, Irish Museum of Modern Art and Whitechapel Art Gallery, 2002–03).

José Bleger, 'Psycho-Analysis of the Psycho-Analytic Frame', *International Journal of Psycho-Analysis*, v. 48 (1967), pp. 511–19.

Jennifer Bloomer, *Architecture and the Text: The (S)crypts of Joyce and Piranesi* (New Haven and London: Yale University Press, 1993).

Christopher Bollas, *Free Association* (Duxford, Cambridge: Icon Books Ltd, 2002).

Nicholas Bourriaud, *Relational Aesthetics*, trans. Simon Pleasance and Fronza Woods (Paris: Les Presses du Réel, 2002).

Rosi Braidotti, *Nomadic Subjects* (New York: Columbia University Press, 1994).

André Breton, *Nadja* [1928], trans. Richard Howard (New York: Grove Weidenfeld, 1960).

André Breton, *Mad Love* [1937], trans. Mary Ann Caws (Lincoln, Nebraska, and London: University of Nebraska Press, 1987).

Josef Breuer, 'Theoretical' [1893], *The Standard Edition of the Complete Psychological Works of Sigmund Freud*, vol. 2 *(1893–1895): Studies on Hysteria*, translated from the

German under the general editorship of James Strachey (London: The Hogarth Press, 1955), pp. 183–251.

Josef Breuer and Sigmund Freud, 'On The Psychical Mechanism of Hysterical Phenomena' [1893], *The Standard Edition of the Complete Psychological Works of Sigmund Freud*, vol. 2 *(1893–1895): Studies on Hysteria*, translated from the German under the general editorship of James Strachey (London: The Hogarth Press, 1955), pp. 1–17.

Elina Brotherus: The New Painting (Next Level & Creative Scape and Thames and Hudson, 2005).

Neal Brown, *TE: Tracey Emin* (London: Tate Publishing, 2006).

Guiliana Bruno, *Atlas of Emotion: Journeys in Art, Architecture and Film* (London: Verso, 2002).

Norman Bryson, 'Introduction: Art and Intersubjectivity', in Mieke Bal, *Looking in: The Art of Viewing* (Amsterdam: G+B Arts International, 2001), pp. 1–39.

Judith Butler, 'Giving an Account of Oneself', *Diacritics*, v. 31, n. 4 (Winter 2001), pp. 22–40.

Gavin Butt (ed.), *After Criticism: New Responses to Art and Performance* (Oxford: Blackwell Publishing, 2005).

A.S. Byatt, *On Histories and Stories* (London: Vintage, 2001).

Italo Calvino, 'Cybernetics and Ghosts', *The Literature Machine* (London: Vintage, 1997), pp. 3–27.

Italo Calvino, 'Literature as Projection of Desire', *The Literature Machine* (London: Vintage, 1997), pp. 50–61.

Italo Calvino, *If on a Winter's Night a Traveller* (London: Vintage Classics, 1998).

David Carrier, *Artwriting* (Amherst, Mass.: University of Massachusetts Press, 1987).

David Carrier, *Writing about Visual Art* (New York: Allworth Press, co-published with the School of Visual Art, 2003).

Cathy Caruth, 'An Interview with Jean Laplanche', © 2001 Cathy Caruth. See http://www3.iath.virginia.edu/pmc/text-only/issue.101/11.2caruth.txt (accessed 3 May 2006).

Adriana Cavarero, *Relating Narratives: Storytelling and Selfhood* [1997], trans. Paul A. Kottman (London: Routledge, 2000).

Mary Ann Caws, *A Metapoetics of the Passage: Architextures in Surrealism and After* (Hanover and London: University Press of New England, 1981).

Howard Caygill, *Walter Benjamin: The Colour of Experience* (London: Routledge, 1998).

Hélène Cixous, 'Sorties' [1975], trans. Betsy Wing, in Susan Sellers (ed.), *The Hélène Cixous Reader* (London: Routledge, 1994), pp. 37–44.

Hélène Cixous, 'Sorties' [1975], trans. Ann Liddle, in Elaine Marks and Isabelle de Courtivron (eds), *New French Feminisms* (London: Harvester Wheatsheaf, 1981), pp. 90–8.

Hélène Cixous, *Three Steps on the Ladder to Writing* [1990], trans. Sarah Conell and Sarah Sellers (New York: Columbia University Press, 1993).

T. J. Clarke, *The Sight of Death: An Experiment in Art Writing* (New Haven and London: Yale University Press, 2006).

Alex Coles (ed.), *Site Specificity: The Ethnographic Turn* (London: Black Dog Publishing, 2000).

Nathan Coley, *Urban Sanctuary: A Public Art Work by Nathan Coley* (Glasgow: The Armpit Press, 1997).

Lisa G. Corrin, 'The Perfect Home: A Conversation with Do-Ho Suh', in *Do-Ho Suh* (London: Serpentine Gallery, 2002), pp. 27–39.

Tess Cosslett, Celia Lury and Penny Summerfield (eds), *Feminism and Autobiography: Texts, Theories, Methods* (London: Routledge, 2000).

Penelope Curtis (ed.), *Gravity's Angel: Asta Groting, Kirsten Ortwed, Cristina Iglesias, Lili Dujourie* (Leeds: Henry Moore Institute, 1995).

Decisive Days: Elina Brotherus: Photographs 1997–2001 (Oulo, Finland: Kunstannus Pohjoinen, 2002).

Jacques Derrida, *Dissemination* [1972], trans. Barbara Johnson (London: The Athlone Press, 1981).

Jacques Derrida, 'Coming Into One's Own', trans. James Hulbert, Geoffrey Hartman (ed.), in *Psychoanalysis and the Question of the Text* (Baltimore: John Hopkins University Press, 1978), pp. 114–48.

Claire Doherty (ed.), *Contemporary Art: From Studio to Situation* (London: Black Dog Publishing, 2004).

Claire Doherty (ed.), *Thinking of the Outside: New Art and the City of Bristol* (Bristol: University of the West of England and Bristol Legible City in Association with Arnolfini, 2005).

Mladen Dolar, 'The Object Voice', in Renata Salacl and Slavoj Zizek (eds), *Sic 1: Gaze and Voice as Love Objects* (London and Durham, North Carolina: Duke University Press, 1996), pp. 7–31.

Jennifer Doyle, 'The Effect of Intimacy: Tracey Emin's Bad Sex Aesthetics', in *Sex Objects: Art and the Dialectics of Desire* (Minneapolis: University of Minnesota Press, 2006), pp. 97–120.

Umberto Eco, 'The Poetics of the Open Work' [1962], in Claire Bishop (ed.), *Participation: Documents of Contemporary Art* (London and Cambridge, Mass.: Whitechapel and The MIT Press, 2006), pp. 20–40.

Diane Elam, *Feminism and Deconstruction: Ms. En Abyme* (London: Routledge, 1994).

Tracey Emin, *Strangeland* (London: Hodder and Stoughton, 2005).

Tracey Emin: This is Another Place (Oxford: Modern Art Oxford, 2002).

Tracey Emin Works 1963–2006 (New York: Rizzoli, 2006).

Shoshana Felman, 'On Reading Poetry: Reflections on the Limits and Possibilities of Psychoanalytic Approaches', in Joseph H. Smith (ed.), *The Literary Freud:*

Mechanisms of Defense and the Poetic Will (New Haven: Yale University Press, 1980), pp. 119–48.

Shoshana Felman, *What Does a Woman Want? Reading and Sexual Difference* (Baltimore, Maryland: John Hopkins University Press, 1993).

Jane Flax, *Thinking Fragments: Psychoanalysis, Feminism and Postmodernism in the Contemporary West* (Berkeley, Los Angeles: University of California Press, 1991).

John Fletcher, 'Introduction: Psychoanalysis and the Question of the Other', Jean Laplanche, *Essays on Otherness*, ed. John Fletcher (London: Routledge, 1999), pp. 1–51.

Michel Foucault, *The Order of Things: An Archaeology of the Human Sciences* [1966], translated from the French (London: Routledge, 1992).

Hal Foster, The Return of the Real: The Avant-Garde at the End of the Century (Cambridge, Mass.: The MIT Press, 2001).

Sigmund Freud, *On Aphasia: A Critical Study* [1891], (New York: International Universities Press, 1953).

Sigmund Freud, *The Complete Letters of Sigmund Freud to Wilhelm Fliess, 1887–1904*, trans. and ed. Jeffrey Moussaieff Masson (Cambridge, Mass.: Belknap Press of Harvard University Press, 1985).

Sigmund Freud, *The Standard Edition of the Complete Psychological Works of Sigmund Freud*, (1886–1939), vols 1–24, translated from the German under the general editorship of James Strachey (London: The Hogarth Press, 1953–1974).

Sigmund Freud, 'On Dreams' [1901], *The Essentials of Psycho-analysis*, trans. James Strachey (London: Penguin Books, 1986), pp. 81–125.

Susan Stanford Friedman, *Mappings: Feminism and the Cultural Geographies of Encounter* (Princeton: Princeton University Press, 1998).

Diane Fuss, *Identification Papers* (London: Routledge, 1995).

Diana Fuss, *The Sense of an Interior: Four Rooms and the Writers that Shaped Them* (London: Routledge, 2004).

Diana Fuss and Joel Sanders, 'Berggasse 19: Inside Freud's Office', Joel Sanders (ed.), in *Stud: Architectures of Masculinity* (New York: Princeton Architectural Press, 1996), pp. 112–39.

Susanne Gaensheimer, 'The Politics of Space: Architecture, Truth, and other Fictions in the Work of Nathan Coley', in *Nathan Coley: There Will Be No Miracles Here* (Edinburgh and Newcastle: The Fruitmarket Gallery and Locus+, 2004), pp. 12–19.

Judy Gammelgaard, 'The Unconscious: A Re-reading of the Freudian Concept', *Scandinavian Psychoanalytic Review*, n. 26 (2003), pp. 11–21, pp. 15–16.

André Green, 'The Double and the Absent' [1973], in Alan Roland (ed.), *Psychoanalysis, Creativity, and Literature: A French-American Inquiry* (New York: Columbia University Press, 1978), pp. 271–92.

André Green, 'The Analyst, Symbolization and Absence in the Analytic Setting (On Changes in Analytic Practice and Analytic Experience) – In Memory of D.W. Winnicott', *International Journal of Psycho-Analysis*, v. 56 (1975), pp. 1–22.

André Green, 'Potential Space in Psychoanalysis: The Object in the Setting', in Simon A. Grolnick and Leonard Barkin (eds), *Between Reality and Fantasy: Transitional Objects and Phenomena* (New York and London: Jason Aronson Inc., 1978), pp. 169–89.

André Green, 'The Unbinding Process', *On Private Madness* (London: The Hogarth Press and the Institute of Psycho-Analysis, 1986), pp. 331–59.

André Green, *Key Ideas for a Contemporary Psychoanalysis: Misrecognition and Recognition of the Unconscious* (London: Routledge, 2005).

André Green, 'The Intrapsychic and Intersubjective in Psychoanalysis', *Psychoanalysis Quarterly*, v. 69 (2000), pp. 1–39.

André Green and Gregorio Kohon, 'The Greening of Psychoanalysis: André Green in Dialogue with Gregorio Kohon', in Gregorio Kohon (ed.), *The Dead Mother: The Work of André Green* (London: Routledge, published in association with the Institute of Psycho-Analysis, 1999), pp. 10–58.

Katja Grillner, Ramble, Linger and Gaze: Dialogues from the Landscape Garden (Stockholm: Axl Books, 2000).

Katja Grillner, 'Writing and Landscape – Setting Scenes for Critical Reflection', in Jonathan Hill (ed.), *Opposites Attract*, special issue of *Journal of Architecture*, v. 8, n. 2 (2003), pp. 239–49.

Katja Grillner, 'Fluttering Butterflies, a Dusty Road, and a Muddy Stone: Criticality in Distraction (Haga Park, Stockholm, 2004)', in Jane Rendell, Jonathan Hill, Murray Fraser and Mark Dorrian (eds), *Critical Architecture* (London: Routledge, 2007), pp. 135–42.

Elizabeth Grosz, *Volatile Bodies: Toward a Corporeal Feminism* (Bloomington and Indianapolis: Indiana University Press, 1994).

Donna Haraway, 'Situated Knowledges: The Science Question in Feminism and the Privilege of Partial Knowledge', *Feminist Studies*, v. 14, n. 3 (Fall 1988), pp. 575–603.

Jonathan Hill, *Actions of Architecture: Architects and Creative Users* (London: Routledge, 2003).

Jonathan Holmes (ed.), *Fallujah: Eyewitness Testimony from Iraq's Besieged City* (London: Constable and Robinson Ltd, 2007).

bell hooks, *Yearnings: Race, Gender, and Cultural Politics* (London: Turnaround Press, 1989).

bell hooks, *Wounds of Passion: A Writing Life* (London: The Women's Press, 1998).

Rolf Hughes, 'The DROWNING METHOD: On Giving an Account in Practice-Based Research', in Jane Rendell, Jonathan Hill, Murray Fraser and Mark Dorrian (eds), *Critical Architecture* (London: Routledge, 2007), pp. 92–102.

Rolf Hughes, 'The Poetics of Practice-Based Research', in Hilde Heynen (ed.), *Unthinkable Doctorates?*, special issue of *Journal of Architecture*, v. 11, n. 3 (2006), pp. 283–301.

Luce Irigaray, 'Women on the Market', in *This Sex Which Is Not One* [1977], trans. Catherine Porter with Carolyn Burke (Ithaca, New York: Cornell University Press, 1985), pp. 170–91.

Luce Irigaray, *Elemental Passions* [1982], trans. Joanne Collie and Judith Still (London: The Athlone Press, 1992).

Luce Irigaray, 'The Wedding between the Body and Language', in *To be Two* [1994], trans. Monique M. Rhodes and Marco F. Cocito-Monoc (London: Athlone Press, 2000), pp. 17–29.

Luce Irigaray, 'I Love to You', in *I Love to You: Sketch of a Possible Felicity in History* [1996], translated from the French by Alison Martin (London: Routledge, 1996), pp. 110–13.

Mary Jacobus, *Psychoanalysis and the Scene of Reading* (Oxford: Oxford University Press, 1999).

Amelia Jones and Andrew Stephenson (eds), *Performing the Body/Performing the Text*, (London: Routledge, 1999).

Rana Kabbani, *The Passionate Nomad: The Diary of Isabelle Eberhardt* (Boston: Beacon Press, 1987).

Caren Kaplan, *Questions of Travel: Postmodern Discourses of Displacement* (Durham, North Carolina: Duke University Press, 1996).

Nick Kaye, *Site-Specific Art: Performance, Place And Documentation* (London: Routledge, 2000).

Grant H. Kester, *Conversation Pieces: Community and Communication in Modern Art* (Berkeley: University of California Press, 2004).

Yasmina Khadra, *The Swallows of Kabul* (London: Vintage, 2005).

Sharon Kivland, *A Case of Hysteria* (London: Book Works, 1999).

Sharon Kivland, 'Memoirs', in Jane Rendell, Jonathan Hill, Murray Fraser and Mark Dorrian (eds), *Critical Architecture* (London: Routledge, 2007), pp. 143–9.

Gregorio Kohon (ed.), *The British School of Psychoanalysis: The Independent Tradition* (London: Free Association Books, 1986).

Miwon Kwon, 'Uniform Appearance', *frieze*, n. 38 (January–February 1998), pp. 68–9.

Miwon Kwon, *One Place After Another: Site Specific Art and Locational Identity* (Cambridge, Mass.: The MIT Press, 2002).

Miwon Kwon, 'The Other Otherness: The Art of Do-Ho Suh', *Do-Ho Suh* (London: Serpentine Gallery, 2002), pp. 9–25.

Christina Lamb, *The Sewing Circles of Heart: My Afghan Years* (London: HarperCollins Publishers, 2002).

Jean Laplanche and J.B. Pontalis, *The Language of Psycho-Analysis*, trans. Donald Nicholson-Smith (London: Karnac and The Institute of Psycho-Analysis, 1973).

Jean Laplanche, *New Foundations for Psychoanalysis*, trans. David Macey (Oxford: Basil Blackwell Ltd, 1989).

Jean Laplanche, 'The Kent Seminar, 1 May 1990', in John Fletcher and Martin Stanton (eds), *Jean Laplanche: Seduction, Translation and the Drives* (London: Institute of Contemporary Arts, 1992), pp. 21–40.

Jean Laplanche, 'The Aims of the Psychoanalytic Process', trans. Joan Tambureno, *Journal of European Psychoanalysis*, v. 5 (Spring–Fall 1997), pp. 69–79.

Jean Laplanche, 'The Theory of Seduction and the Problem of the Other', *International Journal of Psycho-Analysis*, v. 78 (1997), pp. 653–66.

Jean Laplanche, *Essays on Otherness*, ed. John Fletcher (London: Routledge, 1999).

Jean Laplanche, 'Narrativity and Hermeneutics: Some Propositions', trans. Luke Thurston and John Fletcher, *New Formations*, v. 48 (2002), pp. 26–9.

Jean Laplanche, 'Sublimation and/or Inspiration', ed. John Fletcher, trans. Luke Thurston, *New Formations*, v. 48 (2002), pp. 30–50.

Primo Levi, *The Periodic Table* (London: Penguin Books, 2000).

Audré Lourde, 'The Master's Tools will never Dismantle the Master's House' [1979], in Jane Rendell, Barbara Penner and Iain Borden (eds), *Gender, Space, Architecture: An Interdisciplinary Introduction* (London: Routledge, 1999), pp. 53–5.

Rodney Mace, *Trafalgar Square: Emblem of Empire* (London: Lawrence and Wishart, 2005).

Doreen Massey, 'Reinventing the Home', *Blueprint* (March 1999), pp. 23–5.

Mandy Merck and Chris Townsend (eds), *The Art of Tracey Emin* (London: Thames and Hudson, 2002).

Marsha Meskimmon, *Women Making Art: History, Subjectivity, Aesthetics* (London: Routledge, 2003).

Nancy K. Millar, *Getting Personal: Feminist Occasions and Other Autobiographical Acts* (London: Routledge, 1991).

Trinh T. Minh-Ha, *When the Moon Waxes Red: Representation, Gender and Cultural Politics* (London: Routledge, 1991).

Juliet Mitchell, 'Theory as an Object', *October*, v. 113 (Summer 2005), pp. 29–38.

Tracey Moffatt: Free-Falling (New York: Dia Center for the Arts, 1998).

Luciana Nissin Momigliano, 'The Analytic Setting: A Theme with Variations', in *Continuity and Change in Psychoanalysis: Letters from Milan* (London and New York: Karnac Books, 1992), pp. 33–61.

George Monbiot, 'War without Rules', in Jonathan Holmes (ed.), *Fallujah: Eyewitness Testimony from Iraq's Besieged City* (London: Constable and Robinson Ltd, 2007), pp. 107–12.

Mignon Nixon, 'On the Couch', *October*, v. 113 (Summer 2005), pp. 39–76.

Christina Noelle-Karimi, 'History Lessons: In Afghanistan's Decades of Confrontation with Modernity, Women have always been the Focus of Conflict' (April 2002). See http://www.wellesley.edu/womensreview/archive/2002/04/highlt.html (accessed 14 May 2008).

Nikos Papastergiadis, 'Tracing Hybridity in Theory', in Pnina Werbner and Tariq Modood (eds), *Debating Cultural Hybridity: Multi-Cultural Identities and the Politics of Anti-Racism* (London: Zed Books, 1997), pp. 257–81.

Michael Parsons, 'Psychic Reality, Negation, and the Analytic Setting', in Gregorio Kohon (ed.), *The Dead Mother: The Work of André Green* (London: Routledge, published in association with the Institute of Psycho-Analysis, 1999), pp. 59–75.

Steve Pile, *The Body and The City* (London: Routledge, 1999).

Steve Pile, 'The Un(known) City … or, an Urban Geography of what Lies Buried below the Surface', in Iain Borden, Jane Rendell, Joe Kerr with Alicia Pivaro (eds), *The Unknown City: Contesting Architecture and Social Space* (Cambridge, Mass.: The MIT Press, 2001), pp. 263–79.

Della Pollock, 'Performing Writing', in Peggy Phelan and Jill Lane (eds), *The Ends of Performance* (New York: New York University Press, 1998), pp. 73–103.

Griselda Pollock, 'Territories of Desire: Reconsiderations of an African Childhood', in Griselda Pollock, *Looking Back to the Future: Essays on Art, Life and Death* (Amsterdam: G+B Arts International, 2001), pp. 339–69.

Griselda Pollock, 'Thinking the Feminine: Aesthetic Practice as Introduction to Bracha Ettinger and the Concepts of Matrix and Metramorphosis', *Theory, Culture & Society*, v. 21, n. 1 (2004), pp. 5–64.

Elspeth Probyn, 'Travels in the Postmodern: Making Sense of the Local', Linda Nicholson (ed.), *Feminism/Postmodernism* (London: Routledge, 1990), pp. 176–89.

Jeanne Randulph, *Psychoanalysis and Synchronized Swimming and other Writings on Art* (Toronto: YYX Books, 1991).

Jane Rendell, *The Pursuit of Pleasure: Gender, Space and Architecture in Regency London* (London and New Brunswick, New Jersey: The Athlone Press/Continuum and Rutgers University Press, 2002).

Jane Rendell, *Art and Architecture: A Place Between* (London: I.B.Tauris, 2006).

Charles Rice, *The Emergence of the Interior: Architecture, Modernity, Domesticity* (London: Routledge, 2007).

Andreina Robutti, 'Introduction: Meeting at a Cross-roads', Luciana Nissim Momigliano and Andreina Robutti (eds), *Shared Experience: The Psychoanalytic Dialogue* (London: Karnac Books, 1992), pp. xvii–xxvi.

Robert Rogers, 'Freud and the Semiotics of Repetition', *Poetics Today*, v. 8, ns. 3–4 (1987), pp. 579–90.

Irit Rogoff, 'Studying Visual Culture', in Nicholas Mirzoeff (ed.), *The Visual Culture Reader* (London: Routledge, 1998), pp. 14–26.

Ralph Rugoff, *Scene of the Crime* (Cambridge, Mass.: The MIT Press, 1997).

Michael Schreyach, 'The Recovery of Criticism', in James Elkins and Michael Newman (eds), *The State of Art Criticism* (London: Routledge, 2008), pp. 3–25.

Michel Serres, *Angels: A Modern Myth* (Paris: Flammarion, 1995).

Situationist International Anthology [1989], ed. and trans. Ken Knabb, revised and expanded edition (Berkeley, California: Bureau of Public Secrets, 2006).

Michael Snelling (ed.), *Tracey Moffatt* (Brisbane: Institute of Modern Art, 1999).

Gayatri Chakravorty Spivak, 'Can the Subaltern Speak?' in Patrick Williams and Laura Chrisman (eds), *Colonial Discourse and Post-Colonial Theory: A Reader* (Hemel Hempstead: Harvester Wheatsheaf, 1993), pp. 66–111.

Daniel Spoerri, *An Anecdoted Topography of Chance* (London: Atlas Press, 1995).

Susan Rubin Suleiman, *Risking who One is: Encounters with Contemporary Art and Literature* (Cambridge, Mass.: Harvard University Press, 1994).

Catherine Summerhayes, *The Moving Images of Tracey Moffatt* (Milan: Edizioni Charta, 2007).

Rebeccca Swift (ed.), *A.S. Byatt and Ignes Sodré: Imagining Characters: Six Conversations about Women Writers* (London: Chatto & Windus, 1995).

Michael Tarantino, 'Enclosed and Enchanted: Et in Arcadia Ego', in *Enclosed and Enchanted* (Oxford: Museum of Modern Art, 2000), pp. 19–32.

Michael Taussig, *Mimesis and Alterity: A Particular History of the Senses* (London: Routledge, 1993).

Adriana Varejão: Chambre d'echos (Paris: Foundation Cartier pour l'art contemporain, 2005).

Serge Viderman, 'The Analytic Space: Meaning and Problems', *Psychoanalytic Quarterly*, n. 48 (1979), pp. 257–91.

Else Vieira, 'Liberating Calibans: Readings of Antropofagia and Haroldo de Campos Poetics of Transcreation', in Susan Bassnett and Harish Trivedi (eds), *Postcolonial Translation: Theory and Practice* (London: Routledge, 1999), pp. 95–113.

Richard Wentworth (Liverpool and London: Tate Liverpool and Tate Publishing, 2005).

Ulrich Wilmes, 'The Dramatization of Space: Cristina Iglesias: *Three Suspended Corridors*, 2005', *in DC: Cristina Iglesias: Drei Hängende Korridore (Three Suspended Corridors)* (Köln: Museum Lüdwig and Verlag der Buchhandlung Walther König, 2006), pp. 16–21.

D.W. Winnicott, 'Transitional Objects and Transitional Phenomena: A Study of the First Not-Me Possession', *International Journal of Psycho-Analysis*, v. 34 (1953), pp. 89–97.

D.W. Winnicott, 'The Use of an Object', *International Journal of Psycho-Analysis*, v. 50 (1969), pp. 711–16.

D.W. Winnicott, *Playing and Reality* (London: Routledge, 1991).

Elizabeth Wright, *Speaking Desires can be Dangerous: The Poetics of the Unconscious* (Cambridge: Polity Press, 1999).

Index